The Art and History of
Calligraphy

sideris anime sue: 7 iniquus

etur.

Eracerbauit dominum pec

secundum multitudinem ir

queret.

Non est deus in conspectu e

quinate sunt uie illius in on

pore

Luferuntur iudicia tua a f

Patricia Lovett

The Art and History of
Calligraphy

To the next generation: Charlotte, Thea, Joseph and Monty.

Many of the manuscripts illustrated in this book can be viewed online, including almost all of the British Library manuscripts. Digital copies can be accessed at https://www.bl.uk/manuscripts/ and pages can be enlarged for further detailed study.

First published in 2017
This edition published in 2020 by
The British Library
96 Euston Road
London NW1 2DB

Cataloguing in Publication Data
A catalogue record for this publication is available from
The British Library

ISBN 978 07123 5367 0

Designed and typeset by Maggi Smith, Sixism

Printed and bound in China

Contents

If you do not know how to write you will consider it no hardship, but if you want a detailed account of it let me tell you that the work is heavy; it makes the eyes misty, bows the back, crushes the ribs and belly, brings pain to the kidneys, and makes the body ache all over. Therefore, oh reader, turn the leaves gently and keep your fingers away from the letters, for as the hailstorm ruins the harvest of the land so does the unserviceable reader destroy the book and the writing. As the sailor welcomes the final harbour, so does the scribe the final line.

Silos Beatus, twelfth century.

I know of no other craft which imparts so easily and perfectly a strong feeling for rhythm, this conspicuous feature of all modern art. It also provides the best training for both hand and eye in the execution and adjustment of well-proportioned, properly spaced, uniform masses of letters.

Anna Simons, student of Edward Johnston. 'Lettering in Book Production', in *Lettering of Today*, a Studio Production, 1937.

† lucas urculus ꝶ
onginneð god rpell
Incipit euangelium secundum lucam..
 london

QUO
NIAM
QUIDE
MULTI
TISUNTORDINA
RENARRATIONEM

The Art and History of Calligraphy

1 This is the beginning of the Gospel of St Luke. At the top, in gold, is a cross and *Lucus Vitulus* (Luke; calf – the symbol of St Luke). Below that, in red, is the word *Incipit*. This is Latin for 'the beginning' or 'the opening words'. The huge letter *q* is divided into sections and filled with pattern – spirals, animals, interlaced and geometric shapes. Below the bowl of the *q* is a section that looks like a pattern suitable for a luxury silk scarf; in fact it is groups of four birds, necks and legs entwined. At the bottom four more birds are walking straight into the mouth of the monastery cat, who already has eight of their companions in his stomach. Follow the cat up to see his curling tail. The uncoloured *niam* row of red-dot outlined letters in the second line is intriguing.

The Lindisfarne Gospels, Incipit of St Luke.
BL Cotton Nero D.iv, f. 139r.

The glorious riot of intertwining decoration and vibrant colour in the major display pages of the Lindisfarne Gospels, produced by Bishop Eadfrith of Lindisfarne before 720 CE, are simply stunning (image 1). The decoration includes multiple birds, dogs and snakes and mystical, sinuous creatures contained within outline shapes and letters. For many, this is a triumph of embellishment and writing in which the one enhances the other; for Eadfrith, it was simply the best way to show this sacred text, and there was no separation for him between how the written word should be presented: whether written with a pen and using real gold (at the top of the page on the left) and black ink, or painted with a brush and decorated with colour. All was for the glory of God.

Other manuscripts of the time, such as the Vespasian Psalter produced in the south of England in about 730 CE (image 2), have a greater separation between most of the text and the images. Main headings are enlarged and decorated to make them stand out and draw the eye, however, and the earliest historiated initial (a letter that tells a story) shows David and Jonathan encased within a wonderful initial letter **D**.

The simplicity of the David and Jonathan initial and the complex and colourful paintings of the Lindisfarne Gospels developed into intricate decoration and

2 At the top left of the page on the right, in the enlarged initial 'D', is thought to be the earliest historiated initial; it is of David and Jonathan. The discoloration of the following alternate letters could be because they were painted in silver, lead white or vermilion red (cinnabar). The tiny Uncial writing, not more than 2–3 mm high, has a translation between the lines written in a lively Pointed Insular Minuscule; this is the earliest extant English translation of any part of the Bible. On the left page David is depicted as a Psalmist with his lyre; on either side of him are scribes taking down his words, one on a scroll – which could represent the Old Testament – and one on wax tablets – which could depict the New Testament. Below David are dancers, and musicians blowing horns.

The Vespasian Psalter.
BL Cotton Vespasian A.i, ff. 30v–31r.

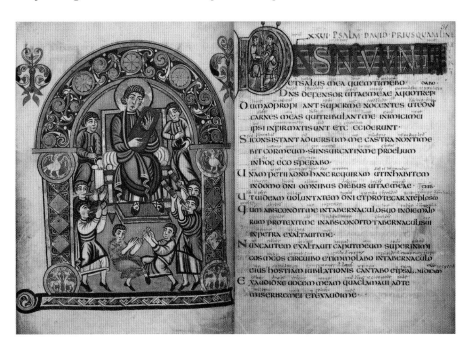

complicated illustration in the later Middle Ages. In a number of manuscripts, and in grand books such as the Bedford Hours, the decoration almost takes over the text altogether (see page 144). In many books it is difficult to isolate the writing from the illustrations, and, as the latter are so essential to the 'look' of the book, the *mis-en-page*, they are inextricably bound to the text. Gothic Black Letter script, Gothic Textura, in the Bedford Hours, for example, needed to be strong, dense, gutsy lettering to hold its own against everything else happening on the page.

The usual and simple definition of calligraphy is 'beautiful writing', although the word did not appear in English until 1613.[1] It comes from two Greek words, *kallos* meaning beauty (beautiful, fine, happy, favourable) and *graphein* meaning to write or draw. The word calligraphy is narrowly defined by some as letters made only with a pen, with letters that are drawn or painted referred to as lettering. This is not a distinction made here. The work of many calligraphers encompasses letters that are drawn, painted *and* written with a pen, sometimes in the same piece. In the manuscripts included in this book, letters that have been drawn – rather than written – with a pen or painted with a brush are not excluded because of the tool used, nor for the fact that more than one stroke was needed to construct the letter. It could also be said that calligraphy is a grand form of handwriting, so manuscripts from the early centuries of the first millennium and later glosses (a translation or explanation of the text), neither of which may always be beautiful in the eyes of all beholders, are all included if relevant. This is therefore a 'broad-church' study of calligraphy from the early centuries of the first millennium to the present day. This widely encompassing view is echoed by Alfred Fairbank (1896–1982), who wrote:

> Calligraphy is 'handwriting as an art'. To some, calligraphy will mean formal penmanship. It will suggest manuscript books, broadsheets and scrolls, with precise scripts against which are set the vivid colours of illuminating and the glitter of burnished gold. Others may think of calligraphy as the cursive handwriting used for correspondence and records which has legibility and beauty in spite of a swift pen. Calligraphy, then, may be considered as covering formal or informal handwriting, and to be found in the enduring and precious manuscript books preserved on the book-collector's shelf or on the envelope already lying in the waste-paper basket.[2]

However, in a book of this size, it would be impossible to include manuscripts representing every single area of production and age, so selection had to take place. The manuscripts featured here are ones from Europe with interesting stories, which represent a particular writing style or which illustrate a particular aspect of book and manuscript development; apologies are proffered to those who feel that their favourites have been omitted. The terminology of palæographers often differs from that of calligraphers. The title of this book does favour calligraphers, but, where appropriate, the palæographic name for the script is also given for clarity.

The earliest example of handwriting in Britain, from the first century CE, is that found on bark tablets of Vindolanda, an army post on Hadrian's Wall in the north of England. The writing style is Old Roman Cursive, which was used throughout the Roman Empire. These alder, oak or birch bark tablets are about the size of a postcard and were usually folded in half with the writing on the inside, similar to modern notepaper. They are mainly concerned with garrison military matters, but there are also delightful personal insights into life at a Roman outpost. In the oldest surviving document written in Latin by a woman, Claudia Severa writes to invite a friend, Sulpicia Lepidina, to her birthday party. Another tablet includes details of socks, sandals and underpants sent to a soldier, along with greetings to 'all your mess mates'.

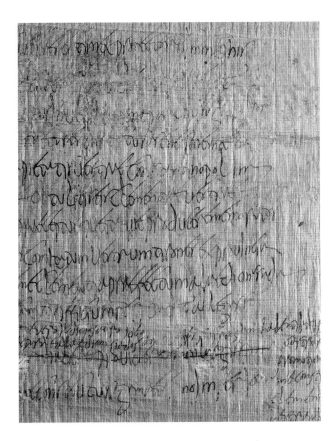

3 New Roman Cursive. Everything about this suggests speed – the many joins between letters, letters not always fully completed and the strong diagonal strokes to the right. The script also looks impossible to read, but it has been transcribed,³ and it is possible to identify some of the letter-forms:

[[]] estia pietatis vestræ constantinopolim
[[]] atque obtulitis eis clementiæ vestræ
[[]] ussit præceptusque itaque producere
memoratus [[]] crum comitatum vestrum
 tirones ex
provincia [[]] vere me clementia
 præfectum alæ
dionusada [[]] eo comiti officium
 respondit allegasse

BL Papyrus 447, recto.

Old Roman Cursive can be difficult to decipher, but was based on the very clear grand Roman Capital letters. New Roman Cursive, where the separate strokes forming the letters sometimes seem to have lost their cohesion, is used in documents from the late third century CE onwards; it can be even more illegible if that is possible. Both are the predecessors of the writing styles in this book (see image 3).

Most writing in these very early centuries was on scrolls. It is frustrating that there is no documented evidence as to why scrolls were replaced by the codex or book form. Certainly, as only one side was used in the main for writing on a scroll, the pages of a book, where writing is usually on both sides, were a much more economical use of a scarce resource such as parchment and vellum. In addition, scrolls usually had several spare sheets at the outer edge of the roll to allow for damage, and also wide margins top and bottom for handling. Neither of these was necessary with more robust animal skin. By the second century CE we do have evidence in Egypt of Christians using a codex form which was similar to a pamphlet. It may have been thought that sacred text should be recorded in a different physical format from secular writing on scrolls. There are also many references in the New Testament to the Old Testament. It must have been so much easier to check the text by turning to a page and marking that place in a book, say in Psalms or Isaiah, and then confirming that in the Gospels of Matthew or Luke than by having to find the relevant scrolls, unroll them to the appropriate place and weigh down each corner to stop them rolling back up again. Books have distinct advantages over scrolls.

A type of codex form was known in ancient times, and its use continued into the nineteenth century. A small block of wood was split into two, and the facing central portions of each hollowed out. Splitting one piece of wood in this way thus ensured a better and closer fit between the two facing panels. The hollows were filled with wax, and the wood panels attached on one long side with thongs to make a hinge. The wax was thus protected inside by the outer wood frame. The sharp metal point of a stylus was used to write the letters, and its flat, spade-like other end did the erasing so that the tablets could be used again and again.

The Springmount Bog Tablets (*c.* 600) indicate that the use of tablets continued beyond ancient times. It is thought that possibly a trainee priest was consulting the Psalms on them when they slipped from his hand into the preserving mud of the bog.

Scrolls gradually gave way to books, and by the middle of the fourth century grand books such as the Codex Sinaiticus (the whole Bible written in one volume, a *pandect*) were being produced. This could be one of the 50 great Bibles commissioned by the Emperor Constantine (280?–337 CE). He wrote to Eusabius of Cæsarea:

> *I have thought it expedient to instruct your Prudence to order fifty copies of the sacred Scriptures, the provision and use of which you know to be most necessary for the instruction of the Church, to be written on well-prepared parchment by copyists most skilful in the art of accurate and beautiful writing, which (copies) must be very legible and easily portable in order that they may be used.*⁴

The Codex Sinaiticus (see page 62) was written in Greek and on animal skin, at a time when papyrus was the common material for book production. The shape of

this book is also different from the rectangular shape of scrolls in that its pages are large (38.1 cm height x 34.3 cm wide; 15 by 13½ inches) and almost square. However, the narrow, four-column layout of the text for many pages in this book does reflect that of scrolls. This could have been a visual reference to the fact that this book contained text with a status equivalent to that of classical writings.[5] The Latin word for these narrow columns is *paginæ (pagina,* singular*)*, from which we clearly get the word 'page', while a roll, as in a scroll, in Latin is *volumen,* volume – a book.

Scripts continued to be based on capital letters, from the Roman Square Capitals (*Capitalis Quadrata,* also *Scriptura Monumentalis*) of the fourth-century Codex Augusteus (see page 64), clearly related to the lettering on inscriptions but in pen form, to the Rustics of the fourth- or fifth-century Vergilius Romanus, featuring slightly less formal (though hardly 'rustic') letters (see page 68). In Roman times the latter style was often written with a brush, which produced a fluid line; it can be seen in painted election posters on the walls and shop signs in Pompeii, as well as in stone inscriptions. For both scripts, when written in texts, a broad-edged pen was used, and a degree of pen manipulation was required. It was difficult to write on the bumpy papyrus surface with a pointed pen, as it caught and sprayed ink spots, so pens, and brushes too, usually had a broad edge. For writing in manuscripts, the broad-edge tip was cut in both a reed (*calamus*) or quill pen (*penna*), making the characteristic thicks and thins shown in the letter-forms.

The angularity of some letters in Roman Capitals became more rounded when written with a slight increase in speed, and this style, developed originally in North Africa, was called Uncial. The Latin for 'inch' was *uncia,* and it was St Jerome (*c.* 347–420 CE) who, apparently in rather a disparaging way, referred to this script as being as large as an inch – although there are very few uncial letters that are as big as this in manuscripts. He wrote in his Preface to the Book of Job:

> *habeant qui volunt veteres libros, vel in membranis purpuris auro argentoque descriptos, vel uncialibus, ut vulgo aiunt, litteris*[6]

> ('*Let those who so desire have old books, or books written in gold and silver on purple parchment, or burdens written in uncial letters, as they are popularly called*').

Perhaps St Jerome felt that this rather business-like style, used in official documents and for trade, was getting a little above itself, becoming too elaborate and having ideas above its station when it was used in books. Uncial was the style of writing used in a number of manuscripts from the middle of the fourth century. It is usually a clear writing style, and easy to read (see image 4).

With continuous writing, without spaces between individual words, and dense columns of text, there are very few clues to find or remember a place in the text. In most formal books from the late sixth century onwards, page design changes and illustrations were inserted; enlarged letters also marked the start of important sections and chapters. Script too was sometimes written out *per cola et commata* (see image 4), with a new line, and often an indentation, according to clauses and phrases, all of which made navigation of the text much easier.

Other writing styles were developing in Europe not using capital letters but based on New Roman Cursive (although this did itself develop from Old Roman Cursive). This resulted in minuscule, or lower-case, letter-forms, where ascenders, such as on letters **b**, **d** and **h**, extend above the body of the letter and descenders, for example on letters **g**, **p** and **q**, extend below the body of the letter. Writing can become peculiar to an area, region or country in a similar way to art, language,

4 Uncial letters in a sixth-century northern Italian Gospel Book in Latin. Note the pen-decorated initial **I** at the top of the page of St Mark, and the enlarged initials made by more than one pen-stroke at the beginning of verses. There is no word division: it is written as *scriptura continua*, and the text is *per cola et commata*, whereby words are written on a new line according to clauses and phrases.

BL Harley 1775, f. 144r.

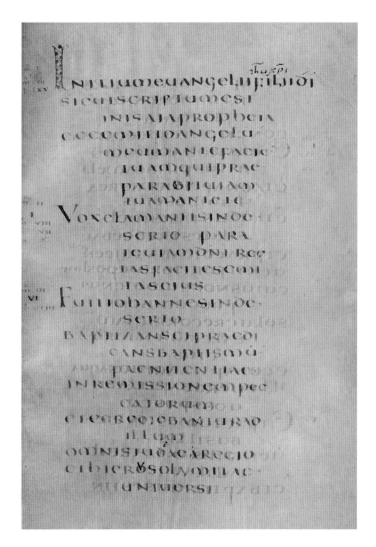

architecture, music and even cuisine. In the British Isles, the letters of New Roman Cursive developed into Half-Uncial, as in the Lindisfarne Gospels (see page 76) and the Royal Bible from Canterbury, probably written around 820–40 (BL Royal 1 E vi). In Spain and Portugal a related style was used in Visigothic manuscripts; this also appeared in southern Italy in Beneventan manuscripts (named after the Duchy of Benevento) and in Merovingian scripts (named after the Merovingian dynasty) in France. Each style had its own characteristic strokes and letter-forms which made the scripts distinctive (see images 5a, b and c).

In Britain and Ireland, Half-Uncial, as in the Lindisfarne Gospels with its roots in New Roman Cursive, had its own legacy. A quicker, less formal script developed – Insular Minuscule – and was used for both books and documents. With its upright nature and distinctive pointed ends to the descenders, it looks very elegant. This style developed over the years into the more formal book hand of Insular Square Minuscule and Insular Round Minuscule.

In about 890 King Alfred (849–899) sent round a copy of Pope Gregory's *Cura Pastoralis* ('Pastoral Care', written around 590) to his bishops, which the king himself had translated into Old English. An accompanying letter used the phrase *englisc gewrit*, which can be translated as '[until they can read] English handwriting'. Alfred's

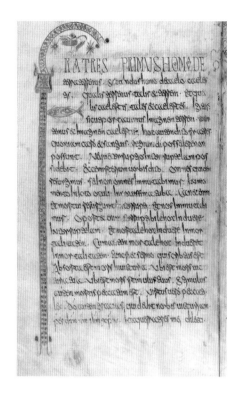

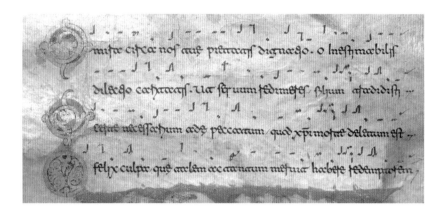

letter encouraged the reform of Insular Minuscule for vernacular texts, and the script was often used for translating Latin into English, such as the glosses in the Lindisfarne Gospels and the Vespasian Psalter (see pages 76 and 80).

Perhaps, though, the height of clarity in lettering styles was that used during the time of Charlemagne (*c.* 747–814), which set the scene until Gothic scripts evolved centuries later. The long-lived nature of Caroline Minuscule (see image 7) was such that it was revived again in the Renaissance as Humanistic Minuscule, with the clear, ninth-century letter-forms adopted and then also adapted as printing typefaces. We recognise the looped **g** and two-storey **a** without giving them a second's thought, yet few of us use these forms in our ordinary handwriting. We have become familiar with them as they are used in typefaces such as the one in this book, and this is just part of the legacy of this historical Carolingian script.

The advantages of literacy were recognised by Charlemagne and it was noted by his biographer Einhard (*c.* 775–840):

Temptabat et scribere tabulasque et codicellos ad hoc in lecto sub cervicalibus circumferre solebat, ut, cum vacuum tempus esset, manum litteris effigiendis adsuesceret, sed parum successit labor præposterus ac sero inchoatus.[8]

('*He also tried to write, and used to keep tablets and blanks in bed under his pillow, that at leisure hours he might accustom his hand to form the letters; however, as he did not begin his efforts in due season, but late in life, they met with ill success*').

Charlemagne also wanted to ensure that the text of the Bible was accurate; at the time it was said that there were as many versions of the Bible as there were copies of it. He wanted Bibles to be written correctly by those who knew how to write well,

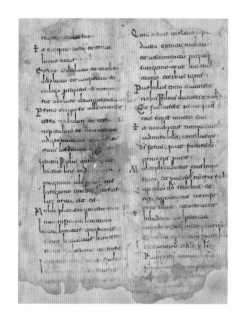

7 (above) This late eighth-century Gospel Book, written probably in Reims, shows a strong Caroline Minuscule. Although the script does not have much word separation, it is extremely easy to distinguish and identify the letter-forms. Note the characteristic two-storey letter **a**, with a huge bowl, and the looped **g**. The wide arches of the letters **u**, **n**, **m** and **r** are echoed in the wide and round letters **b**, **d**, **p** and **q**. Interestingly, the downstrokes do not have the usual heavy club serif on most of the letters, although there is a slight thickening on some, made by pressure on the nib. Not constructing this serif-shape may be because this lettering is all in gold, known as *chrysography*; this has particular challenges when writing as the heavy metallic pigment falls to the tip of the nib in the first stroke or two. To achieve the consistency on the page as here is truly admirable.

BL Harley 2797, f. 22v.

and the written text to be clear to read. In a decree of 789 Charlemagne declared that 'only the most skilful or mature scribes should be entrusted with the most solemn books' and 'if the work is a Gospel Book, Psalter, or Missal, the scribes should be of the perfect age for writing diligently'.[9]

As Holy Roman Emperor, Charlemagne, who was enthroned on Christmas Day 800, also commissioned luxury books with gold writing on purple-dyed skin. This harks back to Roman times, when purple was the imperial colour and gold, of course, represented wealth and power.

Alcuin of York (*c.* 735–804) was recruited by Charlemagne, first to reform the court school at Aachen and then, in 796, when Alcuin was in his sixties, to be abbot of St Martin at Tours in France. It was during Alcuin's time at Tours, and after, that about one hundred great *pandects* were produced, almost two a year for the first 50 years of the ninth century; a pandect is the Bible in one volume, which was unusual for the time. The great books were written in the very readable Caroline Minuscule. This clear, legible minuscule had its roots in Corbie, also in France, and the Corbie 'ab' minuscule[10] evolved into the Maurdramnus Minuscule, named after abbot Maurdramnus at Corbie (*c.* 772–81).

Caroline Minuscule (see above left) was a writing style with extended ascenders and descenders, and a proportionately smaller body to the letters. There is usually a slight forward slant and an almost imperceptible diagonal tension to the script. It is, though, eminently readable, and even those who are not familiar with Latin could identify the individual letters.

It is important to note at this point that although one lettering style may give way to another, this rarely occurs as a sudden switch from one script to the next, with the previous ones being forgotten. It is usually a gradual process, and due reverence is often given to older scripts in their use as enlarged drop capitals, headings, introductions – *incipits* – and endings – *explicits*. All of these are well shown in the

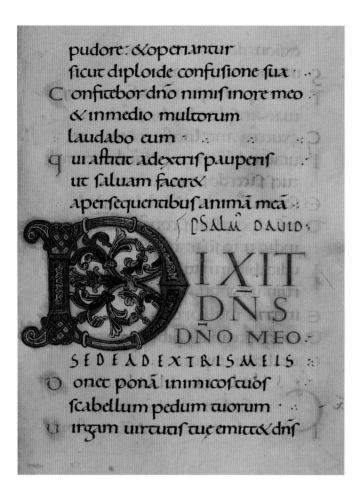

8 The Ramsey Psalter with its bold, clear, English Caroline Minuscule letter-forms and an enlarged **D,** with acanthus leaf decoration and gilded Roman Capital letters. Note the use of Rustics for 'Psalm David' and also the line below the enlarged **D**, and then Roman Capitals for the start of the psalm; each verse begins with an Uncial letter, showing that historical letter-forms were not abandoned but remained in use in manuscripts. The psalter was probably created in Winchester in the last quarter of the tenth century.

BL Harley 2904 f. 144r.

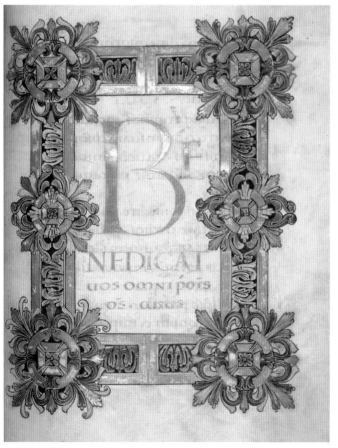

9 Glorious and beautifully formed gilded Roman Capitals, made with more than one pen-stroke, hold their own against an intricate border with six enlarged corner and mid-border decorations. The combinations of squares, crosses and circles in these almost suggest shield bosses. There has been a degree of wear on the raised shiny gold illumination, but when first completed the reflection of light from this brilliant leaf gold must have been almost blinding. This manuscript was also made in Winchester and for St Æthelwold at around the same time as the Ramsey Psalter. We know that Godeman wrote this book (see page 101) and that the scribe of the Ramsey Psalter was a different person. How fascinating to think of Godeman and the unknown scribe, both at the top of their game, sitting next to one another, perhaps in the scriptorium at Winchester, comparing notes and sharing ideas for decoration.

BL Add. 49598, f. 65r.

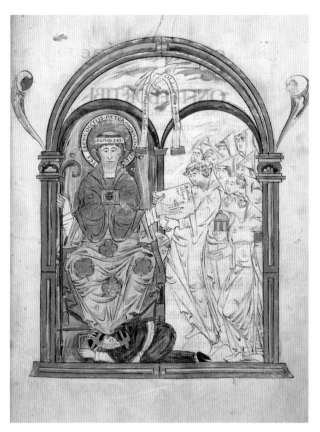

great Bibles from the Abbey of St Martin at Tours in France (see page 92), and in the Ramsey Psalter (see image 8 and page 98).

Caroline Minuscule changed slightly when it crossed the English Channel to Britain. The elegant, delicate script retained its legibility, but the look became sturdier. The lettering in the Ramsey Psalter (see opposite and page 98) and the Benedictional of St Æthelwold (see opposite and page 100), both written towards the end of the tenth century and probably in Winchester, show a more upright style of writing, with shorter ascenders and descenders, producing a more chunky feel. As with its continental cousin, though, the script is extraordinarily clear and easy to read. In both books, grand capital letters with acanthus leaf decoration mark them out as manuscripts with a European influence.

A few decades later, in the first quarter of the eleventh century, the Christ Church, Canterbury, monk Eadui Basan (Edwin the Fat) was very influential in adapting English Caroline Minuscule. He elongated the ascenders and descenders again, maintaining the upright stance, but also slightly compressing the letter-forms. This created a most elegant style evident in a number of manuscripts: the Eadui Psalter (see left), the Eadui Gospels, the Grimbald Gospels (page 106) and a number of charters. The Corpus Christi Pontifical, now in the Parker Library, is a book written by Eadui Basan for archbishops. It includes directions for the coronation ceremony, raising the possibility that the book may have been used in the eleventh century for the coronation services of English and Norman kings such as King Harold and William the Conqueror.

Back in Europe, centres of book production flourished at Metz, St Gall and Reichenau, among other places. Ottonian books, however, were something to behold. The Ottonian dynasty ruled Germany and northern Italy between 919 and 1024, and before, during and after their reign they produced a number of spectacular books, such as the Gospel Book of Emperor Otto III, which is still in its original gold and bejewelled cover.

The twelfth century saw a renaissance in knowledge and learning as well as an increase in the production of manuscripts by lay people outside religious scriptoria, although these, of course, continued to produce books. The first university in Europe was founded in 1088 in Bologna; the university in Paris was founded in about 1150 and that in Oxford in 1167. Scholars needed books, and stationers either provided those books or lent out sections of them, gatherings of folded pages, which students copied themselves. This was called the *pecia* system, a *pecia* being approximately 16 columns of 62 lines of 32 letters, or about 7,500–8,000 words. When one section had been copied it was returned to the stationer in exchange for the next one with additional payment.

However, it was also a time when those other than religious foundations and the very rich could acquire books. The middle classes had more disposable income, but not a great deal of choice of what to spend it on. Manuscript books became a status symbol, with Books of Hours, whereby the religious offices of the day could be followed in the home of a lay person, and Psalters the main choices. These books were commissioned not from scriptoria attached to religious foundations but usually from lay people, stationers. They organised the various craftspeople and oversaw the work, from supplying the skin to final binding into a book. In Catte Street, Oxford, parallel to School Street (where the students lived and worked), craftspeople were producing books from the thirteenth century.

10 The Eadui Psalter (also known as the Arundel Psalter), written between 1012 and 1023 at Christ Church, Canterbury, underlines how important St Benedict was at this time. He is painted on the left, seated and in full colour, with God's hand in blessing. Around Benedict's halo is written 'Sanctus Benedictus pater monachorum et dux' ('St Benedict, father and leader of monks'). On the right, the monks are shown in outline colour only, presenting St Benedict with a book and relics. They are not in full colour because this was the style for 'ordinary' people – as opposed to saints and Christ – at the time. The bottom figure, usually identified as Eadui Basan, is prostrate at St Benedict's feet, offering his book to the saint. Around his waist is a belt indicating a 'zone of humility', but he is in full colour, even intruding into the half where his wraith-like brethren are depicted – not quite so humble perhaps!

BL Arundel 155, f. 133r.

Once the price had been agreed, the size of the book specified, the number of illuminations and enlarged initials (if any) determined, and the amount to be spent on gold and precious pigments such as ultramarine (blue) and cinnabar (vermilion – red) arranged, the prepared skin would be cut to shape and size, and ruled up. Then the scribes got to work. Spaces on the page would be left for the pictures, and gaps for the enlarged initial letters. Just to make sure, the scribe often wrote a tiny letter to guide the person doing the larger decorated letters. Illuminators dealt with the gold and usually the painting too; Walter of Eynsham, Radulfo, Roberto and Job the Illuminator are all known to have been working with gold and colour in Oxford at this time. Each craftsperson would have been paid for their work by the stationer who oversaw book production. Recent research by Erik Kwakkel[11] suggests that there were not scriptoria where all these craftspeople worked together, but that they were working on their own, in their own studios or homes.

There is a detailed record of the prices of making a book from a fifteenth-century manuscript in Cambridge,[12] written by the owner of the book, who perhaps was trying to stop costs running away. However, it would be more usual for these sums to be recorded by the stationer:

> *Pro pergamo 27 quat. precium quaterni iii d. Summa vi s. ix d.*
> *Pro scriptura eorundem viz. xvi d. pro quaterno. Summa xxxvi s.*
> *Pro luminacione viii d.*
> *Pro ligacione ii s*[13]

The parchment cost 3 pence (3d) per quire,[14] or 6 shillings and 9 pence for all the pages (6s 9d); copying the text cost 16 pence per quire (1 shilling and 4 pence; 1s 4d) or 36 shillings for the complete book (£1 16s). The illumination cost 8 pence (8d), which seems like a small sum, and the bookbinding 2 shillings (2s). The total for this book then was £2 5s 5d, which would, very roughly, be about £1,000 to £1,400 today. It depends very much on the size of the book and thus the amount of vellum required, but it would be difficult to replicate this for the same amount now. As the various processes in making the book are recorded separately in this way, it does emphasise that they were carried out by different people.

In religious foundations and for scholars of biblical texts, the renaissance in knowledge in the twelfth century took another turn. Glossed books, whereby commentaries and explanations on the religious text were written on the page, had been known since the seventh century in Ireland. From the time of the universities the glosses became important aids to the study of the scriptures. Peter Lombard (1100–1160) produced major glosses on the Psalms and St Paul. As well as this, books of the Old Testament, such as Psalters, were written with different translations. The Eadwine Psalter, for example (see page 122) contains three columns. In one column the Gallican version of the Psalms is written, which was a translation from the Greek Septuagint;[15] in another column was the Roman version, which was the Gallican version corrected by St Jerome using the Hebrew Bible; and the third column carried the Hebrew version, which was Jerome's translation from the Hebrew Bible. These books required a considerable amount of planning to ensure that the glosses and text, as well as the various translations, related to one another on the page.

This increase in demand all round for books meant that far more skins were needed than previously. However, those large, lavish books with round letter-forms based on Caroline Minuscule and wide spaces between the lines of lettering, many

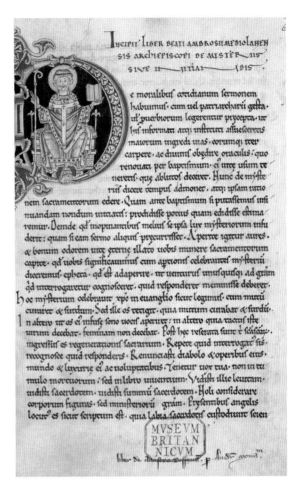

11 A book of theological tracts on St Ambrose, produced probably at Rochester Priory in Kent in the early twelfth century. The letter-forms are distinctly compressed, with heavy, diamond-shaped serifs to the tops and bases of strokes which give a horizontal feel to the page. (On the continent this was less pronounced at the base, and the ending stroke to the letters here was usually constructed just by moving the pen to the right and up with no serif.) The page starts with Rustic Capitals and a beautiful extended tail to the letter **R** at the end of the second line. The vastly exaggerated diagonals to the letter **N** could perhaps be considered a little excessive.

BL Royal 6 B vi, f. 2r.

12a Lettering in the fourteenth-century Luttrell Psalter is impressively even and regular. It is made even more so by the flat horizontal endings to the downstrokes, which are 'constructed' by being drawn with the left-hand corner of the nib and then filled in with ink. This can be seen clearly in the **b** towards the end of the first line, where at the top the darker parts of the letter have been written with the complete nib held at an angle of about 45°. The left-hand corner of the nib is then used to draw the prescissus ending, but for this particular letter it is not filled in. In the letter **b** in line 2, the whole of this outlined section has been filled in, albeit with slightly dilute ink. Note the delightful endings to the letters **g** and **r**, and the similar decoration on punctuation marks. This was not a scribe in a hurry!
BL Add. 42130, f. 158r.

12b Gothic Textura in Latin and French in a thirteenth-century manuscript. Most downstrokes of letters that do not have ascenders, such as **m**, **n**, **r** and **i**, start with a diamond serif and, where appropriate, end with one too. Most ascenders, as on **l**, **h** and **b**, start with 'fish-tail' serifs at the top of downstrokes. It is possible in this extract to detect where the scribe refilled the quill with ink. Look at the second line and the letter **o** in **soit** is slightly paler, then the letter **i** is much denser; this density continues until the letter **i** in **toi**, just a little further along the line, and then the **s** (looks like an **f**) in **semblable** is again darker and so on.
BL Add. 44949, f. 99r.

12c Although it looks very even and regular, the diamond–downstroke–diamond construction of the letters in Gothic Textura breaks down a little here, in that the endstrokes tend to be rounded strokes with no pen-lifts to construct the diamond or prescissus endings. It is called Gothic Rotunda because of the roundness of these last strokes. The guidelines in this thirteenth-century manuscript are marked in lead or silver point and the scribe writes most consistently above it – rather a challenge. The glorious tail of the letter **x**, swooshing to the left in the middle of the top line shown in the enlargement, is perhaps a tiny act of freedom in a very rigid, precise script.
BL Burney 282, f. 35v.

illustrations and enlarged headings took up far too much vellum or parchment for impecunious students and others wanting books. Writing became more compact and more compressed with a narrow, oval form. The Proto-Gothic style (see image 11) was the precursor to full Gothic, and the movement had already been started by Eadui Basan.

In the twelfth century at the Abbey of St Denis, now in the northern suburbs of Paris, a new style of architecture developed. Wide half-moon Romanesque arches gave way to groups of narrow, pointed arches allowing much more light to come into the building. Churches and cathedrals became light and airy spaces, and the huge, heavy columns supporting the buildings became narrower also and were grouped into clusters. It is said that in Gothic buildings, light appears to triumph over substance. Lettering changed too and took a similar, but slightly different, form. The strokes became upright and angular, and the lettering looked almost pointed, rather like the arches of buildings. However, the letter-forms produced were dense, with strokes close together, and the impression was of very black letters; some say they resemble a picket fence.

Gothic Black Letter or Gothic Textura (also *Textualis Quadrata*) letter-forms (see image 12b) typically start with a diamond shape making the serif and, where appropriate, as on letters **i**, **l**, **h**, **m**, **n** etc, end with a diamond serif too. Unlike the easy flow and movement of Caroline Minuscule, there are many separate strokes and pen-lifts to Gothic Textura letters as one stroke finishes and another starts. Because of the time taken to lift the pen and reposition it, this was one of the more expensive styles of the time for those commissioning a book. However, even more expensive was Gothic Prescissus (meaning 'cut off'); here the heads and feet of the downstrokes are flat and horizontal to the line, looking perhaps as if they

13 Italian Rotunda in this Book of Dante's *Inferno*, written less than 50 years after Dante's death in 1321. Here is an extract from the 'Sowers of Discord'. The lettering has many Gothic characteristics including the angular letter-forms as in the letters **l**, **r**,and **e**, and the arches to the letters **m**, **n** and **u**. However, there is not the great compression and narrowing of letters of northern Gothic scripts, and letters based on an **o**, as in **g**, **p**, **h** and **d**, are angular but quite wide. Note the lemon shape to the counter (inner white space) of the letter **o**.

BL Add. 19587, f. 47v.

have been sliced by a knife. In fact, on close examination, many of the 'flat' endings are actually dished, owing to the construction of the letter. For each of these end-strokes, the left-hand corner of the nib was used to draw the 'flat' shape as shown in image 12a. A slightly less formal and quicker style of writing was Gothic Rotunda (see image 12c), not to be confused with Rotunda as written in southern Europe in Italy and Spain (see image 13). With Gothic Rotunda the end shapes are made simply by moving the nib to the right and up at the finish of the stroke, resulting in a slight rounding – hence the name Rotunda. This was much quicker to do as it does not involve a pen-lift or a constructed shape, so Rotunda was one of the least expensive styles of writing to commission.

The density of texture and strength of the letter-forms in Gothic manuscripts were necessary, as otherwise they would have been almost completely swamped by everything else on the page in many manuscripts of this period. Sections of text started with large, colourful gilded letters, with gold leaf attached to raised gesso and polished to a mirror shine with a smooth stone mounted in a handle to make a burnisher. Important pages had detailed painted and gilded miniatures; and these, and the text, were often surrounded by decoration in the margins. Such decoration, with intricately painted flowers and plants and a whole menagerie of animals and grotesques, could hardly be called 'marginal'! Delicate and light lettering such as Caroline Minuscule or Insular Minuscule just would not have been able to stand up to these complicated, strong and in-your-face pages.

In Italy and Spain, scribes could not quite bring themselves to compress and make as rigid the letter-forms to the extent that their northern cousins did. Although there are elements of Gothic in the writing, with many angles rather than curves, the style used, Rotunda, was based on an angular, but rounded letter **o**. This particular letter is distinctive because the counter (inner white space) is typically lemon-shaped as can be seen in image 13; all letters based on a letter **o** follow this pattern, as in **b**, **c**, **e**, **g**, **p** and **q**.

For many of these Gothic scripts, including Rotunda, letters are often squashed together and share a common stroke. This is called 'biting of bows'. The Gothic Textura enlargement (see image 12b) shows this in the first line where in the third and seventh words (**deu** and **des**) the letters **d** and **e** share a common stroke. In the Dante extract (see image 13) this is shown again in the first and second lines, where **p** and **e** of **per** share a common stroke, again in line three with the word **poco**, where the strokes of the letters **p**, **o** and **c** are written over one another, and then at the beginning of line five, with the strokes of the letters **h** and **e** of **che**.

14 A fifteenth-century copy of Boethius's *De Consolatione Philosophiæ* is written in Bastard Secretary and has been graded as 'medium quality', yet it has strength, rhythm and great elegance. Note the long **s** and **f**, strokes that have thickened waists and then taper into nothing, extending well below the line for the rest of the descenders. This stroke is made either by pressing very hard with a flexible quill, or by two separate strokes to create the thickness. Whichever was the method of construction, for the tail of the letter the pen is gradually rotated anti-clockwise from about 40° to 5° (this is also the slant of the writing, so the stroke is then wafer thin) as the stroke is made until it is at its narrowest at the end. This takes some practice, but is not difficult to do. Despite its seemingly delicate nature, the writing holds its own with a large and colourful painted miniature, and an enlarged, decorated and gilded initial letter **A**.

BL Add. 10341, f. 8r.

All of these Gothic scripts took a considerable amount of time to write, as the pen was lifted not only to construct the letters, but also to make the serifs and the ends of the strokes. In prestigious books, such as the Luttrell Psalter, where money seemed to be no object and the scribe even had time to construct little pen-made spirals at the ends of strokes and on punctuation using the left-hand corner of the nib (see image 12a), all this added to the luxury. For getting through state business, though, and for communications, all this pen-lifting was far too time-consuming. A hybrid script developed for use in documents taking elements of Gothic, but also with a more cursive nature; the 'mixed' character gave rise to its name – Bâtarde or Bastard script. This is also called Lettre Bourguignonne and was associated particularly with the Burgundian court. When used as a formal book hand it is most elegant, and that elegance continues on many documents too, where lower-grade scripts are called Secretary, Cursiva Anglicana or Bastard Secretary. All these styles are characterised by thickened and extended letters **f** and long **s** (indistinguishable at a quick glance), with the long strokes ending in a complete point (see image 14).

Although they never went wholly down the route of complete Gothic compression and narrow letter-forms, scribes in Italy did adopt elements of it, and the majuscules, or capital letters, in the Dante enlargement (see image 13) do show signs of complexity. The Renaissance and the associated Humanist movement of the fourteenth and fifteenth centuries favoured individuality, the classics, and scholarship in Latin and Greek texts, and rejected the uniformity of Gothic in most of its forms and used mainly for religious writings. The Humanists' revival of classical texts meant not only searching libraries and monasteries for books and manuscripts containing works of Latin and Greek writers, but also developing a 'completely' different style of writing. Perhaps in a similar way to early Christians, who may have chosen a different physical form, the codex, for their sacred texts to distinguish them from secular works, the Humanists wanted a different writing style for classical texts to make them look different from Gothic religious writings. With the wide, semi-circular arches on the many Roman buildings which were, and are, still standing in Italy, the similar round arches of the letter-forms in Caroline Minuscule must have had an appeal – not least because they were thought to be old;[16] the Humanists regarded them as, if not actually Roman, then pretty close to the time of the Romans. They called this style *Lettera Antiqua* – the

old writing – and *Lettera Moderna* was Gothic script. What they perhaps did not fully appreciate was that they had adopted as their exemplar lettering style that which was used during the time of Charlemagne. The emperor was also a fan of the classics, although the repressive northern dictator was hardly an enlightened Humanist.

Petrarch (1304–1374) is regarded as the Father of Humanism. In his essay *La Scrittura* [17] ('Writing') he criticised Gothic Textura as a style that had exuberant letter-forms (*luxurians*) and artificial or laboured strokes (*artificiosis litterarum tractibus*), suggesting that it may look pretty but was not meant to be read. Petrarch provided the bridge between Gothic scripts and the Humanistic Minuscule that was to come.

Scribes such as Coluccio Salutati (1331–1406), Niccolò Niccoli (1364–1437) and Poggio Bracciolini (1380–1459) were influenced by Petrarch and developed the writing style still further. Based on Caroline Minuscule, their letter-forms were round and words easy to read. However, whereas the earlier writing usually had a simple curved stroke at the ends of the downstrokes, made by the pen moving to the right and up as it was taken from the writing surface, in *Lettera Antiqua*, or Humanistic Minuscule, there was a more precise foot to the ends of the letters; this echoed the serifs of Roman Capitals cut into stone (see image 15).

Roman Capitals, so pleasing to the eye and so clear to read, are still the writing style of choice today for inscriptions in stone and wood, for company logos, for titles and text headings and also for street signs. The revival and use of the Roman Capital form is usually placed at the door of Felice Feliciano (1433–1479). He spent much of his life studying this style in Roman inscriptions, and it resulted in him noting that they can be recreated geometrically. Feliciano worked out that they were based on a circle encased in a square. He wrote about this in a book now in the Vatican Library,[18] which also includes his beautifully drawn letters. Although not quite right in every degree (his letter **D** is too wide, for example) it did provide an exemplar that is still used today (see images 16a and b).

The Paduan scribe Bartolomeo Sanvito (1433–1518) developed his own style of Humanistic Minuscule with a slightly narrower letter **o** and a very regular and even script. Sanvito also wrote a distinctive style of Roman Capitals with a repeated scheme of colours and gold (see image 17). He was a prolific scribe with 125 manuscripts

15 This delicate Humanistic Minuscule is in a sixteenth-century Psalter which belonged to Henry VIII. It was written by Jean Mallard, who is recorded as 'orator in the French tongue' in the king's accounts. The spacing of the letters in this book is particularly regular and even, and the arch-forms of the letters **m**, **n**, **b**, **d**, **u**, **q** and **p** clearly echo the round letter **o**. The ends of the downstrokes, though, are different from those in Caroline Minuscule (see image 7), where in those earlier manuscripts they are usually a simple pen-lift to the right and upwards. Here Mallard has used the pen to construct horizontal feet which give a regularity to the base line. He does seem to have gone a little far in the foot of the letter **r**, particularly in lines six and seven in the enlargement, where the letter almost resembles a **c** with a starting serif! Note, too, the ampersand (*&* – meaning 'and') in lines six and seven, constructed almost as the numeral eight, with two additional strokes to the right, one down and one up.

BL Royal A xvi, f. 8.

16a Felice Feliciano from Verona, known as Felice the Antiquarian, also seems to have been rather bohemian in character, according to Sabadino degli Arienti in his *Novelle Porretane*. Felice made detailed studies of Roman lettering from stone inscriptions, and those studies are certainly put to good use in this manuscript of letters and sonnets from *c.* 1471–5, written by Felice himself. The vellum is tinted green, with rather rough brush strokes still visible as though it was done in a hurry. The lettering is in shell gold, with pen-made decoration also in shell gold in lines two and three. The top border is in silver, which has now discoloured to black.

BL Harley 5271, f. 3r.

16b Felice Feliciano identified that Roman Capitals could be constructed geometrically based on a circle and a square. In this diagram, all the letters of the alphabet, except the letter **W** (not a Roman letter), can be made using elements of that circle and square. Round letters **C**, **D**, **G**, **O** and **Q** are based on a circle or parts of a circle. Symmetrical letters **A**, **H**, **M** (a letter **V** with slightly splayed legs), **N**, **T**, **U** (not a Roman letter, but just about fits this system), **V**, **X**, **Y** and **Z** are the width of three-quarters of that circle encased in a square. Asymmetrical letters **B**, **E**, **F**, **J**, **K**, **L**, **P**, **R** and **S** are the width of half of that square. The letter **I** is a simple downstroke, and the letter **W** is now written as two slightly narrow **V**s. In the first half of the twentieth century the two inner diagonals were often crossed or the second **V** was written close to the first diagonal stroke, both creating rather ungainly letters (see the William Morris manuscript on page 180). All these letters (apart from **W**) have been constructed geometrically in the diagram, however, when the letters are written or carved, artistry and what looks best to the eye prevail, and so the top bowl of the letter **B** is slightly smaller than the lower one, otherwise the letter looks unbalanced, and the same is true of the letter **S**. The letter **P** has a slightly larger bowl than the letter **R**, while the horizontal middle stroke of the letter **E** is shorter than the top stroke – which is itself a little shorter than the bottom stroke – and so on.

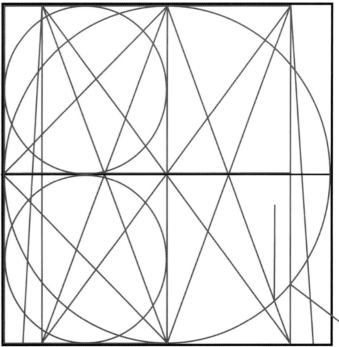

17 Everything about this page of a manuscript made for Bernardo Bembo is typical of the Renaissance and the Humanists appreciating the Roman style – from the Ionic pillars decorated with relief figures, as on the Trajan column in Rome, to the decorated Roman arch, the *putti* playing on and between the columns, the grotesque below the writing and the mythical beasts curling round at the top, swallowing their own tails. The grand Roman Capitals are even placed such that it suggests an epigraph. The lettering is by Bartolomeo Sanvito, and is characterised by coloured letters alternating with those written in shell gold (see page 156). Sanvito's choice of colour for this lettering was usually consistent in his manuscripts, with lines of gold and blue, gold and red, gold and green, gold and purple, and so on repeatedly. His letters are spaced majestically, and the forms are most pleasing. Notice the slight backwards slant to letters that have diagonals, such as **A**, **M** and **V**, the graceful tail to the letter **Q** and the extended letter **Y** which has two arms curving upwards, almost in supplication to the sky.

BL Royal 14. C. iii, f. 2r.

attributed to him, excluding books which have his frontispieces or incipits. He had a number of wealthy and powerful patrons including Bernardo Bembo (1433–1519). Sanvito and Bembo built up a friendship such that Bembo called the illegitimate son he had with Magdalena, from Padua, Bartolomeo, after Sanvito.[19] It is said that Sanvito could write 200 to 300 pages of Italic in seven weeks,[20] a remarkable output. Sadly Sanvito suffered from the scribe's curse of arthritis towards the end of his life. The condition resulted in a less firm line to his letters, suggesting a slight tremor.

The Humanists revived the classics, and the collections of the rich and powerful resulted in large libraries. The manuscript collection of Federigo, Duke of Urbino (1422–1482), for example, consisted of 2,000 to 3,000 volumes and was valued at 30,000 gold ducats[21] at the time, which is about £3 million today. Federigo also employed around 40 *scrittori* (professional copyists, usually fluent in Latin and Greek) to write out his selected texts. Vespasiano da Bisticci (1421–1498), a bookseller or *cartolai*, employed 45 *scrittori* who wrote 200 volumes for Cosimo de Medici (1389–1464) in 22 months.[22] This works out at about four-and-a-half books per scribe in less than two years, which is not a huge amount. It is thought that they probably also worked for other patrons, but that number of books produced in such a short time for one patron is still impressive.

It is rare that the development, invention even, of a particular style of writing can be attributed to one person, but this seems to be the case with Niccolò Niccoli. In the 1420s Niccoli began to write a sloping, cursive running script, known as *Cancelleresca all'Antica*, Humanistic Cursive Book Script, or, more commonly, Italic. Scholars have noted that Niccoli's Italic is not simply Humanistic Minuscule speeded up, as letter-forms such as **a** and **g** are different from *Lettera Antiqua*, and the movement, angle and speed of writing the letters not only makes it look distinct on the page, but also creates an asymmetrical arch-form to letters such as **b**, **d**, **g**, **h**, **m**, **n** etc. James Wardrup, the renowned scholar of the Humanists and their writing, has noted: 'Informality is the keynote of Italic; rapidity its virtue; utility its aim.'[23] This writing style spread across Europe, and was used both for handwriting (see image 18a) as well as for a formal book hand (see image 18b). Letter-forms were extended and made elaborate when used for the papal chancery,[24] which is where the Milanese Giovan Francesco Cresci (*c.* 1534/5–early seventeenth century) worked from 1556. The style used in the chancery even had its own name – *Cancelleresca*. The script became a beautiful and elegant writing style.

Italic spread throughout Europe, and was adopted by learned men and women in many royal courts. Among them was the future Queen Elizabeth I (1533–1603), who was taught the script by Roger Ascham (*c.* 1515–1568); Ascham sent Elizabeth a new pen and one he had mended specially for her when she was still a princess.[25] It is interesting to note that a style of writing developed in the early fifteenth century is often considered nowadays to be the mark of an artistic and educated person.

18a (above) Bernardo Bembo's writing from his commonplace book, including two elegant *maniculae*, or hands, pointing to a particular passage. The book contains various extracts from contemporary and classical writers, arranged alphabetically. The marginal notes relate Bembo's own personal experiences from 1471–1518.

BL Add. 41068A, f. 167v.

18b (right) This fragile and rather damaged manuscript, written probably in 1489 in Rome but with Venetian characteristics, consists of a collection of elegies in memory of Orsino Lanfredini, who died when he was just 18 years of age in 1488 in a street brawl between the rival factions of Orsini and Cibò. The editor of the elegies was Vasino Gambara and they are written by an unknown scribe. It is a very graceful script, written in shell gold on vellum, which has been dyed black. The ascenders start with a slight curve from the right and the descenders have pronounced feet. The pen-made floral decorations and flourishes are most pleasing.

BL Add. 22805, f. 2v.

Ludovico degli Arrighi (1475–1527) from Vicenza worked in the papal chancery in 1515. He was a scribe of great talent and his Italic writing is exquisite (see image 19a). It is graceful and there is a remarkable consistency of form, with a slight forward slant of 2°–5° to the letters and ascenders that start with a curve to the left, echoed by the shape of the descenders of letters such as **f** and the long **s** curving to the left. Arrighi published the first practical manual on writing, *La Operina* ('The Little Work'), which is usually dated 1522, but probably printed in Rome in about 1524 (see image 19b).

Arrighi's printed book was followed by that from another great scribe. The Venetian Giovani Antonio Tagliente (*fl.* 1468–1527) published *Lo Presento Libro* ('The Present, or Current, Book') in 1524. He was writing master to the Venetian chancery, and Arrighi may have been one of his pupils.[26] Giovanbattista Palatino (1515–1575) wrote the *Libro Nuovo d'Imparare a Scrivere* ('The New Book of Learning to Write'), which was published in 1550, while Giovan Francesco Cresci published his *Essemplare* ('Exemplar') in 1560 and *Il Perfetto Scrittore* ('The Perfect Writer') in 1570. Writing and copybooks were not confined to the Italians, though; Francisco Lucas from Spain wrote his *Arte de Escrevir* ('The Art of Writing') in 1571, and the Frenchman Jean de Beauchesne published *Le Trèsor d'Escriture* ('The Treasury of Script') in Lyon in 1580.

These printed copybooks meant that far more people could learn how to write in this style. Soon much of Europe had adopted Italic as the normal handwriting, and also as a book hand for a number of manuscripts. However, it was this same printing process that led to the demise of the need for scribes to copy out books. A printing press produced books in greater numbers, more cheaply and far more quickly than someone writing out text by hand. Two printers from Germany, Konrad Sweynheym from Mainz and Arndol Pannatz from Cologne, arrived at the Benedictine Abbey of Subiaco in 1464. It is thought that Sweynheym may have worked with Johannes

Gutenberg in Germany. However, unlike Gutenberg's own type they adopted a 'half Roman' type to print both religious and classical texts. It was Nicolas Jenson (1404–1480), though, from Sommevoire in France, who is credited with designing one of the finest early complete Roman typefaces. He was sent to Mainz in 1458 by Charles VII of France to study printing with Gutenberg, and ended up in Venice in 1468. By the late 1470s Jenson ran 12 presses producing books in both Roman and Gothic type.

Aldus Manutius (1449–1515), from Bassiano near Rome, developed the Italic typeface at his press in Venice, which he set up in 1490; he also established the semi-colon and standardised the full stop, the colon and the comma. James Wardrup[27] suggests that Aldus's Italic typeface, which was cut by Francesco Griffo (1450–1518), was actually inspired by Bartolomeo Sanvito. Wardrup says: 'His [Sanvito's] script and Aldus's type are not identical: but I know of no other script which, in form and spirit, so closely resembles it.' Nor does the link with Sanvito stop there: it extended to his great friend Bernardo Bembo. Manutius promoted an early pocket book; his idea was to create the kind of book that 'gentlemen of leisure' could carry in a pocket or satchel to read when and where they wished. Virgil's *Opera* in 1501 was his first octavo volume.[28] In a letter to Pietro Bembo (Bernardo Bembo's son) in his 1514 printed version of Virgil, Manutius wrote that he 'took the small size, the pocket book formula, from your library, or rather that of your most kind father'.[29]

The printing press provided relatively inexpensive books in greater number than before. However, it did not mean that there was no need whatsoever for scribes;

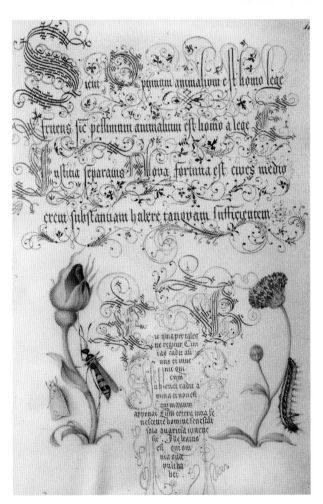

in fact luxury volumes have always been hand-written, and continue to be so today. One such is the small manuscript book, about the same size as a modern paperback, entitled *Mira Calligraphiæ Monumenta* ('Model Book of Calligraphy'). The book was produced between 1561 and 1562 by the Croatian calligrapher Georg Bocskay for the Holy Roman Emperor Ferdinand 1 (1503–1564). It is a real tour-de-force of calligraphic skill, with page after page of various delightful writing styles. There are Gothic scripts, tiny writing, *Cancelleresca*, elaborate flourishes and even mirror writing showing the same fine skill as that written normally: it is an amazing accomplishment. As if the lettering could not stand gloriously on its own, Ferdinand's grandson, Rudolph II (1552–1612), commissioned the artist Joris Hoefnagel (1542–1601) to add fruit, flowers and insects to each page. The trompe l'œil paintings are truly remarkable and look, in many cases, as if insects have just alighted on the page or flowers have simply been dropped (see image 20). However, there are many instances where the paintings far overwhelm the lettering.

Scribes still wrote out single documents such as legal agreements, indentures and house deeds, even with the rise in use of the printing press (see image 21). Many of them were on vellum or parchment, even though paper had been produced in Europe from the eleventh century, reaching Germany in the fourteenth century, and in England the first paper mill was set up in 1490, by John Tate near Stevenage in Hertfordshire. Animal skin is known to be long lasting, and recording the deeds of property on vellum or parchment was a legal requirement in the UK until the Land Registry was set up in 1926.

In London in 1733 there were at least 25 excellent writing masters, such as B. Whilton, Jo Champion, Nathaniel Dove and Samuel Vaux, who were approached by George Bickham the Elder (1684–1758) to contribute to his 'copybook', *The Universal Penman*.

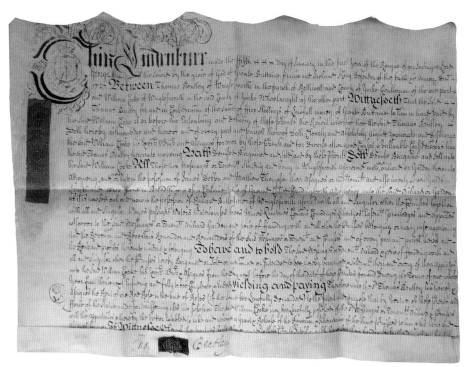

In fact, the copybook was a series of 52 individual prints, issued in a series of parts over eight years. Bickham, a supreme writing master himself, was also an engraver; he cut the copper plates for the book and revealed incredible skill in the medium by doing so. Most of the plates show letters in intricate designs, with rural scenes, engraved images or even more elaborate lettering at the top; the texts are on various topics such as religion, knowledge, modesty etc. The ones on writing include:

> *Strive to excel, with ease the pen will move;*
> *And pretty line add charms to infant love.*
>
> *If you would write both legible and fair*
> *Copy these alphabets with all your care.*

As the letters were carved on copper plates with a pointed metal burin, the movement of the tool resulted in the letters in *The Universal Penman* being smoother and more rounded, not pointed or angular as in some Italic styles. However, many of the letter-forms in Bickham's book could rarely be achieved by a pen without a great deal of skill and manipulation, so even 'careful copying' seldom had the desired effect. It did, though, provide one of the links between the Italic of the Humanists and Copperplate writing, taking on the promotion of the English Round Hand from writing masters such as William Banson and John Ayers (*fl.* 1680–1700) of the second half of the seventeenth century. Other writing styles developing at this time give a clue as to their origin, for instance, Engraver's Hand and also Engrosser's Hand.

The increase in trade throughout the world meant that a good, efficient style for clerks was required, a style that could be read relatively easily and written efficiently. In the nineteenth century schoolchildren were expected to practise their writing at some length, usually in copybooks, often using scratchy pens and poor quality ink. Copperplate, the writing named after the engraved plates used to make the prints,

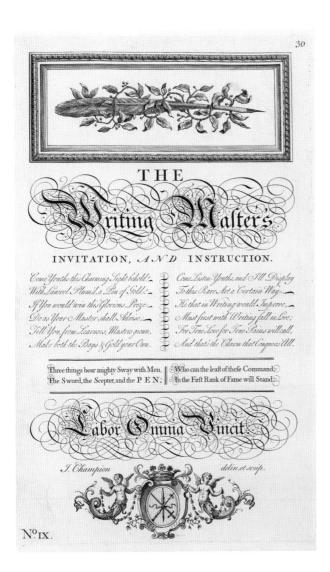

23 This glorious mix of Gothic script and Renaissance decoration is a page from a presentation volume from 1876 to Andrew Cowie, the Collector of Inland Revenue in Birmingham for 50 years. The border is shell gold in which geometrical and swirling patterns have been embossed with a pencil burnisher. On this are painted typical Renaissance symbols such as decorated columns with hanging foliage, curling stems with flowers and leaves, men's faces with exaggerated beards and moustaches, and beautiful birds with elegant tails. The lettering, though, is very Gothic, although the letter-forms are most idiosyncratic. A broad-edged nib has been used to form the main diamond-downstroke-diamond features of the text which starts 'His Colleagues and Friends', but there are few joining strokes, so the strokes in the letters **n** and **m** stand isolated and unjoined. A narrow pen has been used to add a form of fishtail serifs and to extend strokes with a fine line and a curl such as on the letters **s**, **g**, **a**, **d** and **r**.

Private collection.

22 (above) George Bickham the Elder's *The Universal Penman* consists of pages by the best writing masters of the day. They are stunning to look at, but set a rather high standard for the ordinary writer. It would be possible to recreate the title and the writing at the bottom of this page, but this would require a great deal of practice and skill. The admonition to do as 'Your master shall advise' to improve writing is, though, sound advice if you have a good writing master!

BL 788.g2, p. 30.

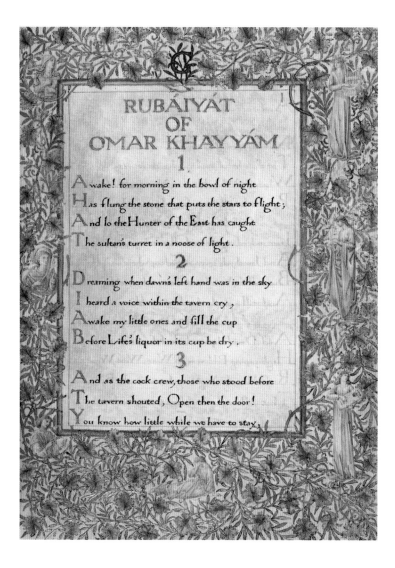

24 Early in his five-year period working on mediæval manuscripts, William Morris wrote out and illuminated *The Rubáiyát of Omar Khayyám,* finishing it on 16 October 1872. The poem was translated from the Persian by Edward J. Fitzgerald in 1859, and became very popular in Victorian times. The lettering for the text is based on Humanistic Minuscule with its two-storey letter **a** and looped **g**. The title, verse numbers and initial letters to the lines are all in gold leaf on gesso. The entwining gold and subtle blue leaves, together with the painted figures (designed by both William Morris and Edward Burne-Jones and painted by Charles Fairfax Murray), are reminiscent of a combination of Gothic and Renaissance manuscripts. The **G** at the top is for Georgie Burne-Jones, to whom William Morris dedicated this and other manuscripts.

BL Add. 37832, f. 1r.

became the style of the working class, and therefore, in the UK, of the clerks of the British Empire. Interestingly, good, neat handwriting was not considered essential for the nobility and literary classes. The writing of Queen Victoria, and also of distinguished authors and poets of the time, for example, is often very difficult to read.

Those who could write a 'good hand' were still required, though, for important documents and presentations. Queen Victoria received a number of addresses at her various jubilees, and they were often written on vellum with gold and colour (see page 178). Similarly, when people needed to be recognised for something important, often a skilled scribe, and even an illuminator, were involved. E. Morton of Birmingham was one such: he prepared a stunning address bound in a book to recognise the services of Andrew Cowie to the Inland Revenue, accompanied by a 'service of plate' (see image 23).

William Morris (1834–1896) was a great polymath, with a wide range of interests that took in designing furniture, Icelandic sagas, stained glass, dyeing fabric, embroidery, architecture and much more. Fiona MacCarthy[30] notes that Morris's interests overlapped and extended for about five years before he moved on to something else. One such interest was mediæval manuscripts, and between 1870 and 1875

Morris 'worked on eighteen manuscript books and many trial fragments, a total of over 1,500 pages'.[31] Manuscript painting and illumination was an accepted pastime for a 'lady in society', and illumination boxes, or kits, for such an occupation had been sold by Windsor & Newton since the middle of this century. Morris, though, rejected the Victorian over-elaborate mishmash of styles used by E. Morton, as in image 23 and in the many Jubilee loyal addresses to Queen Victoria, and took calligraphy to another level by studying and developing his knowledge of manuscripts in the Bodleian Library and the British Museum (where the British Library collections used to be housed). However, he did not achieve the level of letter analysis of others who followed him, such as Edward Johnston (1872–1944). Graily Hewitt (1864–1952), initially one of Johnston's students, became himself a renowned expert on illumination; he noted that there was a certain roughness in Morris's calligraphy, and the somewhat spikey feel was created by 'the dash of diagonal strokes he made for his commas and tails to p's and q's'.[32] It was not only the lettering that interested Morris, though. His study of the manuscripts led him to illumination, and he spent much time experimenting with quills (although not cutting them himself), vellum skins (which he bought from Rome), gold and pigments.

Edward Johnston came to London from Edinburgh in 1898 after abandoning his medical studies because of ill-health. This was two years after William Morris died, so he never met the great man. However, he did develop a lasting friendship with Morris's secretary, Sydney Cockerell (1867–1962). Six years after their meeting, Johnston wrote to Cockerell:

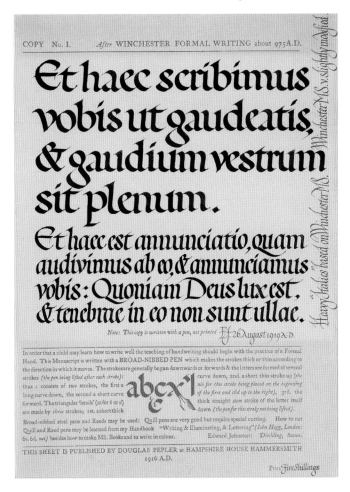

You may have forgotten meeting me at the British Museum, on 28th October 1898 and giving me criticism and advice (for abt [about] half an hour) wh [which], were and have been of gt [great] value to me.[33]

Cockerell himself later noted about this first meeting:

I merely took Johnston from case to case pointing out the finest pieces of handwriting, and laying special stress on the Winchester scripts of the tenth and eleventh centuries, which he soon after took as his models.[34]

And in 1913 Johnston wrote in a dedication: *To S C Cockerell who (very kindly) always tore me to pieces.*[35] Cockerell had not been that impressed with Johnston's first efforts at writing, but he did introduce him to the Winchester scripts on which Johnston based his Foundational Hand (see image 25). Johnston also studied Roman Capitals, and those studies not only influenced his students, but are also the basis for Johnston's clear and distinctive typeface for the London Underground, which is still used today.

Amazingly, it was only a year after that first meeting with Cockerell and his guidance in the British Museum that Johnston was asked to start teaching at the Central School by W. R. Lethaby (1857–1932). Lethaby was a renowned architect, co-founder of the Art Workers' Guild in 1884 and a friend of William Morris, and Morris, of course, inspired the Arts and Crafts movement. Lethaby was also founder, in 1896, of the London County Council's Central School of Arts and Crafts.

In some ways it is no surprise that Lethaby asked Johnston to teach there as the school recruited expert craftspeople rather than teachers; its central premise was to break down the barriers between design and production.

Johnston's classes were popular. Among his students were Eric Gill (1882–1940), the letter-cutter, artist and sculptor, who became a lifelong friend, and his younger brother MacDonald Gill (1884–1947), known as Max, an artist, cartographer, calligrapher and letter designer. It was Max Gill who designed the majestic Roman Capitals for the First World War gravestones of northern Europe – the lettering style inspired, no doubt, by Johnston. Graily Hewitt was a lawyer and novelist, and also a student of Johnston, and it was he who revived the mediæval technique of gilding with gesso that raises the gold leaf from the surface of the skin to make it look like areas of solid gold. Hewitt experimented with the different ingredients for gesso throughout his working life. He used different variations for each page of the book of *The Rubáiyát of Omar Khayyám* and recorded the ingredients in an accompanying notebook, now in the British Library (see image 26b). He often collaborated with other practitioners, such as the gifted artist and illuminator Ida Henstock, and she decorated borders and panels on Hewitt's work.

Johnston's eye for detail, his meticulous studies and his appreciation of the letter-forms in historical manuscripts created a legacy which still endures today. Johnston's seven-point analysis (see pages 53–7) – pen nib angle, x-height, shape of the letter o, slant of the letters, serifs, the sequence of strokes and finally the speed at which the letters were written – is used by many teachers in their classes. Three women students in particular took on Johnston's studies.

26a This wonderfully lettered manuscript by Graily Hewitt was made to record the early history of the Art Workers' Guild, founded in 1884. A riot of blue leaves, Tudor roses with raised gold centres, and a whole flock of birds surround the strong black lettering. William Morris was the Master in 1892 and a bronze bust of him, slightly smiling, looks down on all in the Lecture Hall.

Reproduced by kind permission of the Art Workers' Guild. Photograph by Yanko Tihov.

Both Irene Wellington (1904–1984) and Dorothy Mahoney (1902–1984) stood in for Johnston as teachers when he was unwell and could not take his classes. Image 27 is one of Johnston's many 'p.c.'s' (postcards) to Dorothy Mahoney, or Miss Bishop as she was then, telling her that he would not be able to teach and asking her to take his class. On the main side of the postcard he explains why he likes to use double pencils or 'twin-points', and includes a pen-made diagram of how to make them.

Anna Simons (1871–1951), also one of Edward Johnston's first students, took his work and ideas on lettering back to her native Germany; she translated his 1906 book *Writing & Illuminating, & Lettering* into her own language in 1910. This raised considerable interest in calligraphy and lettering in Germany that still continues today.

Calligraphers were occasionally asked to write enlarged or decorated letters in printed books. Johnston wrote strong, large initial letters, often in red, in a number of such books. Philip Mairet (1886–1975), husband of the weaver Ethel Mairet (1882–1952), composed a song to the tune of the sea shanty *Sally* (or *Shallow*) *Brown*, when they were settled at Ditchling, East Sussex, which he sang at one of the celebrated Ditchling Press Suppers. It includes the verse:

26b (above) Graily Hewitt noted the various ingredients to make gesso for a manuscript book (BL Egerton 3783 A), where a different recipe was used for every page.

BL Egerton 3783 B, f. 16r.

27 (above right) In this postcard to Dorothy Mahoney (née Bishop) Edward Johnston describes the value he places on using double pencils because they show more clearly the actual form of the strokes, whereas 'a wet nib … tends to conceal one's faults'.

Private collection.

The local scribe we sought and did invite
Way Ho, a-writing we will go.
Some fine capital letters in red to write,
As the old writers wrote their writing long ago.[36]

The 'local scribe' was, of course, Edward Johnston.

The Johnstonian tradition of looking to historical manuscript books for inspiration continued throughout the twentieth century and many formal pieces were produced, often in Johnston's Foundational Hand. Books of Remembrance for the First and Second World Wars usually recorded the names of those who died or were injured in this grand style (see page 192).

Sadly, the teaching of lettering, once part of most art courses in the UK, ceased in the 1950s and 1960s. There may now be very few full-time calligraphy and lettering courses throughout the world, but there is still considerable interest in being able to write calligraphically.

As with lettering styles through the ages, things calligraphic do not stand still. The formal book scripts of earlier times have been adapted and manipulated in the late twentieth and early twenty-first centuries, when calligraphy has been used not only for traditional purposes, such as writing out rolls of honour, presentation certificates and book texts, but also to create expressive and interpretative artworks where the words inspire the design.

SCRIPTOR·SCRIPTORVM PRINCEPS EGO·NEC OBITVRA DEINCEPS LAVS MEA·NEC FAMA·QVÆ SIM MEA LITTERA CLAMAT·

PREDICAT EGO VINVS FAMA PER SECVLA VIGCO · INGENIVM CVIVS LIBRI DECVS INDI

TE TVA SCRIPTVRA QVEM SIGNAT PICTA FIGVRA·

CAT HVIVS· QVEM TIBI SEQ DATVM MVNVS DEVS ACIPE GRATVM·

How Manuscripts are Made

28 Eadwine describes himself as the 'Prince of Scribes' (red lettering at the start of the top line) and is shown here sitting on an elaborate chair, writing in his book at a sloping board draped with a cloth. He is inside a building decorated with columns, elongated windows and two round towers. Certainly this is the furniture and surroundings fit for a prince. Christ Church, Canterbury, *c.* 1160.

The inscription from top left:
The scribe (in green): *I am the chief (prince) of scribes, and neither my praise nor my fame shall die: shout out, oh my letter, who I may be. The letter* (in green): *By its fame your script proclaims you, Eadwine, whom the painted figure represents, alive through the ages, whose genius the beauty of this book demonstrates. Receive, O God, the book and its donor as an acceptable gift.*
Courtesy the Master and Fellows of Trinity College, Cambridge, R 17. 1, f. 283v.

There is nothing quite like writing with a newly cut quill on prepared vellum. The velvet or fine suede-like surface gives a slight resistance, a 'tooth', and a control to the writer that is not often found with paper. And unlike paper, when painting on vellum or parchment the pigment stays on the surface and does not soak in, so that paint can be lifted off or manipulated with a brush; the actual colours also remain particularly vibrant. Then changing the pale pink, sometimes powdery compound of gesso into something that looks like solid gold by applying tissue-thin leaves of gold has been likened to alchemy. It is no wonder that writing with a quill and gilding and painting on skin have lasted for so many hundreds of years.

Pens

It is likely that both reed pens and pens made from feathers – the Latin for 'feather' is *penna* – were used in ancient times. In the seventh century the Spanish theologian Isidore of Seville wrote: *Instrumenta scribæ calamus et penna*[1] ('The tools of the scribe are the reed-pen and the feather'), so no preference for one or the other was given at this time. A reed pen, because the sides of the barrel and the shaft itself are thicker, is generally less responsive and letter-forms may not be so fine, but this pen would have worked well with the sometimes bumpy surface of papyrus, skating over it rather than catching on the rougher parts. Feathers, which have thinner barrels, are much more flexible. Their use became almost synonymous with vellum and parchment, where such responsiveness allowed for particularly fine letter-forms.

For both reed and feather pens, the tip was cut usually as a broad edge, and this gives the characteristic thicks and thins of the letters (see image 31a and b).

In mediæval manuscripts, feathers used for quills came from the wings of larger birds such as geese, swans and, later, turkeys. Feathers moult naturally and can be picked up in bird sanctuaries and on the banks of the lakes, ponds and rivers where these birds live. Swans, being the larger birds, have commensurately larger feathers, and the barrels can be cut to make wider nibs; Canadian geese have similarly large feathers. Crows' feathers, and those of similar-sized birds, produce small quills (crowquills) for fine lines, although it can be very fiddly cutting quills from them.

Feathers suitable for quills are the first five feathers on the outer edges of the wings; these have the longest usable barrels (see image 29). It is not difficult to identify the different feathers. Pinion feathers have very few barbs, or feathery bits. Seconds – second and third flight feathers – have longer barbs on the leeward side and a distinct curve on the windward side, while thirds – fourth and fifth flight feathers – have longer barbs on both sides. Because of the way the feathers curve, those from the left wing of the bird are more suitable for right-handers, and feathers

from the right wing for left-handers. Although the feathers are, of course, cut to pen length (about 17–20 cm, 7–8 inches) if they are to be used for any prolonged period, the slight curve to the quill can be distracting when writing.

The barrels of newly moulted feathers are white, opaque and soft, and the sides can be squeezed together; in this state they are far too pliable to make good pens. They need to be hardened, and the waxy outer coating removed, as well as the inner opaque vascular membrane. The process of hardening feathers is called curing, and this requires heat or time. When hardened, the barrel of the feather becomes transparent and yellowish.

Simply allowing time for the feathers to dry and harden was probably the process in mediæval times. With the demands of business and government records the demand for quills increased considerably, so the hardening process had to be speeded up. Feathers were hardened, or cured, by heating. This was, and is, a delicate procedure. If subjected to too much heat too quickly, the barrels bubble and crack, making them useless for quills; if not given enough heat, the barrels remain soft and are unusable. Hot sand can be used to cure a number of feathers at a time, although many now prefer the more controlled method of using a dutching tool,[2] and the not very romantic heat source of a domestic iron (see image 30).

Once the inner membrane has been removed (a crochet hook is the most effective method nowadays) and the feather cured, the outer waxy coating is scraped off by using the back of the knife blade or a rough cloth, such as hessian or sacking. This coating can get in the way of creating a fine tip to the quill, resulting in letter-forms that are not as crisp as they should be.

Penknives were, and are, used to cut quills, and almost all depictions of quill knives in manuscripts show them with a curved blade; indeed, modern penknives always have a curved blade, too. They also had sturdy handles, as hardened feathers are tough to cut, and flimsy knives can turn in the hand. Cennino Cennini, writing in the fourteenth century, described how to cut a quill:

If you need to learn how this goose quill should be cut, get a good, firm quill, and take it, upside down, straight across the two fingers of your left hand; and get a very sharp penknife, and make a horizontal cut one finger along the quill; and cut it by drawing the knife toward you, taking care that the cut runs even and through the middle of the quill. And then put the knife back on

31a Cutting a quill using a curved-bladed knife, with the blade facing away from the hand.

31b A cut quill and also one from the underside, showing the broad-edged tip.

one of the edges of this quill, say on the left side, which faces you, and pare it, and taper it off toward the point. And cut the other side to the same curve, and bring it down to the same point. Then turn the pen around the other side up, and lay it over your left thumb nail; and carefully, bit by bit, pare and cut that little tip; and make the shape broad or fine, whichever you want, either for drawing or for writing.[3]

This, the traditional way of cutting quills, and many historical images of quill-cutting show the quill knife being drawn down on to the thumb. The safer way, which I use, is to move the knife away from the hand; there is slightly less control, but if the razor-sharp blade slips, it does not then cut into flesh. Essentially, a shape similar to the nib of an old-fashioned fountain pen is cut into the tip of the feather (see images 31a and 31b).

A well-cut quill will make wonderfully crisp edges to the letters and very fine strokes. However, this sharpness does dull with use and so, after about half a page of writing, the tip will need to be shaved a little, and then the 'nib cut' made – a straight cut at the very edge of the quill. This process can continue until the nib starts to get wider because of the flared shape at the base curve of the nib (see image 31b). At this point, the nib will need to be completely re-cut, and so the process continues until the whole barrel of the feather is used up. It is not possible to say how long a quill lasts because that depends on how much it is being used; those that are used a lot need frequent re-cutting and so the barrel decreases more quickly, while those used less do not require re-cutting so often.

The barrel of a complete feather is tough, but once it has been cut into to make a quill it loses its strength. After use, the feathers dry out and the tines of the nib separate. It looks as if the quill is ruined, but it only needs soaking in a jar of water for an hour or so for the two sides to come back together again.

Quill-cutting was a skilled job, and in the first half of the nineteenth century (but after the 1820s, when metal nibs were first successfully manufactured), 'a pen-cutter could cut in a day two-thirds of a long thousand, consisting of 1200 according to the stationer's computation', and one man was known to cut double that number.[4]

Mechanical quill-cutters must have been welcomed by those who found cutting quills a chore (see image 32), however, most are designed to take only small barrelled feathers, such as those from geese.

32 A selection of Victorian writing implements. From the right: three cut quills, with the barbs removed on one side only, and above them the quill box; quill nibs – 'cut by hand', according to the box – which could be inserted into a pen holder, an ivory-handled quill knife with a curved blade, a mechanical quill-cutter (the knife was to make the first cuts into the barrel of the feather, and then the quill-cutter cut the shape of the nib and made the slit), and a sander containing 'sand', tipped slightly to show the 'dished' shape at the top. The sander has holes for shaking out the powder contained inside, and also a dished top, so that excess powder can be tipped easily back into the container. A sander contains not sand from a beach, but **sandarac** – gum sandarac. This was shaken on to paper or skin before the writing took place as it 'sealed' the paper and helped to prevent ink bleed. Unlike the action shown in many films and television programmes, 'sand' is not shaken on afterwards to blot the ink. Crystalline sand does not blot liquids well!

Ink

Much of the ink used in Egyptian times was made from carbon – soot from burned organic matter collected on a smooth-sided vessel – to which water and an adhesive, such as gum Arabic, were added. This ink remained on the surface and did not sink in; it was suitable for papyrus scrolls where only one side was used for writing. Once the codex (book) form became popular, both sides of the writing surface were used and a more 'biting' form of ink was necessary to stop the text smudging or being worn away by the pages sliding over one another. Oak galls – the reaction of oak trees to the oak gall wasp laying its egg on new growth, creating a hard, round ball – provided the basis for this ink (see image 33).

The galls were crushed by hitting with a weight such as a hammer. They were then mixed with *copperas* (ferrous (iron) sulphate), covered with water and left in the sun for a few days. The warmth and time allowed the tannic and gallic acids to leach out, which, when mixed with iron sulphate, created a purplish or brownish liquid. Gum Arabic was added to this, which thickened the mix and also meant that it would adhere to the writing surface .

The acids in oak gall ink bite into the surface of vellum and parchment, and there are mediæval manuscripts, such as the Vergilius Romanus (see page 68), where the ink has actually destroyed the skin entirely where there were letters. The corrosive nature of oak gall ink did not affect quill pens, which are more ephemeral, but it did corrode metal nibs when they were machine-made from the 1830s. When these became more popular, another type of ink had to be developed.

Despite this 'biting' nature of the ink, it is possible to remove words completely and even whole sections of text on vellum. This was done by scraping with a knife or a piece of pumice stone. When this is done with a knife, it roughens the surface. It is rarely obvious at the time, but over the years this rough surface attracts dirt, and so

33 Oak galls. Note the hole where the gall wasp grub has escaped. Mediæval recipes favour galls with the grub still inside. They also often specify stirring with a fig stick. The reason for this is not clear; perhaps it is because a cut fig twig bleeds sticky gum, and this may help increase the adhesiveness of the ink.

there is often a grubby smudge where there has been an erasure and a correction. In some manuscripts, known as palimpsests, the whole text has been removed and a new one written. Because of the greasy nature of the skin, erasing ink from parchment is not so easy and always leaves a visible trace.

Oak apples and peach and cherry stones could also be used to make ink, but of the first, as Gerarde notes in his Herbal, 'Oke apples are much the same nature as gals, yet they are farre inferior unto them and of lesser force'.[5] It is likely that the same could be said for other hard fruit stones.

Vellum and parchment

Vellum and parchment were used as well as leather for the substrate in ancient times. Only one side of the surface was used with leather, but both sides were used with vellum and parchment. Skin was regarded as a rather inferior product, and in the fourth century CE, 'in a country far removed from Egypt [for the supply of papyrus], we find Augustine apologising for using vellum for a letter, in place of either papyrus or his private tablets [wax tablets: wooden blocks with the inner part hollowed out and filled with wax], which he has dispatched elsewhere'.[6]

Vellum is calfskin and parchment is sheepskin. In mediæval times there were four grades of skin, from the highest quality with very few blemishes to skins which might have rough patches or holes in them, or have had water spilt on them making hollows and wrinkles. Nowadays skins for vellum and parchment are carefully selected for preparation, as those with small blemishes or holes are usually unsaleable; the tension under which the skins are treated often results in even the tiniest nick expanding into a hole. Careful selection was not always the case in mediæval manuscripts, and thick, poorly prepared skins, often with holes, were used even for high-quality manuscripts. Occasionally in mediæval skins holes were 'darned', with narrow strips of skin serving as 'thread' to pull the edges of the hole together; in lower-grade manuscripts, though, the text was simply written around the hole.

To make vellum the skins are first soaked in lime water; this slightly pickles or rots them, and the hair follicles begin to expand. The skins are stirred to ensure the even penetration of the lime liquid, and, as with most craft processes, this is skilled work: too little soaking and the hair is retained by the skin, and too much soaking and the skin rots too much and is unusable (see images 34a–d). The process is also very much faster in the summer than in the winter. When ready, each skin is washed and laid over a rounded wooden support, hair side uppermost. A scudder, a flat-bladed two-handled sharp knife, is used to scrape the hair away. Again, hair is more easily removed in the summer than winter, and if there are many visible dark hair follicles in the vellum it is likely to be a winter skin.

The skins are then stretched out for further preparation on large wooden frames, with wooden pegs on all four sides; thongs are attached to the pegs. The skins cannot be attached firmly to the frames because there needs to be a degree of flexibility as they are worked on. The wooden pegs allow the tension to be adjusted as the skins are processed. The skin is scraped with the curved, razor-sharp lunar knife, made from sheet steel; this raises the nap and also ensures that the skin is of a reasonably even thickness. After treatment the skins are allowed to dry, still attached to the frames, and then they are cut and rolled for storage or use. The length of drying time again depends on the weather, and can be anything from just over a day to a number of days.

The result of this treatment is a flat surface of relatively even thickness. Skins are composed mostly of collagen, which is very susceptible to changes in the atmosphere. Heat and damp will make the skins buckle or cockle where they are thinnest, and pages in a manuscript books are rarely as flat and even as when paper is used.

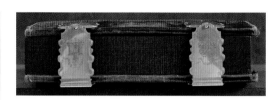

The process of vellum making.

34a Soaking the skins in vats of lime.

34b Scraping the skins with a scudder to remove the hair.

34c Scraping the stretched skin with a lunar knife to ensure an even thickness and to raise the nap.

34d Drying the skins on the frames.

Photographs taken by the author and reproduced by kind permission of William Cowley Parchment Works.

35 Heavy metal clasps keep mediæval manuscript books closed and the vellum pages flat.
BL Add. 18850.

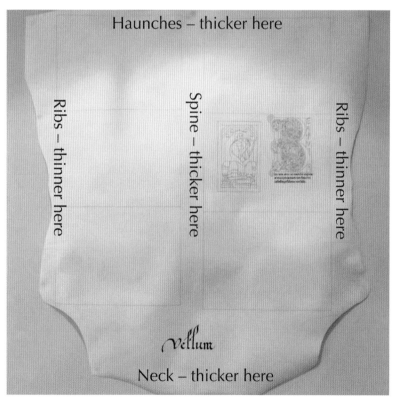

Haunches – thicker here

Ribs – thinner here

Spine – thicker here

Ribs – thinner here

Vellum

Neck – thicker here

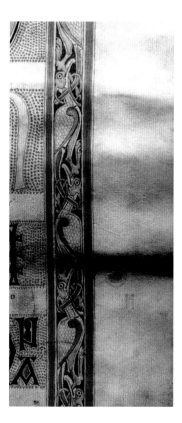

36a A skin of vellum is not even all over as is a sheet of paper. The skin over the spine, haunches, shoulders and neck are all thicker, and that over the ribs is thinner. Note that in this skin, even though the edges are being held down by tiny pieces of 'tac', the skin still looks quite bumpy.

This skin was prepared for the British Library exhibition *Genius of Illumination*, 2012–13.

36b The spine of the skin, indicated by this darker dip on the right-hand side, is horizontal on every page in the Lindisfarne Gospels.

BL Cotton Nero D IV, f. 139r.

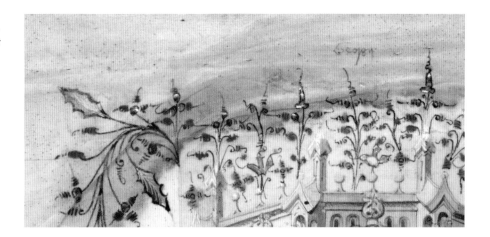

Most mediæval books had thick, heavy wooden covers; these not only helped to protect the inside from bookworm, but the weight helped to keep the pages flat, especially when they were secured by metal clasps (see image 35). In addition, books were often stored flat and not upright as now, with smaller and lighter books piled on top of the larger heavier ones; this additional weight helped again to keep the pages flat.

Despite the best work of a skilled parchmenter, skins are never completely even all over. The skin over the spine, and over the haunches, shoulders and neck, is thicker, while that over the ribs is thinner (see images 36a and b). This makes a difference when selecting sections for pages of a book. For large books, it might seem appropriate simply to cut a rectangle with the spine as the fold. However, this makes a very bulky 'gutter' (central fold) of the book, and the pages spring open. With thicker parts of the skin at the edges of the pages, again the book will be difficult to close because it will be much bulkier there than at the central fold.

Vellum calfskin (the word comes from the same root as veal) is by far and away the preferred writing and painting surface. Both sides are prepared by the parchmenter for use, but the hair side gives that much more 'tooth' for writing, while the flesh side is smoother, more waxy and ideal for painting. In manuscript books, though, care must be taken in terms of how the pages are folded and put together, as the hair side has more colour and may have a sprinkling of dark hair follicles (see image 37). The flesh side is whiter, and so traditionally hair and hair are placed together for an opening, and flesh and flesh similarly; this means that the look when the book is opened is more pleasing. Skin can be quite robust and thick, as in early manuscripts and particularly the de Brailes Hours (see page 128), but it can also be scraped so finely that it is almost transparent. Newborn or uterine calves also have very fine skins and their skin is called slunk vellum (see image 38). It was often used for small books with many pages, as the book was then less bulky. However, because the skin is so thin there is always 'show-through'.

Because of the challenging environment where they live, sheep have not only a thick woolly coat, but also a fatty insulating layer between the outer hair side of their skin and the inner flesh side. This means that the skin can be pulled apart into two. The inner flesh side is used for parchment, as it is easier to work with the grain when being prepared by the parchmenter. Lime is used to remove the fat, but despite this, over time the grease in the skin gradually works its way to the surface. Parchment is not that easy for scribes and illuminators to work with as a result. The skin is usually much thinner than vellum (apart from slunk vellum), and so care has

to be taken not to have the paint too wet, otherwise the skin cockles. Parchment requires careful preparation by the scribe before use, and it is not possible to erase mistakes completely from the surface.

The nap of the skin is usually raised by the parchmenter, and this means that the skin is not totally smooth and slippery. Most scribes prepare the skin themselves additionally nowadays by abrading the hair side with fine-grade abrasive paper where there is to be writing to create a velvet or fine-suede surface; only a little sanding is required for the flesh side. For painting, raising the nap in this way is not necessary.

Grease is then removed with pounce, which is a mixture of powdered pumice and powdered cuttlefish. The powder is sprinkled on, rubbed gently over the surface and then removed with a soft brush. Where there is to be writing only, gum sandarac is often used as well; this acts as a resist and very slightly shrinks the ink in the letter-strokes, creating finer forms. Gum sandarac is a resin from the small *tetraclinis articulata* tree, similar to a cyprus and found in north-west Africa. The resin is either exuded naturally or, like rubber, is made by scoring the bark of the tree; it hardens on exposure to air (see image 39).

Brushes

Mediæval miniatures are characterised by fine details and tiny decorations. To make these fine lines, brushes made from the tail hair of the stoat or weasel would have been used. Cennini writes about making brushes from the tail hairs of the mini-ver (stoat), explaining that the straightest and firmest hairs are the best, and that these should be tied 'with two bights or knots' and then pushed into a cut-off quill, from the appropriate size of bird – a vulture, goose, hen or dove are all suggested.[7] He goes on to explain that 'one brush ought to be pointed, with a perfect tip for outlining; and another ought to be very, very tiny, for special uses and very small figures'. The best brushes nowadays are made from the tail of the male kolinsky weasel (*mustela sibirica*), which is erroneously called sable, and the very best are from the winter coat of animals that live on the northern slopes in Siberia. Even then things are not completely straightforward, since if the hairs are not long enough there will not be sufficient spring in the brush. With good brushes there is more hair in the ferrule than there is exposed in the brush.

39 Materials to prepare vellum and parchment. Grease is removed by using pounce, the pale grey powder on the left; pounce is a mixture of ground pumice and ground cuttlefish. Yellow gum sandarac 'tears' increase the 'tooth' of the skin for writing. The tears are ground to a fine, pale yellow, slightly crystalline powder as shown just above in the mortar and again on the fine cotton fabric below. The sides of the fabric are gathered together and secured with string to create a little bag which is dabbed over the areas of skin only where there is to be writing.

40 Brushes with feathers as the ferrules. The 'two bights or knots' specified by Cennini can be seen as coloured bands of red and green thread inside the quill, which has also been 'crimped' to give additional security in holding the hairs of the brush.

(Photo courtesy of L. Cornelissen & Son. www.cornelissen.com.)

Pigments

Colours in many mediæval books are bright and dense, almost as they must have been on the day they were painted. The fact that they are in books with closed covers helps to maintain the vibrancy, but the pigments used were also usually relatively pure and undiluted. With many pigments either glair (egg white beaten to remove the stringiness, and the liquid under the froth then used) or yolk was added as the adhesive to create egg tempera. Gum Arabic also provided the adhesion to make the paint attach to the surface, and that is what is normally used now in gouache paints. These are the closest paint form to traditional egg tempera, and the easiest to use for painting miniatures and for writing calligraphy.

The best-known pigment of all must surely be the intense blue of lapis lazuli, ground and processed into ultramarine. This was the rich blue of the Virgin Mary's robes in later mediæval manuscripts, as seen in the Dunois Hours (see image 41); it was also often used for the robes of the wealthy and manuscript patrons when depicted. Cennini described ultramarine as 'a colour illustrious, beautiful and perfect, beyond all other colours'. At this time lapis lazuli was available only from north-west Afghanistan, at Sar-e-Sang – 'the place of the stone'. The stone was mined from mountain hillsides and taken along the Silk Route to Europe. Its Latin name, ultramarine, means 'over' or 'beyond the sea', which is apt.

Ultramarine needs a lot of processing to change it from the stone to usable pigment, and there were a number of grades of the colour. The lowest one was ultramarine ash, which is a pale greyish blue in which tiny pieces of the blue ore are just visible.

A much cheaper blue, and similar in colour, was citramarine – 'this side of the sea'. It is difficult to tell the difference between the two blues unless they were next to one another, when it is obvious that citramarine is slightly greener; it derives from a copper compound. The problem with citramarine was that it gradually changed to a dull olive hue within about one hundred years.

Another expensive pigment was cinnabar, the deep red of vermilion. The ore was mined at Almaden, 200 km south of Madrid. It could also be made, as Cennini says, 'by alchemy', that is, by heating together equal quantities of mercury and sulphur. Vermilion was the colour used for the Virgin Mary's robes before ultramarine, and it is still used for them in many Russian icons.

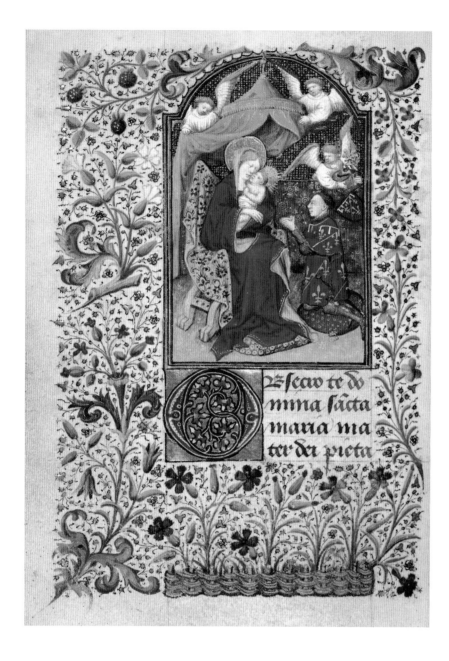

41 The Dunois Hours (named after the Dunois Master). *c.* 1440–*c.* 1450. Virgin and Child, and Jean, Comte de Dunois.

Note the rich ultramarine blue of the Virgin Mary's robes, echoed in the robes of Jean, Comte de Valois, who wears the French coat of arms as a surcoat over his armour. Although difficult to confirm without scientific evidence, it is probable that the canopy over Mary is painted in green malachite with a lining of pink madder. The cushion and lower backdrop are in red cinnabar. The decoration on both, as well as the fleurs-de-lis on the shield and surcoat, the Infant Jesus's crown and the highlights on the green canopy are all in shell gold – gold paint. Mary's crown, the background to the large illuminated letter **O**, and the many dots, trefoils and leaves in the border are all in gold leaf on gesso, which gives a raised appearance to the gold.

BL Yates Thompson 3, f. 22v.

A bright white was made by suspending lead shavings in or over a bowl of vinegar and heating them; animal dung was often added to the chemical formula. The reaction produced lead carbonate, which looked like little scales or flakes, and so it was, and is, called flake white; in mediæval times it was called ceruse. A mediæval treatise, *De coloribus et artibus Romanorum*,[8] explains how to make lead white:

> *If you wish to make the white which is called ceruse, take lead plates and put them into a new jar, and so fill the jar with very strong vinegar and cover it up, and set it in some warm place, and leave it so for a month; then open the jar and put what you find adhering to the strips of lead into another jar, and place it upon the fire, and keep stirring up the colour until it becomes as white as snow.* (Between seventh and twelfth centuries.)

42 (below) The Nativity scene with Mary and child, and Joseph standing behind. The smiling ox and ass can be seen near Mary's feet. The *Abingdon Apocalypse* was unfinished, and in this miniature the outline in minium (hence the word miniature) can clearly be seen. No modelling or shading is shown, as that would have been covered with paint.

BL Additional 42555, f. 80.

The problem with lead white is that it can turn black over time.

If lead white was heated it turned an orangey-red; this was call *minium*. This colour was often used to fix the outlines in mediæval miniatures (see image 42). Because it was used for this purpose, the pictures so outlined were called miniatures; they were not called miniatures because they were small, and 'miniatures' can be quite large in manuscripts, for example in the huge twelfth-century Bibles (see page 118, the Bury Bible). However, because most miniatures were small, the word was used for the little illuminations.

Another mineral was red ochre, called *rubrica* in mediæval times. Titles and subtitles in service books were written in red initially, and often the colour *rubrica* was used; these then became known as rubrics, and the name extended to the text that follows subtitles as well. A rather fantastic colour was dragon's blood (see image 43), a deep red made from a resin from plants such as croton and dracæna. In mediæval times it was thought to be a mixture of the blood of elephants and dragons that had died in mortal combat.

Orpiment, *aureus pigmentum* or *auripigmentum* (gold pigment), is a rich golden egg-yolk yellow colour and has been used since Mesopotamian times; it is arsenic trisulphide and very toxic. As a mineral it occurs naturally, but in small quantities. It cannot be ground too finely as it then loses its glorious colour and becomes a pale yellow. Orpiment is rather gritty in use, but this is an advantage in that the crystals reflect light. It was used in both the Lindisfarne Gospels (where there is very little gold, see page 76) and the Book of Kells (where there is no gold, see page 86). Realgar is another arsenic compound that produces arsenic sulphide, a yellow pigment.

It was not easy to make green pigment that would last, as most vegetable dyes were not strong enough. Verdigris (Greek green), the green on many war memorials where the copper has weathered, is very corrosive. Cennini[9] wrote that verdigris 'was very lovely to the eye but did not last'. He also noted that flake white (lead white) and verdigris 'are mortal enemies in every respect'. To get around this, verdigris was mixed with yellow saffron, but it changed the colour of the green.

A safer green is malachite, but it again loses its colour if ground too finely, and often flakes off the surface. The best colour was said to be from stone that was the colour of a frog's back. Another earth pigment giving a green colour was terre verte. This was often used for painting flesh, which would then be overlaid with white and vermilion to achieve the best tone.

The famous Lincoln green said to be worn by Robin Hood is a mixture, not a single green pigment. It was created by combining woad, a blue colour, and weld, a yellow; both colours come from plants and both were used in manuscripts. Woad is made from the leaves of the *isatis tinctoria* plant and was used from Egyptian times. The stronger colour, indigo, comes mainly from the *indigofera tinctoria* and *indigofera suffruticosa* plants, and provides a deep purplish blue. When it is made it is formed into small 'bricks'; Pliny thought that it came from river silt.

The root of the *reseda luteola* plant produced the yellow colour weld, used mainly in dyeing, and in fact it was thought to colour the clothes of the Vestal Virgins. The brilliant yellow stigma from the saffron crocus can also be used as a yellow pigment, and there is sufficient natural adhesive in it that no additional gum or egg is required.

Another root, that of the madder plant – *rubia tinctorum* – produces a dusty pink colour. Madder red has been known since the third millennium BC.

Animals, too, produced colour used in mediæval manuscripts. A deeper shade than madder is crimson, which comes not from a root but from an insect. The female scale insect *kermes vermilio* lives on the kermes oak around the Mediterranean. The word 'kermes' is from the Persian *qirmiz*, meaning red or crimson, while *qirmiz* in turn comes from the Sanscrit word for 'worm-made'. The insects were dried and crushed and used for dyes as well as pigments. A similar colour is produced from the female cochineal beetle from South America and Mexico. This gradually took over from European crimson because it needs one-tenth of the number of insects to give a good colour.

A deep rich purple dye, Tyrian purple, comes from the sea snail *murex brandaris*; the mollusc defends itself by exuding a purple liquid. The city of Tyre in Phoenicia (now Lebanon) became famous for the production of this eponymous colour, and the purple was used by the Phoenicians from 1570 BC; in fact, the name Phoenicia itself means purple. Pliny wrote that it is 'most appreciated when it is the colour of clotted blood, dark by reflected and brilliant by transmitted light'.[10] When the sea snail is harvested and squeezed a tiny sac yields a drop of white liquid, which on exposure turns purple. A huge number of molluscs are required; it has been estimated that 'twelve thousand snails of Murex Brandaris yield no more than 1.4 g of pure dye, enough to colour only the trim of a single garment'.[11] Because production was so labour intensive the colour was precious, and thus used to denote royalty. It was also used to colour whole pages in manuscripts (see image 44) and as a dye for cloth. The Emperor Justinian and his wife Theodora are shown wearing purple robes on the sixth-century wall mosaics in the Basilica of San Vitale in Ravenna, Italy.

Gold, silver and other metals

There are many references in the Bible to gold, but perhaps Haggai 2: 8 gives one reason as to why gold was used in mediæval books: 'The silver is mine, and the gold is mine, declares the Lord of Hosts.' Gold does not tarnish, as silver does, and it is also the most expensive metal. Using gold gave status to the book, indicating the generosity of the patron as well as making the book beautiful. Polished, or burnished, gold reflects light from the pages of the book, and so the book itself is 'illuminated'.

Gold was used in two forms in manuscript books: gold leaf and gold ground to a powder and suspended in gum liquid to make ink or paint. Almost pure gold is needed to create the tissue-thin leaves that attach and wrap around a cushion of gesso. In 1252 the Italian city of Florence introduced the florin, which was 24 carat gold weighing 3.53 gm (about 0·1 oz); on today's market this would cost about £85. This pure gold coin became the 'gold standard' of its day and was not adulterated. It could also be used to make gold leaf, and it was said that a good gold-beater could get 100 leaves of tissue-thin gold from a Florence florin.

In books that are handled a lot, gold leaf will not attach to vellum without some form of adhesive. (It is, however, possible to attach gold leaf by pressure to small areas, but the attachment is very fragile.) In early mediæval manuscripts it is likely that glair, gum Arabic or a sticky substance such as garlic juice may have been used. For many high-grade manuscript books, though, areas of solid gold stand proud from the surface and glisten and gleam in the light. In fact, the gold itself is very thin – tissue thin – if it is not, it will not wrap round the edges of the 'cushion' on which it sits. This cushion is made from gesso, a compound of slaked (water-added) plaster of Paris, lead carbonate (flake white), a glue that is sticky at room temperature, such as fish glue, and some form of sugar – honey or sugar candy. The plaster

43 *Top row (left to right)*: woad paint, woad leaves in a traditional ball that needs to be soaked to release the colour, an indigo 'brick', indigo; *second row*: azurite (citramarine), ultramarine, verdigris, malachite; *third row*: carmine, vermilion (cinnabar), madder, lead red (minium); *bottom row*: dragon's blood, madder root (*below*), saffron strands made into paint, orpiment, realgar.

44 (above) The background of the page in this manuscript has been dyed purple. This gives a rich and glorious background to the gold lettering, columns and arch, and provides a background for the vibrant colours used for decoration. The text shows a dedication to Henry VIII, with the opening text. (Attributed to the Renaissance scribe Pier Antonio Sallando.)

BL Add. 30067, f. 1v.

45 (above right) A letter from Graily Hewitt to one of his students in 1943 describes his experiences with gesso, showing that he was still experimenting with the medium and not always getting it right. 'I experiment with proportions endlessly … one goes on trying to get a better result,' he observes (halfway down). On the second page (not shown) Hewitt considers grinding, and in the second paragraph from the bottom he explains that he has just had a failure from too much glue. In his last line, referring to illumination, Hewitt declares 'I bless it endlessly'.

Private collection.

of Paris needs to be slaked because heat is created as soon as the water is added, which would cockle and buckle the skin, and, unless there are copious quantities of water, the plaster sets hard. Lead carbonate is a fine powder and provides added bulk as well as acting as a fungicide. The glue ensures that the mix is sticky and so the gold adheres, and sugar is hygroscopic, meaning it absorbs humidity from the air.

The ingredients are ground together to ensure a fine mix. Water is added, and then the gesso is used straightaway or allowed to dry in small quantities to be reconstituted with water later. Graily Hewitt did much to research and experiment with ingredients and methods of making gesso and contributed the chapters on illumination to Edward Johnston's *Writing & Illuminating, & Lettering*. Some 40 years after his original work on this, Graily Hewitt was still experimenting, as shown in a letter he sent to one of his students (see image 45).

Gesso is applied, usually with a quill, and laid over the specific areas where there is to be gold. When it has dried the gesso is often scraped to ensure it is completely smooth and polished so the gold adheres well. The stickiness in the gesso is reactivated by breathing heavily on it, and the hygroscopic sugar ensures that the moisture moves through the mix. Immediately after breathing – within three seconds – a piece of gold leaf is pressed on to the gesso. A burnisher (see image 46), made of a polished stone, is moved quickly over the gold to make it shiny and gleaming. Cennini records that good burnishers can be made from 'a stone known

as hæmatite ... sapphires, emeralds, balas rubies, topazes, rubies and garnets; the choicer the stone the better it is. A dog's tooth is also good, or a lion's, a wolf's, a cat's, and in general that of any animal which feeds decently on flesh'.[12]

Gold powder was made by grinding gold leaf. However, one of the qualities of gold leaf is that it sticks to itself, so salt was used to prevent this from occurring. Jehan le Begue (1368–1457) writes:

> *Take leaf gold, grind it with salt on the marble, leave it for a long time in water, stir it and let it settle. Then pour off the water to remove the salt, and the gold will remain at the bottom. Distemper it with gum for writing, and the letters you make will be dark; but when they are dry, polish them with a tooth and they will be of a beautiful yellow shining gold colour.*[13]

Gold powder, mixed with gum, used to be sold in mussel shells, which acted as the palette for the gold. This was, and is, called 'shell gold' (see image 47). Brushes used for gold were washed out in a separate water pot, and the washings from the brush could be re-used with the addition of more gum; often these were the 'artist's perks'.

46 Burnishers made from polished stone or metal ore, such as hæmatite (iron ore), on the left, and psilomelanite (manganese ore), centre; the remaining burnishers are polished agate. The varied shapes include dog tooth (left and second from right), spade shape (right), lipstick shape (centre) and pointed (second from left); the last is used to indent patterns in the gold. All these burnishers polished metallic leaf and paint until they shone and reflected the light.

47 Writing with liquid gold is challenging because the heavier metal particles drop to the tip of the pen. The evenness of the chrysography (gold writing) in this dedication to King Henry VIII is particularly fine, especially as it has been written on a coloured background. Shell gold has also been used to paint a floral pattern below the writing and as the background to the border.

Martin de Brion, *Tresample description de toute la Terre Saincte*, Paris, c. 1540.

BL Royal 20 A.iv, f. 2r.

Not everything in mediæval manuscripts was in real gold; if budgets were limited then 'mosaic gold' might have been used instead. This was tin sulphide, which is a gold colour. It is made by grinding and mixing tin, mercury, sal ammoniac and *fleur de soufre* (sulphur 'flowers'), and then leaving the mix in heated sand for a number of hours. Gold mosaic settled at the bottom of a dirty liquid and was used in manuscripts once it had separated.

Silver was also used in mediæval manuscripts, but not nearly as much as gold because it tarnishes after a few years and eventually turns black. This metal can be sealed using glair, but as there are few remaining shiny silver areas in historical manuscripts and more dull black areas, it seems unlikely that this practice was widespread.

The process of making a manuscript

Making a mediæval manuscript book was not something left to chance; everything was carefully planned and thought out in advance.

First, once the purpose of the book itself had been determined – psalter, gospels, missal, lectionary etc – the budget was agreed between the patron and the person supervising the making. The fee then determined the quality of the skin, the size of the book, the amount of gold and precious pigments used and even the lettering style, as some scripts took longer to write.

48a Pin prick marks indicating the position of the lines for writing in the edges of the *Topographia Hibernica* by Gerald of Wales.

Lincoln (?), c. 1196–1223.

BL Royal 13 B. viii, f. 28v.

48b God measuring the world using dividers – two points, one at each end of conjoined arms. Similar dividers were used to mark out the positions of the lines in manuscripts.

Bible Historiale: Genesis to the Psalms.
Clairefontaine and Paris, 1411.

BL Royal, 19 D. iii, vol. 1, f. 3r.

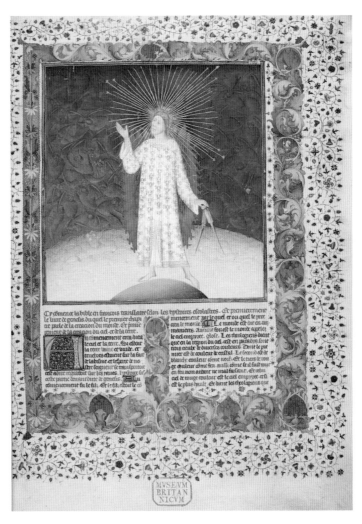

After this the skin was selected and cut to size, usually with hair sides facing and flesh sides facing to ensure that the pages of the opening spread looked similar. The skin was then prepared, and the pages in the book laid out with measurements for the writing lines. The start and end of these lines were marked by pin pricks using the very tip of a knife, a sharpened awl or the points of dividers (see images 48a and b). A straight edge was placed at the pin pricks marked and the lines ruled with lead or silver point, paint or ink, or blind embossed. The advantages with blind embossing, or indenting the lines, would be that a furrow on one side would appear as a ridge on the other side of the skin, so the two sides of a page were ruled up at the same time.

Later a ruling frame might be used. This was a board over which strings were stretched, indicating all the line markings. Four or five pieces of skin would then be positioned over the strings and placed under a press. The weight of the press indented the lines, and again an indent on one side resulted in a ridge the other.

The writing was often completed first on unfolded pages, then gathered together in sections, leaving spaces for the illuminations and larger initials. The style of writing was determined either by convention or, in later mediæval times, by the budget. Letters that required a degree of pen manipulation, and thus took more time, were more expensive. It is much easier to write and complete the illuminations on flat pieces of skin (and paper), so folding was left until the writing and painting were finished.

Painting mediæval miniatures is unlike most other forms of painting in that there is no room for change. The design has to be worked out completely, as once the gesso and leaf gold have been laid there can be no alterations. There is evidence in the Lindisfarne Gospels of back drawing which suggests the careful construction of the design – including pin prick marks made by dividers to ensure that the lines were a consistent distance apart (see image 49).

The design would probably have been worked out elsewhere and then transferred to the skin. There is evidence of a form of tracing paper, made by using very thin vellum, as well as some form of backlighting to see lead point images on the reverse of pages.

Instruction books were created on how to design and layout the decoration in mediæval manuscripts, such as the Göttingen Model Book. Step-by-step diagrams of how to paint and model cloth and foliage are shown, with careful instructions.

Gesso for gold was always applied first (see images 50a–f), so the areas to be gilded were identified. The liquid gesso was usually applied with a quill. The gesso was allowed to dry, then, if necessary, scraped to a smooth surface, and usually polished with a smooth stone. The dry gesso is not overly sticky in itself, so the adhesion needs to be reactivated by breathing heavily and the gold leaf attached swiftly. The metal was polished to a shine with a burnisher, and any extraneous leaf scraped off with a knife.

Then the colour was applied: the 'base' colour first, then the shades and tones, the white highlights and finally the black outline bringing everything to life.

49 The Lindisfarne Gospels. The reverse of the cross carpet page of Mark, showing the underdrawing and the pin prick marks of the construction. BL Cotton Nero D VIII, f. 94r.

opposite
Illuminating and painting a mediæval miniature.
50a Outline in minium.
50b Gesso laid with a quill.
50c Gold leaf attached to the gesso and burnished.
50d 'Base' colours painted.
50e Shades and tones painted and the white highlights added.
50f The black outline completed with the details; this brings the miniature to life.

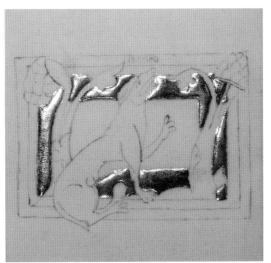

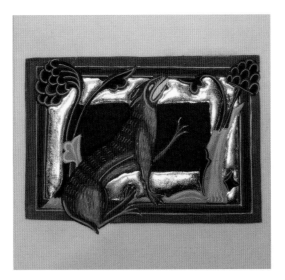
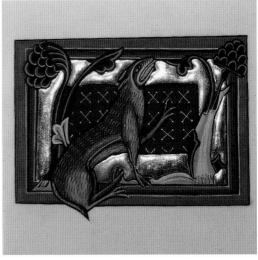

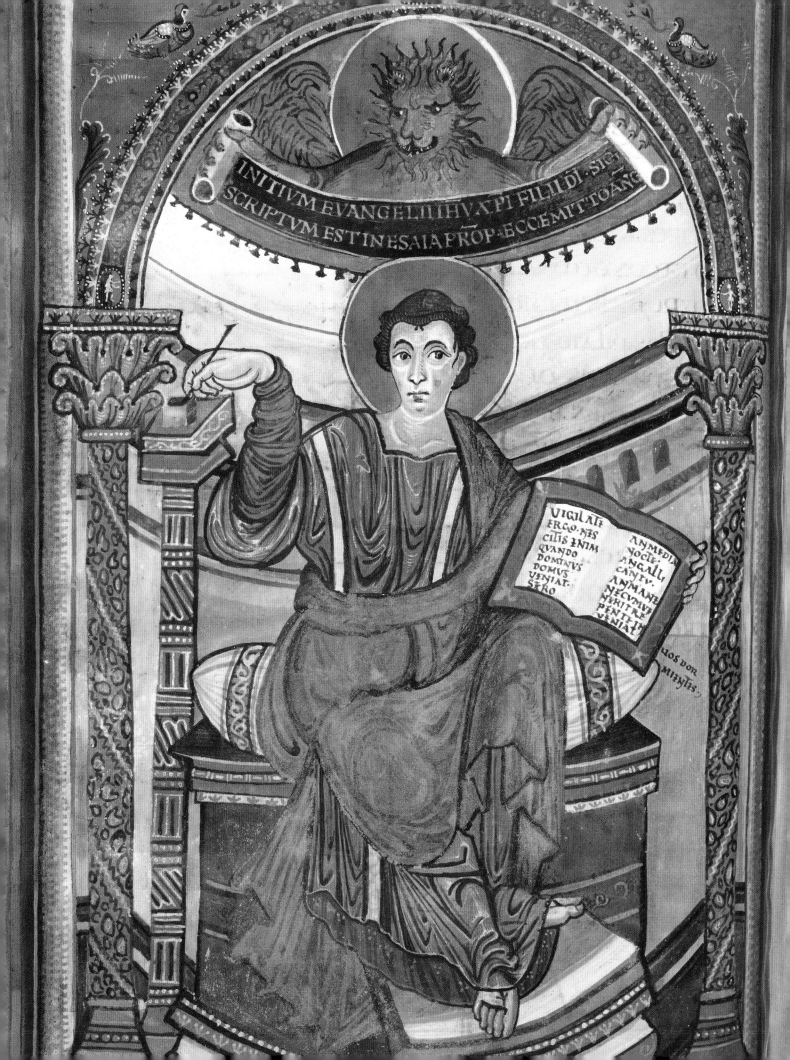

INITIVM EVANGELII IHV XPI FILII DI SIC
SCRIPTVM EST IN ESAIA PROP ECCE MITTO ANG

VIGILATE
ERGO NES
CITIS ENIM
QVANDO
DOMINVS
DOMVS
VENIAT
SERO

AN MEDIA
VOCTE
AN GALLI
CANTV
AN MANE
NE CVM VE
NERIT RE
PENTE IN
VENIAT

51 The Harley Golden Gospels are rightly named: the brilliance of the metal shines from almost every page. The gospel text is written in two columns of gold Uncial letters, which are encased within narrow, coloured and decorated borders. Opposite this image of St Mark is an amazing page of huge gold letters, with wide gold borders and interlace patterns. A young St Mark is shown here seated on a white cushion, on an elaborate coloured stool; his feet in turn are resting on a footstool, and it looks as if he is writing within the rounded apse of a church. Two blue marble columns with decorated carved capitals on the right and left support a painted arch. The most intricately decorated inkpot support ever seen is to hand, as St Mark twists his wrist to replenish his quill. His symbol of a lion holds a scroll and smiles benevolently down as the saint completes his gospel.

BL Harley 2788, f. 70v.

52 Quills cut so that the nibs have a broad edge at their tip, although the width of this broad edge varies.

Almost all the letters written in the manuscripts in this book are made with a nib that has a broad or straight edge – not pointed; this gives the characteristic thicks and thins to their form (see image 52).

The great calligrapher Edward Johnston, who was mainly responsible for the revival of broad-edge nib writing at the beginning of the twentieth century, devised a way of analysing letter-forms in historical manuscripts so that they could be studied and reproduced. He identified seven specific points for study: pen nib angle, x-height, shape of the letter **o**, slant of the letters, serifs, the sequence of strokes and finally the speed at which the letters were written. Time has shown that focusing on these aspects of historical scripts does provide an excellent foundation for writing the different scripts.

Pen nib angle

Broad-edge pen nibs are usually held so that they are at a specific angle to the horizontal writing line; this angle is determined by the writing style. When the pen is moved to the right or left at that specific angle, it makes a fine stroke; when the pen is moved at 90° to that writing angle, then the stroke is thick. Most of the strokes made are smooth, the thin stroke gradually becoming thick and vice versa, rather than there being a sudden change. The marked change comes when the pen is lifted from the writing surface to make a new stroke, as on the diamond serifs in Gothic letters.

The pen nib angle against a horizontal line is different from how the pen is held in the hand, although the position of the wrist and elbow do help to achieve that pen nib angle. Most people would hold their elbow tightly into their side and rotate their wrist outwards to achieve an angle of 0°–3°, as used in Half-Uncial in the Lindisfarne Gospels (see page 76), and Flat Pen Uncial as used in the Greenwell Leaf. For Rustics, however, letter-forms in the Vergilius Romanus, which are written with an angle of about 80° (see page 68), the wrist is rotated to the left, and the elbow held away from the body.

Most scripts, however, are written with the pen nib held at a comfortable 30°–45° angle. The elbow is neither held tightly to the body nor away from it, and the wrist continues usually in a straight line from the arm. It is how most people hold their pen nowadays to write, and it causes little stress to the wrist, elbow or shoulder.

The angle of the pen nib against the horizontal guidelines changes the shape of the letters (see image 53).

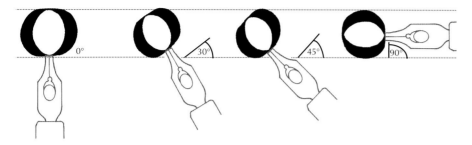

53 Holding the pen at various angles changes the shape of the letter and the position of the thick and thin strokes. Note the counter (the inner white space) in each of these letters **o**. On the far left, the pen nib is held at an angle of 0° to the horizontal guidelines, and so the thin parts are at the top and bottom, and the thickest parts right and left. On the furthest right, the pen nib is being held at 90° to the horizontal guidelines, and the thinnest parts of the letter are right and left, and the thickest parts top and bottom. The second letter from the right is made with the pen at an angle of 45° and the second from the left at 30°, and so the places where the letters are thickest and thinnest are very slightly, but significantly, different.

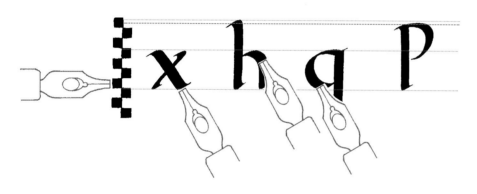

54 To determine the x-height and the extent of ascenders and descenders, the widest parts of the letters are matched up to a pen nib of similar width. This is turned to 0° and a series of little steps made from the base guideline. The x-height is the number of little steps there are from base to upper guideline for x-height. This may not always be a whole number, but allowance should be given for a lack of precision when writing the original letters. The steps can be continued beyond the lines for x-height to determine the dimensions of the ascenders and descenders, and of the majuscules. Note that the majuscule (capital letter) is lower in height than the height of the ascender. Here the x-height is four nib-widths, the ascenders and the descenders seven nib-widths and the majuscules six-and-a-half nib-widths.

55 Shape of the letter **o**. Letter-forms in the Ramsey Psalter, as on the left, have a round letter **o**, and the arch of that letter determines the shape of the letter **n**, the bowls of the letters **b**, **p** and **q**, and the width of other letters too. That for Gothic Black Letter, as in the Bedford Hours, is angular and narrow (see images 59 and 60).

56a Serifs. From the left – simple entry and exit strokes made by a slight movement upwards at the start and ending of the downstroke. Then serifs made with a short stroke at varying pen angles before making the downstroke; the base serif is then made with the pen at the same angle as the first serif. On the far right is a 'beak' serif (because it looks a little like a bird's beak) at the top of the letter; this is constructed by a small curved stroke to the right before making the downstroke. At the base of the letter the pen is moved slightly to the left, lifted and then the horizontal stroke made with a very slight upwards lift as the pen is taken from the writing surface.

56b Some downstrokes in Gothic manuscripts have fish-tail serifs. These are formed by making a downstroke curving from the right and then down, and then using the left-hand corner of the nib to pull the wet ink out into a hairline to the left and upwards (see far right).

57 Writing the letters. Letters are formed by the pen being lifted between strokes as shown here by these 'exploded' letters. Unlike a modern-day pen, a broad-edged nib is not easy to push upwards to complete the letter **o** in one stroke. The letter **o** is made with two strokes and the pen lifted between them and placed where the next stroke starts; this is indicated by the dotted red lines with arrows. This lifting of the pen slows down the writing, but it does generally give clarity to the letter-forms and avoids ink blots.

58 Speed of writing. It takes nine strokes to construct a Gothic Black Letter **m** as written in the Bedford Hours (see page 144), as opposed to three strokes for the letter **m** in the Ramsey Psalter (see page 98). Writing Gothic scripts is thus usually much slower.

x-height

The height of the body of the letters is called the x-height. For majuscules, or capital, letters, this is easy to see because it is simply the height of the whole letters; rarely do majuscules have strokes that extend beyond the general body of the letter. For minuscule, or 'small', letters, the x-height is the height of the main part of the letters, with ascenders and descenders going respectively up and below the body of the letters. Ascenders occur on letters such as **b**, **d** and **f** and descenders on letters such as **g**, **p** and **q**.

Letters that have a small x-height and extended ascenders and descenders, such as Italic and Caroline Minuscule, look elegant and almost 'airy'. Letters which have a larger x-height and shorter ascenders and descenders often look more formal and contained, such as those in the Ramsey Psalter (see page 98 and image 59).

The x-height is determined by matching up the widest part of the letters with a pen nib that has the same width; this would have been the width of the pen nib used to write the original letters. That same nib is then turned to 0° and used to make a series of little steps which just touch, with no gaps, and do not overlap. Starting at the base guideline for x-height and using the correct width of pen nib, those little steps indicate the x-height (see image 54). The steps can be extended beyond the lower base guideline for x-height to determine the extent of the descenders, which is not always consistent, and again extended above the top guideline for x-height to determine the height of the ascenders.

In every writing style but Gothic Black Letter the capital letters, or majuscules, are lower in height than the ascenders.

59 Letter-forms in the Ramsey Psalter, as on the left, have a round letter **o**, and the arch of that letter determines the shape of the letter **n**, the bowls of the letters **b**, **p** and **q**, and the width of other letters too.
BL Harley 2904, f. 27v.

60 The letter **o** for Gothic Black Letter, as in the Bedford Hours, is angular and narrow.
BL Add. 18850, f. 24r.

Shape of the letter o

The shape of the letter **o** determines the style of the script, depending on whether that letter is round and fat, narrow and slanting or even angular. The rest of the letters usually take not only their form from the letter **o**, but also their width (see images 55, 59 and 60).

Slant of the letters

Letters that are written more slowly are usually upright as in those in image 59, but those written more quickly tend to slant forwards, see image 61.

Serifs

Serifs are the shapes at the beginnings and ends of letters. These are formed by small movements of the broad-edged nib used to write the letters. When a script is written at a reasonable speed – although not as fast as we write now with modern writing implements – the serifs tended to be simple entry and exit strokes, as shown on the far left of image 56a. Others are more contrived and complicated (see image 56b).

Stroke sequence

Because pens making these letter-forms have a broad-edged nib, if the pen is pushed upwards against the width of the nib it resists the movement, hindering the formation of the stroke. Thus the letter-forms are usually made with separate strokes, which are to the left and a little right, and also downwards; pushing upwards can cause ink spray. Analysing the way in which these separate movements of the pen are made determines the order and direction of strokes, or 'stroke sequence' (see image 57).

Speed

Letter-forms that have a number of pen-lifts are written slowly, as the nib has to be positioned each time for the next stroke. Those with few pen-lifts are written more quickly. This is clear from the number of separate strokes needed to write the letter **m** in Gothic Black Letter, compared with those for a letter **m** in the letter-forms of the Ramsey Psalter (see image 58).

Letters that are joined also indicate a degree of speed in their construction, as the pen moves to the right to start the next stroke without being lifted from the writing surface (see image 61).

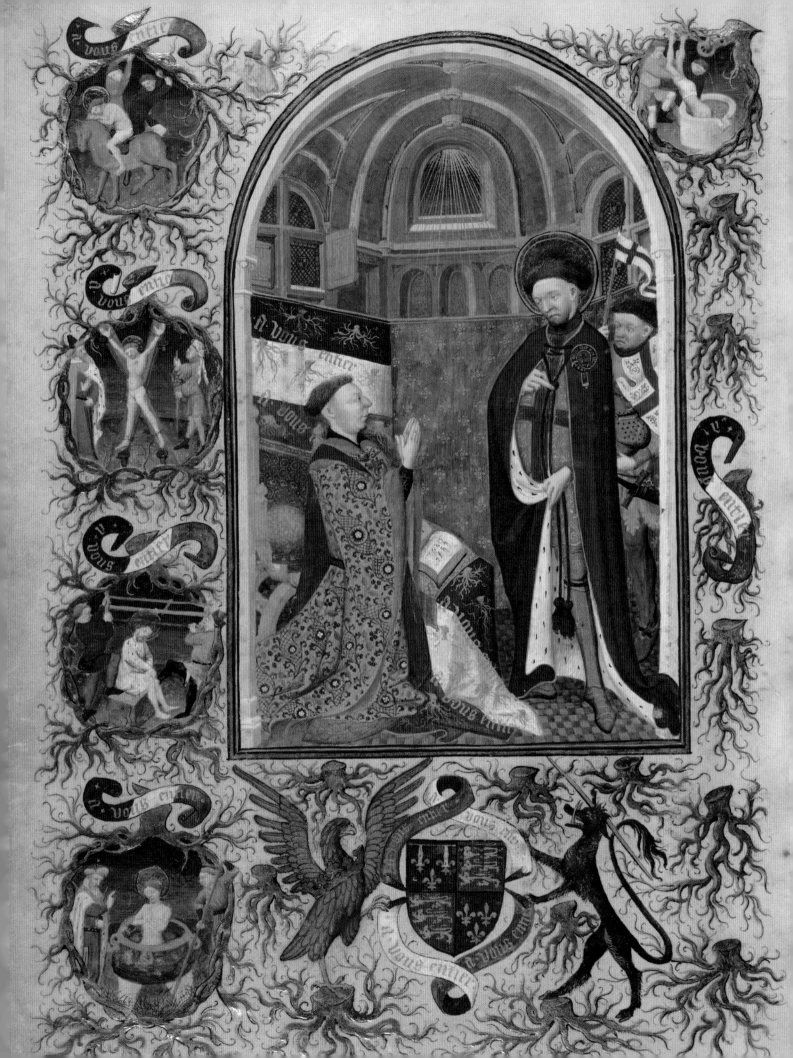

Calligraphy through the Ages

Many different strands could be followed when considering the art and history of calligraphy – the scribes, the history of writing, patrons of the writers of the manuscripts, calligraphy with illumination, writing styles and their development, page design, details of pen angle and how the letters were formed and so on. Rather ambitiously, in selecting the following manuscripts aspects of all of these threads have been considered. Manuscripts in this section have been chosen because they illustrate the history of writing, the development of the codex, the technique for writing the scripts, the relationship of scribes and their patrons, and also the development of how the pages looked, from the first dense pages of text to the artistic interpretation of words in the calligraphy of the present day. In so doing it has been impossible to include every slight nuance in change of letter-forms and the selection process had to be ruthless, leaving out some firm favourites. The British Library has an unrivalled collection of the highest-grade manuscripts in the world, so it has not been difficult to select a number of manuscripts from this treasure trove, supported by gems from other collections.

John, Duke of Bedford, is wearing a magnificent belted embroidered robe lined with fur, and has a haircut that now we may consider to be rather unfortunate. He is kneeling in front of St George, patron saint of England, who can be identified by the red cross on a white background. They are surrounded by a border of woodstocks, one of John's inherited emblems; the woodstocks have amazing twirling roots (see also page 144).

France, c. 1410–30.
BL Add. 18850, f. 256v.

1

An early papyrus codex

Oxyrhynchus, Egypt, third century CE
BL Papyrus 447, recto

This rather unprepossessing scrap of papyrus is far more significant than its appearance suggests. It is written in Greek with a pointed nib, dates from the third century and was found at Oxyrhynchus in Egypt. Oxyrhynchus is Greek for 'sharp-nosed fish', and is the name of a town situated west of the River Nile in Upper Egypt. This is a renowned archæological site because of the number of papyrus texts discovered there, including the Gospel of Thomas and previously unknown works from classical writers such as Sappho and Menander. The text on the folio has fragments from the Gospel of John, chapter 1 and chapter 20; chapter 1 is on the right and chapter 20 on the left. It would not be in this form if the text had been written on a scroll, in which case chapter 1 would be on the first and followed by chapter 2, side by side, and so on. The logical conclusion is that this papyrus fragment forms the outer pages of a codex, or book, gathering, with chapters 2 to 19 written consecutively on pages inside which were folded in a codex form.

There is no documented evidence as to why scrolls were replaced by codices, but some historians think that the early Christians wanted their holy scriptures to be in a different physical form from secular classical texts. Almost all extracts found of the New Testament from the first few centuries are from codices and not scrolls, yet secular texts, especially those written in Greek, continued to be in scroll form. This papyrus from the third century would seem to bear evidence of that. However, scholars urge caution in drawing conclusions, as most of the early codex and Christian evidence is from Egypt and usage may be different elsewhere. Another fragment – Papyrus 745 (P. Oxy I 30) – also found in Oxyrhynchus and actually written on parchment, not papyrus – is probably the earliest codex that has been found in any language. It is in Latin, probably written in Italy at the end of the first or the beginning of the second century, and the text is written with a broad-edged nib; it contains an extract from *De Bellis Macedonicis* ('On the Macedonian Wars'), a secular text.[1] This questions somewhat the Christian-codex versus secular-scroll theory, and the next developments on this will be very interesting. The text here is in Greek and it seems to have been written in rather a hurry as the letter-forms appear a little rushed.

ΠΑ
ΝΕΠΠ
-ΤΡΗ
ΟΥΘΤ
ΗΚΑΕ
Ο ΚΑΕ
ΥΝΤΑΕΕ

ΟΛΟΥΘΟΥ
ΕΡΙΝΕ ΚΛΑΘ
ΟΛΟΥΘΟΥΝΤΟΣ
ΕΙ
ΜΝΕΥΤΟΜΕ
ΛΕΓΕ
ΔΕ ΗΙΘΑΝ
ΝΠΑΡΑΥΤΟ

ΜΝΗ
ΠΑΡΕΚ
ΗΔΑ

ΔΙΟ
ΤΑΥΤ
ΕΡΚΑ
ΛΗΔΕ
ΓΙΝΗ
ΔΟΚΟ
ΛΥΤΩ
ΜΟΙΠ

208

ΕΑΡΑ

ΚΡΙΘΗΣΑΝΑΥΤΩΤΙ
ΝΕΣΤΩΝΓΡΑΜΜΑ
ΤΕΩΝΚΑΙΦΑΡΙΣΕ
ΩΝΛΕΓΟΝΤΕΣΔΙ
ΔΑΣΚΑΛΕΘΕΛΟΜΕ
ΑΠΟΣΟΥΣΗΜΙΟΝ
ΙΔΙΝ
ΟΔΕΑΠΟΚΡΙΘΙΣΕΙ
ΠΕΝΑΥΤΟΙΣΓΕΝΕ
ΑΠΟΝΗΡΑΚΑΙΜΟΙ
ΧΑΛΙΣΣΗΜΙΟΝΕΠΙ
ΖΗΤΙΚΑΙΣΗΜΙΟΝ
ΟΥΔΟΘΗΣΕΤΕΑΥΤΗ
ΕΙΜΗΤΟΣΗΜΙΟΝ
ΙΩΝΑΤΟΥΠΡΟΦΗ
ΤΟΥΩΣΠΕΡΓΑΡΗΝ
ΙΩΝΑΣΕΝΤΗΚΟΙ
ΛΙΑΤΟΥΚΗΤΟΥΣΤΡΙ
ΗΜΕΡΑΣΚΑΙΤΡΙΣ
ΝΥΚΤΑΣΟΥΤΩΣΕ
ΣΤΕΟΥΣΤΟΥΑΝΟΥ
ΕΝΤΗΚΑΡΔΙΑΤΗΣΓΗ
ΤΡΙΣΗΜΕΡΑΣΚΑΙΤ
ΝΥΚΤΑΣ
ΑΝΔΡΕΣΝΙΝΕΥΕΙΤΕ
ΑΝΑΣΤΗΣΟΝΤΕ
ΤΗΚΡΙΣΙΜΕΤΑΤΗ
ΓΕΝΕΑΣΤΑΥΤΗΣ
ΚΑΙΚΑΤΑΚΡΙΝΟΥΣΙ
ΑΥΤΗΝΟΤΙΜΕΤΕ
ΝΟΗΣΑΝΕΙΣΤΟΚΗ
ΡΥΓΜΑΙΩΝΑΚΑΙ
ΙΔΟΥΠΛΕΙΟΝΙΩ
ΝΑΩΔΕΒΑΣΙΛΙΣ
ΣΑΝΟΤΟΥΕΓΕΡΘΗ
ΣΕΤΕΕΝΤΗΚΡΙΣΕΙ
ΜΕΤΑΤΗΣΓΕΝΕΑ
ΤΑΥΤΗΣΚΑΙΚΑΤΑ
ΚΡΙΝΙΑΥΤΗΝΟΤΙ
ΗΛΘΕΝΕΚΤΩΝΠΙ
ΡΑΤΩΝΤΗΣΓΗΣΑ
ΚΟΥΣΕΤΗΝΣΟΦΙ
ΑΝΣΟΛΟΜΩΝΟ
ΚΑΙΙΔΟΥΠΛΕΙΟΝ
ΣΟΛΟΜΩΝΟΣΩ
ΔΕ
ΟΤΑΝΔΕΤΟΑΚΑΘΑ
ΤΟΝΠΝΑΕΞΕΛΘΗ

ΑΠΟΤΟΥΑΝΟΥΔΙΕΡ
ΧΕΤΕΔΙΑΝΥΔΡΩΝ
ΤΟΠΩΝΖΗΤΟΥΝ
ΑΝΑΠΑΥΣΙΝΚΑΙ
ΧΕΥΡΙΣΚΕΙΤΟΤΕ
ΛΕΓΕΙΣΤΟΝΟΙΚ
ΜΟΥΕΠΙΣΤΡΕΦΩ
ΟΘΕΝΕΞΗΛΘΟΝ
ΘΟΝΕΥΡΙΣΚΕΙΣΧ
ΧΑΖΟΝΤΑΚΑΙΣΕΣΑ
ΡΩΜΕΝΟΝΚΑΙΚΕ
ΚΟΣΜΗΜΕΝΟΝ
ΤΟΤΕΠΟΡΕΥΕΤΕ
ΠΑΡΑΛΑΜΒΑΝΙΜΕ
ΘΕΑΥΤΟΥΕΠΤΑΕΤ
ΡΑΠΝΑΠΟΝΗΡ
ΤΕΡΑΕΑΥΤΟΥΚΑΙΕΞ
ΕΛΘΟΝΤΑΚΑΤΟΙ
ΚΙΕΚΙΚΑΙΓΙΝΕΤΕ
ΤΑΕΣΧΑΤΑΟΥΑΝ
ΕΚΙΝΟΥΧΙΡΟΝΑ
ΤΩΝΠΡΩΤΩΝ
ΟΥΤΩΣΕΣΤΕΚΑΙ
ΤΗΓΕΝΕΑΤΑΥΤΗ
ΤΗΠΟΝΗΡΑΕΤΙ
ΑΥΤΟΥΛΑΛΟΥΝΤ
ΤΟΙΣΟΧΛΟΙΣΙΔΟΥ
ΗΜΗΤΗΡΚΑΙΟΙ
ΑΔΕΛΦΟΙΑΥΤΟΥ
ΙΣΤΗΚΙΣΑΝΕΞΩ
ΟΔΕΑΠΟΚΡΙΘΕΙ
ΕΙΠΕΝΤΩΛΕΓΟΝ
ΤΙΑΥΤΩΤΙΣΕΣΤΙ
ΗΜΗΡΜΟΥΚΑΙΤΙ
ΝΕΣΕΙΣΙΝΟΙΑ
ΦΟΙΜΟΥΚΑΙΕΚΤ
ΝΑΣΤΗΝΧΙΡΑΑΥΤΟΥ
ΕΠΙΤΟΥΣΜΑΘΗ
ΤΑΣΑΥΤΟΥΕΙΠΕΝ
ΙΔΟΥΗΜΗΡΜΟΥ
ΚΑΙΟΙΑΔΕΛΦΟΙ
ΜΟΥ
ΟΣΤΙΣΓΑΡΑΝΠΟΙ
ΗΣΗΤΟΘΕΛΗΜΑ
ΤΟΥΠΡΣΜΟΥΤΟΥ
ΕΝΟΥΝΟΙΣΑΥΤΟ
ΜΟΥΑΔΕΛΦΟΣΚ
ΑΛΕΛΦΗΚΑΙΜΗ

ΕΣΤΙΝΕΝΤΗΗΜΕ
ΕΚΙΝΗΕΞΕΛΘΩΝ
ΟΙΣΕΚΤΗΣΟΙΚΙΑ
ΕΚΑΘΗΤΟΠΑΡΑΤΗ
ΘΑΛΑΣΣΑΝΚΑΙΣΥ
ΝΗΧΘΗΣΑΝΠΡΟ
ΑΥΤΟΝΟΧΛΟΙΠ
ΛΟΙΩΣΤΕΑΥΤΟΝ
ΕΙΣΠΛΟΙΟΝΕΜΒΑ
ΤΑΚΑΘΗΣΘΕΚΑΙ
ΠΑΣΟΟΧΛΟΣΕΠΙ
ΤΟΝΑΙΓΙΑΛΟΝΙΣΤΗ
ΚΙ
ΚΑΙΕΛΑΛΗΣΕΝΑΥ
ΤΟΙΣΠΟΛΛΑΕΝΠΑ
ΡΑΒΟΛΑΙΣΛΕΓΩΝ
ΙΔΟΥΕΞΗΛΘΕΝΟ
ΡΩΝΤΟΥΣΠΙΡΕΚΑ
ΕΝΤΩΣΠΙΡΙΝΑΥ
ΤΟΝΑΜΕΝΕΠΕΣΕ
ΠΑΡΑΤΗΝΟΔΟΝΚΑ
ΗΛΘΕΝΤΑΠΕΤΙΝΑ
ΚΑΙΚΑΤΕΦΑΓΕΝ
ΑΥΤΑ
ΑΛΛΑΔΕΕΠΕΣΕΝΕ
ΠΙΤΑΠΕΤΡΩΔΗΟ
ΠΟΥΟΥΚΕΙΧΕΝΓΗ
ΠΟΛΛΗΝΚΑΙΕΥΘΕ
ΩΣΕΞΑΝΕΤΙΛΕΝΔΙΑ
ΤΟΜΗΕΧΙΝΒΑΘ
ΓΗΣΗΛΙΟΥΔΕΑΝΑ
ΤΙΛΑΝΤΟΣΕΚΑΥΜΑ
ΤΙΣΘΗΚΑΙΔΙΑΤΟ
ΜΗΕΧΕΙΝΡΙΖΑΝ
ΞΗΡΑΝΘΗ
ΑΛΛΑΔΕΕΠΕΣΕΝΕ
ΠΙΤΑΣΑΚΑΝΘΑΣ
ΚΑΙΑΝΕΒΗΣΑΝΑΙ
ΑΚΑΝΘΑΙΚΑΙΕΠΝΙ
ΞΑΝΑΥΤΑ
ΑΛΛΑΔΕΕΠΕΣΕΝ
ΕΠΙΤΗΝΓΗΝΤΗΝΚΑ
ΛΗΝΚΑΙΕΔΙΔΟΥ
ΚΑΡΠΟΝΟΜΕΝ
ΚΑΤΟΝΟΔΕΕΞΗΚ
ΤΑΔΕΛΕΘΕΧΩΝ
ΩΤΑΑΚΟΥΕΤΩ
ΚΑΙΠΡΟΣΕΛΘΟΝΤΕ

ΟΙΜΑΘΗΤΑΙΕΙΠΑ
ΑΥΤΩΔΙΑΤΙΕΝΠΑ
ΡΑΒΟΛΑΙΣΑΥΤΟΙ
ΛΑΛΕΙΣ
ΟΔΕΑΠΟΚΡΙΘΕΙ
ΕΙΠΕΝΟΤΙΥΜΙΝ
ΔΕΔΟΤΑΙΓΝΩΝΕ
ΤΑΜΥΣΤΗΡΙΑΤΗ
ΒΑΣΙΛΙΑΣΤΩΝΟΥ
ΡΑΝΩΝΕΚΙΝΟΙΣ
ΔΕΟΥΔΕΔΟΤΑΙ
ΟΣΤΙΣΓΑΡΕΧΕΙΔΟ
ΘΗΣΕΤΕΑΥΤΩΚΑΙ
ΠΕΡΙΣΣΕΥΘΗΣΕΤΕ
ΟΣΤΙΣΔΕΟΥΚΕΧΙ
ΚΑΙΟΕΧΕΙΑΡΘΗΣΕ
ΤΕΑΠΑΥΤΟΥΔΙΑΤ
ΤΟΕΝΠΑΡΑΚΟΛ
ΑΥΤΟΙΣΛΑΛΩΟΤΙ
ΒΛΕΠΟΝΤΕΣΟΥ
ΒΛΕΠΟΥΣΙΝΚΑΙΑ
ΚΟΥΟΝΤΕΣΟΥΚΑ
ΚΟΥΟΥΣΙΝΟΥΔΕ
ΣΥΝΙΟΥΣΙΝ
ΚΑΙΑΝΑΠΛΗΡΟΥ
ΤΑΙΑΥΤΟΙΣΗΠΡ
ΦΗΤΙΑΗΣΑΙΟΥΗ
ΛΕΓΟΥΣΑΑΚΟΗ
ΑΚΟΥΣΕΤΕΚΑΙΟΥ
ΜΗΣΥΝΗΤΕΚΑΙ
ΒΛΕΠΟΝΤΕΣΒΛ
ΨΗΤΕΚΑΙΟΥΜΗ
ΔΗΤΕΕΠΑΧΥΝΘΗ
ΓΑΡΗΚΑΡΔΙΑΤΟΥ
ΛΑΟΥΤΟΥΤΟΥΚΑΙ
ΤΟΙΣΩΣΙΝΑΥΤ
ΒΑΡΕΩΣΗΚΟΥΣ
ΚΑΙΤΟΥΣΟΦΘΑΛ
ΜΟΥΣΑΥΤΩΝΕΚΑΜ
ΜΥΣΑΝΜΗΠΟΤ
ΙΔΩΣΙΝΤΟΙΣΟ
ΦΘΑΛΜΟΙΣΚΑΙΤΙ
ΩΣΙΝΑΚΟΥΣΩΣΙ
ΚΑΙΤΗΚΑΡΔΙΑΣΥΝ
ΣΙΝΚΑΙΕΠΙΣΤΡΕ
ΨΩΣΙΝΚΑΙΙΑΣΟΜ
ΑΥΤΟΥΣ
ΥΜΩΝΔΕΜΑΚΑΡΙ

ΖΗΤΟΥΝΤΕΣΑΥΤ ... ΑΛΛΑ ... ΕΙΠΕΝΟΤΙ
... ΕΝΤΙΔΑΟΙ ... ΝΑΙΤΟΥ ... ΥΜΗΡ ...
ΚΑΙ ... ΑΔΕΛΦ ... ΓΥ ... ΖΗΤΟΥΣΙΝ

2

Codex Sinaiticus

Cæsarea(?), fourth century
BL Add. 43725, f. 206v

The Codex Sinaiticus is a truly remarkable book. It was discovered in the monastery of St Catherine, at the foot of Mount Sinai in Egypt, and was described in 1859 by the German theologian, Constantine Tischendorf, as 'the most precious biblical treasure in existence'. It was said to have been donated by the monastery to the Russian Tsar, and arrived at the British Library after being sold by Joseph Stalin in 1933 to raise money for his second Five-Year Plan for the USSR. A fund-raising campaign was set up in Britain to buy the book. Donations, which included the tiniest amounts from the public, were also made by King George V, the British Museum (which incorporated the British Library at the time) and the British government; the final sum paid was £100,000 (£6.4 million today).

The Codex Sinaiticus contains much of the Old Testament, including books such as Tobit and Judith, and the oldest complete copy of the New Testament. It has been dated to the mid fourth-century, and could possibly be one of the fifty bibles written at Cæsarea that were commissioned by the Emperor Constantine (see page 11). The text is written in Greek Uncials with a broad-edged nib and a fairly flat nib angle, which makes the downstrokes rather thick and the horizontal strokes thin. The lettering is grand and evenly spaced, with a few strokes descending below the lower guideline for x-height, for example on letters **Y** (upsilon) and **P** (rho). No strokes extend beyond the top guideline for x-height. It is written in *scriptura continua*, which means that there is no spacing between the words and makes the text rather difficult to read. In later centuries an impressive large book such as this would have been used as the grand monastery Bible from which extracts would be read during services; this seems unlikely for this book, however, because of the reading challenges. There are 23,000 corrections in the 800 preserved pages, more than 30 per page,[2] which is substantial – although two-thirds of those are simply going over faded strokes, correcting spellings and so on. The rest, which date from when the book was written until the twelfth century, deal with insertions of text and changes of meaning, as well as deletions of text. The ink used throughout the book is brown, black and red, and most of the skin is vellum rather than parchment; this has been established by the pattern made by the hair follicles. About 360 animals were required to provide the skins for the book. Three, or possibly four, different scribes have been identified. The page shown on the left is by Scribe A and is from the Gospel of Matthew, 12: 38 to 13: 16.

3
Codex Augusteus

Italy, fourth century
Biblioteca Apostolica Vaticana, MS Vat.Lat. 3256, f. 3r

There are only seven leaves remaining of this large book (*c.* 31.9 by 37.9 cm [12½ by 15 inches]) which contained the works of the Roman author Virgil: four leaves are in the Vatican Library and three are in the Staatsbibliothek zu Berlin (Lat. fol. 416). It truly was a luxury volume with wide margins and letters almost a 6mm (¼ inch) in height; these are remarkably even with a very challenging lettering style. Note the places around the edges of the page, especially on the right, that have been neatly repaired by carefully cut vellum shapes.

The Square Capitals or *Capitales Quadratæ* (called Square Capitals because they are based on a circle encased in a square) are based on those cut into stone in Roman inscriptions. Written with a reed pen (calamus) they show great artistry. There is a fairly consistent pen nib angle of 0° to the horizontal for many letters, resulting in thick downstrokes and thinner horizontal strokes, giving a deceptive lightness to the script. To maintain this pen nib angle the elbow is held tightly into the waist and the wrist twisted to the right so that the knuckles of the hand are almost in a horizontal line. This is not that difficult to do and indeed later manuscripts, such as the Lindisfarne Gospels and the Vespasian Psalter required a similar pen hold and arm position. However, the letter-forms in the Codex Augusteus are very contrived with many pen-lifts and almost constant pen manipulation particularly to construct the serifs of strokes that are not vertical, such as on letters **A** (without its crossbar), **V**, **N**, **S** and **M**, all on the top line.

This would have been a very time-consuming manuscript to write. Stanley Morison was particularly scathing about the lettering, declaring that 'it involved extravagant waste of time, expense of material, irrational misuse of lettering and confusion of purpose,

and was a formula that could serve only for a very few patrons who desired a sumptuous text of a classical writer having a message compatible with Christianity'.[3] As an example of this 'extravagant waste of time', the letter **R** is written with a downstroke that is very narrow, made by turning the pen to 0° to the horizontal; the serif is then most contrived using the left-hand corner of the pen nib to 'draw' a tiny triangle. The pen nib angle is then back to 0° form the bowl and the tail. This is in contrast to the letter **P** where the 0° angle is maintained throughout, including the base serif; both are shown on the top line. Meticulous care has been taken to write exactly between two horizontal guidelines with just a few letters extending beyond. The letter **L** invariably extends beyond the top guideline for x-height as shown towards the middle of line two. The tail of the letter **Q** extends below the lower line for x-height, as would be expected, as in line seven from the bottom of the text, but not always as in line two from the top. The letter **F**, as in the first two letters on the top line after the enlarged **O**, extends above with the most exuberantly fine top stroke often wafting upwards to the right, and with a long base serif that can be as long as the crossbar. Occasionally the thin right-hand stroke from the letter **V** (with another nib angle change) extends below, rather far in the last line towards the end and less so in the line above to the right. Note the letter **A**, which has no crossbar as towards the end of the second line. The letter **T** is constructed with a very small stroke to the right of the downstroke, however at the ends of lines eight, eleven and twelve, this stroke extends in a way whereby the movement of the pen can be almost felt as it travels to the right and is lifted from the vellum surface with a flourish. What is particularly important about this manuscript, though, is the enlarged and decorated letter at the beginning of the page – the pre-cursor to the many enlarged initials to follow in later manuscripts..

OFFICIVNTAVTVMBRANOCETPATERIPSECOL[endi]
HAVDFACILEMESSEVIAMVOLVITPRIMVSQ·PERART[em]
MOXETAGROSCVRISACVENSMORTALIACORDA
NECTORPEREGRAVIPASSVSSVAREGNAVETERNO
ANTEIOVEMNVLLISVBIGEBANTARVACOLONI
NESIGNAREQVIDEMAVTPARTIRILIMITECAMPVM
FASERATINMEDIVMQVAEREBANTIPSAQ·TELLVS
OMNIALIBERIVSNVLLOPOSCENTEFEREBAT
ILLEMALVMVIRVSSERPENTIBADDIDITATRIS
PRAEDARIQ·LVPOSIVSSITPONTVMQ·MOVERI
MELLAQ·DECVSSITFOLIISIGNEMQ·REMOVIT
ETPASSIMRIVISCVRRENTIAVINAREPRESSIT
VTVARIASVSVSMEDITANDOEXTVNDERETARTIS
PAVLATIMETSVLCISFRVMENTIQVAERERETHERBA
VTSILICISVENISABSTRVSVMEXCVDERETIGNEM
TVNCALNOSPRIMVMFLVVIISENSERECAVATAS
NAVITATVMSTELLISNVMEROSETNOMINAFECIT
PLEIADASHYADASCLARAMQ·LYCAONISARCTO[n]
TVMLAQVEISCAPTAREFERASETFALLEREVISCO
INVENTVMETMAGNOSCANIBCIRCVMDARESAL[tus]

ΩΣΚΑΙΤΑΣΛΟΙΠΑΣΓΡΑΦΑΣΠΡΟΣ
ΤΗΝΙΔΙΑΝΑΥΤΩΝΑΠΩΛΕΙΑΝ
ΥΜΕΙΣΟΥΝΑΓΑΠΗΤΟΙΠΡΟΓΙΝΩ
ΣΚΟΝΤΕΣΦΥΛΑΣΣΕΣΘΕ
ΙΝΑΜΗΤΗΤΩΝΑΘΕΣΜΩΝΠΛΑ
ΝΗΣΥΝΑΠΑΧΘΕΝΤΕΣΕΚΠΕ
ΣΗΤΕΤΟΥΙΔΙΟΥΣΤΗΡΙΓΜΟΥ
ΑΥΞΑΝΕΤΕΔΕΕΝΧΑΡΙΤΙΚΑΙΓΝΩ
ΣΕΙΤΟΥΚΥΗΜΩΝΚΑΙΣΡΣΙΧΥ
ΑΥΤΩΗΔΟΞΑΚΑΙΝΥΝΚΑΙΕΙΣ
ΗΜΕΡΑΝΑΙΩΝΟΣΑΜΗΝ

ΙΩΑΝΝΟΥ Α

ΟΗΝΑΠΑΡΧΗΣΟΑΚΗΚΟΑΜΕΝΟΕΩΡΑ
ΚΑΜΕΝΤΟΙΣΟΦΘΑΛΜΟΙΣΗΜΩ
ΟΕΘΕΑΣΑΜΕΘΑΚΑΙΑΙΧΕΙΡΕΣΗΜΩ
ΕΨΗΛΑΦΗΣΑΝΠΕΡΙΤΟΥΛΟΓΟΥ
ΤΗΣΖΩΗΣΚΑΙΗΖΩΗΕΦΑΝΕΡ
ΩΘΗΚΑΙΕΟΡΑΚΑΜΕΝΚΑΙΜΑΡΤΥ
ΡΟΥΜΕΝΚΑΙΑΠΑΓΓΕΛΛΟΜΕΝ
ΥΜΙΝΤΗΝΖΩΗΝΤΗΝΑΙΩΝΙΟ
ΗΤΙΣΗΝΠΡΟΣΤΟΝΠΡΑΚΑΙΕΦΑ
ΝΕΡΩΘΗΗΜΙΝΟΕΩΡΑΚΑΜΕ
ΚΑΙΑΚΗΚΟΑΜΕΝΑΠΑΓΓΕΛΛΟ
ΜΕΝΚΑΙΥΜΙΝΙΝΑΚΑΙΥΜΕΙΣ
ΚΟΙΝΩΝΙΑΝΕΧΗΤΕΜΕΘΗΜΩ
ΚΑΙΗΚΟΙΝΩΝΙΑΔΕΗΗΜΕΤΕ
ΜΕΤΑΤΟΥΠΡΣΚΑΙΜΕΤΑΤΟΥΥΥ
ΑΥΤΟΥΙΥΧΥΚΑΙΤΑΥΤΑΓΡΑΦΟΜΕ
ΥΜΙΝΙΝΑΗΧΑΡΑΥΜΩΝΗΠΕ
ΠΛΗΡΩΜΕΝΗ

ΚΑΙΑΥΤΗΕΣΤΙΝΗΑΓΓΕΛΙΑΗΝ
ΑΚΗΚΟΑΜΕΝΑΠΑΥΤΟΥΚΑΙΑΝΑ
ΓΓΕΛΛΟΜΕΝΥΜΙΝΟΤΙΟΘΣΦΩΣ
ΕΣΤΙΝΚΑΙΣΚΟΤΙΑΕΝΑΥΤΩΟΥΚΕΣ
ΟΥΔΕΜΙΑΕΑΝΕΙΠΩΜΕΝ
ΟΤΙΚΟΙΝΩΝΙΑΝΕΧΟΜΕΝΜΕΤΑΥ
ΤΟΥΚΑΙΕΝΤΩΣΚΟΤΕΙΠΕΡΙΠΑ
ΤΩΜΕΝΨΕΥΔΟΜΕΘΑΚΑΙΟΥΠΟΙ
ΩΜΕΝΤΗΝΑΛΗΘΕΙΑΝΕΑΝΔΕ
ΕΝΤΩΦΩΤΙΠΕΡΙΠΑΤΩΜΕΝ
ΩΣΑΥΤΟΣΕΣΤΙΝΕΝΤΩΦΩΤΙ

ΚΟΙΝΩΝΙΑΝΕΧΟΜΕΝΜΕ
ΚΑΙΤΟΑΙΜΑΙΥΧΥΤΟΥΥΙΟΥ
ΤΟΥΚΑΘΑΡΙΖΕΙΗΜΑΣΑΠΠΑ
ΣΗΣΑΜΑΡΤΙΑΣΕΑΝΕΙΠΩ
ΟΤΙΑΜΑΡΤΙΑΝΟΥΚΕΧΟΜΕΝ
ΕΑΥΤΟΥΣΠΛΑΝΩΜΕΝΚΑΙΗ
ΛΗΘΕΙΑΕΝΗΜΙΝΟΥΚΕΣΤΙΝ
ΕΑΝΟΜΟΛΟΓΩΜΕΝΤΑΣΑΜΑΡ
ΤΙΑΣΗΜΩΝΠΙΣΤΟΣΕΣΤΙΝ
ΚΑΙΔΙΚΑΙΟΣΙΝΑΑΦΗΗΜΙΝ
ΤΑΣΑΜΑΡΤΙΑΣΚΑΙΚΑΘΑΡΙΣΗ
ΗΜΑΣΑΠΟΠΑΣΗΣΑΔΙΚΙΑΣ
ΕΑΝΕΙΠΩΜΕΝΟΤΙΟΥΧΗΜΑ
ΤΗΚΑΜΕΝΨΕΥΣΤΗΝΠΟΙΟΥ
ΜΕΝΑΥΤΟΝΚΑΙΟΛΟΓΟΣΑΥΤΟΥ
ΟΥΚΕΣΤΙΝΕΝΗΜΙΝ
ΤΕΚΝΙΑΜΟΥΤΑΥΤΑΓΡΑΦΩΥΜΙ
ΙΝΑΜΗΑΜΑΡΤΗΤΕΚΑΙΕΑΝΤΙΣ
ΑΜΑΡΤΗΠΑΡΑΚΛΗΤΟΝΕΧΟΜΕ
ΠΡΟΣΤΟΝΠΡΑΙΗΝΧΝΔΙΚΑΙΟΝ
ΚΑΙΑΥΤΟΣΕΣΤΙΝΙΛΑΣΜΟΣ
ΠΕΡΙΤΩΝΑΜΑΡΤΙΩΝΗΜΩ
ΟΥΠΕΡΙΤΩΝΗΜΕΤΕΡΩΝΔΕ
ΜΟΝΟΝΑΛΛΑΚΑΙΠΕΡΙΟΛΟΥ
ΤΟΥΚΟΣΜΟΥΚΑΙΕΝΤΟΥΤΩ
ΓΙΝΩΣΚΟΜΕΝΟΤΙΕΓΝΩΚΑ
ΜΕΝΑΥΤΟΝΕΑΝΤΑΣΕΝΤΟΛΑΣ
ΑΥΤΟΥΤΗΡΩΜΕΝ
ΟΛΕΓΩΝΟΤΙΕΓΝΩΚΑΑΥΤΟΝ
ΚΑΙΤΑΣΕΝΤΟΛΑΣΑΥΤΟΥΜΗ
ΤΗΡΩΝΨΕΥΣΤΗΣΕΣΤΙΝ
ΕΝΤΟΥΤΩΗΑΛΗΘΕΙΑΟΥΚΕΣΤΙ
ΟΣΔΑΝΤΗΡΗΑΥΤΟΥΤΟΝΛΟΓΟ
ΑΛΗΘΩΣΕΝΤΟΥΤΩΗΑΓΑΠΗ
ΤΟΥΘΥΤΕΤΕΛΕΙΩΤΑΙΕΝΤΟΥ
ΤΩΓΙΝΩΣΚΟΜΕΝΟΤΙΕΝΑΥ
ΤΩΕΣΜΕΝ ΟΛΕΓΩΝΕΝΑΥ
ΤΩΜΕΝΕΙΝΟΦΙΛΕΙΚΑΘΩΣ
ΕΚΕΙΝΟΣΠΕΡΙΕΠΑΤΗΣΕΝ
ΚΑΙΑΥΤΟΣΠΕΡΙΠΑΤΕΙΝ
ΑΓΑΠΗΤΟΙΟΥΚΕΝΤΟΛΗΝΚΑΙΝΗ
ΓΡΑΦΩΥΜΙΝΑΛΛΕΝΤΟΛΗΝ
ΠΑΛΑΙΑΝΗΝΕΙΧΕΤΕΑΠΑΡΧΗΣ
ΗΕΝΤΟΛΗΗΠΑΛΑΙΑΕΣΤΙΝΟΛΟ
ΓΟΣΟΝΗΚΟΥΣΑΤΕ
ΠΑΛΙΝΕΝΤΟΛΗΝΚΑΙΝΗΝΓΡΑΦΩ
ΥΜΙΝΟΕΣΤΙΝΕΝΑΥΤΩΚΑΙ
ΘΕΣΚΑΙΕΝΥΜΙΝΟΤΙΗΣΚΙΑ
ΠΑΡΑΓΕΤΑΙΚΑΙΤΟΦΩΣΤΟΑΛΗ
ΘΕΙΝΟΝΗΔΗΦΑΙΝΕΙΟΛΕΓΩ
ΕΝΤΩΦΩΤΙΕΙΝΑΙΚΑΙΤΟΝΑΔΕ

4
The Codex Alexandrinus

Constantinople or Asia Minor, fifth century
BL Royal 1 D.viii, f. 81v

The Codex Alexandrinus is one of the three great surviving Uncial Greek Bibles (the other two are the Codex Sinaiticus [see page 62] and the Codex Vaticanus and it is the most complete Bible from early Christian times. Its early history is not known, but the book was brought to Alexandria in Egypt at the beginning of the fourteenth century, from there to Constantinople (now Istanbul in Turkey) and eventually it was presented to King Charles I in 1627. The book was in the Old Royal Library which was donated to the nation by King George II in 1757. It is a large book with 773 vellum folios (630 in the Old Testament and 143 in the New Testament) and the skin is finer than that of the Codex Sinaiticus. The Codex Alexandrinus marks the next stage in book design, in that although there is no separation between the words (*scriptura continua*) the enlarged initial letters in the left-hand margins indicate the beginnings of new sections and so it is much easier to navigate; they are made with the same width pen-nib, indeed the same pen, as that used for the letters in the rest of the text, which is why they look more delicate and airy. There is also space left at the ends of lines just before these initial letters, again enhancing clarity and navigation of the text.

A much larger space and a delightful pen-made decoration at the end of the book of Second Epistle of Peter and the beginning of the First Epistle of John is shown towards the top of the left-hand column. It is unlikely that the same parallel guidelines were drawn, or even adhered to, in this book compared with the Codex Augusteus. There is not such a rigid feeling to the letters and many extend below the base guidelines for x-height, such as the letters Y (upsilon) in the left-hand column and towards the beginnings of lines six and seven, and ф (phi) in the left-hand column in line one towards the end and line four towards the middle. In fact ф (phi) is an enlarged letter just about everywhere it appears; it seems that writing it in two semi-circles, with a central vertical line – extending both above and so far below the base guideline for x-height that it intrudes into the letters on the following line – somehow upset the order of things, and all ideas of relating this letter to the size of the others disappeared.

Other letters extend below the base guideline, including **P** (rho) in the right-hand column, lines three and four, and **Ψ** (psi) at the beginning of line eight in the left-hand column, at the start of John's Epistle (after the decorative pattern). The letter **A** (alpha) often starts with a delightful slight movement to the right before making the thick diagonal stroke, most obvious in line five of the left-hand column. The pen nib has again been held at a flat angle with thick downstrokes and thinner horizontal ones, but there has also been some pen manipulation. The diagonal of the letter **N** (nu) on the top line of the second column is narrower than it would have been had the nib not been turned, the bowl of the letter **A** (alpha) is very fine, as in the second enlarged initial in the margin on the left-hand column, the first middle 'V' of the letter **M** (mu) is very wide, as in the first and second lines of the second column, and in many places the second stroke of the letter **X** (chi) swooshes from the top right to bottom left. Unlike the Square Capitals in the previous manuscript, as is typical with Greek Uncials, these letters have no real serifs to speak of.

DAMT SEU HEU QUAM PINGUI MACER EST MIHI TAURUS IN ARU
IDEM AMOR EXITIUM EST PECORI PECORISQ MAGISTRO
MENTIS SCERTE NEQ AMOR CAUSA EST VIX OSSIBUH AEREN
NE SO QUIS TENEROS OCULUS MIHI FASCINAT AGNOS
DAM DIC QUIBUS IN TERRIS ET ERIS MIHI MAGNUS APOLLO
TRIS PATEAT CAELI SPATIUM NON AMPLIUS ULNAS
ALEN DIC ON LEUS IN TERRIS INSCRIPTI NOMINA REGUM
NASCANTUR FLORES ET PHYLLIDA SOLUS HABETO
PAL NON NOSTRUM INTER VOS TANTAS COMPONERE LITES
ET VITULA TU DIGNUS ET HIC ET QUISQUIS AMORES
AUT METUET DULCIS AUT EXPERIETUR AMAROS
CLAUDITE IAM RIVOS PUERI SAT PRATA BIBERUNT

5
The Vergilius Romanus

Italy, late fifth century
Biblioteca Apostolica Vaticana, MS Vat.Lat. 3867, f. 9r

This is another grand, large and almost square book measuring 350 by 335 mm (14 by 13 inches). It originally had 410 and now 309 fine vellum folios without any blemishes. When completed it contained all the accepted works of the Roman writer Virgil. The fineness of the vellum has caused problems over the years in that the tannic acid in the ink used has bitten into the surface resulting in the abrasion of the skin under some of the letters which can be seen in this page; this has even caused the vellum to fall out between the letters in places, though it is not apparent here. This erosion of the skin can be seen in a number of the letters, especially the base curve of the **B** at the beginning of the line five (**QUIBUS**) and the thicker parts of the two letters **A** (without their crossbars) in the line below just before and after that **B**. It is also evident in two diagonal strokes to the middle of the top margin of the illustration, where the ink from letters in the page overleaf has destroyed the vellum leaving narrow holes. The illustration emphasises the strong ancient Roman influence in art in the fifth-century with the author of the texts, Virgil, sitting in a wooden chair with carved round balls at the ends of the arms, and carved feet at the bases; his own sandalled feet rest on a foot stool. He is holding a scroll and dressed in a long white tunic with a broad red stripe which has a wide sleeve over his right arm. A white cloak goes around his back, is draped over his left arm and then across his lap. On the left, what looks like a hat box is in fact a *capsa*, a cylindrical container for scrolls, and on the right is a lectern ready for Virgil, in this second author portrait in the book, to read out his fourth *Eclogue*, which is the text here.

The lettering is Rustics and the letters are formed by turning the nib anti-clockwise until it is at a steep angle to the horizontal guideline for the downstrokes; these are very thin and in complete contrast to the previous Uncial scripts which have thick vertical strokes. With a slight change of pen nib angle, the strokes that go from top-right to bottom-left, are also very fine. The thickest strokes, in contrast, are the diagonals as well as the hefty feet to many letters; the nib for these is held from 45°–60°, depending on the actual stroke. There is a really strong top-left to bottom-right weight to the lettering and this is very much emphasised by the thick strokes on the letters **V**, **M**, **N** and **A**, such as those in the first line, and the thinnest of strokes in the opposite direction, top-right to bottom-left, as on letters **V**, **A** and **M**. Also heavy are the base serifs and in places they are almost as long as the lower strokes of the letters **E** and **L**, see **BIBERUNT**, the last word on the page, and compare the base strokes of the letters **E** and then **I**, **R** and **T**. These serifs also have the tiniest of curved entry and exit strokes making them very elegant. Most of the letters, which are large – about 8 mm (about ⅓ of an inch) high – are contained between horizontal guidelines. However some extend above the top guideline for x-height, such as the letter **L**, in the middle of the fourth line and in **FLORES** in line eight, where the base stroke, rather than being horizontal, usually has a slight downwards slope that does not extend below the baseline. The letter **F**, a few letters along in the fourth line is wonderfully exuberant; it is as if the control needed to maintain the nib angle and keep that diagonal feel is thrown to the wind with this free top stroke, and this is echoed by the crossbar to the letter **H**, at the beginning of lines one and three.

Quoniamquidemmulti
conatisuntordi
narenarratione·
quaeinnobiscon
pletaesuntrerũ·
sicuttradiderunt
nobis
quiabinitioipsiuide
runtetministris
 etfueruntt
sermonis
uisumestetmihi
adsecutoaprincipio
omnibus
diligenterexordine
tibiscribere
optimetheofile
utcognoscaseorum
uerborumde
quibuserudi
tusesueritate
Fuitindiebushero
disregisiudeae
sacerdosquidam
nomineZaccharias

6

The Harley Gospels

Northern (?) Italy, last quarter of the sixth century
BL Harley 1775, f. 232r

After the density of the previous scripts, the Harley Gospels must have seemed like a godsend to anyone reading it. With other books, glancing away from the page for even a second would often result in losing the place, but here there are sufficient clues on the folios to help to mark the spot visually. First, the chapters start with huge initial letters, as in the letter **Q** shown here. This is a Versal letter written with a pen, and the thicker parts of the curves are made with more than one stroke; a central line on the lower part of the left curve indicates this. The tail is made with one stroke of the pen, but it has a delightful flourish to the right and upwards; this last part is made by twisting the pen anti-clockwise so that the finest line is made by just the left-hand tip of the nib. The letter **F** towards the bottom of the page has been written with one pen-stroke, but a degree of pressure has been used on the nib to make this stroke thicker – indicated by the white line down the middle of the down-stroke. There are similar fine line endings to the crossbars on this letter. The letter-forms are Roman Uncials, written by holding the nib at an angle of 0° to the horizontal guidelines. There have been a few pen nib angle changes, though, such as the bowl of the letters **A**, as in the first and second lines, when the pen has been turned to an angle of about 45°. The first part of the bowl is written down-wards to the left, and then there is an almost imperceptible pause before the pen moves upwards to complete the bowl and join the diagonal downstroke; this is indicated by the point to the shape of the bowl as it meets the lower guideline for x-height. The left-hand

tip of the nib has also been used to create the finest of strokes on the tail of the letter **G** on lines three and eight from the bottom. The nib has been changed to about 45° too for the two downstrokes of the letter **N**, without which change the letter would appear very heavy. Compare the thickness of the downstrokes of the letter **T** in **SUNT** on the second line with those of the letter **N**, for exam-ple, and elsewhere. It seems that this page has been completed in more than one writing session as the first five lines are in a darker ink from the rest of the page. There are also some corrections. Although there are no spaces between the words, they have been written *per cola et commata*, meaning to divide the text according to clauses and phrases, and so there is a pattern to the page that makes it visually more interesting.

The name of this manuscript indicates that it was collected by Robert Harley, first Earl of Oxford and Mortimer (1661–1724), and his son Edward (1689–1741). Edward Harley left his collection to his widow, Henrietta Cavendish (1694–1755), and to their daughter Margaret Bentinck (1715–1785), the Duchess of Portland. They sold the coll-ection to the nation in 1753 for £10,000, nothing like its worth, and it was one of the three collections that formed the British Museum (the others being the Cotton Collection and the Royal Collec-tion). These manuscripts usually have the British Museum (Museum Britannicum) stamp. The British Library was separated from the British Museum only in 1973, following an Act of Parliament in 1972.

7
The St Augustine's Gospels

Italy, sixth century
The Master and Fellows of Corpus Christi College, Cambridge, MS 286, f. 129v

The St Augustine's Gospels are particularly important historically and it is the oldest surviving illustrated Latin Gospel book in the UK. The book is reputed to have been brought over [4] by St Augustine (first third of the sixth century–604) when he was sent by Pope Gregory the Great (c. 540–604) in 597 to bring Britain back to Christianity. The manuscript had great significance at St Augustine's Abbey in Canterbury, and six important books are shown placed on the high altar of St Æthelbert's shrine at the east end of the cathedral in a manuscript drawing of 1410–13;[5] it is 'intrinsically probable that they included the St Augustine's Gospels'.[6] The abbey was destroyed during the Dissolution of the Monasteries (1536–1541).

This sixth-century manuscript still has significance today, as it is the book on which all new archbishops of Canterbury take their oath when enthroned; an open page of the book is also kissed by the new archbishop, which can be rather worrying for conservationists! That it was in Canterbury by the late seventh or early eighth century is clear because additions and corrections were made to the text in an insular script of that period. Later, various records of charters related to the abbey were copied into it, such as on folio 74v the Grant of Renders from Land at Brabourne near Canterbury by Ealhburg to St Augustine's Abbey, c. 850. The script is a grand Roman Uncial, written with a pen nib angle of 0° to the horizontal, resulting in very fine horizontal strokes and thicker downstrokes. There is little pen manipulation to construct the letters apart from the bowl of the letter **A**; here the nib has been turned to about 45°, showing a slight thickening to the part of the stroke on the furthest left (see top line). Chapter headings are in vermilion in a nib a little larger than the main text, as can be seen towards the top of the right-hand column, and the mercury in the pigment has reacted, turned black and smudged. The first line of verses starts further to the left than the remainder of the text, which is indented; this makes navigating the text easier than with most previous manuscripts.

The shrine of St Æthelbert at St Augustine's Abbey, drawn in the early fifteenth century. Six books are clearly visible (see enlargement), three on either side of the central, pedimented structure. One of these is thought to be the St Augustine's Gospels.
Trinity Hall, Cambridge 1, f. 77.

DE FRATRESSTA
BANT FORIS QUA
RENTESLOQUI EI
DIXIT AUTEM EI
QUIDAM
ECCEMATERTUA
ET FRATRES TUI
FORISSTANT
QUAERENTESTE
AT ILLE RESPON
DENSDICENTI
SIBIAIT
QUAEESTMATER
MEA ET QUISUN
FRATRESMEI
ET EXTENSMANUS
INDISCIPULOS
DIXIT ECCEMA
TERMEA ET FRA
TRESMEI
QUICUMQ ENIM
FECERITUOLAN
TATEMPATRISMEI
QUIINCAELISEST
IPSEMEUS ET FRA

TER ET SOROR
ET MATER EST.

XIII IN ILLO DIE
EXIENS IHS DE
DOMOSEDEBAT
SECUSMARE
ET CONGREGATAE
SUNTADEUM
TURBAEMULTAE
ITAUT INNAUICU
LAMASCENDENS
SEDERET
ET OMNISTURBA
STABATINLITOR
ET LOCUTUSEST
EISMULTAINPA
RABOLISDICEN
ECCEEXIITQUISE
MINATSEMINARE
ET DUMSEMINAT
QUAEDAMCECIDE
RUNTSECUSUIA
ET UENERUNTUO
LUCRESETCOME
DERUNTEA

NON ENIM ADMENSURAM
DAT DS SPM
PATER DILIGIT FILIUM ETOMNIA
DEDIT INMANU EIUS
QUI CREDIT INFILIUM
HABET UITAM AETERNAM
QUI AUTEM INCREDULUS EST FILIO
NON UIDEBIT UITAM
SED IRA DI MANET SUPER EUM
VT ERGO COGNOUIT IHS QUIA
AUDIERUNT PHARISAEI QUIA IHS
PLURES DISCIPULOS FACIT
ETBAPTIZAT QUAM IOHANNES
QUAMQUAM IHS NON BAPTIZARET
SED DISCIPULI EIUS
RELIQUIT IUDAEAM ETABIIT
ITERUM INGALILAEAM
OPORTEBAT AUTEM EUM
TRANSIRE PER SAMARIAM

8
The St Cuthbert Gospel

Northumberland, seventh century
BL Add. 89000, f. 12v

The St Cuthbert Gospel is a small, personal book at 13.8 by 9.2 cm (3½ by 5½ inches); it is smaller than a paperback and easily held in the hand. The book has an intimate connection with St Cuthbert (*c.* 634–687); it was found in his coffin when his relics were translated to a new shrine behind the altar at Durham Cathedral in 1104. It was first thought that the book was placed originally in St Cuthbert's coffin much earlier than this, in 698, when his body was disinterred after his burial on Lindisfarne Island (now Holy Island) to be placed near the altar at the church there. St Cuthbert had been a rather reluctant bishop of Lindisfarne for just under two years, far preferring to live the life of a hermit on the Inner Farne Island. In 698, eleven years after his death, St Cuthbert's body was found to be 'incorrupt', that is, with no deterioration and the joints still flexible – the mark of a true saint. Studies now suggest that the manuscript was written after this and dates from *c.* 710–30, and the covers of the binding dating from *c.* 700–30. It may also not have been written on Lindisfarne Island but in Monkwearmouth (now Sunderland), and given as a gift to the monks on Holy Island.

The Uncial script is not as grand as the Latin Uncial in previous manuscripts, but it does have a great clarity, with rhythm and flow. There are ascenders on the letters **D** (second line), **L** (third line), and **H** (sixth line), and descenders on the letters **Q** (fifth line), **P** (third line), **F** (third line) and **G** (tenth line). The text is written *per cola et commata*, the verses starting with an enlarged initial written with the same pen as the rest of the text. Chapters begin with enlarged letters, often in red (as can be seen halfway down the page), although in many places the red, probably vermilion (cinnabar), has turned black – as here on the **V** and all but the crossbar of the letter **T**. This is due to the mercury content in the pigment (vermilion is mercuric sulphide) deteriorating over time. The letter **V** on line ten has been constructed from several strokes to create a thicker left diagonal and also the serif at the top of the right diagonal. The pen has first been held horizontally to make these thicker strokes, and then at an angle of about 60° to make the thinner one. The pen nib is held at a more comfortable angle of 20° to the horizontal guidelines for the text, and there are few pen manipulations to construct the letter-forms here. Dry point ruling is clear and the letters keep mainly to the base guideline for x-height. However, the letters do dance around rather, and there is not quite such a rigid 'tramline' feel to the script.

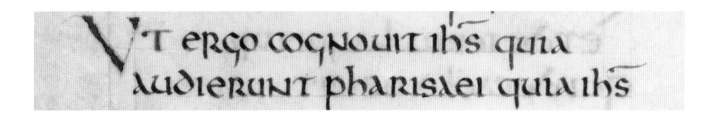

7 FUNER NOMA · · DEM FEDEN

AD FILII NOMEN PATRI

RESTITUENS EUM FILIIS

SIUE PRINCIPIO SIUE

FINE OSTENDENS UNUM

SECUM PATRE ESSE QUIA

UNUS EST IN QUO EUAN

GELIO UALE DESIDERAT

UB: DM SIC PRIMA UEL

MEDIA UEL PERFECTA

COGNOSCERE UT EUOCA

UIT APOSTOLI AD OPUS

EUANGELII AD ILECTIONE

DI INCARNE NASCENTES

PER UNIUERSA LEGENTES

INTELLEGANT ATQ: QUO

APPRAEHENSI SUNT

AD APPREHENDERE

EXPETUNT RECOGNOSCAT

NOBIS ENIM HOC STUDIO

ARGUMENTA FUIT APROE

FACTAE RETRACTARE

COOPERATUS DI INTELLE

GERRAM DILIGENTER ESSE

DISPOSITIONEM QUEREN

NOLUERE EXPLICIT ·······

ONGINNED ... T HEAFUD ...

INCIP CA · PRAEFA LECTIO

SEC MATTHEUM ··

LIBER GENERATIONUM

QUADRAGINTA DUARU

AB ABRAHAM USQUE

AD XPM ORDO NARRATUR

NATIUITAS IHU XPI DE MA

RIA SPONSO EIUS IOSEPH

ANGELO REUELANTE ·

PRAE DICITUR

NATUM XPM MAGI STELLA ·

SIBI DUCE NUNTIANTE

OBLATIS MUNERIBUS

ADORAUERUNT

ANGELO PRAEMONENTE ·

IOSEPH CUM XPO FUGIT

IN AEGYPTUM ET HERODES

OCCIDIT INFANTES

DE PRAEDICATIONE IOHAN

BAPTISTAE QUOD UOX

CLAMATIS SIT PENITENTIA

9
The Lindisfarne Gospels

Lindisfarne, before 720
BL Cotton Nero D.iv, f. 19r

The colophon[7] written at the end of the Lindisfarne Gospels by the provost Aldred, who called himself 'an unworthy and most miserable priest', notes that this magnificent book was 'written for God, St Cuthbert and – generally – for all the saints who are on this island'. Aldred belonged to the monastic community of St Cuthbert during the hundred years or so (from 883–995) it was at Chester-le-Street, and he wrote not only the colophon in the late tenth century, but also the gloss.[8] He also recorded that Eadfrith (d. 721), bishop of Lindisfarne probably from 698 until his death, wrote the book – it was his *opus dei* (work for God). The binding was made by Æthelwald ('as he knew well to do'), bishop of Lindisfarne from 731, while Billfrith, an anchorite, 'forged the ornaments which are on the outside of and adorned it with gold and with gems'. If the outside was anything like the inside, it must have looked magnificent. Michelle Brown[9] has written that the designs by Eadfrith bring together Anglo-Saxon, Celtic, Roman, Coptic and Eastern styles to create a very English result, yet it is not a mess or mish-mash. The skin used is vellum, and as a result not only the painting but also the writing is very fine. Brushes and pens were used for the illustrations; the red dots that surround many of the display letters and also create patterns were, according to tests done by the author, made with a quill rather than a brush. High magnification shows that they are domed with a slight central indentation, indicating that they would have been tiny 'blobs' originally rather than flat dots. These can be created only by pressing a flexible quill down on the surface to release a raised globule of paint; the hairs of a brush retain the pigment and so it is very difficult to control the amount of paint to replicate this. With the vast number of dots on some pages, the preferred implement would have been the one that is most effective, thus a quill. The lettering is Half-Uncial, with a number of ascenders and descenders, and the pen nib was held at a fairly consistent angle of about 2° – not quite horizontal, as can be seen by the tops of the serifs on the letters. The fine strokes are wonderfully crisp: this is the hand of a real master. There are spaces between the words and generous interlinear spaces. Aldred's dancing Insular Minuscule gloss can be seen between the lines.

10

The Ceolfrið Bible

Monkwearmouth-Jarrow, before 716
BL Add. 45025, f. 11r

The three Ceolfrið Bibles were huge books by any standards: the surviving one weighs in at almost 5½ stone (75 lbs, 34 kg) and needs two people to carry it. This volume is the earliest known manuscript of the Bible that is almost complete – missing only the Book of Baruch – and it is the most accurate copy of St Jerome's late fourth-century Vulgate Latin translation. It is thought to have been based on Cassiodorus's (c. 485–c. 585) Codex Grandior, which included all the books of the Bible in one volume, a pandect. Abbott Ceolfrið (c. 642–716), of Monkwearmouth (now Sunderland) and Jarrow, in the north-east of England, commissioned three great Bibles, one each for the twin foundations and one to take with him to present to the Pope in Rome. Ceolfrið left England on 16 June 716, taking the great Bible with him, but he sadly died, aged 74, in Langres in France on 25 September the same year. The Bible disappeared, only to reappear, unidentified, in the ninth century in Monte Amiata in Tuscany; this book became known as the Codex Amiatinus as a result. Centuries later, in 1888, at the Laurentian Library in Florence, the scholar Giovanni Battista de Rossi, noted that the dedication *Ceolfridus Anglorum* ('Ceolfrið of England') in the Codex Amiatinus had been replaced by *Petrus Langobardorum* ('Peter of Lombardy') – this showed that it was one of the great Ceolfrið Bibles!

The writing style is a grand form of Roman Uncial. The script is finely written, and it was therefore presumed that the Codex Amiatinus had been written in Rome. Once it had been identified as the Ceolfrið book, it was thought that the book had come from Rome, then that the scribe had travelled from Rome and written the book in Northumbria. Only in the last century was it accepted that, because of the similarity of script with manuscripts known to have been Northumbrian, the book was produced in England and written by an English scribe. The two books that remained in England also disappeared, but a few single leaves have reappeared, as wrappers for estate documents or as paste-downs [10] in bound books. In these, the vellum is usually discoloured, often with corners cut out to allow for turning in. There are few word divisions and no punctuation, and the text is written *per cola et commata* in two wide columns. The pen nib is held at a flat angle to the guidelines for most of the letters, and the writing is quite evenly spaced with a degree of rhythm. The hand is slightly twisted anti-clockwise and the nib turned for many of the endings of horizontal strokes and serifs, such as the letters **L** on the top line, first column, and the letter **F** on the second line, first column. Some letter-forms are quite contrived, with pen-lifts and changes to the nib angle, for example the letters **N** in the third and fifth lines, first column and the letters **S** in the fourth and sixth lines, first column.

multiplicauit
ut faceret malum coram dño
et inritaret eum
posuitquoq; idolum luci quam
fecerat intemplo dñi
super quo locutus est dñs ad dauid
et ad salomonem filium eius
in templo hoc et in hierusalem
quam elegi de cunctis
tribub; israhel
ponam nomen meum insempiternu
et ultra non faciam commoueri
pedem israhel de terra
quam dedi patrib; eorum
sic tamen si custodierint opera
omnia quae praecipiei s
et uniuersam legem quam man
dauit eis seruus meus moyses
illi uero non audierunt
sed seducti sunt a manasse
ut facerent malum super
gentes quas contriuit dñs
a facie filiorum israhel
locutus q; est dñs in manu ser
uorum suorum prophe
tarum dicens
quia fecit manasse rex iuda
abominationes istas pessimas
super omnia quae fecerunt
amorrei ante eum
et peccare fecit etiam iudam
in inmunditiis suis
propterea haec dicit dñs ds isrl
ecce ego inducam mala super
hierusalem et iudam
ut quicumq; audierit tinniant
ambae aures eius
et extendam super hierusalem
funiculum samariae et pondus
domus ahab et delebo hieru
salem sicut deleri solent
tabulae
delens uertam et ducam cre
brius stilum super faciem eius

dimittam uero reliquias
hereditatis meae
et tradam eas in manu inimicorum eius
eruntq; in uastitate et rapina
cunctis aduersariis suis
eo quod fecerint malum coram me
et perseuerauerint inritantes me
ex die qua egressi sunt patres
eorum ex aegypto usque
ad diem hanc
insuper et sanguinem innoxium
fudit manasses multum nimis
donec inpleret hierusalem
usque ad os
absq; peccatis suis quib; peccare
fecit iudam
ut faceret malum coram dño
reliqua autem sermonum
manasse et uniuersa quae fecit
et peccatum eius quod peccauit
nonne haec scripta sunt in libro
sermonum dierum regu iuda
dormiuitq; manasse
cum patribus suis
et sepultus est in horto domus
suae in horto oza
et regnauit amon filius eius pro eo
Uiginti et duo annorum erat
amon cum regnare coepisset
duob; q; annis regnauit in hierusm
nomen matris eius mesalemeth
filia aruz de iethba
fecitq; malum in conspectu dñi
sicut fecerat manasse pater eius
et ambulauit in omni uia
per quam ambulauerat pater eius
seruiuitq; inmunditiis quibus
seruierat pater suus
et adorauit eas
et dereliquit dñm dm
patrum suorum
et non ambulauit in uia dñi
tetenderuntq; ei insidias
serui sui

SALVVMME

FAC DS QM INTROIERUNT AQ
USQUE AD ANIMAM MEAM INFIXV
SUM INLIMUM PROFUNDI ET
NON EST SUBSTANTIA ···
VENI INALTITUDINEM MARIS ETTEMPESTAS
DEMERSITME ···
LABORAUI CLAMANS RAUCE FACTAESUNT FAU
CES MEAE · DEFECERUNT OCULI MEI DUM SPE
RO INDM MEUM ···
MULTIPLICATISUNT SUPER CAPILLOS CAPITIS
MEI · QUI ODERUNT ME GRATIS ···
CONFORTATISUNT SUPERME QUIMEPERSE
QUUNTUR INIMICI MEI INIUSTE · QUE NON RA
PUI TUNC EXSOLUEBAM ···
DS TU SCIS INSIPIENTIAM MEAM ET DELICTA
MEA ATE NONSUNT ABSCONDITA ···
NON ERUBESCANT INME QUITE EXPECTANT
DNE DS UIRTUTUM NON REUEREANTUR SUPE

The Vespasian Psalter

Kent (Canterbury or Minster-in-Thanet), second quarter of the eighth century
BL Cotton Vespasian A.i, f. 64v

While Half-Uncial was being used as the script for the Lindisfarne Gospels in the north of England, in the south the influence of Rome was still very strong. This is evident in the Vespasian Psalter, written a decade or so after the Lindisfarne Gospels. Grand Roman Uncials, written with a flat pen nib angle and with clearly defined horizontals to the top and bases of strokes, look almost as if they have been written between tramlines, which is emphasised by strong horizontal serifs. The first part of the Gospels, some 19 pages, declare the Roman influence too; they are in Rustics and a form of Square Capitals, and the headings to each Psalm are in red Rustics as well. However, all is not lost on the British front as two parallel vertical lines of red dots, typical of insular manuscripts, indicate where the enlarged coloured Versal[11] letters should be written to start each new verse. There are also horizontal lines of dots marking the guidelines for writing.

Enlarged decorated initial letters begin the chapters, with whole lines larger at the start of the major sections; in the case of this page, a very insular animal or bird head is included at the tail of the initial letter **S**, while just above that and at the start of the letter, there are spirals and coloured interlace. There is more knotwork within the counter (white space) of the Lindisfarne-inspired letter **A** and further along the line, with a wonderful wiggly snake, or maybe a fishbone, between the letters **M**. The gold leaf on the letters here has slightly worn and is flat, in contrast to the raised gold of later manuscripts. The tiny Uncial letters in this manuscript are very slow to write and show a number of pen lifts and nib angle changes. The left-hand corner of the nib is used to make the hairline bowl and the little flick below the base guideline of the letter **A** (second line of text), as well as the thin diagonal stroke of the letter **X** (fifth line from the bottom), while the serifs to the letters **E**, **C**, **G**, **N**, **S**, **X** and **T** are quite contrived. St Jerome (347–420) translated the Psalms from Hebrew into Latin in c. 384. These Psalms also contain the earliest extant examples of historiated[12] initials, showing David and Jonathan on f. 31 and the shepherd with his sheep on f. 53r. The dancing Pointed Insular Minuscule gloss was added around the second quarter of the ninth century, and is the oldest extant translation into English of any biblical text. Michelle Brown[13] suggests that the manuscript may have been produced by the nuns of Minster-in-Thanet; it may also have been written at Christ Church Abbey or St Augustine's Abbey, both in Canterbury.

12
The Stockholm Codex Aureus

England (Canterbury?), *c.* 750
National Library of Sweden, Stockholm, MS A. 135, f. 11r

It is thanks to Alderman Alfred of Surrey and his wife Wærburg that we have the Stockholm Codex Aureus ('Golden Book') today. In the late ninth century he bought it back from the Vikings with 'money, that was with pure gold'.[14] No doubt the book had been looted, its jewelled cover ripped off, and, as the Vikings had no use for the contents, it was sold to Alfred who presented it to Christ Church in Canterbury 'for the love of God and for the benefit of our souls'.[15] At the very end of the inscription, and almost lost, they also name Alhthryth, their daughter. This explanation is written in Pointed Insular Minuscule above and below the glorious gold letters of the main part of the page ('Alfred Alderman' is towards the middle of the top line and 'golde' is in the middle of the second line). Four other people connected to the book are asked to be remembered in prayer in a written inscription in the manuscript. Three of them are presumably the ones responsible for making it – Coelhard, Niclas and Ealhhun; the fourth, Wulfhelm, is identified as a goldsmith. This is a Gospel Book, written in the mid-eighth century probably in Canterbury, and although by this time there were strong insular influences, there is still a Roman, or Italian, feel to the manuscript.

It is a stunning book to look at. Purple-dyed double spreads of pages with writing in gold, silver and white alternate with undyed pages with writing in colour and gold. Purple is a significant colour as it represented Imperial manuscripts; it was used rarely in Britain at this time, and then only for a few pages. This page of gold letters at the beginning of the Gospel of Matthew is magnificent. The chi-rho (**XP**) symbol at the top is an abbreviation of 'Christ' in Greek, and the designs show a distinct Insular influence, with twirling spirals and interlace. There are two birds in the upper part of the letter, whose tails interlock all the way up to their necks, and two animals below them with extended hind legs whose tails do the same. Three more animals feature in the bowl of the **P**, and above and below that letter and the **I**, and more appear in the counters of letters along the top line, together with even more knotwork. The letters themselves are in gold leaf that has become a little worn over the years, but is still in remarkable condition. A line of letters in colour, decorated with patterns and interlace, follows, and under this is another line of gold letters with a central coloured horizontal line to add to the mix. Alternating lines of gold letters and coloured letters with a gold background follow; not only is each line encased within a coloured rectangle, but so is the whole page, making each line and the page itself look like stone inscriptions.

expositis ... palmae
gaudia milites religiosus amplis
ctur; Triumphant pontifi
ces hortabantur furit sine sanguine
Triumphant uictoria fide
rata non uiribus; Conposita
itaque Insula recuperata mult-
plici. ruisliatur que hortab uel
muribilib. uel carne Conspicitur.
pedram molliuntur pontifices
quib tranquillam nauiga
onem. et mshuta propria ccn
dhichrso beati martyris alban
parauhunt. quibtorque eor suo
rum obsidcuir felix arma
persistant:
Hac multo intsppofito
tempore. nuntiatur
ex eadem Insula pela
gianam persuasionem rehato
paucis auctoribus dilatari
puppurque ad beatissimum uiru
prsabis sacerdotum omnium

dscriuntur; ut cauram dci
quam primus obtinuerat uita
petur; quorum petitioni filsi
anur obtmplhat; Namque ad
iuncto fibi reuiso totius fti
atis uiro. qui ipat dyscipulus
beatissimi patris lupi troca
fenorum episcopi. et tunc tre
usfur ordinatur episcopus.
ghitab primae ghimaniae
uisibum praedicabat
Mare conscidit. et consh
tistab clementis tranquillo
nauigio buttaniar petit;
lutdsi ea finistri sspisitur sh
uolantis totam in sulam
ghimanum ubisue inuitis uati
cinatiomb nuntiabant. Intau
tum utelasiur quidam psio
nis illuis primus Inoccupsu
slopsum sine ulla manifso
nuntii pelatione pnopisis
Et hibshy ssccum filium qu

13

Bede's *Ecclesiastical History of the English People*

Monkwearmouth/Jarrow, eighth century
BL Cotton Tiberius A.xiv, f. 20v

This manuscript, which was owned by Sir Robert Cotton MP (1571–1631), a renowned bibliophile and antiquarian, is in a dreadful state as it was very badly burned. Sir Robert's collection of books, papers and manuscripts were given in 1701 'for Publick Use and Advantage'[16] by his grandson, Sir John Cotton, and became one of the three collections that formed the British Museum, later the British Library. What is ironic is that this collection, once it was owned by the nation, was moved from Essex House in the Strand in London (thought to be a fire risk), to Ashburnham House, now part of Westminster School, yet it was here that it was burned, along with many other manuscripts, on 23 October 1731. Up to one-quarter of the collection is thought to have been either destroyed or damaged. Pages have been conserved here by mounting on paper leaves and repaired where necessary.

The book is an early copy of the *History* by the Venerable Bede (672/3–735), written where the great man lived, in Northumberland. The Pointed Insular Minuscule had been used in previous manuscripts as a gloss, but here it is elevated to a formal book hand. The writing is regular and even, and the fact that it is a minuscule script means that there are clear ascenders and descenders to the letters. Three letter-forms are particularly confusing, however. The letter **p** has a bowl which does not meet the downstroke; it has a small ending stroke to the right, and looks a little like the letter **R**. The letter **r**

meanwhile has a downstroke which is as long as that of the **p,** and an arch which extends to the base guideline for x-height, and so looks a little like a **p**! Then the letter **s** also has a tail as long as the **p** with an arch that makes it look like an **r**! All three letters are in the last word – (*ex multo*) *interposito* – of the first full line after the enlarged initial **H** in the lower half of the page, and the letters also appear in the enlargement below. The letter **e** is usually higher than expected, extending above the top guideline for x-height, often as high as ascenders. Ascenders usually start with a wedge serif, but, as the nib angle is quite steep to the horizontal, about 50° with the hand rotated anti-clockwise and the elbow extending out from the body, the serifs do not dominate. The enlarged initial letter **H** shows the insular influences with an 'egg-timer'-shaped internal pattern of interlace between the two uprights, which have themselves been decorated with circles at the top and at the bottom, as well as on the right-hand stroke.

Sir Robert Cotton kept the books in his library in bookcases that were surmounted by busts of Roman emperors. He named and numbered the books, first by the name of the Roman emperor, which, in the case of this book, was Tiberius, and then by the shelf letter. The letter A indicates that this volume would have been on the top shelf. Lastly, the shelf number indicates the position of the book; this one would have been the fourteenth book along.

galileae uidit duos fratres simonem

quiuocabatur petrus etandream fra

tremeius mittentes rete inmare erant

enim piscatores :· ~~~~~~~~

Etaitillis ihs uenite postme · et

faciam uos piscatores fieri

hominum atilli continuo relictis re

bus secutisunt eum ~~~~~~~~

Et procedens inde uidit alios

duos fratres iacobum zebedei etio

hannen fratrem eius innaui cum ze

bedeo patreeorum reficientes retia

sua · etuocauiteos · Illi autem statim

relictis retibus suis et patre secu

ti sunt eum ~~~~~~~~

Et circum ibat ihs totam galile

am docens insinagogis eorum etprae·

14
The Book of Kells

Britain or Ireland, *c.* 800
The Board of Trinity College, Dublin, MS 58, f. 39v

The importance of the Book of Kells, named after the Abbey of Kells in County Meath where the book was housed for many centuries, cannot be over-estimated; many regard it as Ireland's greatest treasure. It was made around the year 800 at a disputed location – Ireland, Iona, Scotland and England have all been suggested, although Iona and/or Kells are accepted by many. The work is a triumph of Celtic artistry, with ten full-page illustrations and many smaller pictures of animals, humans, mythical beasts and Christian symbols. The Gospel Book still has two evangelists portraits taking up the whole page, three pages of the four evangelist symbols, a carpet-page, a page showing the Virgin and Child – the earliest extant image in a Western manuscript – a full-page of Christ enthroned, one showing the Arrest of Christ and one the Temptation of Christ. There are also 13 pages with enlarged and decorated text, including the famous 'chi-rho' page (see over and caption). They show supreme artistry, skill, imagination and knowledge of tools and materials. The book has no gold, so technically it is not an illuminated but a decorated book, but perhaps this is splitting hairs. For a book of this age it is in reasonable condition, although about 30 folios are thought to have been lost. However it has suffered in its history:

> In 1826 the binding carried out in 1742 had become loose, so the manuscript was handed over to George Mullen, the leading Dublin binder, who did a lot of work for the Library.

In this case he did a lot of damage, trimming the leaves (and some of the decoration), gilding the edges and wiping the leaves with a wet cloth, then pressing them while they were damp. He also added white oil paint to some of the margins which has now become purplish in places.[17]

Interestingly, some consider the text to be written out from memory because it is based on St Jerome's Vulgate version, but there are many differences. The writing is Half-Uncial, written in a single column and with between 17 to 19 long lines to the page. Three different scribes are thought to have written the book, and scribe C wrote the text on the page here. The pen is held at a fairly consistent angle of 0° to the guidelines and the serifs are thick and wedge-shaped, which emphasises the horizontal feel to the script. Half-Uncial has a characteristic form to the letter **a**, which looks like two **c**'s written closely together, as in the top line and the word **Fratres**. Here the lower crossbar of the letter **f** also has an interesting pen-made decoration using the left-hand corner of the nib forming a little square. It is, though, the line fillers, delightful enlarged initial letters and coloured letters throughout the book which make the Book of Kells such a delight to the eye. Even at such a small scale as here, interlace, pattern and rather a grumpy-looking bird and dog or lion in the lower coloured initial letter all show what mastery Scribe C possessed.

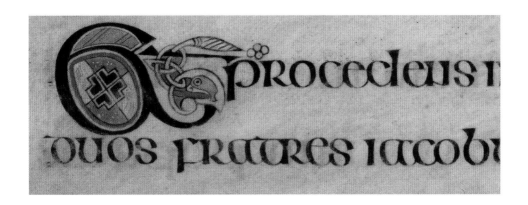

BELOW: In this image of the Virgin and Child, the Virgin has a halo, but the Child does not, although Christ does have a strange line joining up his ear to his nose. They are surrounded by four angels, the upper two filling the space available well, but the lower two are rather squeezed in: one is behind Mary's throne and the other has an awkward neck angle at Mary's feet. The interlaced feet and arms of two rather squashed men with beards fill semi-circles on either side of the holy couple. The border shows dogs or lions each biting the next, with their bodies and legs a mass of pattern.

The Board of Trinity College, Dublin, MS 58 f. 7v.

OPPOSITE: A real tour-de-force of swirling decoration that is simply stunning. The 'chi-rho' page in the Book of Kells shows the first three letters of Christ ('Christos') in Greek – 'X P I' – although these are sometimes confused with an x and a p. The New Testament was first written in Greek, and abbreviating sacred names (sacra nomina) in this way occurred from the second century. It is thought that, similar to the Hebrew practice of writing the name of God as a device, there was a spiritual significance to the combination of letters, and the use of Greek in later Latin books emphasised the link back to early Christianity. (Look closely at this page to find two cats, four rats, a moth and an otter, among intertwined men and other creatures.)

The Board of Trinity College, Dublin, MS 58 f. 34r.

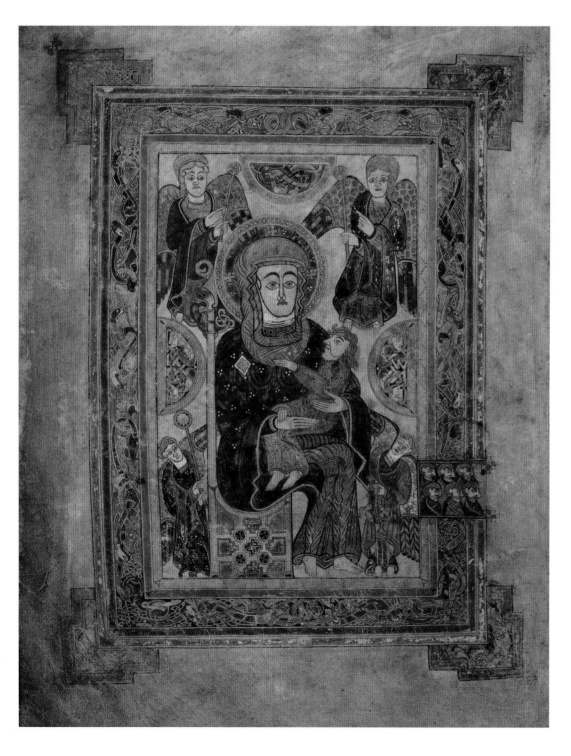

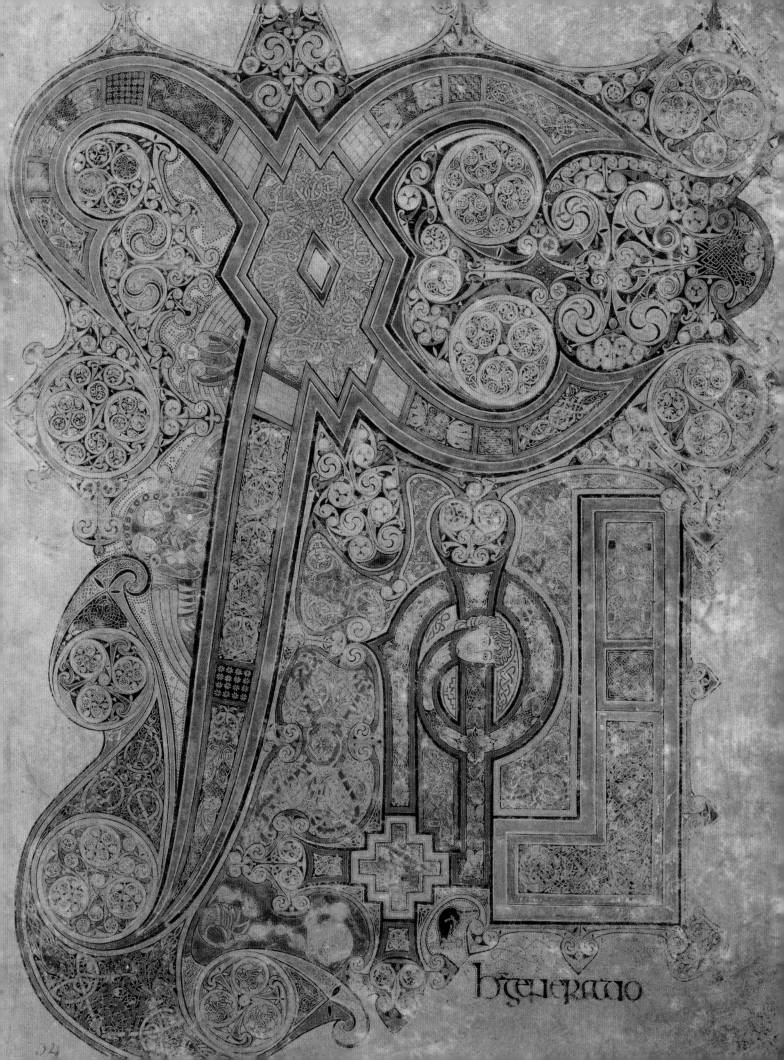

hGeneratio

15
The Harley Golden Gospels

Germany (Aachen?), first quarter of the ninth century
BL Harley 2788, f. 9r

These grand painted architectural columns show yet again the huge influence of Rome in manuscripts, even centuries after the fall of the Empire. This whole page resembles a building, with its large, semi-circular Romanesque arch at the top which houses three small arches below, very similar to paintings in Late Antique books. The sections on either side of this large arch have even been painted with grey flowers and leaves that look as if they are cut in stone. The capitals to the smaller arches look rather like the tops of Corinthian columns, while the stepped base and decorated sections to the columns could also represent stonework. Certainly the script has a very architectural feel. Within the large arch are three of the symbols of the Evangelists – the man on the left representing Matthew, with the calf of Luke in the middle, and the eagle of John on the right. The Evangelist symbols are the four living creatures that drew the throne-chariot, the Merkabah, and feature in the first chapter of the book of Ezekiel and also in the fourth chapter of Revelation. It was Rabanus Maurus (*c.* 780–856) who explained the link and the significance of the symbols, each of which has three levels of meaning relating to the gospel text: the Gospel of Luke for example, starts with the duties of Zacharias in

the temple's Gospel, then links to Christ as a High Priest, and then the bull indicates the sacrifice.

The large painted letters at the top are in shell gold with an infill of silver which, over time, has turned black. Roman numerals within the columns are also in shell gold. This medium does not help writing with rhythm and flow, as during lettering the nib has to be charged very frequently to ensure that the heavy pigment is distributed evenly throughout the medium. The consistency of ink cover in the lettering here and throughout this manuscript, the rest of which is written in Roman Uncials with coloured and gilded decorated borders, is most impressive. Shell gold is very much more extravagant than leaf gold as far more is used, indicating the importance of this book. The columns are Eusabian Tables, devised by Eusabius of Cæsarea (*c.* 260/65–339/40), Bishop of Cæsarea from about 314. He devised ten tables (Greek: *kanones*) that showed, as here, where each individual gospel contained similar text, or where there was a slight difference from the other gospels. This is the third table in the series that compares Matthew, Luke and John, as indicated by their symbols within the upper large arch.

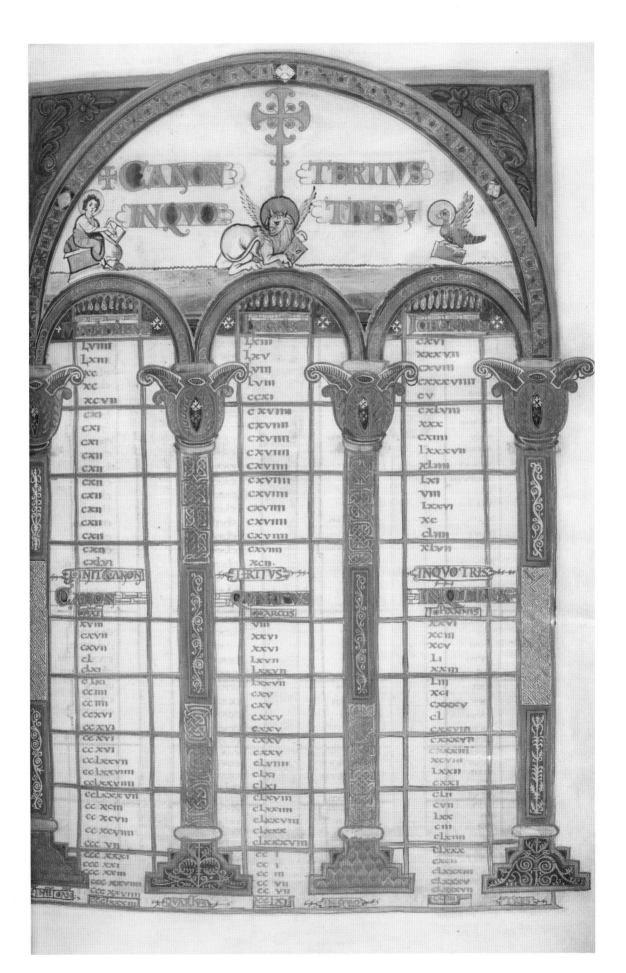

16
The Moutiers-Grandval Bible

Tours, France, ninth century (*c. 840*)
BL Add. 10546, f. 26r

This is a huge book – 49.5 by 38.0 cm (20½ by 15 inches), with 449 folios – and it is most impressive. Written at the scriptorium of St Martin in Tours, France, around 840, during the time when they were producing about one hundred of these grand pandects (see page 15), it is one of only three surviving copies. The book has a page style that seems to bring together all that has gone before in lettering, and yet make it new. The large, red, generously spaced Roman Square Capitals begin the book of Exodus in the Old Testament. A large decorated initial **H** with some interlace has many elements of Roman design, as in the similarity to architectural columns in the two downstrokes and the decoration of leaves and flowers. Roman Uncials with a flat pen nib angle start the chapter, after which the body of the text is in Caroline Minuscule, with enlarged Uncials at the beginning of each verse. Despite its size and the density of text on the page, it is immensely legible and easy to navigate the text.

Although written so long ago, the script still has relevance to printed media today. Newspapers and magazines are the shape they are because that is the shape of a calf. They often have articles where the headline may well be in large Roman Capitals. Many also start with a 'drop cap' – an enlarged letter that extends over three or four lines of text – and the first few lines of an article may well be in capitals or a bold typeface. And, of course, Caroline Minuscule was the lettering script used by the Humanists in the Renaissance when they wanted to return to the classical style, and the one also adopted by type designers and printers of the same period. Excluding the long **s** and the slightly rounded **t**, which sometimes can be confused with the letter **c**, all the letters written here can be read without difficulty, including the looped **g** and the two-storey **a**. We recognise these forms because they were adopted for type and still are used.

The pen nib angle used for writing the letters is a comfortable 30° and, being a minuscule style, there are ascenders and descenders which are extended well beyond the guidelines for x-height. Many ascenders have a thickened stroke, known as a club serif. With a flexible quill this can be made by starting the stroke about halfway down, moving the pen up and slightly to the left, then, without a pen-lift, making the downstroke. To replicate this with a much stiffer metal nib this serif usually takes two strokes, both moving downwards. There is a distinct forward slant to the letters and some joins that suggests a degree of speed in writing, yet there appears to be little haste in constructing them as they are well formed.

INCIPIT LIBER EXODVS

HAEC SUNT Cap. I.
NOMINA
FILIORŪ
ISRAHEL
QVI INGRES
SI SUNT IN II
AEGYPTŪ
CUM IACOB
SINGULI
CUM DOMI
BUS SUIS
INTROIE
RUNT

Ruben. symeon. leui. iuda. issachar. zabulon
et beniamin. dan et nepthalim. gad et aser.
Erant igitur omnes animae eorum quae egres
sae sunt de femore iacob. septuaginta quinque
Ioseph autem. in aegypto erat Quo mortuo et
uniuersis fratribus eius omniq; cognatione sua.
filii isrl creuerunt. et quasi germinantes multi
plicati sunt. ac roborati nimis impleuerunt terrā
Surrexit interea rex nouus super aegyptum
qui ignorabat ioseph. et ait ad populum suum
Ecce populus filiorum isrl multus et fortior
nobis é uenite sapienter opprimamus eum ne
forte multiplicetur Et si ingruerit contra nos
bellum. addatur inimicis nris. Expugnatisq;
nobis. egrediatur e terra. Praeposuit itaq; eis
magistros operum ut affligerent eos oneribus IIII
Aedificaueruntq; urbes tabernaculorum pha
raoni phiton et ramesses Quantoq; opprime
bantur tanto magis multiplicabantur et cres
cebant Oderantq; filios isrl aegyptii et affli
gebant illudentes eis atq; ad amaritudinem
perducebant uitam eorum operibus duris luti et
lateris omniq; famulatu quo in terrae operibus p
mebantur Dixit autem rex aegypti obstetrica
b; hebraeorum quarum una uocabatur sephra
altera phua praecipiens eis. quando obsteri
cabitis hebraeas et partus tempus aduenerit.
si masculus fuerit interficite illum si femina.
reseruate Timuerunt autem obstetrices dm
et non fecerunt iuxta praeceptum regis aegypti sed
conseruabant mares quib; ad se accersitis rex
ait quidnam é hoc quod facere uoluistis ut

pueros seruaretis Quae responderunt non
sunt hebraeae sicut aegyptiae mulieres Ipse enim
obstetricandi habent scientiam Priusquam ue
niamus ad eas pariunt Bene ergo fecit ds obste
tricib: et creuit populus Confor
tatusq; é nimis Et quia timuerant obstetrices
dm. aedificauit illis domos Praecepit ergo pha
rao. omni populo suo dicens Quicquid masculini
sexus natum fuerit. in flumine proicite Quicquid
feminei. reseruate

Egressus é post haec uir de domo leui. accepta uxo Cap: 2
re stirpis suae. quae concepit et peperit filium
Et uidens eum elegantem abscondit tribus mensib:
Cumq; iam celare non posset. sumpsit fiscellam
scirpeam. et liniuit eam bitumine ac pice posuitq;
intus infantulum et exposuit eum in carecto ripae
fluminis stante procul sorore eius et considerante
euentum rei Ecce autem descendebat filia pha
raonis ut lauaretur in flumine. et puellae eius
gradiebantur per crepidinem alluei Quae cum
uidisset fiscellam in papyrione. misit unam e fa
mulis suis Et allatam aperiens cernensq; in ea
paruulum uagientem miserta eius ait De infan
tib: hebraeorum é hic Cui soror pueri Uis in
quit ut uadam et uocem tibi hebraeam mulierem
quae nutrire possit infantulum Respondit
Uade perrexit puella et uocauit matrem eius
Ad quam locuta filia pharaonis Accipe ait pue
rum istum et nutri mihi. ego tibi dabo mercede
tuam Suscepit mulier et nutriuit puerum
Adultumq; tradidit filiae pharaonis Quem
illa adoptauit in locum filii Uocauitq; nomen
eius mosi dicens quia de aqua tuli eum

In dieb: illis postquam creuerat moyses egressus ad
fratres suos uidit afflictionem eorum et uirum
aegyptium percutientem quendam de hebraeis
fratrib: suis Cumq; circumspexisset huc atq; il
luc et nullum adesse uidisset percussum aegyp
tium abscondit sabulo Et egressus die altero.
conspexit duos hebraeos rixantes Dixitq; ei qui
faciebat iniuriam Quare percutis proximum
tuum Qui respondit quis constituit te principe
et iudicem super nos Num occidere tu me uis sicut
occidisti heri aegyptium Timuit moyses et ait
Quomodo palam factum é uerbum istud Audiuit
q; pharao sermonem hunc. et quaerebat occide
re moysen Qui fugiens de conspectu eius mora
tus é in terra madian et sedit iuxta puteum
Erant sacerdoti madian septem filiae quae ue
nerunt ad hauriendam aquam Et impletis

17
The Charter of King Æthelwulf of Wessex

Christ Church, Canterbury, 843
BL Stowe Charter 17, obverse

It is extremely rare to have the original note made by a scribe indicating who was present as witnesses when a grant of land or property was made, but that is exactly the case with this charter. The rectangular slip of skin, sewn with large stitches using a strip of alum-tawed leather[18] to the main charter at the lower right, lists the names. This charter, the earliest extant charter of any king of Wessex, records a grant of land at Little Chart in Kent by King Æthelwulf (795–858) to Æthelmod, one of his thegns. It is possible, just, to make out some of the names on the aide-mémoire: Perbeald (?) is the second to last name in the second column, below the stitching, and Perbald is the last name recorded at the bottom of the second column on the charter. The king's name is, as expected, the first name in the first column – *Ego Æthelwulf rex* ('I am King Æthelwulf') – and below that is the name of his eldest son, Æthelstan, who was appointed king of Kent in 839. Æthelwulf's name also appears towards the middle of the top line. Interestingly, royal charters were usually made by religious foundations at this time, but Æthelwulf kept their production in-house.

Although written in Latin, the charter is in Anglo-Saxon Pointed Minuscule, or Insular Minuscule. Many of the letters are familiar, but some are unusual in form. The ȝ in **Eȝo**, both at the top of the charter just before Æthelwulf and also repeated before each name in the list, has no top bowl to speak of, simply a horizontal line followed by a curved shape that seems to take some of its form from the letter **s**. The letter **s** itself looks a little like a letter **r** with a tail, for example in **ꝝeȝıꞅ**, the fourth word on the top line. The letter **r** meanwhile looks like a letter **n** with a tail, as in that same word. The letter **e** often has an extended horizontal stroke attached to the lower part of the bowl; this occasionally joins the letter to the next, as in **ꝝeȝıꞅ** on the top line, where it shares the stroke with the letter ȝ. The descenders to the letters ꞅ, ꝑ, ꝑ, q, ꝼ and so on are usually long, but also end in a point, made by rotating the nib anti-clockwise as the stroke is written. The Tironian[19] **et** symbol, looking a little like the numeral 7, is used extensively throughout. For a charter the lettering is remarkably even and regular, and there are few contractions or abbreviations.

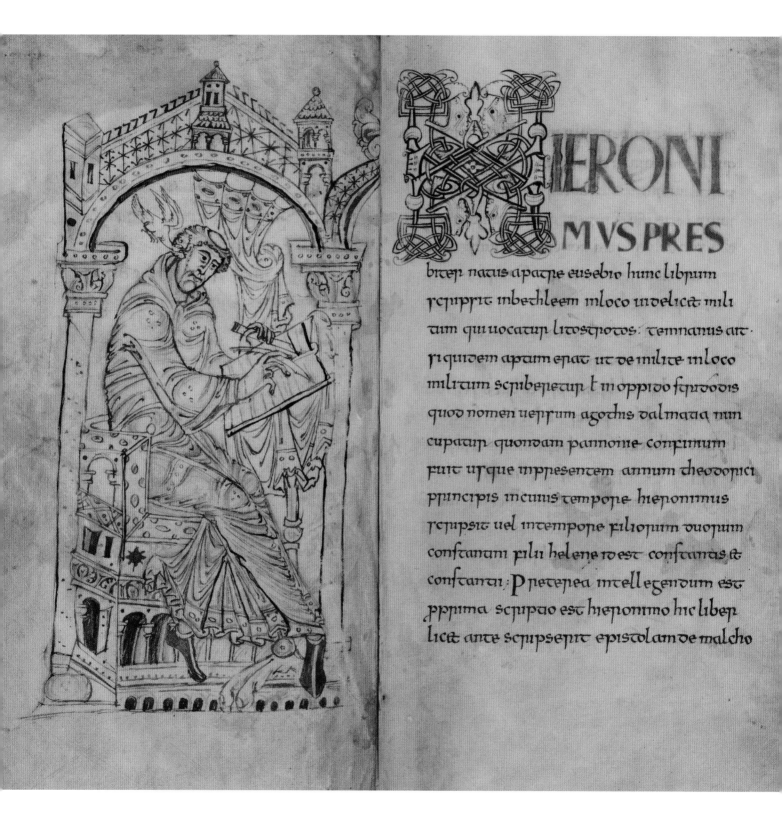

ƎRONI
MVS PRES

bitep natus apatpe eusebio hunc libpum
peripit inbethleem inloco indelicet mili
tum qui uocatup litostrotos: teinnanus air
pi quidem aptum epat ut de milite inloco
militum scpibepetup ł in oppido sepidodis
quod nomen uepum agodis dalmana nun
cupatup quondam pannonie confmium
fuit utque inppesentem annum theodopici
ppincipis incuius tempope hiepommus
pepipsit uel intempope piliopum duopum
constantini pilu helene idest constancus &
constanni: Pretepea intelligendum est
pppima scpipdo est hiepommo hic libep
licet ante scpipsepit epistolam de malcho

18
Lives of Hermits Paul and Guthlac

St Augustine's, Canterbury, ninth century?
The Master and Fellows of Corpus Christi College, Cambridge, MS 389, ff. 1v-2r

The very first page of this manuscript shows St Gregory the Great (*c.* 540–604), pope from 590 until his death, tonsured, as a scribe. Encased within an architectural arched structure, which is surmounted with one square and two round towers and supported by two decorated columns – the slanting coloured pattern on each is just visible – St Gregory sits on a throne-like chair; this itself has round arches and a great deal of decoration, and really is far too grand to be near anyone with ink! He writes on a cloth-covered sloping board that is supported by a base of three carved animal legs and a single narrow carved leg; it is unlikely that this would be sufficiently steady for writing. In his right hand St Gregory holds a quill which, although touching the paper, is loosely held; in his left hand is a curved-bladed penknife with a decorated red tip to the handle. The scribe's knife holds down bouncy vellum or parchment, and it was also immediately and literally to hand if a mistake was made. If this happened, the quill would then be put down or exchanged for the knife, and the sharp curved blade used to erase the mistake. If the surface of the skin was very rough as a result of the erasing, the back of a fingernail could be used to calender[20] it smooth again.

St Gregory is shown with his symbol of a dove, representing the Word of God – particularly relevant for the saint. His friend, Peter the Deacon, tells[21] that the pope was behind a curtain and dictating to his secretary; the words were interspersed with long silent pauses. The secretary made a hole in the curtain and peered through; he saw that a dove had its beak in St Gregory's mouth and when he withdrew it St Gregory spoke, indicating that what the great man said came directly from God. This page starts with an enlarged letter **H** with interlace, animal head and leaf decoration, and the display capitals are green and red Versals. The script of the text is an Insular Square Minuscule, and is remarkably even and precise, as well as being pleasing to the eye. Although there may be similar confusion with Insular Minuscule letters **s** and **r**, the letter **p** is more usual. The round-backed letter **ð** has virtually no ascender and is almost entirely enclosed within the two guidelines for x-height, while the letter **e** is the same height as the other letters. Note too the very insular form of the letter **ᵹ**, as in the middle of line six in **aᵹoðhiſ**.

mala qm mecum es .

Virga tua & baculus tuus

ipsa me consolata sunt

Parasti inconspectu meo mensam

aduersus eos qui tribulant me .

Impinguasti inoleo caput meu .

&calix ms inebrians qua pclarus. e .

Et misericordia tua subsequ&ur me .

omnib; dieb; uite meae .

Et ut inhabite indomo dni .

inlongitudine dierum

PSALMUS DAUID PRIMA SABBATI

xxiii Dni est terra & plenitudo eius .

orbis terraru & uniuersi :

qui habitant ineo .

uia ipse sup maria fundauit eu .

&sup flumina pparauit eum :

uis ascend& inmontem dni .

19
The Ramsey Psalter

Winchester, late tenth century
BL Harley 2904, f. 27v

It is possible that the Ramsey Psalter was made for the use of St Oswald, the founder of the Benedictine Abbey of Ramsey, although the decoration and script suggest that it was produced at Winchester. Interestingly, a wonderful line drawing of the crucifix (see below right) has a fluidity and confidence of line and a style that suggests it could have been made by the same artist who worked on the Fleury manuscript in France (BL Harley 2506, see page 102), so a continental influence is evident here too. Whoever was involved and wherever it was produced, the Ramsey Psalter was identified by master calligrapher Edward Johnston (1872–1944) as a suitable manuscript to study as a starting point for calligraphy, and he named the lettering based on this script the Foundational Hand.

Changes in style took place in the tenth century when the forward sloping Caroline Minuscule script, with its long ascenders and descenders and a small x-height, crossed the Channel. The writing became upright, the ascenders and descenders decreased and the x-height increased, creating a feeling of less speed and more grandeur. This is a formal hand with carefully written letters, many pen-lifts and few instances of letters joining one to the other. It is, similar to Caroline Minuscule, based on a round letter **o**, and all the other letters take their form from this: note the generous bowls to the letter **q** (on the first line), **b** (second line) and **p** (fourth line). The start of arches for the letter **m** (line one), **n** (line three) and **b** (line two) occur quite high up the downstroke and mirror Romanesque architectural forms. The letter **g** (line 2) has a very exaggerated tail which goes considerably to the right before the last stroke is made from left to right, for completion; this is 'tidied up' and made neater when written as a modern hand, and sits under the letter itself. There is good spacing between the lines with no clashes of ascenders and descenders. The rubrics are written in red and in a Rustic style.

Each new chapter starts with an enlarged gilded Versal letter and the verses too start with an enlarged, but smaller, gilded letter (note the two different styles of the letter **E** towards the middle of the page). Leaf gold is raised from the vellum surface by a compound such as gesso. An intriguing feature is the dark smudging or dirt that occurs around all of these gilded letters throughout the manuscript. There are occasions when gold leaf, applied with some pressure, sticks to the surface of the skin and needs to be removed. This is done with a sharp knife which roughens the skin slightly and, over

time, attracts dirt. However, the illuminator in the manuscript is such a consummate professional, with gold adhering even to the finest strokes, that it is unlikely that there was a lack of skill. Although we do not have scientific evidence, it is possible that the gesso included an adhesive that has leached out into the skin over the years and attracted the dirt. At significant magnification, particularly around the Greek letter **E** form on this page, the darkening resembles leaching rather than a roughened surface.

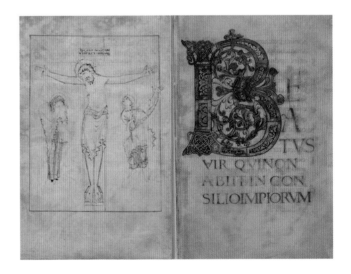

This delicate, pen-made line drawing of the crucifixion with the Virgin Mary and St John the Disciple was done by the same artist as the manuscript on page 102. It shows a similar sureness of line and ability to create a three-dimensional effect with simply a line and wash. On the opposite page, the beginning of Psalm 1 (*Beatus vir …*), is a glorious coloured letter **B** with gold leaf on gesso, with enlarged Roman or Square Capitals.
BL Harley 2904, ff. 3v–4.

atq: ipso pastore uos ad aeterno
rum gaudiorum pascua aeterna
perducat. AMEN

Et qui per eius incarnationem ter
rena caelestibus sociauit. internę
pacis & bonę uoluntatis uos nec
tare repleat. & caelestis militiae
consortes efficiat. AM quod

Populum tuum
qs dne pio fauore prose
quere. proquo dignatus es
in hac sacratissima nocte tuam
mundo praesentiam exhibere. AM
cunctis eum aduersitatibus
paterna pietate custodi. pro
quo mundo hoc intempore
dignatus es exuirgine nasci. AM

Ut te redemptorem suum semper

20

The Benedictional of St Æthelwold

Winchester, late tenth century
BL Add. 49598, f. 21r

Godeman was a monk at the Old Minster in Winchester at the time that the Benedictional was written, before going on to become Abbot of Thorney in Cambridgeshire. He was a master craftsman and produced the Benedictional of St Æthewold as required by his bishop and noted on f. 4r and 5v of the manuscript:

> A bishop, the great Æthelwold, whom the Lord had made patron of Winchester, ordered a certain monk subject to him to write the present book, and also to be made in this book many arches well adorned and filled with various figures decorated with manifold beautiful colours and with gold ... Let all who look upon this book pray always that after the term of the flesh I may abide in heaven. Godeman the scribe, as a suppliant, earnestly asks this.

St Æthelwold (c. 904/9–84) would no doubt have been very satisfied by the result because the book does indeed contain many arches (see below right). The English Caroline Minuscule in this book is based on a round letter **o**, with a pen nib angle of about 30°, but the lettering has a lighter feel than the Ramsey Psalter on the previous page. The letter **g** has a neater tail than those in the Ramsey Psalter and is positioned mainly under the bowl of the letter. Intriguingly, however, it often has no little 'ear' to the top right of the bowl, and the second diagonal of the letter **x,** going from top right to bottom left below the lower line for x-height, is nothing if not exuberant. Serifs are similar to Caroline Minuscule club serifs, but there is a slight thickening only towards the very top of the strokes, as on the letters **d** on the top, second and third lines. The huge initial Versal letter **P**, written in a compound such as gesso and with the thinnest of serifs, is a tour-de-force, and getting gold leaf to adhere to such fine lines shows true mastery. Initial letters are also gilded, and written as Roman Uncials with a flat pen nib angle, as indeed are the rubrics, here written in red. The letter **A** in 'Amen' has, similar to the letter **x**, a wonderfully exaggerated leftward diagonal stroke. This manuscript and the Ramsey Psalter were both written in Winchester at around the same time, but by different scribes. It is intriguing to think that these two craftsmen may have been cutting their quills, mixing the ink and writing in very similar, but not quite identical, styles in the same scriptorium.

St John the Evangelist is shown seated at a lectern with his symbol of an eagle. The lectern and chair are similar in style to those on page 96, although the leg and clawed feet look more sturdy. Opposite him, the gold leaf around the decorated borders in this manuscript must have been stunning when it was first completed, and even now it is very striking. However, the gold leaf on the lettering is even more impressive. Letters are formed with consummate skill and a mastery of line, and gold leaf adheres to the thinnest of lines.

BL Add. 49598, ff. 19v–20r.

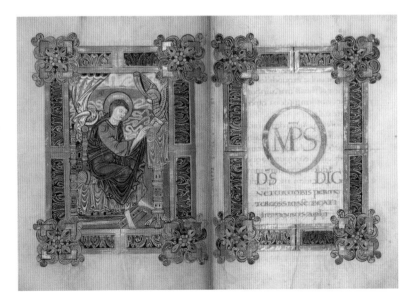

An astronomical compilation

Fleury, France, with contributions from an English artist, *c.* 900–*c.* 1000
BL Harley 2506, f. 41r

Religious books were not the only ones produced during this period. This astronomical compilation was made in France at the end of the tenth century, and its delightful, precise line drawings were produced probably by the artist of the Ramsey Psalter. This page is taken from a translation from the Greek into Latin of the *Phænomena*, also known as the *Aratea*, by Aratus of Soli (*c.* 270 BC), and shows the constellation of Orion, the giant hunter, who was put into the heavens by Zeus. The command of line and supreme economy of stroke in the pen and wash drawings indicate a true master. Orion is shown with his sword in his right hand ready to strike, and his left hand holds his cloak (in some manuscripts this is an unidentified animal skin). The pose has great energy of purpose – it looks as if Orion really will strike, leaning back on his right foot ready to thrust his sword forwards. With just a few lines the bunching of his sleeve as he bends his arm is clear, as are the folds on his socks, short hose or very soft leather or fabric boots, which look really rather wrinkled. The body of his hunting dog contains so few strokes and the head has just a few more yet it is clearly that animal. The large red dots indicate the positions of the constellation of stars, and the three of Orion's belt are very obvious.

The lettering is in Caroline Minuscule, with red used for the column on the right where it is well-spaced; there are large Versal initials at the beginning of each section. The drawing must have been done first as the writing goes around Orion's sword in the fourth line. Note the use of the ampersand in the third line to replace the letters **et** in **habet**. The verse between the figures is in black. There is less rhythm here and some letters are rather bunched together, such as the beginning of **suspiciens** towards the middle of the third line, **disp**(er)**sum** on the fourth line and **se** and **speret** on the last line. Each of these lines starts with a red initial letter, in a slightly darker colour to that used in the right-hand column, and these have has a more Rustic feel. At the bottom of the right-hand column is a *lacuna*, a hole in the skin caused by an insect bite, or by carelessness with a knife when skinning the animal or preparing the vellum. Scribes were not overly concerned about these, the holes were either left as here, with writing simply avoiding the holes, or occasionally were sewn together with, for example, alum-tawed leather, which was treated with a solution of salts to produce a white, supple skin that is very strong. Luxury books often had very carefully selected skins with few blemishes.

Ex me de orion obliquo corpore nitens.
Inferiora tenet truculenti corpora tauri.
Quem qui suspiciens mediu nocte serena
Aste dispsum nonuiderit bauditia uero
Cetera se spe& cognoscere signa potesse

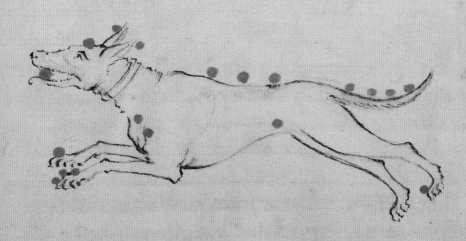

Orion oblieus quidam tauro hab& incapite stellas splendidas iii exquib· una é splendidor c&eris· In utroq· humero splendidam i· Indextro cubito i· obscuram. Insumitate manus i· In rona iii· In mantile iii· obscuras Inutroq· genu· i· In utrisq· pedib; i· Sus omnes XVIII·

Cenicula quae oritur post orionem hab& stellam splendidam inlingua i· qua syrion· &cane uocant· rutilante multu· & pcolores immutante· In utroq· humero· obscura i· Inpectore ii· In anteriore pede sinistro iii· Indextro i· Supra dorsu iii· In uentre ii· Insinistro lubo i· Inposterio ripede sinistro i· Insumitate

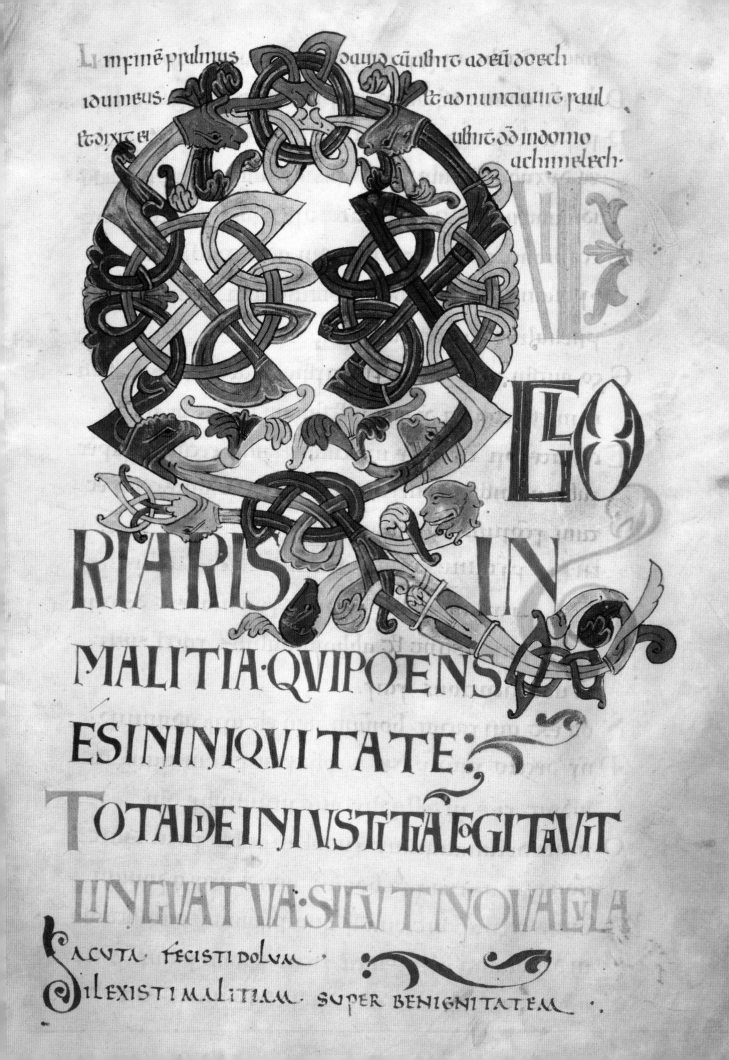

EO

RIARIS IN

MALITIA·QVIPOENS

ESINJNIQVITATE:

TOTADEINIVSTITIAEGITAVIT

LINGVATVA·SICVTNOVACELA

ACVTA FECISTI DOLVM

ILEXISTI MALITIAM SVPER BENIGNITATEM·

22
The Bosworth Psalter

Canterbury, Christ Church or St Augustine's, last quarter of the tenth century
BL Add. 37517, f. 33r

There is no gold in the Bosworth Psalter, but when the illustration is as rich and eye-catching as it is on this page, for the beginning of Psalm 51, there is no need for anything in addition. This letter **Q** is a carefully constructed, almost mirror pattern of interlace and animal heads. The right-hand section is very slightly narrower than the left, which may have been accidental, or possibly intentional, throwing the eye to the right as it does. Most of the lines are very sure and secure, but a few are not. The black central line on the tomato-red part of the outer shape of the letter **Q**, which bends into the centre and then curves into interlace, is sure and steady, yet the pale pink section of a similar shape that crosses the central black line is not central and appears rather wobbly. Could this have been done by an apprentice learning the craft? The four animal heads in the outer circles are all very similar in design and pose, yet three of them are eating the strip that goes through them. The one on the bottom right, meanwhile, is painted with its mouth open, but the line is going over the face and not through it; this could be a mistake.

The choice of colours used on this page is very sympathetic, with nothing dominating and little receding; even the pale yellow in the tail of the letter **Q** holds its own with the pale pink, blue and brown of the other areas. The pen-made Versals of the remainder of the text have been written with a flat pen angle and multiple strokes: the pen is turned at 90° for the narrowest of strokes, as on the letters **N** (lines two, three and four of the main body of the text after the letter **Q**) and the first stroke of the letter **M** (line three). The thin diagonal strokes of the letters **M**, **A** and **V** are likely to have been made by turning the nib to the same angle as the stroke. The swirling blue scroll decoration at the bottom of the page is also pen-made. This, the beginning of Psalm 51, is decorated lavishly, as indeed is Psalm 1 and Psalm 101 (also 109). A number of manuscript Psalters have only a highly decorated initial **B** for Psalm 1 (*Beatus vir*, 'Blessed is the man …'). The tripartite division of the Psalms 'perhaps originated in early Irish psalters',[22] and learning the Psalms in their 'fifties' was also a form of penance.[23] The text script in red at the top of the page is in Insular Square Minuscules.

23
The Grimbald Gospels

Christ Church, Canterbury(?) *c.* 1020
BL Add. 34890, f. 45v

This simple but exquisitely written manuscript was made by Eadui Basan (Edwin the Fat, see page 17), probably at Canterbury. The display capitals are remarkably pure, not only well-formed but also beautifully spaced. There is hardly any difference in fineness of strokes and construction of letters at the top of the page between the blue and red lettering, written in ink on the first and third lines, and the central gold line of letters (*Incipit…*), written in gesso and challenging to handle in a pen. The large initial Uncial letter **M** is particularly well-written, with wonderfully smooth curves to the strokes, but it is reassuring for contemporary scribes to note that, with magnification, the gesso is a little bumpy towards the top of the central stroke. The body of the text is in Eadui Basan's distinctive style, a compressed form of English Caroline Minuscule based on an oval letter **o** and written with a comfortable pen nib angle of about 30°. He has extended the ascenders and descenders and increased the x-height of the letters compared to the Ramsey Psalter (see page 98) and the Benedictional of St Æthelwold (see page 100); this has resulted in a very elegant and graceful hand.

Two characteristics of Eadui Basan's lettering are the letter **d** and the tail of the letter **g**. In constructing the letter **d** in calligraphy when writing with a broad-edged nib, the first stroke forms the left-hand side and main part of the bowl, then the second stroke completes the top of the bowl and finally the downstroke finishes the letter. Eadui Basan actually writes a complete letter **o** before writing the downstroke. This has not been observed in the work of any other scribe, nor in any other manuscript seen by the author, before Bartolomeo Sanvito, who constructs this letter in the same way in his manuscripts written during the Renaissance. The construction of this letter can be seen in the first letter **d** on the top line of the text body, where a tiny part of the letter **o** protrudes to the right of the downstroke, and particularly in **ad[fidem]** (two lines below). For such a skilled scribe, and with such fluidity in letter-forms, the angularity of the tail of the letter **g** is surprising. Rather than a smoothly curved form there is a distinct angle close to the bowl before making the lower curve.

Grimbald (820–901/3), after whom the gospels are named, was a French Benedictine monk. He worked for King Alfred (849–899) in the school established by the king for the education of the nobility. An eleventh-century copy of a letter from Fulk (d. 900), the Archbishop of Reims, recommending Grimbald to King Alfred, has been copied in the book (ff. 158r–160v).

EXPL·EVGL·SCI·MATHAEI·EVGLE·
INCIPITARGVMENTV IN
EVGLM·SCI·EVGLAE MARCI

ARCVS EVANGE
LISTA DI ET PETRI IN BAPTISMATE FILIVS·
atq: indiuino sermone discipulus·
sacerdotium misiwhel agens secundum carnem leuita· con
uersus ad fidem xpi euangelium initalia scripsit· Ostendens
in eo· quid & generi suo debere & xpo· Nam initium prin
cipii inuoce propheticae exclamationis instituens· ordinem
leuiticae electionis ostendit· Ut predicans predestinatu
iohannem filium zachariae· Inuoce angeli annuntiantis
emissum· non solum uerbum caro factum· sed corpus dni
in omnia per uerbum diuinae uocis animatum· Initio
euangelicae predicationis ostendere· Ut qui haec legens
scire& cui initium carnis indno & iħu aduenientis habitacu
lum caro debere& agnoscere· Atq: inse uerbum uocis quod
in consonantibus perdiderit inuenire& · Denique & psecti
euangelii opus intwens· & abaptismate dni predicare dm
inchoans· non elaborauit natiuitatem carnis quam inprio
ribus uidere dicere· Sed potius inprimens expositionem
deserti· ieiunium numeri· temptationem diaboli· congre
gationem bestiarum & inministerium protulit angelorum·

sieft intellegens aut re
quirens dm ..
mnes declinauerunt simul
inutiles facti sunt · non
est quifaciat bonum non
est usque adunum
onne cognoscent omnes·

quiopariur iniquitate·
uideuorent plebe mea
sicut escam panis·dm n
inuocarunt·illic trepi
dauerunt timore ubi
non erat timor
uo ds dissipat ossa hominu

sibi placentu confusi sut
quia ds spreuit eos·
us dabit exsion salutare
isrt·dumauesterit drs
captuitatem plebissue·
xultabit iacob· & letabi
tur israhel

INFINEM INCARMINIBUS
INTELLECTUS DAUID

SINNOMINE
tuo salnum mesac·
& inuirtute tua libera
me
s exaudi orationem mea
auribus percipe uerba
oris mei
m alieni insurrexerunt

CUMUENISSENT ZIPHEI ET
DIXISSENT ADSAUL·ECCE DD
inme· & fostesquesierun
animam meam · & nonp
posuerunt dm ante con
spectum suum
cce enim ds adiuuat me
& dominus susceptorest
anime meae
ueste mala inimicis meis·

LATITAT APUDNOS·LIII·

& inueritate tua disp de
illos
oluntarie sacrificabo ab
& confitebor nomini tuo
dne· qm bonum est
m exomni tribulatione eri
puisume· & sup inimicos
meos respex oculus tuus·

24

The Harley Psalter

Christ Church, Canterbury, first half of the eleventh century
BL Harley 603, f. 29v

It must have seemed like a good idea at the time. The monks of Christ Church, Canterbury borrowed the ninth-century Utrecht Psalter from Reims to copy. They introduced just a few changes. First the Utrecht Psalter was in the Gallican version of the Psalms and the monks of Christ Church were writing out the Roman version (apart from Psalms 100–105). Then they changed the writing style from the majuscule Rustics (which are widely spaced, but require less space between the lines, as there are no ascenders and descenders to clash) to the minuscule of Compressed English Caroline Minuscule – a script which, although it has ascenders and descenders to allow for, is more condensed and requires less space overall. In addition the illustrations often took up more space.

It is clear that there was a division of labour with the artists working first, placing the illustrations on the new vellum pages in about the same place as those in the Utrecht Psalter. However, the different version of text and the change of writing style did not work out well; there are gaps on the page where the writing ended, and occasionally sections where the writing had to be squeezed up to fit on the last line. A single scribe completed the writing for the first 27 folios and then folios 50–57, and it seems that the intention was to copy the Utrecht Psalter as closely as possible. This same scribe picks up again from folios 58–73, but then simply left gaps for the illustrations. At some point it seems that Eadui Basan became involved in the project; and writing with his distinctive **d**s and **g**s (see page 106) is evident in the manuscript, and there are also fewer blank spaces on the page. The lettering on the left is more even and the letters better formed as would be expected from a master of the craft such as Eadui Basan, but his writing is not quite so assured as in other manuscripts possibly because he was more elderly at this point. This page shows that the writing was completed before the illustrations as the circle on the roof decoration of the building on the right has not been completed and allows for the crossbar of the letter **t** (in –**tur**).

The construction of club serifs can be seen in the letter **l** at the end of the second to last line in the upper third column. There is a tiny white triangle within that serif indicating that the shape is made by two strokes, which, with a flexible quill, would be upwards to the left and then down to complete the downstroke. The delightful pen and wash drawings illustrate what is in the text of the psalm, as explained for the two pages overleaf.

OVERLEAF LEFT: Utrecht Psalter. The ninth-century Utrecht Psalter is in grand Rustics, well-spaced with a steep nib-angle. Verses start with a red Roman Uncial initial, as do headings and endings to chapters. Each psalm is 'interpreted' by a line and wash drawing of the text. Psalm 6 shows the Lord holding a pennant and rebuking the psalmist who is shown with 'troubled bones' and watering his couch with tears. Those in hell (lower left) cower, are prodded with spears by devils, and are unable to confess their sins. Meanwhile the workers of iniquity are departing on the right.
Utrecht, Universiteitsbibliotheek, Bibl. Rhenotraiectinæ I Nr 32, f. 3v.

OVERLEAF RIGHT: Two centuries later, the Harley Psalter, copying the style of the Utrecht Psalter, was written in Compressed English Caroline Minuscule with headings in red Rustics, an enlarged initial at the beginnings of chapters – here in green – and verses beginning with a form of Square Capitals. There are line and wash drawings but in subtle and delicate colours. A more benevolent Lord, holding a staff, looks down on the psalmist. Devils with very long sticks prod those in hell, and the workers of iniquity look more perplexed at their banishment, holding their hands to their faces in bewilderment.
BL Harley 603, f. 3v.

O DISTIOMNES QUIOPE
RANTURINIQUITATE
PERDESOMNESQUILO
QUUNTURMENDATIU
UIRUMSANGUINUMET
DOLOSUMABOMINA
BITURDNS EGOAUTEM
INMULTITUDINEMISE
RICORDIAETUAE
INTROIBOINDOMUM
TUAM ADORABOADTE
PLUMSCMTUUMIN
TIMORETUO
DNEDEDUCMEINIUSTI
VI INFINEM

TIATUAPROPTERINIMI
COSMEOS DIRIGEIN
CONSPECTUMEOUIATUA
QNMNONESTINORE
ORUMUERITAS COR
EORUMUANUMEST
SEPULCHRUMPATENIST
GUTTUREORUM LIN
GUISSUISDOLOSEAGE
BANT IUDICAILLOSDS
DECIDANTACOGITATI
ONIBUSSUIS SECUN
DUMMULTITUDINEM
IMPIETATUMEORUM
PSALMUSDAUID

EXPELLEEOS QMIRRI
TAUERUNTTEDNE
ETLETENTUROMNESQUI
SPERANTINTE INAE
TERNUMEXULTABUNT
ETHABITABISINEIS
ETGLORIABUNTURIN
TEOMNESQUIDILI
GUNTNOMENTUUM
QMTUBENEDICES
IUSTO
DNEUTSCUTOBONE
UOLUNTATIS
CORONASTINOS
PROOCTAUA

DNENEINFURO
RETUOARGUASME
NEQUEINIRATUA
CORRIPIASME
MISEREREMEIDNE
QNMINFIRMUSSU

SANAMEDNEQNM
CONTURBATASUNT
OSSAMIA
ETANIMAMEATURBA
TAESTUALDE ETTU
DNEUSQUEQUO

CONUERTEREDNEERI
PEANIMAMMEAM
SALUUMMEFACPROP
TERMISERICORDIAM
TUAM
QNMNONESTINMORTE

iniquitatem perdes eos qui
locuntur mendacium ;

Virum sanguinu & dolosum .
abominabitur dns ;

Ego autem inmultitudine
misericordiae tuae intro
ibo dne indomum tuam .
adorabo adtemplum scm
tuum intimore tuo ;

Deduc me dne intua iustitia
ppt inimicos meos :

dirige inconspectu tuo uia
meam ;

Qm nonest inore eoru ueri
tas. cor eorum uanum est ;

Sepulchrum patens est gut
tur eorum . linguis suis do
lose agebant. iudica illos
ds ;

Decidant acogitationibus
suis. secundum multitudi
nem impietatum eorum

expelle eos. quo exacerba
uerunt te dne ;

Et letentur omnes quispe
rant inte ingternum exul
tabunt & inhabitabis ineis
& gloriabuntur inte omnes
quidiligunt nomen tuum ;

Quo tu dne benedices iusto
dne ut scuto bone uolunta
tis tuae coronasti nos

INFINE INCARMINIB;
NE NE INIRA
tua arguas me. neq:
infurore tuo corripias
me ;

Miserere mihi dne qm in
firmus sum. sana me dne

PRO OCTAVA PSALMVS
quo conturbata sunt
omnia ossa mea : & ani
ma mea turbata est
ualde

Et tu dne usquequo? con
uertere & eripe animam

DAVID . VI .
meam. saluum mefac ppt
misericordiam tuam

Quo noneft inmorte quime
morsit tui . ininferno aute
quis confitebitur tibi ;

Laboraui ingemitu meo

25
The Domesday Book

England, 1086
The National Archives, E31/2, f. 155r

By any stretch of the imagination the Domesday Book is a remark-able manuscript. Researching and recording the information today with all the technology now available would be impressive; to do this in the eleventh century, with the challenges of travel and com-munication and of limited written records, was an extraordinary feat. Twenty years after he defeated King Harold (1022–1066) at Hastings in 1066, King William I (1028–1087):

> sent his men all over England into every shire and had them find out how many hundred hides[24] there were, or what land and cattle the king himself had, or what dues he ought to have in twelve months … there was no single hide nor a yard of land, nor indeed one ox nor one cow nor one pig which was there left out… and all these records were brought to him afterwards.[25]

Essentially the Domesday Book was a document prepared for tax purposes, recording who owned what and therefore how much tax they should pay. It valued the land in the country at the time of the death of Edward the Confessor (1003–1066), when the new owner took it over, and when the survey was conducted. After its completion in 1086, King William lived only another year to reap the fruits of the survey, although the Domesday Book was invaluable to his successors. The king would not have known it by that title, as the name 'Domesday Book' was adopted only from the late twelfth century. It was called this because the work was seen as akin to the Last Judgement – no escape from what is due. In the large areas covered by the Domesday Book (not everywhere in England was surveyed), there are 13,418 settlements recorded.

The 413 pages in the final Domesday Book ('Little Domesday' is a separate volume) were written completely by one scribe with another scribe checking; this, too, is a breathtaking achieve-ment. There are many contractions and abbreviations in the manuscript with much use of the Tironian **et** symbol, looking like the number 7; unlike now, a line scored through a word did not mean a mistake, but was there to highlight it. Headings are in Rustics, and names start with an enlarged Versal initial letter and there is little space between the lines, so the impression is of a dense page of text. The script is eminently readable, though, and written most efficiently, so it would have been relatively easy to look up and check records. For a document that is essentially functional, its pages do have a distinct beauty.

TERRA ARCHIEPI CANTUARIENS

Archieps Cantuar ten HEDTONE. De ecta fuit.
7 ecta. Ibi ē. xx. hidæ. Tra ē. xviii. car.
In dnio vi. car. 7 v. serui. 7 xxii. uilli cu x. bord hnt
xiii. car. Ibi. xv. ac pti. 7 ii. quareñ pasture. Silua
una leu lg. 7 una lat. Cu onerat. uat. xx v. solid.
De hac tra ten Robt de odgi. i. hid. 7 Roger. i. hid.
T.R.E. ualt. xl. lib. Modo. xv. lib.

TERRA EPI WINTONIENSIS

Eps Wintoñ ten SUTTONE. Stigand tenuit
Ibi ē. xxx. hide. Tra ē. xxiiii. car. In dnio
vi. car. 7 xx. serui. 7 xxxvi. uilli cu. xi. bord hnt xx.
car. Ibi. ii. molini de. xxxii. sot. 7 vii. den. 7 c. ac pti.
Silua. iii. leu lg. 7 ii. leu lat. Cu onerat. uat. l. sot.
T.R.E. ualt. xx. lib. Modo. xxx. lib.

Ide eps ten EDBURGBERIE. De ecta fuit. 7 est.
Ibi ē. xviii. hide. 7 dim. Tra ē. xx. car.
In dnio. iii. car. 7 xx. serui. 7 xxvii. uilli cu. xx. bord
hnt. xix. car. Ibi. ii. molini de. xxx. sot. 7 xxxvi. ac
pti. de. x. sot. Tot. iii. leu. 7 ii. quareñ lg. 7 i. leu dim lat.
T.R.E. ualt. xii. lib. Modo. xx. lib.

TERRA EPI SARISBERIENS

Eps Sarisber ten DICHESDENE. De ecta fuit. 7 ē.
Ibi ē. xx. hide. 7 tra ē. xx. car. In dnio. ii. car.
7 xl. uilli cu xxvi. bord hnt xx. car. 7 ibi. i. seruus
7 l. ac pti. Silua. i. leu 7 ii. quareñ lg. 7 dim leu lat.
aluū 7 uat. xv. lib.

TERRA EPI DE EXECESTRE

Eps Exoniens ten de rege. vi. hid in BERTONE.
7 Rotbert de eo. Leuric eps tenuit. Tra ē. vi. car.
In dnio. ii. car. 7 ii. serui. 7 x. uilli cu. vii. bord hnt
iii. car. Ibi. ii. piscariæ de. xxxii. sot. 7 xl vii. ac pti.
T.R.E. ualt. iiii. lib. Modo. vi. lib.

TERRA EPI LINCOLIENSIS. In DORCHECESTRE hd

Eps Lincoliens ten DORCHECESTRE. Ibi sunt
c. hide. x. min. De his hñt eps in sua firma. lx hid
una v min. 7 milites xxx. hid 7 una v træ.
In dnio tra. iiii. car. sed. iii. car tantum ē. 7 xxxviii.
uilli cu xxii. bord hnt. xv. car. Ibi molin de. xx. sot.
piscator redd. xxx. stich anguill. 7 un ho. xii. sot. p dim
hida. de pdco. xl. solid. Silua minuta. vi. quareñ lg. 7 iii. lat.
Inter hæc redd hoc ō. xxx. lib p annu. T.R.E. ualt xviii. lib.
De ead tra hui ō ten Bristeua. xx. hid 7 dim ad
firmā. Tra ē. xxi. car. In dnio. iiii. car. 7 xl vi. uilli
cu. xv. bord hnt. xx. car. Ibi. iiii. molini de. xxxvii. sot.
de pas piscariis. xxv. sot. 7 vii. den. 7 x. stich anguill.
Inter h redd ista tra. xx. lib. T.R.E. x. lib. Cu recep. viii. lib.
In hac ead tra eps in Stoch. xxii. hid 7 una v træ.

De his hñt. viii. fc in dnio. 7 ibi. ii. car. 7 xix. uilli cu. v. bord
7 i. seruo hnt. vii. car. Ibi. xxiiii. ac pti.
Valet. vi. lib T.R.E. m redd. xii. lib. 7 xii. stich anguill.

Ipse eps ten TACHE. Ibi ē. lx. hide. De his hñt in firma
sua. xxxvii. hid. 7 milites eî hñt alias. Tra ē. xxxiiii.
car. In dnio. v. car. 7 v. serui. 7 xx vii. uilli cu. xxvi. bord
hnt. xix. car. Ibi molin de. xx. sot. De pas. lx. sot.
T.R.E. ualt. xx. lib. Cu recep. xvi. lib. Modo. xxx. lib.

Ide eps ten MIDDELTONE. Ibi ē. xl. hide. De his hñt in sua
firma. xxxi. hid. 7 milites alias. Tra ē. xxvi. car.
In dnio. v. car. 7 xx iiii. uilli cu xxxi. bord p̄ro hnt
xix. car. Ibi molin de. xv. sot. 7 ptu de. x. sot.
T.R.E. 7 post ualt. xviii. lib. Modo. xxx. lib.

Ipse eps ten BANESBERIE. Ibi ē. l. hide. De his hñt eps
in dnio tra. x. car. 7 iii. hid. 7 hoc ē uille. xxxii. hid 7 dim.
T.R.E. erant ibi. xxxiii. car. 7 dim. 7 totid eps. R. inuent.
In dnio. vii. car. 7 xiiii. serui. 7 lxx vi. uilli cu xviii. bord
hnt. xxx ii. car. Ibi. iii. molini de. xl. solid. pastura hñt
iii. quareñ lg. 7 ii. qreñ lat.
T.R.E. ualet. xxxvi. lib. Cu recep. xxx. lib. Modo uat totid.

Ipse eps ten CROPELIE. De ecta s marie Lincol fuit. 7 est.
Ibi ē. l. hide. De his hñt eps in firma. xxv. hid. 7 milites alias
Sup has. l. hid ē ora in dnio ad. x. car. Inter totu tra ē. xxxx car
eps inuen. xxx v. In dnio. vi. car. xii. serui. 7 v.
uilli cu. xxii. bord hnt. xxx iii. car. Ibi. ii. molini de xxvii. sot.
7 c xx. ac pti. 7 c xxii. ac pasture.
T.R.E. ualt. xxviii. lib. Cu recep. xxx. lib. Modo uat totid.

Ipse eps ten TOLESBIA 7 Cotuban monach de eo. Ibi ē
xv. hide. 7 dimid pan eid ecclæ.
Tra ē. xviii. car. 7 totid inuen. In dnio ē tra. vi. car inland
In dnio. iii. car. 7 iii. milites cu xxxv. uillis 7 xxxiii. bord
hnt xvi. car. Ibi molin de. xii. sot. 7 cccc l. anguill. 7 cc l. v.
ac pti. 7 c. ac pasture. Silua. i. leu 7 dim lg. 7 i. leu 7 ii. qreñ lat.
Cu onerat. uat. xxv. sot. Valent. 7 uat. xx. lib.

Ide Cotuban ten de epo SERTONE. Ibi ē. iii. hide. Tra ē. v.
car. In dnio. i. car. 7 vii. uilli cu. v. bord hnt. v. car.
Ibi. l. ac pti. 7 pastur. i. qreñ lg. 7 i. qreñ lat.
7 cc l anguill. iiii. sot 7 iii. den. Valent. iiii. lib. modo. c. sot.
Ide Cotuban ten de epo v. hid in parua HOLLANDRI.
7 pan ad ecclam. Tra ē. vi. car. In dnio fc. ii. car. 7 ii. serui.
7 xii. uilli cu. iii. bord hnt. vi. car. Ibi. xx v. ac pti. Valent
7 uat. c. sot.

De tra DORCHECESTRE ten angli Ibi hoc. iiii. hid 7 dim.
Conan. viii. hid una v min. Walcher. vi. hid 7 dim. Isuuard
v. hid 7 dim. Iacob. ii. hid. Rainald 7 Vitalis. v. hid.
Tra ē. xxi. car. Ibi fc in dnio. x. car. 7 xx vi. uilli cu. v. bord
7 iii. serui hnt. xxvi. car. Ibi hnt int se. l. ac pti.
Tot T.R.E. ualt. xv. lib. Cu recep. xii. lib. Modo. xx vi. lib.

Parce tuis queſo
monachiſ clementia ihy;

ONFITEMINI
dño quoniam bonuſ:
qm in ſclm miſcdiaei.
Quiſ loquetur poten
tiaſ dñi ? auditaſ
faciet omiſ laudeſ ei.
Beati qui cuſtodiunt
iudicium : & faciuṅ

iuſticiam in omni tempore.

Memto nři dñe inbeneplacito populi tui :
uiſita noſ inſalutari tuo .

Ad uidendum inbonitate electoꝛꝩ tuoꝛꝩ :
adletandum inleticia gentiſ tue ?
ut lauderiſ cum hereditate tua .

Peccauim cum patribuſ nřiſ ?
iniuſte egim iniquitatem fecim .

Patreſ nři inegypto ñ intellexerunt
mirabilia tua : nonfuerunt memoreſ
multitudiniſ miſcdie tue .

Et irritauerṫ aſcendenteſ inmare mare
rubrū :&ſaluauit eoſ ꝓpt nom ſuum :

26
The St Albans Psalter

St Albans, 1120–45
Dombibliothek Hildesheim, St Godehard 1, p. 285

It must have been difficult being a woman in the twelfth century, particularly one as attractive as Theodora was reputed to be. Theodora, or Christina of Markyate (*c*. 1096–*c*. 1155) as she became, had visited St Albans Abbey when younger and had promised herself to God, but her parents forced her to marry Beorhtred and, with his forceful advances, she struggled to remain a virgin. She ran away from home and was protected for some years by a number of Anglo-Saxon hermits, including Alfwen, the anchoress at Flamstead. She later came to Roger the deacon-hermit at Markyate; he gave her protection for four years, with Christina living in an almost secret room, sealed with a log, attached to his cell. Christina took over his dwelling when he died and made her vows in 1131. She established a Benedictine community at Markyate that included her sister Margaret; her brother joined the monastery at St Albans. Abbot Geoffrey de Gorham of St Albans (d. 1146) protected and supported her financially after about 1124, and she became his friend and counsellor. Geoffrey did not appear to be the wisest of people; he was described as haughty and worldly, ignoring the advice of others, but he did listen to Christina. Although it is probable that their relationship was chaste there was certainly gossip, not least because she called him her 'beloved' and he called her his 'girl' and 'beloved maiden'. Christina was a skilled needlewoman and made Geoffrey some undergarments 'not for pleasure, but to mitigate the discomfort of the journey'[26]

when he travelled to Rome in 1136. Making underwear for an abbot was hardly likely to douse the flames of gossip!

There are thought to have been six scribes working on the St Albans Psalter, all commissioned by Geoffrey, and four artists, including the Alexis master. Artist three painted the image of a nun, no doubt Christina, within an enlarged gold letter **C** at the beginning of Psalm 105; this is his only contribution to the manuscript. Above the illumination is written in green and red 'Spare your monks I beseech you, O merciful Jesus'. Christina is doing the beseeching, and she is shown with her hand actually touching Christ; behind her, four monks; one of them with his hand on her shoulder, are all looking to Jesus who is shown with a blue background of heaven and stars. Interestingly, the image is pasted in, but does not cover another picture, so it is probable that it was intended for this space. The edges of this piece of skin have been shaved and abraded so that they are wafer thin.

The lettering is in Proto-Gothic based on an oval letter **o**. There are many contractions, often indicated by a horizontal line as in the first words on the first and second lines of the text block. This scribe writes a characteristic enlarged bowl to the letter **a** (see **quoniam** in line one), which hardly leaves sufficient room to write the rest of the letter at the top.

27
The Melisende Psalter

Jerusalem, 1131–43
BL Egerton 1139, f. 24r

Basilius worked in the monastery of the Holy Sepulchre in Jerusalem, where he made this manuscript; on folio 12v he writes a colophon *'Basilius me fecit'* ('Basilius made me'). It was probably made for Queen Melisende (1105–1161), the wife of Fulk, Count of Anjou (*c.* 1089/92–1143). Melisende was the daughter of King Baldwin II (d. 1131) who, while he was king, regarded his eldest daughter as 'heir to the kingdom of Jerusalem'.[27] Although Fulk was a good warrior, who would, and did, protect the realm, it was a shrewd move by King Baldwin to name Melisende in this way, as his son-in-law certainly ruffled feathers in the court at Jerusalem by favouring his Angevin countrymen. After a palace coup Melisende became the dominant partner, and following Fulk's death from a hunting accident she became queen regnant, proving herself to be a wise and astute ruler. King Baldwin and Queen Morphia, his wife, are named in the calendar in this manuscript, but the death of Fulk is not, so it is suggested that the Psalter was made between the deaths of Melisende's parents but before that of her husband.

The Psalter is rich with gold and jewel colours on many pages. Opposite the page shown on the right is an enlarged letter **B** for *Beatus* (the beginning of Psalm 1), which is all in raised leaf gold on gesso: a magnificent start to this section of the book. The psalm continues on this page as shown: *'vir qui non abiit in consilio impiorum…'* (['Blessed] is the man who walketh not in the counsel of the ungodly…'). Two separate strands of raised gold create a complicated interlace pattern in the border, encasing the lettering with a black background, and there are broad horizontal bands of smooth raised gold between the letters; it is not easy to achieve gesso that smooth over such a large area. The raised gold letters are set on a maroon background, and are widely and evenly spaced in the first four and the last three lines. On line five spacing seems to be a problem; it starts well, but letters are then squashed at the end, with the same thing occurring in the following line, suggesting insufficient planning. Writing in gesso, however, is technically difficult to do. Not only must the gesso be smooth – gold leaf is tissue thin and will show any imperfection – but it is also a challenge to have sufficient gesso on the vellum surface, such that the gold leaf will stick but also retaining fine lines to the letter-forms. This has been achieved here. The Psalter contains many beautifully decorated, expertly executed, letters that continue to inspire scribes today.

UIR QUI
NON ABIIT
IN CONSI
LIO IMPIO
RUM · ET IN UIA
PECCATORUM NO
STETIT · ET IN
CATHEDRA P
ESTILENTIE
NON SEDIT ·

28
The Bury Bible

Bury St Edmunds, c. 1130–35
The Master and Fellows of Corpus Christi College, Cambridge, MS 2 iii, f. 245v

This magnificent half-page illumination at the beginning of Jeremiah in the Old Testament was executed by the 'incomparable Master Hugo' (*fl. c.* 1130–*c.* 1150); he is not only the earliest recorded professional artist in Britain, but also the earliest named English artist. Hugo was referred to as a *magister* (master) rather than a *pictor* (painter or artist), *scriptor* (scribe) or *illuminator* (someone who works with gold); perhaps it was his versatility with different media that meant it was difficult to classify him. He was at Bury St Edmunds from before 1136 until after 1148, and while there worked on the Bury Bible – made between 1130 and 1135 – as well as a great bell, huge bronze doors for the abbey, and a carved crucifix. The making of the book was recorded:

> This Hervey, brother of Prior Talbot, met all the expenses for his brother the Prior to have a great bible written, and he had it incomparably illuminated by Master Hugo. Because he could not find calf skins that suited him in our region, he procured parchment in Scotia.[28]

It is not clear why this procurement was necessary, but it is possible that because many of the illuminations are large, as here, applying expanses of wet paint and gesso made the skin cockle and buckle;

to avoid this, another piece of vellum was pasted on top. This would also have avoided show-through, another advantage. The painting style ('damp linen') is typical of the period and makes clothes look as if the wearers have been drenched with water. The style of armour painted, and the architecture too, suggests that Hugo may have been on the first Crusade (1096–1099), while the defenders of the castle are thought not to be throwing rocks but 'Greek fire', an incendiary weapon. The painted border design looks incredibly modern.

One scribe is thought to have written the text, but it is not known whether Master Hugo wrote this bible as well as illuminating it. Certainly the detail in the pictures and the time required to paint complicated borders[29] would have been sufficient occupation for anyone, but he was in Bury for some years. The script is Proto-Gothic, a transition style from English Caroline Minuscule to Gothic Textura; letter-forms are based on a narrow **o** and quite compressed, with a comfortable pen nib angle of about 30°. There are also many contractions, indicated by a variety of symbols such as the dash above the letter **e** (first line, first column) and the strange z-shape at the end of **trib** in the same line. The *incipit* to the prophet Jeremiah at the end of the second column is in coloured Versals.

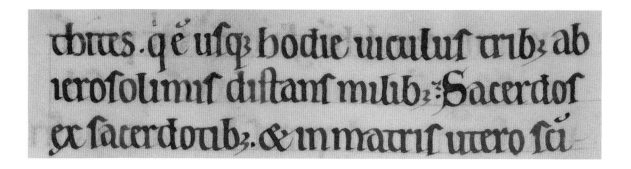

chites. q̃ usq̄ hodie uiculus trib; ab
ierosolimis diſtans milib; Sacerdos
ex ſacerdotib; & in matris utero ſcī
ficatus: uirginitate ſua euangelii
uirū xp̄i eccl̄ie dedicans. hic uatici
nari exorſus eſt puer: & captiuitate
urbis atq; iude n̄ ſolum ſpū ſed &
oculis in tuitus eſt. Iam dece tribus
iſr̄l aſſyrii in medos tranſtulerant.
iam tras earū colonie gentiū poſſi
debant. Vnde in iudā tantū & ben
iamin pp̄hauit & ciuitatis ſue rui
nas quadruplici planxit alfabeto.
qd nos menſure metri uerſibuſq̄
redidim. Prꝯa ordine uiſionū q̄ apd

grecos & latinos omnino confuſus
eſt: ad priſtinā fidem correxim̄. Li
brum autē baruch notarii eius quia
apud hebreos nec legitur nec habet
prec̄niſim̄. pb̄is omibus maledic
ta abemulis preſtolantes: quib;
me neceſſe eſt p̄ſingula opuſcula re
ſpondere. Et hoc patior: quia uos
me cogitis. Ceterū ad compendium
mali. rectius fuerat modū furorū cor
ſilentio meo ponere. qm cotidie noui
aliquid ſcriptantē mūdos in ſa
niam puocare. EXPLIC̄ PP̄hATIO:
INC̄P. HIEREMIAS. PROPhA:

Quarta subit mundi pluuiosus februarius ordine
humidus inde locos colluceret aqri orbem.
Februarius habet dies xxviii. Luna xxix.

				FEBR	S̄c̄ē Brigide uirḡ.
xi	f	iiii	N	P	VRIFICATIO SC̄ē MARIE.
xix	E	iii	N	S	c̄ū Blasu epi ꝫ mr̄
viii	G	ii	N	S	
	A	NON		S	c̄ē Agathē uirḡ & m̄. Vltima mensis hieme
xvi	B	viii	ID	S	
v	C	vii	ID	S	
	D	vi	ID	S	
xiii	E	v	ID	S	
ii	f	iiii	ID	S	c̄ē Scolastice uirḡ.
	G	iii	ID	S	
x	A	ii	ID	S	
	B	IDVS		S	
xviii	C	xvi	kl MAR.	S	Sc̄ī Valentini m̄r̄.
vii	D	xv	kl	S	Sol in piscibus.
	E	xiiii	kl	S	
xxv	f	viii	kl	S	
iiii	G	viii	kl	S	
	A	ix	kl	S	
xii	B	x	kl	S	
i	C	ix	kl	S	
	D	viii	kl	CATHEDRA SC̄I PETRI.	
ix	E	vii	kl	S	
	f	vi	kl	Sc̄ī Mathie apl̄i	
xvii	G	v	kl	S	
vi	A	iiii	kl	S	
	B	iii	kl	S	
xiiii	C	ii	kl	S	

Memento qd annabissectili luna
ne paschalis lune ratio uacillet. Nov hoh anno bx

29
The Shaftesbury Psalter

Dorset? England, second quarter of the twelfth century
BL Lansdowne 383, f. 3v

Calendars were included in a number of mediæval books, particularly Books of Hours and Psalters. They were important for determining the major feast days of the Christian year, such as Christmas, Easter, Whitsuntide and Lady Day (one of the four quarter days), as well as the saints' days. The last sometimes help to identify the patron or where the book was made, or where it was intended to be used, as specific saints were often peculiar to a region or town. If the budget allowed, major celebrations such as Christmas would have been written in gold – Golden Days – and slightly less, but still important, days would be written in red – Red Letter Days.

On this page the Purification of the Virgin, on 2 February, is written in red. This is Candlemas, when the tradition was that candles would be taken to the church to be blessed, signifying Mary being purified and re-entering the synagogue 40 days after the birth of Jesus. The months' days were rarely written from 1 to 28/30/31, as the Roman calendar of kalends, nones and ides was still used. A large **KL** at the top of each month indicated the beginning of the kalends, from which the word 'calendar' is derived. Nones followed on the fifth or seventh day according to the month – here on the fifth and marked by the red **NON** – and the ides on the 15th day, marked by the red **IDVS**. Dates were usually referred to as being days before the kalends, nones and ides, which is why there are **NO**, **ID** and **KL** written next to the saints' names, and then Roman numerals in green counting down before each change (**viii**, **vii**, **vi**, **v**, **iiii**, **iii**, **ii**, before **IDVS**). The column of letters in red from **A** to **G** are the Dominical Letters, used to identify the Sundays of each month, using a complicated calculation process. The column of brown Roman numerals on the far left, called the Golden Numbers, were used to work out the date of Easter, in an even more complicated calculation.

The lettering is Proto-Gothic showing heavy wedge serifs, with initial letters written in Versals, while the Dominical Letters and Golden Numbers are written in a form of Rustics. Initial letters are in blue, alternating with red and maroon. At the top is a man wrapped up in a fur cloak that even covers his head under his hat, warming himself by the fire while he shelters within a gilded and painted tower. The position of his hands and feet, and then his body leaning on the left-hand column, cunningly suggest the letter **K**, and the right-hand column with its scroll has a base extending to the right in blue making the letter **L**: **KL**, kalends. Two colourful fish, joined by a wonderfully fluid line from mouth to mouth in a roundel, represent the astrological sign Pisces.

30
The Eadwine Psalter

Christ Church, Canterbury, *c.* 1160
Courtesy the Master and Fellows of Trinity College, Cambridge, R 17.1, f. 43v

The Eadwine Psalter is a most complicated book. It includes not only the Book of Psalms, but has three versions of it in Latin – the Gallican (translated from the Greek Septuagint),[30] the Roman, which is the Gallican corrected by St Jerome (*c.* 347–420), and the Hebrew version, again translated by St Jerome, but this time from the Hebrew. Note 'Gall', 'Rom', 'Hebr' in red at the top. Between the lines is a translation of the Hebrew version into Norman-French and the Roman into Old English. It is a very complicated book! There is a prologue, a commentary and a concluding prayer to each of the Psalms. It is thought that 13 scribes wrote the text, achieving a consistency that makes it difficult sometimes to identify each one. The illustrations are based on the Utrecht Psalter (see page 110) and are delightful coloured ink line and wash drawings. In the Eadwine Psalter, unlike the Utrecht and Harley Psalters, the drawings are encased in rectangular frames with colourful line borders.

What makes the Eadwine Psalter so unusual, though, are three illustrations. First on f. 10r there is an image of a Halley's comet in 1145, with a written note describing it in Latin as the 'the long-haired star'. At the end of the book (ff. 284v–285r) is a two-page diagram of the waterworks of Canterbury Cathedral. And just before that is a full-page depiction of Eadwine himself. He is shown as a monk, tonsured, sitting at a sloping desk with his cut quill in his right hand and quill knife in his left (see page 34). His desk and chair are very elaborate, featuring 'Gothic' leaded glass windows, arches and quatrefoils. He even has a platform to rest his feet, possibly to protect them from the cold stone floor. The background colours of deep blue, malachite green or verdigris and vermilion all indicate the high status of the person depicted. The inscription surrounding this portrait further emphasises this.

The Eadwine Psalter shows how complicated books of the period can be, and illustrate the time it must have taken to plan before even one letter was written. The Gallican version of the Psalms is in the outer column on each page, with wide line spacing. Towards the middle is the Roman version and close to the gutter of the book is the Hebrew version, with Old English and Norman French glosses. The pages present a harmonious whole, yet each version is of a different length and written here in two x-height sizes.

ex omnibz an
gustiis meis.

de cureb
sel anguscer
gustus exit.

Ex omnibz tribulationibz suis.

Vide q̄s domine humi
litatem nr̄am & laborem
nr̄m & ꝓpitiare peccatis nr̄is
quia multa sunt. & pꝯ ut ita
defleamus p̄terita ut p̄sentia
caueamus. p.

Iudica me d̄. Maria est uir p̄fectus. Mod? p̄mo
petit, ꝯseruari. in hac discretione q̄ sem̄ hac uita
a mal’ discreuit. Sc̄do. ut sic hic sp̄u discernit a
mal’ ita infuto etia corpore & loco separent̄. In
tertio est quos in sup̄iori psalmo de exitu babylo
nis monuit: hic ut p̄fectos de conuictu docet.

ut nullus .s. cū impiis habeat uiuendo ꝯsen
su. Iudica me. Petitio de ꝯseruanda dis
cretioē in hac uita. Jcomplacui in ueritate
hoc ē ꝯserua me. ex sponte me discreui.
Dn̄e. d̄. Sc̄a pars q̄ de secunda discretoē
orat s; causa p̄mittit dies. d̄. d̄. Hepdas. oratio.

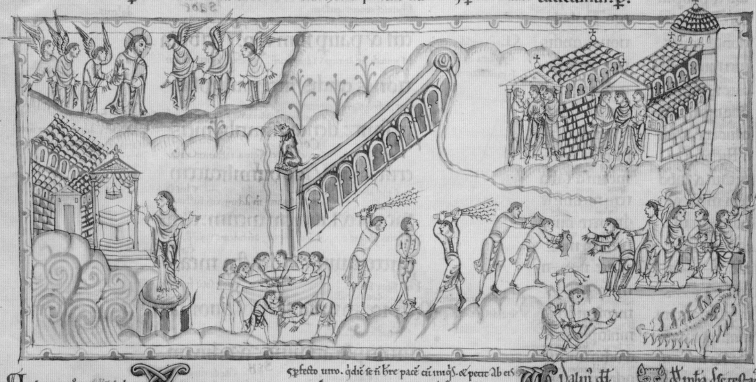

Iudica. qui p̄ mutal’ habeo in
nocentie mr̄cu. cū uia custodi
tī. nec ꞇ sic ime .s. in d̄io spar’
p̄manebo. qui q̄ī bon̄ noto ꞇ
malos. eō : salsmalī & p̄iore
so. & ut palee ꞇā ꝺn̄ ipsam uen
tilatione rapturī. iudica. ꞇī
est p̄scriptio iusti. s; certitudo
inisedie di. q̄d ibi ostidit. in
d̄io spar’. de ī ꝥ infirm̄. Tuū
ꝓba. in t̄ptoiib; nech delict’ re
maneat. alit̄ negligentes essem.
Teptat d̄s ut erudiat. diabol ut
se ducat. hic p̄fecū p̄catur. tri
bulo ē nech de eis murmurat.

expecto urō. q̄ die se n̄ hre pace cū meis. & petit ab eis
discer...

Insinem ꝑ d̄t.

ꝺ discite amal’ q̄
simul nobcum in eccl̄a. ne simul eam in igne. e.

Iudica me domine quon̄
n̄ est elatio. s; n̄ign̄ confessio.

am ego innocentia mea
quiam mor’. ꝟ ꞇꞇ peccatores.

alit̄ ꞇꞇ malos ꞇ

ingressus sum: & in domino
trubaē. qui & si cadunt iste stat
q̄ n̄ meis. s; d̄io spar. s; n̄ro peccatores.

sperans non infirmabor. Pro
quid occultor̄ meor̄ lateat me? iudica. ꞇī tibi.

ba me domine & tempta me:

Ps̄ iste monet uitare
consoria iniquor.
ungi iustis. q̄ ex ꞇ
nictu mores formani.

Annō. mea. n̄ dnglōr
s; ꞇꞇ ē bōn.

Proba .i. p̄ uires
inspice. & tunc ut
ferre ualeo tēptari
p̄mitte.

Iudica me
domine quon̄
iam ego innoc
centia mea
ingressus sū:
& in domino
sperans non in
firmabor. Pro
ba me dn̄e &
tempta me:

Iudica me
deus quon̄
iam ego īsim
plicitate mea
ambulaui.
& in domino
confidens non
deficiam. Pro
ba me dn̄e &
tempta me:

O felicia oscula lacteulis labiis impressa. cū
inter crebra indicia reptantis infancie
utpote uer[us] er te fili[us] mi[hi] alludret. cū
uer[us] er patre[m] [m] di genuit impare[t].

PREꟹATHIAS: PꟹSTꟹS

31
Historia Anglorum, Chronica Majora, Part III – Matthew Paris

St Albans, first part of the thirteenth century
Royal 14 C.vii, f. 6r

By the beginning of the thirteenth century, the demand for books and manuscripts was such that the various crafts involved in making them were often carried out by different specialists. There may have been a supervisor – perhaps the stationer – who would arrange the supply of the text to be copied, the provision of the skins, the gatherings to put together and the selection of the scribe for the task. When the writing was finished, the pages would then be passed to the illuminator to complete the pictures, perhaps with an even further job division – the illuminator carrying out the gold work and a *pictor*, or artist, painting the image. Matthew Paris (*c.* 1200–1259), a monk at St Albans from January 1217 until his death, however, was all of these and more. He wrote as an author as well as a scribe, he compiled texts, and he illuminated and painted.

This *Historia Anglorum* – covering the period from 1070 to 1253 – includes, after prefatory matter, an itinerary of how to get from London to Jerusalem with the stops along the way, a map of Britain which shows the road from Dover through London and on to St Albans and north to Durham, and then this delightful drawing

of the Virgin and Child. It is very similar to the tinted line drawings of the Harley Psalter (see page 108), with similar delicacy of style. Mary sits on an elaborate stool with a cushion holding her baby; it is the little human touches, such as Jesus's tiny left foot poking out from Mary's green cloak, the big toe catching in her belt, that are so masterful. The wash, which adds a great deal of depth to the painting, is very skilfully applied. Below, and outside the rectangular frame, Paris has not only drawn a self-portrait of himself in a brown, not coloured, wash; he has also written his name in alternate red and blue Versals. *Mathias Parisiene* could suggest that he was called 'Matthew the Parisian', but it is thought that he was born in England, possibly in Cambridgeshire. Paris's hands are particularly expressive in this gesture of supplication. The lettering on the left-hand side is his, and is written in an almost hasty 'informal' Gothic; the strangely constructed fishtail serifs look more like the letter **v** written on top of the downstrokes. It is not that this was an afterthought or a dedication note: this style of serifs continues throughout the book that contains the text of Paris's *Historia Anglorum*.

32
The Westminster Psalter

Westminster (?), England, beginning of the thirteenth century
Royal 2 A.xxii, f. 15r

William Postard, abbot of Westminster Abbey from 1191 to 1200, may have commissioned the Westminster Psalter, or it could have been his successor, Ralph de Arundel, abbot from 1200 who was removed from office in 1214 for 'high handedness'. The book seems to have been in constant use in services at the abbey until the Dissolution in 1540; it certainly featured in an inventory of 1388 and formed part of the contents of the vestry at the abbey. Five different artists are thought to have completed the decoration in this book, but the first artist gilded and painted this magnificent **B** for *Beatus vir* – the remainder of (*B*)*eatus* and *vir* are shown vertically in a column on the right of the page. Key events in King David's life are depicted in the two roundels and one semi-circle on the left of the enlarged letter. In the centre David is shown crowned as a king and as the psalmist with his lyre. At the bottom, sword in hand, he is about to remove Goliath's head; Goliath is so huge that he is bent round the roundel, his feet poking out through the circle almost into the text beneath; David's sword and Goliath's metal armour were probably in silver, which has since discoloured. At the top David is presenting Goliath's head to King Saul and looking rather pleased with himself.

The gilded and painted initial letter **B** is a carefully worked out design. The interlaced circles echo the two round bowls of the letter, but, although looking very similar, with almost the same number of decorative elements, the upper bowl is actually smaller than the lower, giving a balanced letter. The exotic flowers and leaves of the design, together with the spirals, hold their own against a raised leaf gold on gesso background of the letter and the pink (probably madder) background to the whole miniature. Lions grace the outer parts of the two bowls of the **B**. The malachite green used for the outer border, some of the spirals and David's cloak has almost completely worn, indicating the challenges of getting a good green pigment in mediæval times. The top line of lettering is in Gothic majuscules; note the sharp angular shape to the first letter **q** and the letters **o** in **consilio**. Apart from the letter **m**, which has a lovely line to the second curve extending below the base guideline for x-height, the other fine lines ending the strokes in the first **l** and the letters **n** look a little like an afterthought. The serifs at the base of many of the strokes are Gothic Textura diamonds, yet in the rest of the letters in the text there are prescissus, or cut-off straight endings, which take time to do and were the most expensive as a result, indicating the status of this manuscript.

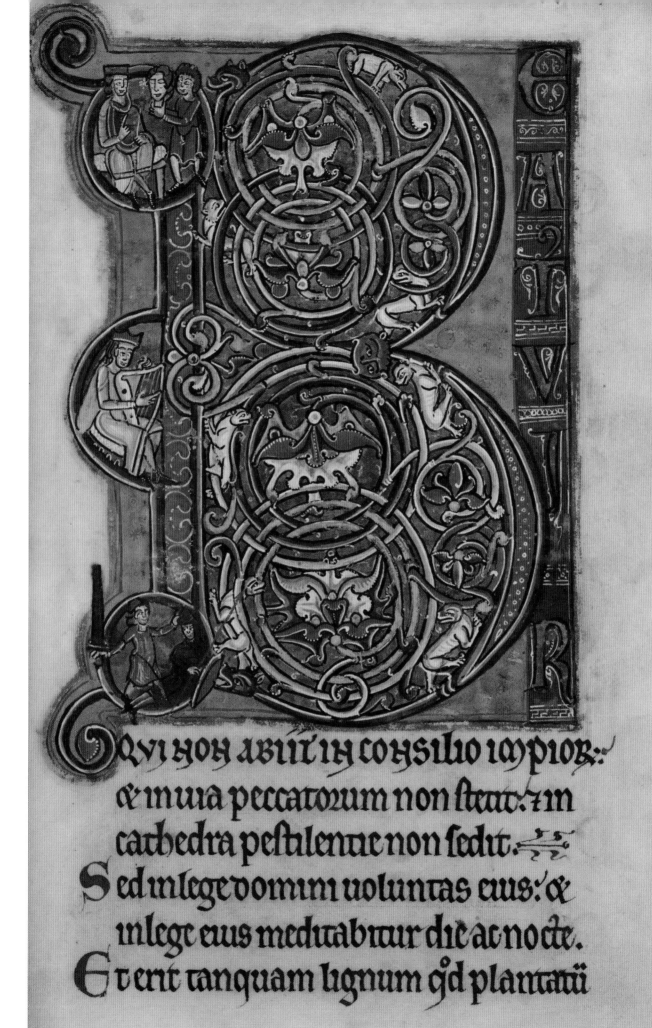

Qui non abiit in consilio impiorum:
et in via peccatorum non stetit. 7 in
cathedra pestilentie non sedit.
Sed in lege domini uoluntas eius: et
in lege eius meditabitur die ac nocte.
Et erit tanquam lignum qd plantatu

dei genitrix virgo semp oraria. interceded p nobis ad dnm deu nostrum. Gloria. Post par tum virgo inviolata p man sisti. Dei genitrix intercede p nobis. Domine exaudi o rationem meam. Et clamor meus ad te veniat. Concenos famulos. Domine exaudi or. Et clamor. Benedicamus do mino. Deo gratias.

33
The De Brailes Hours

Oxford, *c.* 1240
Add. 49999, f. 43r

It is possible that the woman for whom the De Brailes Hours was made was called Suzanna and came from North Hinksey, near Oxford; the book was probably intended for a woman because it contains four generic female portraits. We know a little more about William de Brailes the artist. He probably came from Brailes in Warwickshire, but worked in Oxford from 1238 to 1252. De Brailes painted himself as tonsured, but as he was married to Celena it is likely that he was not a monk but in minor orders. He owned property in Catte Street in Oxford, which is where the crafts of making books were focused at this time, near St Mary the Virgin Church, now the chapel of All Souls College. To the left of the gilded miniature in the lower part of the page on the right, almost swallowed by the binding, is written in red *de Brail' me depeint* ('de Brailes had me made/painted me'). The figure is being touched and blessed by the hand of God. In a separate leaf from a psalter now in Cambridge (Fitzwilliam Museum, 330. iii), William de Brailes paints himself again. This time he is being rescued from a crowd of fellow sinners by the left hand of the Archangel Michæl at the Last Judgement; the archangel holds his avenging sword in his right hand. Held in St Michæl's left hand, is a scroll on which are written the words *W de Brail me fecit* ('William de Brailes made me'); the suggestion here is that William de Brailes was 'saved by virtue of his art'.[31]

The De Brailes Hours is a small book, only 15.0 by 12.5 cm (6 by 5 inches), and suitable for holding in the hand for personal reading and reflection. It has unfortunately been trimmed (note the fine-line decoration abruptly cut off at the top and bottom of this page), yet the letters are proportionally large. Versal letters made with more than one pen-stroke to construct the thicker strokes are at the beginnings of sentences and rubrics, and alternate between those in raised leaf gold on gesso, and those written in blue. They are surrounded by what appears to be a tangle of fine lines made with a pointed pen, but they are in fact carefully designed and placed; red fine lines decorate blue letters, and blue the gold letters. These lines extend into the margins where letters are on the left or the last line. It is not known whether William de Brailes wrote the text as well as creating the illuminations, but this is a bold hand, written with a degree of heaviness of stroke. Letters start, where appropriate, with a pronounced diamond, and the stroke has been reinforced and thickened on a number of letters, particularly for the first strokes. Under magnification, it looks as if this stroke has, for some reason, been written twice, as for example in the letters **i**, **n** and **u** of **inuiolata** in the middle of the fourth line. The prescissus, or cut-off, endings to the letters, taking time to complete, indicate a high grade manuscript.

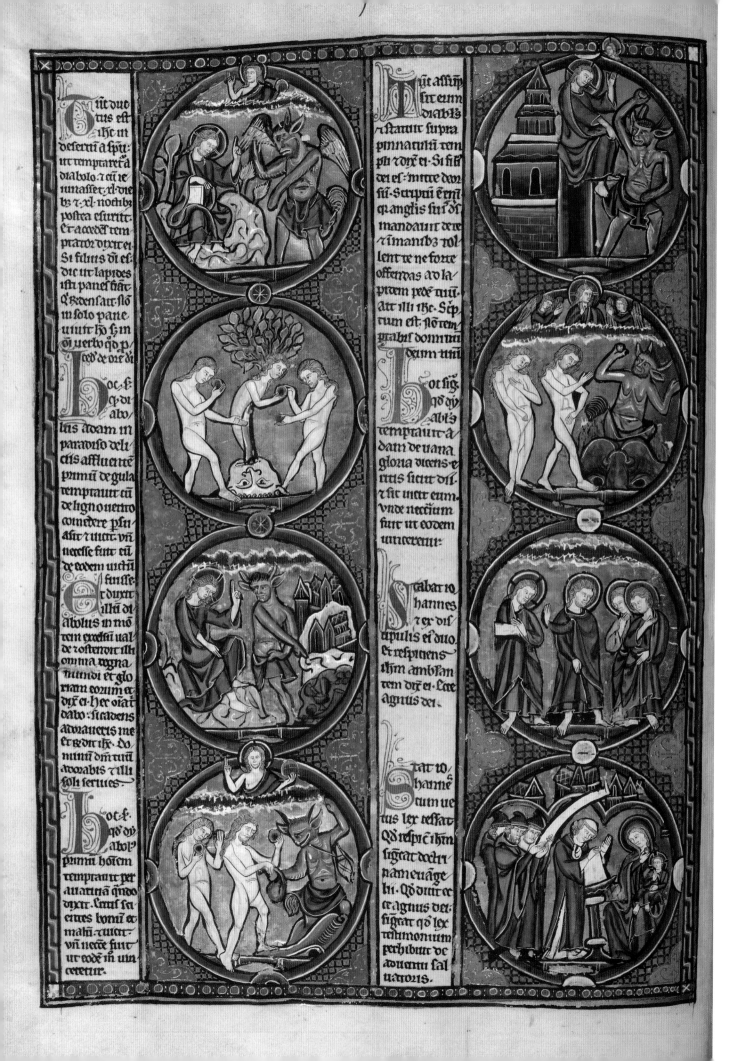

Tut duc
tus est
ihe in
deserti a spu-
itt temptaret a
diabolo. 7 cu te
iunasset. xl. dre-
bz 7. xl. noctibz
postea esurut.
Et accede tem-
prator dixit ei.
Si filius di es
dic ut lapides
isti panes fiant
z redens sait. Jo
in solo pane
uiuit hoz. in
oi uerbo qd p.
ced de ore di

Hoc .e.
qd di-
abo-
lus adam in
paradiso deli-
cis affluente
primu degula
temptauit cu
de ligno uetito
comedere psua-
sit 7 uicit. un
necesse fuit eu
de eodem uicti
fuisse.
Et dixit
illi di-
abolus in mo
tem excelsu ual-
de 7ostendit illi
omnia regna
mundi et glo-
riam eorum et
dixit ei. Hec oia
dabo. si cadens
adorauers me
et redit ihe. Do
mini dm tuu
adorabis 7illi
soli seruies.

Hoc .e.
qd di-
abol.
primu hotem
temptauit per
auaritia quando
dixit. Eritis sc-
entes bonu et
malu. tulerut-
un necce fuit
ut eode in uin
cererur.

Hunc assum-
psit eum
diabls
7 statuit supra
pinnaculu tem-
pli 7 dixit ei. Si fili
dei es: mitte deo
si. Scriptu e. enim
qr anglis suis de
mandauit dete-
7 manibz tol-
lent te ne forte
offendas ad la-
pidem pede tuu
Ait illi ihe. Sc-
riptu est. Jo tem-
ptabis dominu
deum tuu.

Hoc sig.
qd di-
abls
temptauit a-
dam de uana
gloria dicens. e-
ritis sicut dii.
7 sic uicit eum
unde necciu
fuit ut eodem
uincerenur.

Stabat io-
hannes 7 ex dis-
cipulis ei duo.
et respiciens
ihm ambulan-
tem dit ei. Ecce
agnus dei.

Stat io-
hannes
cuiu ue-
tus lex testat.
Qd respic ihm
signat docti-
nam euange-
lii. Qd dixit ec-
ce agnus dei.
signat qd lex
testimoniu
perhibuit de
aduentu sal
uatoris.

34
A Bible Moralisée

Paris, second quarter of the thirteenth century
BL Harley 1527, f. 18v

A *Bible Moralisée* is a picture Bible, lavishly illustrated, but without the full biblical text; instead, selected images and short captions serve as explanation. Another name for a *Bible Moralisée* is a *Biblia Pauperum* ('Pauper's Bible'), but there is nothing associated with poverty in this particular manuscript. First, there are many blank pages: a spread of two facing pages has explanatory text and is illustrated, and then the next two pages are left blank, and so on throughout the book. However, the dense lettering, combined with heavily gilded miniatures where the gesso is very raised, has affected the reverse of the vellum with show-through on occasion, and this would have made it very difficult to work on the backs of these pages. And to reinforce the wealthy, rather than poor, connection, this book was commissioned in 1234 by royalty – Blanche of Castile (1188–1252), Queen Consort of France. It is thought that she probably gave it as a wedding present to Margaret of Provence (1221–1295), who was married to Blanche's son, Louis IX.

Bibles Moralisée usually have similar layouts. Eight round medallions are arranged in two columns of four, with text to the left of each column of picture circles. Often passages are illustrated from the Old Testament with a moral or a lesson drawn from the New Testament. On this page there are illuminations of the temptation of Christ in the desert, along with the temptation of Adam and Eve. The couple are shown being tempted with red and orange fruit from the tree, and they continue to hold the fruit in the lowest roundel on the left. It is clear that all will be damned forever; they are saved only by the birth of Christ in the last roundel on the page. The illustration in the second roundel on the right portrays the devil jumping up from the jaws of Hell. This was a popular way of depicting the fiery inferno, as if a beast was lying down on its back with its mouth open, ready to devour unwary sinners. The lettering for the captions is Gothic, written it seems very speedily as letters are not particularly well formed. The larger initial letters, alternately red and blue, were added after the text, as is usual, and in the caption on the lower right the serif of the red letter **S** has gone over the black letter **t**. Pointed nib fine lines decorate each letter, using red for blue and blue for red. Just above the word **mundi** in the left-hand column, written next to the second to bottom roundel, the vellum has a slit, which has been neatly mended with tiny stitches. This has roughened the surface and caused problems for the scribe.

35
A Bestiary

South-eastern England (Rochester?), first decade of the thirteenth century
Royal 12 F.xiii, f. 45r

The *herinacius*, or hedgehog, was a slightly different creature in mediæval times from the one we know now, according to bestiaries, or books of beasts. It was said to resemble a young pig and to be covered with sharp spines or quills. At harvest time, usually shown by ripe grapes or apples, the hedgehog was believed to climb up the vines or trees, shake the fruit on to the ground and then roll around the vineyard or orchard. Its prickles spiked the fruit, enabling the hedgehog to carry food back to its young. However, there were always lessons to be learned for those who lived in mediæval times. First it was said that this was one of the ways in which the devil steals man's spiritual fruits, so care was needed at all times. Hedgehogs were also likened to sinners, covered in spines, the prickles of sin; if his sins were pointed out, the sinner would roll up into a ball and seek to hide his faults.

Bestiaries contained a mixture of real animals, such as the hedgehog, lion, dog and horse, and fantastical ones, such as the bonnacon (a mythical bull with horns facing inwards), the caladrius (a bird that could tell whether sick people would live or die) and the salamander (a serpent that was so cold it could put out any fire). They were written mainly between the late twelfth and late thirteenth centuries and, although often produced on the Continent, these works seemed to appeal particularly to the English, yet for no apparent reason.

This manuscript was probably made for the librarian of the Benedictine abbey at Rochester by an itinerant artist, and was left unfinished. Each section starts with an enlarged and gilded initial (not shown here), usually with a background of pink and blue; on this were painted white patterns of dots and scroll-like ornament. The slightly backward-sloping text script is Gothic, but not of a high-grade; it seems to have been written in haste, with letters starting with simple curved entry strokes and finishing in a similar way, as opposed to the diamonds characteristic of the letter-forms at this time. Perhaps the librarian at Rochester did not have very much money. The backward-sloping strokes have caused problems with many of the letters **a** in that the downstrokes do not close the letter, as in **aues** (beginning of the top line), **verba** (beginning of the second line) and **iudea** (towards the beginning of the third line); here the letter **d** also has a gap between the bowl and downstroke, as it has elsewhere. The smiling hedgehogs have white stomachs, but have no modelling apart from this and their spines. The foliage looks more like trees than vines, but the orangey-red circles of fruit have many fine lines, creating a grid that could indicate a bunch of grapes.

& sunt aues cum longis rostris · ⁊ significant predicato
res xpi · uerba xpi usq; ad fines orbis terram dissemi
nantes tam in iudea · qz in solitudine gentium · Hericius
est ipse xpc · tectus similitudine carnis peccati · uel p
dicator spiritus sententiarum subtilium · peccata nostra
delens · Coruus est predicator gentilis · qui niger fuit
in peccatis · sed in aduentu xpi · cantat predicando · in
fenestris sensuum nostrorum · et in superliminari · uidelicet
menti nostre sapientie uerba infigens · Vel in ma
lam partem totum legi potest · Per hec enim animalia
que omnia inmunda sunt · significantur uicia uel de
monia que habitant in anima p ypocrisis similitudi
nem · spinosa · ⁊ mentis rationem · ⁊ sensus nostros se
ducunt · Limen enim · corpus uel sensualitas est · Super
liminare autem anima uel ratio · que omnia seduc
tione demonium inuacantur ·

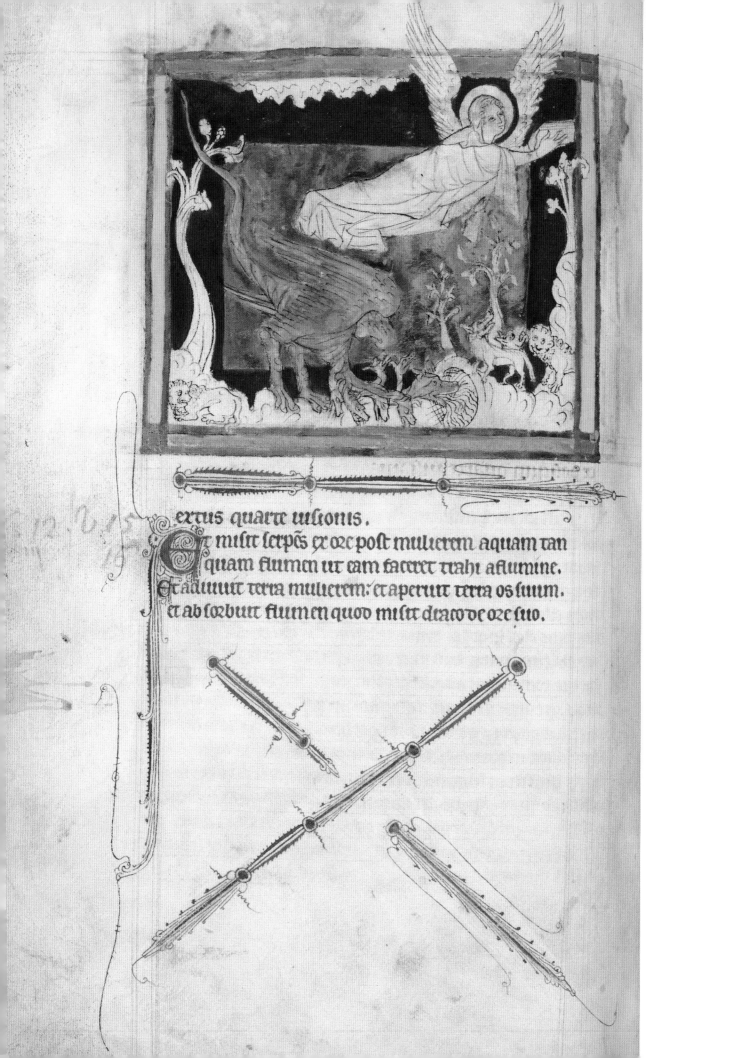

extus quarte uisionis.

Et misit serpēs ex ore post mulierem aquam tan
quam flumen ut eam faceret trahi aflumine.
Et adiuuit terra mulierem: et aperuit terra os suum.
et absorbuit flumen quod misit draco de ore suo.

36
The Abingdon Apocalypse

Southern England, third quarter of the thirteenth century
BL Add. 42555, f. 36v

There are 156 half-page miniatures in this splendid book of the Apocalypse, or the Book of the Revelation of St John; it is no wonder that they are not all finished. What they do show, though, are the stages in manuscript miniature production, from the first outline drawings in black ink (f. 83r and f. 64v) to the gold leaf applied with the body colours painted (57r, 55r) – usually these were the most precious ones of ultramarine and cinnabar (vermilion) – and finally the other colours, the tones and shades, the details, the white highlights and the black outlines. What is fascinating in the manuscript is that in many of the unfinished miniatures, even when all the body colours have not been applied, often the background patterns and painting have been finished. Usually when painting a miniature all the body colours are completed, leaving the fine details to last, but to have painted the patterns on the background before the rest of the paint has been applied does suggest that this was done almost as a campaign, perhaps by one person, possibly even a skilled apprentice. The unfinished miniature here shows the black outline, leaf gold on a raised base of gesso, and a dense blue background, probably ultramarine. The dragon has been painted a dilute wash of orangey-red, probably minium, ready to receive the more expensive vermilion. The miniature shows Revelation Chapter 12:

And there appeared a great wonder in heaven; a woman clothed with the sun, and the moon under her feet, and upon her head a crown of twelve stars … And there appeared another wonder in heaven; and behold a great red dragon, having seven heads and ten horns, and seven crowns upon his heads. And when the dragon saw that he was cast unto the earth, he persecuted the woman which brought forth the man child. … But the woman was given two wings of a great eagle … So the serpent spewed water out of his mouth like a flood after the woman.

The seven-headed dragon is indeed spewing water, and the woman with her eagle wings is flying. Further details of the sun, moon, stars and so on, are omitted. Two inscriptions added to the book indicate that it was given to the Benedictine Abingdon Abbey, and also that it was lent in 1362 to Joan, wife of King David II of Scotland. Pages are decorated with 'sceptres' of gilded and pen-made decorated lines, which are vertical, horizontal and also drift across at various angles. This page shows the Latin text, while on the facing page is a French translation. It is written in Gothic Textura with defined diamond serifs. The first line has been erased and written over, which has led to less fine, rather blobby lettering.

temptacionis in deserto.

Ubi temptauerunt me patres uestri:

probauerunt ⁊ uiderunt opera mea.

Quadraginta annis offensus fui

generacioni illi ⁊ dixi semper hii er-

rant corde

Et isti non cognouerunt uias me-

as: ut iuraui in ira mea si intrabūt

in requiem meam

Cantate domino canticum

nouum: cantate domino

omnis terra

Cantate domino ⁊ benedicite no-

mini eius: annunciate de die in diē

37
The Luttrell Psalter

Lincolnshire, 1330s
BL Add. 42130, f. 171v

The Luttrell Psalter should not work as a page design. There are enlarged gilded and painted initials, smaller coloured Versal initials – some gilded – with background designs, wide borders of pattern, scroll-like borders of leaves, flowers and wavy stems, animals and grotesques of all types positioned at various places on the page, patterned and gilded line endings, figures as line endings as on this manuscript page, and then realistic delicate paintings of agricultural, domestic, court and other scenes at the base of the blocks of text. Opposite pages are not even symmetrical. It should not work – but somehow it does, as it is all pulled together by the large, regular, vibrant Gothic Prescissus writing. Of all the Gothic scripts this was the most expensive, taking longer to write with many pen-lifts and much nib manipulation.

It is this script that carries the whole Psalter from beginning to end. The pen is held at an angle of about 45° to the horizontal guidelines, resulting in a comfortable position for the arm and hand. The prescissus (flat) tops to some ascenders and the bases of appropriate strokes are made by using the left-hand corner of the nib to 'draw' the shape and fill it in with ink. The same left-hand corner of the nib was used to create the wonderful extensions to some of the letters ending in a spiral. There are 23 on this page alone, some even on the punctuation; this was not a scribe in a rush. Note also the hasty dashes above the letters **i**: these are 'jots' (as in 'jots and tittles'), introduced in Gothic writing for the clarification of letters. The enlarged initial **C** towards the bottom of the page shows three men, as it says in the psalm that follows, 'Sing(ing) to the Lord a new song'. Gold and patterned line fillers are all different on this page. The marginalia of a stork with a snail's back, a bird with a boy's face and a man without legs but with the body and tail of a serpent trying to pin down the head with a pitchfork is most creative.

The inventiveness and delight of the mediæval imagination is exemplified on almost every folio of this manuscript. A delicate painting at the base of the page shows a rather poorly-looking man and a woman smashing stones or lumps of earth with sledge-hammers, an image that Michelle Brown[32] suggests shows breaking the earth to receive the word of God. The book was created for Sir Geoffrey Luttrell (1276–1345) of Irnham in Lincolnshire, and he appears in a half-page miniature as a knight in armour, together with his wife Agnes (née Sutton, d. 1340) and his daughter-in-law Beatrice (née Scrope); the two women are wearing dresses that feature their families' coats of arms impaled with those of Luttrell (see over page). Michelle Brown has suggested that Sir Geoffrey felt his impending death and had the book made to 'play a part in his eternal fate',[33] possibly to use at his funeral. The painting of him as a knight when he was a young man, it is suggested, shows that he did his duty on earth too, and was loyal to the crown during his lifetime.

OVERLEAF: If there was any doubt as to who had this book made, it is written in Latin just above this almost half-page miniature: *D(o)m(inu)s Galfridus Louterell me fieri fecit* ('Sir Geoffrey Luttrell had me made'). Sir Geoffrey is shown as a young man in armour on his horse being handed his helmet by his wife Agnes, who is also holding his spear with the Luttrell arms on a pennant. Heraldry was a way of identifying people, and if you could not read who commissioned this book, the 12 depictions of the Luttrell arms in this painting alone aid recognition. There are even more parts of the Luttrell arms, five martlets, painted in mandorla shapes on the right-hand side of the opposite page. In heraldry, martlets were swallows, house martins or swifts that, it was thought, lived the whole time in the air and did not need to land; they were thus depicted without feet. Symbolically it was thought that such birds represented those who had achieved a position in society by their own endeavours, rather than by inheritance – as they had no foundation on which to stand.
BL Add. 42130, f. 202v–203r.

contrisione sua

Confitebor domino nimis in
ore meo: et in medio multorum
laudabo eum.

Qui astitit a dextris pauperis:
ut salvam faceret a persequentibz
animam meam.

Gloria patri

Dns Galfridus louterell me fieri
fecit

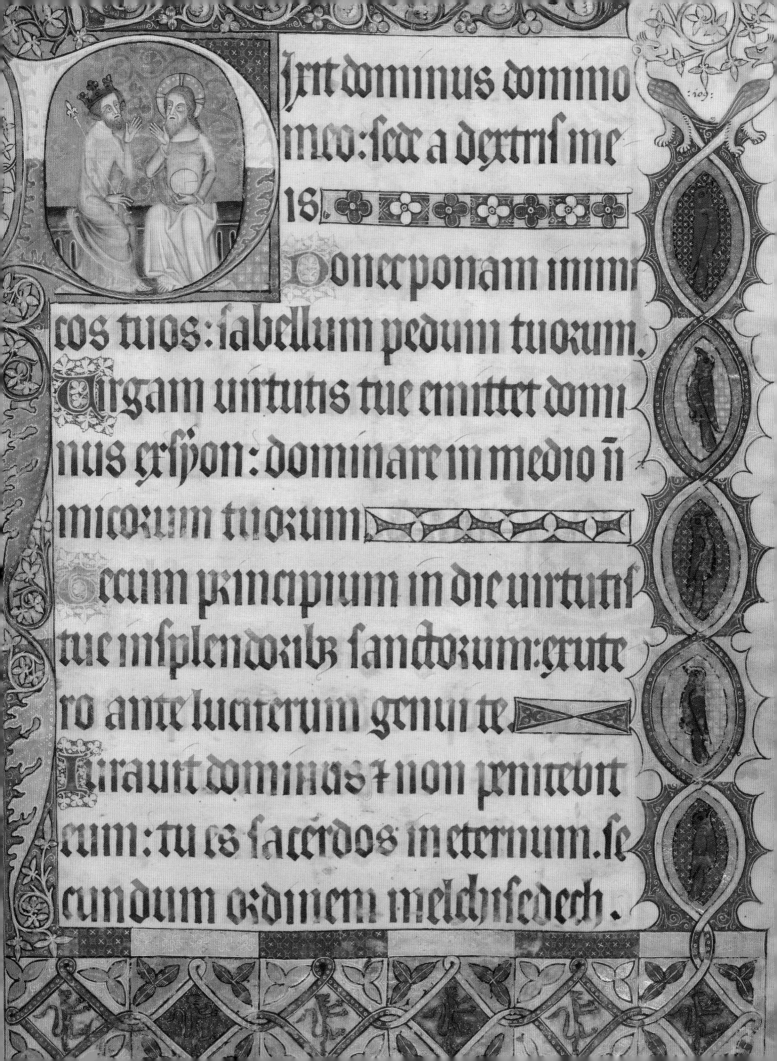

xit dominus domino
meo: sede a dextris me
is

Donec ponam inimi
cos tuos: scabellum pedum tuorum.
Virgam virtutis tue emittet domi
nus exsyon: dominare in medio in
imicorum tuorum

Tecum principium in die virtutis
tue insplendoribz sanctorum: exute
ro ante luciferum genui te

Iurauit dominus ⁊ non penitebit
eum: tu es sacerdos in eternum. se
cundum ordinem melchisedech.

38
The Sherborne Missal

Sherborne, England, 1400–1407
BL Add. 74236, p. 216

This is a 'name-check' book, with very many instances of those connected with the manuscript being named, depicted and alluded to. It is also huge: there are 347 vellum leaves, 53.5 by 38 cm in size (21 by 15 inches), and it weighs 20 kg (44 pounds, just over 3 stone). The work was commissioned by Robert Bruyning, abbot of St Mary in Sherborne from 1385 to 1415, and was made for the abbey between 1400 and 1407. Robert Bruyning is shown on over 100 pages. Richard Mitford, Bishop of Salisbury and Robert Bruyning's bishop, is also shown in many miniatures. There were at least five artists involved in this book, but by far and away the main one was John Siferwas, a Dominican portrayed in his white habit under a black cloak, and on the right towards the bottom left. John Siferwas also worked on the Lovel Lectionary (BL Harley 7026) and a copy of Stephen Langton's Glosses on the Pentateuch (Trinity College, Cambridge B.3.7). He was not only a superb artist, but also someone with great imagination, able to combine visually and depict heraldic elements, architectural structures, natural history (there are 48 paintings of birds, most of them identified) and portraits; Continental influences are reflected too, as this was the period of 'International Gothic'. John Siferwas's image appears on ten pages of the manuscript, including two at Easter, and for the first three instances he is named as well.

It is thought that there was one scribe, John Whas, shown here on the left of his fellow artist, and there is a colophon written by him in the book:

Librum scribendo Ion Whas monachus laborat,
Et mane surgendo corpus multum macerabat.

('John Whas, the monk, wrote this book, and his body sorely aches with the early rising').

As if heraldic emblems and portraits are not sufficient, there are also written and pictorial allusions to John the Baptist, favoured by John Whas, and John the Evangelist, favoured by John Siferwas on many pages of the manuscript[34] – more name-checking. A page like this demands a strong script, so that it was not completely overshadowed, and for the most part it succeeds. However, as can be seen on this page, the larger and more dense sections on the lower left-hand column are far more successful than the section above and in the right-hand column. A luxury volume also demands the highest-grade of Gothic styles, Gothic Prescissus – a script written slowly and in which the flat endings to the ascenders and descenders require much pen manipulation. Main sections start with an enlarged decorated initial letter, here showing Christ rising from the tomb, with sleeping Roman soldiers, below that the letter **D** with Saint Veronica holding her handkerchief, which shows the face of Christ. Smaller initials are still very detailed, with figures and flowers at a tiny scale. Between the columns of text are not only decoration but also small portraits, and everything is surrounded by a cornucopia of images and pattern.

Walto de Godaruile. Thom de Ebelebourn. Nichol Malemans.
Ad rector eccłie de Gatesden. Ric Longespeye. Johanne de Moul.
Magro Rogo de Stokes. Dno Rogo de Baskeruile. Petro de Galceto
Dno Petr psona de Treubugge. Philippo de Depeford clico. Thoma
Makerel clico. Robto de Holte clico. ⁊ aliis

Vniusis sce matris eccłie filiis ad quos psens scptum puenit
Wills Longespeye salutem in dno. Nouit vniusitas vra
nos cartam venabilis mris nre Ele comitisse Sax in hiis verbis
inspexisse. Sciant psentes ⁊ futuri qd ego Ela comitissa salesbur
p deo ⁊ pro anima Willi longespeye qndam mariti mei ⁊ omnium
antecessor suor ⁊ meor ⁊ pro salute mea ⁊ Willi longespeye filij
mei primogeniti ⁊ omnium aliorum liberor meor ⁊ heredum
meor In viduitate ⁊ ligia potestate mea dedi ⁊ concessi ⁊ pre-
senti carta mea confirmaui deo ⁊ beate marie ⁊ sco Bernardo to-
tum manium meum de Lacok cum aduocatone eccłie eidem ma-
nio ⁊ cum omnib libtatib ⁊ libis consuetudinib in omnib locis
⁊ in omnib reb sine aliquo retinemento ad faciend ibi abbathi-
am monialium qn volo nominar locum beate marie. Qre vo-
lo qd Abtisse ⁊ moniales ibidem deo inppetuum seruiture heant ⁊
teneant totum predtm manium cum ptinenciis suis in libam ⁊
puram ⁊ ppetuam elemosinam. solutu penit ⁊ quietum ab oi
seculari seruicio ptinente ad dominum Regem ⁊ Ballivos suos
⁊ ad me ⁊ ad heredes meos. ⁊ ab omni modo seruicij ⁊ exactonis

39
Lacock Cartulary

Lacock Abbey, first half of the fourteenth century, no earlier than 1304
BL Add. 88974, f. 2r

Much of the writing in charters tended to be purely functional – that was the purpose of the document. They recorded, for example, grants of lands and buildings, and rights to hold fairs and markets. A cartulary (from the Latin *chartularium*) is formed when a group of charters is bound together. The Abbey of Lacock in Wiltshire was founded by the Abbess Ela, Countess of Salisbury (*c.* 1190–1261), a wealthy heiress who married William Longespée (1176–1226); Longespée was an illegitimate son of King Henry II, and so there was also a royal connection here. This page from the 'new' cartulary has many duplicates of those in the 'old' cartulary – not to replace the previous ones, but to be in addition. This charter is a confirmation of an older charter made by Abbess Ela, whose name is written towards the end of the fourth line in the second section. The name of their second son, Richard Longespée, who became a canon of Salisbury, appears in the middle of the second line of the top section. Their eldest son, William Longespée II, has his name written at the beginning of the second line in the lower section as well as on the fifth and the sixth lines here.

For something so functional, and only a 'copy', this charter is remarkably elaborate. The top line has a riot of flourishes and extended ascenders; the thicker strokes are made by pressing the flexible quill nib down so that it splits widely, but for parts of the two

letters **d** the pen nib must have been pressed almost to breaking point. The initial letters for Richard Longespée's name have additional strokes to make the lines thicker in the tail of the letter **R** and towards the top of the downstroke on the letter **L**. Other initial letters in this section have fine lines for decoration. After a gap of three lines, the second section starts with a space left for a decorated two-line initial letter which has not been written. It should be the letter **v**, and this has been written quite small in the margin on the left-hand side.

The lettering style, a charter hand, contains a number of contractions and suspensions where letters have been missed out. This is usually indicated by a symbol of some sort, such as the horizontal line above **ecclie** in line one of the second section, or the rather dancing shapes above the first word in that line, then **psens** towards the end of it, and **puerut** at the end. For that last word the horizontal line on the descender of the letter **p** also indicates that the letters 'ro' have been omitted (**pro**). On line six the symbol that looks a little like the number 7 is the Tironian[35] 'et' (and) symbol, while the rather weird symbol – resembling the number 4 – after the letters **meo** in the next word indicates that 'orum' has been omitted. There is a real rhythm to this lettering with many pen nib turns to make the finest of strokes.

40
The Bedford Hours

France, c. 1410–30
BL Add. 18850, f. 24r

The Bedford Hours is a lush and expensive manuscript; it was probably a royal manuscript from the beginning, possibly made initially for Louis (d. 1415) Duke of Guyenne and Dauphin[36] of France. In the early 1420s it was owned by the third son of King Henry IV (1367–1413), John of Lancaster (1389–1435), who was Duke of Bedford and regent of France. John gave it to his third wife as a wedding present in June 1423; she was Anne of Burgundy (1404–1432), the daughter of John the Fearless, Duke of Burgundy. Although this was an arranged marriage, made to mark the alliance between England and Anne's brother Philip the Good, Duke of Burgundy, it was apparently a happy one, though the couple had no children. Once the manuscript had been taken over by the Duke of Bedford various additions were made which put his stamp on it, not least portraits of John praying to St George, patron saint of England, and of Anne praying to St Anne. John's coat of arms also appears in the manuscript, and one page has a border filled with woodstocks (see page 58), or cut tree-trunks with their roots showing. This was one of John's symbols, inherited as a badge from King Edward III (1312–1377), and a reference to the royal residence of Woodstock Palace, at Woodstock in Oxfordshire.

The large miniature that dominates the page is of St Mark, writing his Gospel in a vaulted and arcaded room. He is identified by his symbol the lion, which is very playful here; standing on two red-covered books, it is actually peering over the Evangelist's writing desk. The lion, to be helpful, is holding in his mouth St Mark's pen case and his ink pot, with the lid of the latter clearly visible. Mark writes with his quill in his right hand and his curved-bladed quill knife in his left, ready to erase mistakes and trim the quill tip. The wide margin is filled with flowers, leaves, a bird and people, set in a spattering of gold dots and shapes. Medallions are filled to bursting with intricate scenes including a baptism, a hanging, a bishop on a glorious red chair, a black devil being driven out by a bishop and emerging through the mouth of a man and, just above that, a man checking the sharpness of a knife by running his thumb along the edge. All this requires pretty strong letter-forms not to get completely swamped on the page, but the enlarged, gilded and painted initial Versal letter **I**, the smaller letter **R** and the Gothic Textura letters all magnificently hold their own. The Gothic Textura letters are remarkably even, creating almost a 'picket fence' texture, densely packed together.

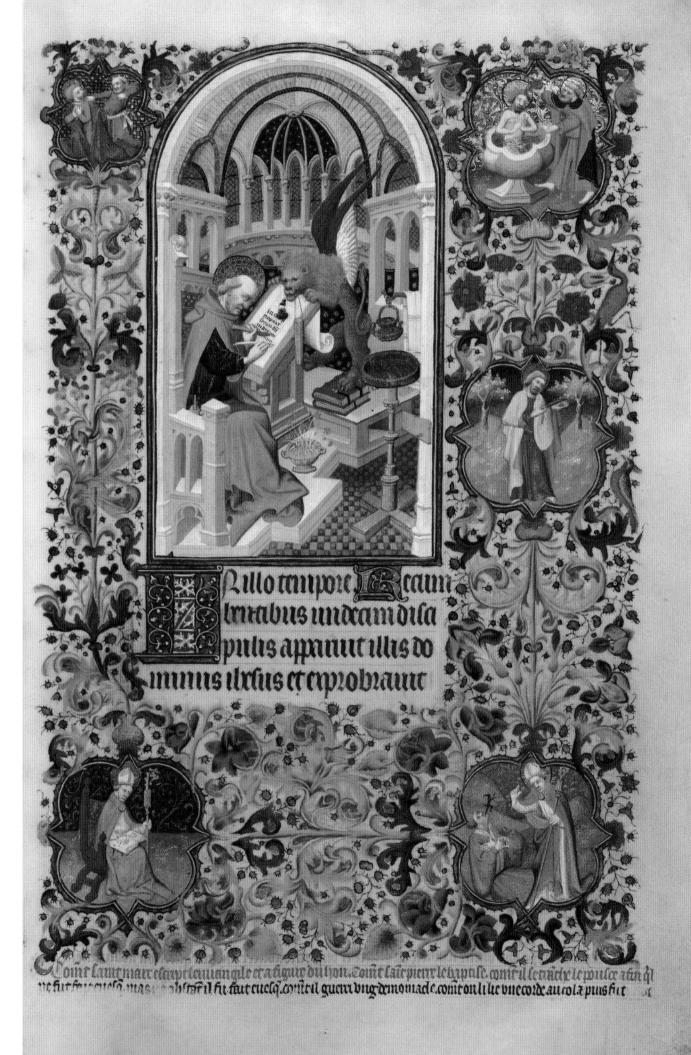

N illo tempore. Recum
bentibus undecim disci
pulis apparuit illis do
minus ihesus et exprobrauit

Ci commencent Cent Balades.



Aucunes gens me prient que ie
face Quelque beaulx dis et q
ne leur envoye.. Et de dicter
dient que iay la grace. Mais
faute soit leur prie ne se
roye.. faux beaulx dis ne bons mais toutesvoye
Puis que prie men ont de leur bonte
Peine y mettray combien q ignorie soye
Pour accomplir leur bonne voulente

Mais ie nay pas sentement ne espace
De faire dis de solas ne de ioye
Car ma douleur qui toutes autres passe
Mon sentement roieux du tout desuoye
Mais du grant duel qui me tient morne et coy
Puis bien parler assez et a plante
Si en diray voulentiers plus feroye
Pour accomplir leur bonne voulente



Et qui vouldra sauoir pour quoy efface
uueil tout mon bien de letter le duyre
e fist la mort qui fert sans menace
ellui de qui trestout mon bien auoye
a quelle mort ma mis et met en voye
e desespoir ne puis te nos sante
e ce fery mes dis puis que on men proye
Pour accomplir leur bonne voulente

Princes prenes en gre se ie failloye
Car le dictie nay mye hante
Mais maint menont prie et ie sottoye
Pour accomplir leur bonne voulente

Au temps tadis en la cite de romme
Orent romain maint noble besoigne
En en pot tel fu que quant vn homme
En fait darmes sen aloit en voyage
Qil y fasoit auain leau vasselage
Apres quant a romme estoit retourne
Cellui estoit pour pris de son bernage
Digne destre de laurier couronne

De cel honneur on prisoit moult la somme
Car le plus preuil lauoit ou le plus sain
Pour ce plusieurs que pop pas ie ne nôme
Sefforcoient den auoir sauantacte
Bien y parut car de hardi visaie
Domptrent ceulx dauffrise en leur regne
Dont maint furent au retour de cartaie
Digne destre de laurier couronne

Ce faisoit on tadis mais vne somme
Ne sont prise en france cest dommaie
Apres ses bons mais tous ceulx on renomme
Et ne ont auoir ou tresgrant heritaie
Mais par sorte trop plus q par lignaie
Soit estre honneur et pris et los donne
A ceulx qui sont pour leur noble courraie

41
The Book of the Queen by Christine de Pizan

Paris, France, *c.* 1410–*c.* 1414
BL Harley 4431, f. 4r

The Italian-French author Christine de Pizan (1364–*c.* 1430) wrote:

> I know a woman today, named Anastaise, who is so learned and skilled in painting manuscript borders and miniature backgrounds that one cannot find an artisan in all the city of Paris – where the best in the world are found – who can surpass her, nor who can paint flowers and details as delicately as she does, nor whose work is more highly esteemed … People cannot stop talking about her … she has executed several things for me which stand out among the ornamental borders of the great masters.[37]

This is quite something from a woman who not only ran her own manuscript book production studio, but also wrote poetry and prose, biographies and guides for women on manners and how to behave at court. It does, though, show the value that Christine placed on her female peers, who would rarely be mentioned or named otherwise. Christine de Pizan was born in Venice; she came to Paris probably when she was about four years old, when her father became the Royal Astrologer and Alchemist to the French king, Charles V (1338–1380). Christine was educated, was married at the age of 15 and widowed at 24. She then had to work to support her mother, three children and a niece. She poured out her grief in poetry, ballads and discourses on the role of women in society, as well as running a scriptorium. Her patron was Queen Isabeau of France (1370–1435), who commissioned this manuscript book.

The enlarged miniature shows Christine writing in a book, placed on a table covered with a green cloth. Her quill is in her right hand and her red-handled, curved-bladed quill knife in her left. To the right of the book is her pen box, and sitting by her chair is a little white dog with a golden (?) collar. This could simply be Christine's dog, but it could also represent loyalty, faithfulness and love. The French text, here the beginning of her *Cent Balades,* is arranged in two columns separated by a gilded and decorated border, different from that which encases the whole. Surrounding it all is a decorated and gilded border with a restrained colour scheme of red, blue and gold. An enlarged letter **A** begins the body of the text, which is Gothic Cursive. Note the letter **d** where a fine line made by the corner of the nib joins the bowl to the top stroke, making it look a little like the number 8 (lines two and three). There is a distinct thickening to the long letters **s** (as in line one, second verse), and the little 'ear' on the left of the stroke can make this letter very similar to the letter **f** with a cross bar (line two, same verse). Some of the writing in this book is thought to be in Christine's own hand.

42

L'image du Monde by Gautier de Metz

The Netherlands, (Bruges?), June 1464
Royal 19 A.ix, f. 4r

This is a manuscript that looks as if it was completed in a hurry. Written in French on paper – the laid lines[38] are visible – it is in Gothic Cursive with many joining strokes and few pen-lifts, all indicating a degree of speed. The letter **d**, as in the first line of black lettering, has been written simply in two strokes, the bowl and the curved back, with no corner of the nib joining the two to make this into a figure 8 (as in the previous manuscript). The first stroke of the letter **v** (at the end of the second line of red lettering, and towards the beginning of the fifth line from the bottom) stretches wonderfully from the left, exaggerating the beginning of this letter and creating almost an umbrella for previous letters. There are two forms of the letter **s**: the long **s**, seen in previous scripts, as in the first, second and fourth lines of black text, has the swelling typical of this period with the nib turning anti-clockwise as the stroke descends resulting in a fine hairline at the tip at the end. The top arch stroke on the long letter **s** and the **f** gives the impression of an afterthought and is often in a paler ink. The small letter **s** most often appears at the ends of words, as in the first three words in the second full line below the miniature.

The miniature, again a little clumsily done, with a rather shaky red line inserted in the border, shows a master with his rapt class of four students, some of them smiling. The teacher, sitting in a grand chair in front of a patterned wall, is holding down the bouncy vellum in a manuscript book with a quill knife in his left hand. The lettering at the top in red explains what is in the body of the text. This manuscript has a direct link with William Caxton (*c.* 1422–*c.* 1491), who, it is thought, translated it and printed it in 1481. N. F. Blake wrote: 'The text of the French manuscript is so close to that of Caxton's own and the illustrations in Caxton's print are so clearly modelled on those in the manuscript that there can be little doubt that this is the original French copy he used.'[39] Blake suggests that Caxton actually commissioned this manuscript from the Bruges workshop, which is why Caxton was so sure of the date of completion.

Prologue decla
rant a qui ce vo
lume appartient

Considerant
que polices sont
e demeurent baines
et escriptures p
mamentes ont
les fais des anci
ens este mis par
declaracon en

beaulp p acuurees volumes affin que
des sciences acquises e choses passees fust
pptuelle memoire pour les oes des
nobles oppeuosez en lisat p estudiant
les fais des sayes jadiz travaillant en
bret? prouffitables Dont il aduient q
les ungs sont enclins a visiter les luds
traitans de sciences pticulieres Et les
aultres a visiter les luures parlans
de fais darmes e damours ou aultre
ment Et est ce pnt volume appelle
lymage du monde Et fu translate de
latin en franchois p le comandement

ymage du monde
translate de latin en
francois.

ancte yuo — oz
ancte martine — oz
ancte traciane — oz
ancte hylaiu — oz
ancte antstoni — oz
ancte maure — oz
ancte morice — oz
ancte nicholae — oz
ancte lupe — oz
ancte ludouice — oz
ancte Joseph — oz
ms sancta confessores — oz
ca maria magdalena — oz
ca maria egipciaca — oz
ancta feliatas — oz
ancta anna — oz
ancta elizabeth — oz
ancta oportuna — oz

43

The Hours of Louis XII, or Hours of Henry VII

Tours, France, c. 1498–9
Royal 2 D.xi, f. 13r

Writing out repeated words or letters can be anathema to a calligrapher; it is so difficult to get handwritten letters exactly the same, and identical letters can deaden a piece. However, the challenge is neatly overcome in this glorious manuscript with a border on the right by the French artist Jean Bourdichon (1456/7–1520/21). This page is from a Book of Hours and shows a list of 17 saints with an exaggerated **S** for *sainte*, while the twelfth entry has the letter **O** for *Omnes sancti*, ('All the saints'). The exaggeratedly wide letters sit on a border with a painted background. Every letter **S** is almost the same shape, but the decoration is different within each one; there are similarities, certainly, with two green leaves on the lower right and a flower to the top left in some, but the flowers are subtly different in colour or shape, and the central curve of the letter has a different white pattern on it. This gives an overall cohesion, but also visual variety. Line endings too differ, although not completely – note the blue line decorated with half gold fleurs-de-lis. The lowest one has a painted gold zig-zag, while in the next the fleur-de-lis are separated by a wavy line, and above that there is no line.

The lettering is Gothic Cursive of a high grade with typical 'figure-of-eight' letters **d** (see sixth line from the end), where a fine line curves between the lower bowl and the top right of the upper stroke. The letter **g** is also very characteristic, being the 'two-horned' **g** (also the sixth line from the bottom, as well as the third line from the top). Here the first stroke of the bowl and the start of the stroke for the descender extend a little above the top guideline for x-height, so that when the horizontal stroke completes the bowl the curved strokes stick up looking a little like horns. This is a graceful script with the finest of hairlines that have worn away in places.

It is, though, the border that is truly magnificent. Flowers and foliage sit on a background of shell gold looking as if they have just fallen or been placed there; even a fluorescent bee at the top has been fooled! The detail makes the flowers look realistic, while the very subtle shading on the gold pushes them forwards to create a three-dimensional effect. The border is surrounded with a thin dark red line, which has even been indented to accommodate two letters of text for the seventh line from the bottom. This Book of Hours was thought to have been produced for King Louis XII of France or King Henry VII of England – how fortunate either sovereign must have been to possess such a beautiful work.

44
Vita Christi – David Aubert

Ghent, 1479
Royal 16 G.iii, f. 8

David Aubert (b. 1413; *fl.* 1449–79), the French scribe, is seen here inside his scriptorium with wonderful Romanesque stone arches, a stone-flagged floor and with a brick foundation. He is writing at a steeply sloping board placed on a round table; the text he is copying or translating is displayed on a lectern behind his writing board. David Aubert is wrapped up against the cold with a thick red shawl, and wears a green hat draped around his ears and extending down to his chest. Fortunately this unappealing headgear is removed when he comes out of his workshop to present the book to his patron, Philip the Good, Duke of Burgundy (1396–1467), and David Aubert's red robes, which look almost like velvet, are enhanced by the long ultramarine blue scarf.

It is the writing, Bâtarde, that is so magnificent in this book; it is the highest grade of this group of scripts. There is a majesty and rhythm to the writing, and care has been taken over constructing the letters; they have not been dashed off in a hurry. The letter o-shape is a pointed oval, which gives a narrowness to the other letters. The letter **d** echoes this, and the round back to it often extends far to the left, even over preceding letters. There is also a very fine hairline stroke on the back of this stroke, made with the left-hand corner of the pen, creating a little u-shaped loop. The letter **g** is generally two-horned, as on lines two and four in the second column; it has a magnificent tail swooshing to the left and then slightly downwards, extending under other letters. The long **s** and **f** have the typical thickening of stroke, with pressure on the nib to make it splay; the pen is then turned anti-clockwise as the stroke extends beyond the lower guideline for x-height, creating the finest of tips. There is almost a corner on some of these long letters, where the top 'curve' has on occasion turned into a simple straight stroke: for example, in the letter **s** in **saulueur** at the beginning of the third line in the second column. The enlarged initial letter **L** extends into the border, which is painted and gilded. There are daisies, poppies and violets, with acanthus leaves hiding tiny birds and two chickens pecking away at foliage in the bottom right. David Aubert's father Jean was also a calligrapher, and the son was thought to have set up a workshop to co-ordinate the production of lavish books for the court.

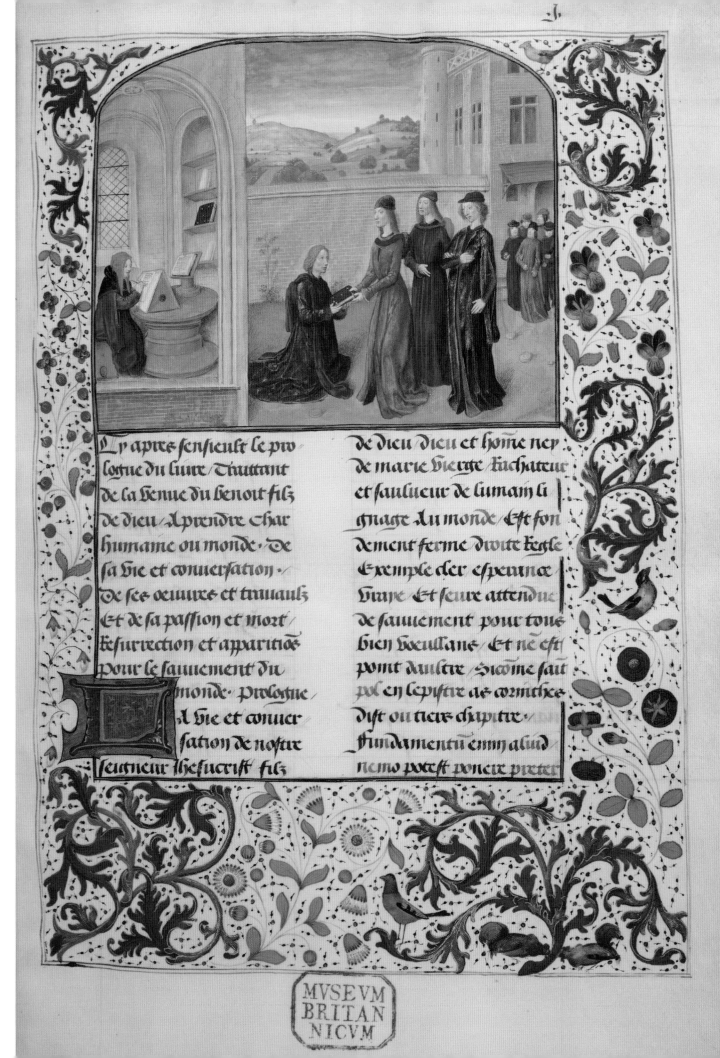

Cy apres senfieult le pro
logue du liure / Traittant
de la Genue du benoit filz
de dieu / Aprendre char
humaine ou monde · De
sa Gie et conuersation ·
De ses oeuures et trauaulz
Et de sa passion et mort /
Resurrection et apparitios
pour le sauuement du
monde · Prologue
A Gie et conuer
sation de nostre
seigneur Ihesucrist filz

de dieu dieu et home ney
de marie Gierge / luchateur
et saulueur de lumain li
gnaige Au monde · Est fon
dement ferme droite Regle
Exemple cler esperance
Giue Et seure attendue
de sauuement pour tous
bien Goeullans · Et ne est
point daultre / Sicome sait
pol en lepistre as corinthee
dist ou tiers chapitre ·
fundamentū enim aliud
nemo potest ponere preter

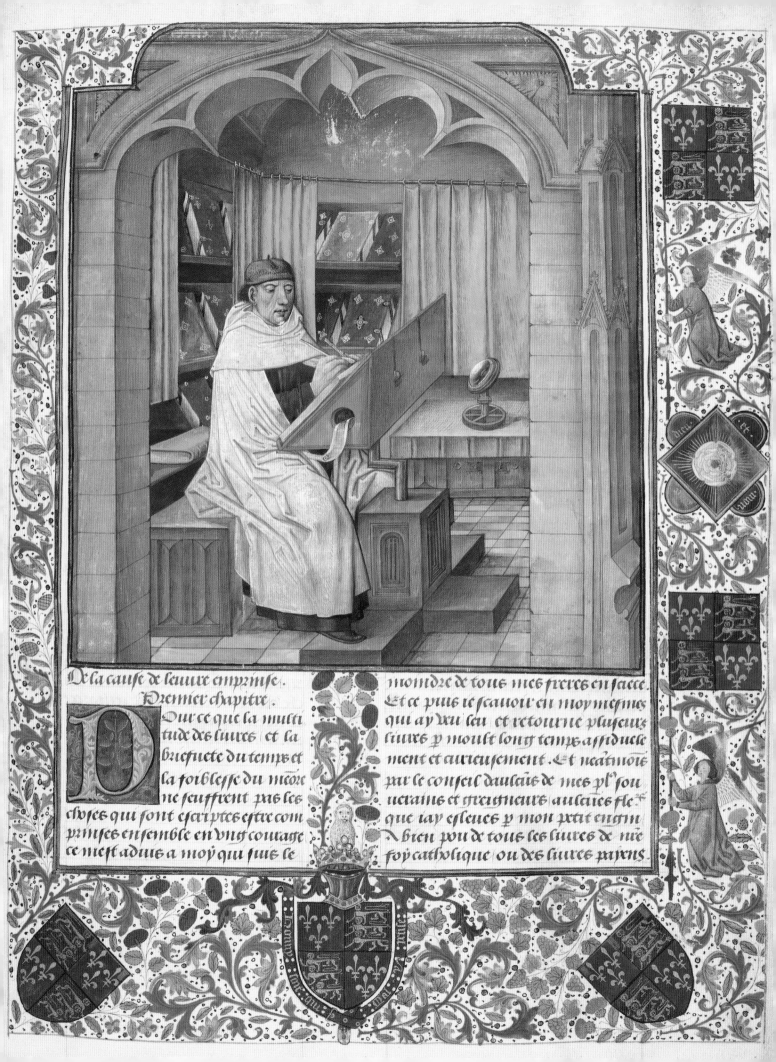

De la cause de seuure emprinse.
Premier chapitre.

Pour ce que la multi
tude des liures et la
briefuete du temps et
la foiblesse du memore
ne seuffrent pas les
choses qui sont escriptes estre com
prinses ensemble en vng courage
ce mest aduis a moy qui suis le

mondre de tous mes freres en sacce.
Et ce puis ie scauoir en moy mesmes
qui ay veu leu et retourne plusieurs
liures p moult long temps assiduele
ment et curieusement. Et neatmois
par le conseil daulcuns de mes plus sou
uerains et greigneurs aulsaiues fle
que iay esleues p mon petit engin
bien pou de tous les liures de ma
foy catholique ou des liures prins

45
Speculum Historiale by Vincent de Beauvais

Bruges, Netherlands, 1478–80
Royal 14 E.i, vol. 1, f. 3r

The scribe sitting at his desk dominates this page; he is a Dominican monk, as is shown by his black and white garb. His heavy wooden sloping desk is one of the most precarious in any manuscript, balanced as it is on angled tubing that allows the board to protrude into the scribe's lap for ease of writing. The wooden flat cross on which it is based would, though, make it very sturdy and also keep the scribe's feet from the chilly stone floor.

With his quill in his right hand and quill knife in his left, Vincent de Beauvais is shown in his study. Large volumes, similar to the one in which he is depicted, are arranged on sloping bookshelves and protected by vivid green curtains. The script is a lively, high-grade Gothic Cursive with the typical thickening to the strokes on letters **f** and the long **s**. The two-horned **g** is also in evidence. The style may be considered to be a little lightweight here, with the large initial, huge miniature, and detailed border, but it works well on other pages in the book. The two columns of text are separated by red roses and leaves, an acanthus scroll and a rather glum animal, perhaps a sheep. The red roses here contrast with

the Yorkist badge, the *rose-en-soleil* – a white rose set on the sun's rays, here painted on a lozenge with a red and blue background. The white rose is positioned between two angels holding the English coat of arms on banners.

The shield of King Edward IV (1442–1483), who brought a number of books such as this one from France, is shown in the centre of the lower border. It is surmounted by a helmet with a gold collar and a gold crown, and surrounded by the ribbon of the Order of the Garter, the highest order of chivalry in Britain, founded in 1348. Flanking his shield amidst a border of more red roses and blue and gold acanthus leaves are the shields of Edward's sons: Edward (1470–c. 1483), who became Edward V of England, and Richard (1473–c. 1483), the ill-fated Princes in the Tower.[40] Their shields are tilted for design and are shown with their white labels. For the sake of symmetry the shield on the left has been reversed; the gold fleurs-de-lis of France should be depicted in the most important first and fourth quarters on a shield, not the second and third as on the left, and the lions are looking to the right.

P·VIRGILII MARO
NIS GEORGICON
LIBER·I·
AD MECAENATEM·
VID FAC
AT LAE
TAS SE
GETES,

QVO SIDERE TERRÀ

Vertere mecænas: ulmisq, adiungere uites
Conueniat: quæ cura boum: qvis cultus habendo

46
The King's *Virgil* – Bartolomeo Sanvito

Rome, Italy, between 1483 and 1485
BL Kings 24, f. 17r

The Paduan scribe Bartolomeo Sanvito not only had a very characteristic way of writing Roman Capitals, or Square Capitals, but his colour scheme was also distinctive. He had mastery of the form, but with a decided backward slant to the diagonal letters such as **V** and **M** (the letter **M** is formed of a **V** with two supporting strokes) on the first line, and **A** on the fourth line. Letters **R** are also usually written with a very large bowl but the most exquisite tail, and have a wonderful movement. These majestical letters were written in shell gold that alternates with colours: blue in the first line, red in the second, followed by green and lastly purple, with the sequence then repeated. Writing in shell gold is always a challenge because the heavier metal pigments fall to the tip of the nib, leaving only the medium; the pen thus has to be charged frequently, which interrupts the rhythm. To achieve letters that are consistently as densely gold as these, and yet with fine serifs, requires the hand of a true expert.

The body of the text is written in Sanvito's Humanistic Minuscule. However, rather than being upright the letters here slope slightly forwards, and they are based on an oval letter **o** rather than a round one. The scribe also has a characteristic letter **d**, which emulates that of Eadui Basan. The bowls of the letters **d** and **q** in minuscules are written as complete letter **o**s and the downstroke is then added, as can be seen in the top line of the text block, particularly with the letter **q** in **ulmisq**; this gives a slightly different look to the top stroke of the bowl where it meets the upright. Usually this shape is flat or even moves upwards, but when a full letter **o** is written first this stroke goes clearly downwards. There is also a form of 'sideways' fishtail serif to the top of the ascenders, constructed by a slight curve to the right and down and then lifting the pen, repositioning it a little higher, and making the downstroke. The enlarged coloured initial letter **Q** is being carried by one satyr, with another sitting inside the letter itself. The satyr on the right has a sling round his body to support the tail, which has been cut to ensure that it fits into the rectangle. The decoration is typical of the Renaissance style, with borders of decorated urns, garlands and foliage, here consisting of wheat sheaves. The purple shading, which throws the decorative borders forwards, consists clearly of many tiny strokes that would have taken a considerable time. The delightful miniature shows two oxen ploughing a field with a small village behind, the image representing spring. This manuscript of the works of the Latin author Virgil was made for Ludovico Agnelli, bishop of Cosenza from 1497 to 1499; he was also apostolic protonotary.

consuetudo carnalis. Respice et exaudi me domine deus meus. Re
spice refert ad id quod dictum est. Vsq; quo auertis faciem tuam a me
Exaudi refertur ad id quod dictum est. Vsq; quo obliuisceris me in
finem. Illumina oculos meos ne unq; obdormiam in morte. Oculos
cordis oportet intelligi. ne delectabili defectu peccati claudantur Ne
quando dicat inimicus meus preualui aduersus eum. Diaboli insul
tatio metuenda est. Qui tribulant me exultabunt si motus fuero. Di
abolus et angeli eius qui non exultarunt de iusto uiro Iob cum eum
tribularent. Quia non est motus. idest de stabilitate fidei non recessit
Ego autem in tua misericordia speraui Quia id ipsum qd non mouetur
homo. et fixus in domino permanet. non sibi debet tribuere. ne cum
se gloriatur non esse motum ipsa superbia moueatur. Exultabit cor
meum in salutari tuo. In christo in sapientia dei. Cantabo domino qui
bona tribuit mihi. bona spiritualia. non ad humanum diem pertine
tia. Et Psallam nomini domini altissimi. Idest cum gaudio gratias ago
Et ordinatissime utor corpore. qui e cantus animæ spiritalis. Si au
aliqua hic differentia consideranda est. Cantabo corde. Psallo operib;
domino quod solus uidet Nomini autem domini qd apud homines
innotescit. quod non illi sed nobis est utile: A M E N

EXPLICIT·DE·PSALMO·XII·
INCIPIT·DE·PSALMO·XIII·
IN FINEM·PSALMVS·DAVID·

VID SIT IN FINEM
non est saepius repetendum. Finis legis christus ad iu
stitiam omni credenti apostolus dicat· Illi credimus qua
do incipimus uiam bonam ingredi ipsum uidebimus
cum peruenerimus & ideo ipse finis.

EXPLICIT·TITVLVS·INCP·
DE·PSAL MO·XIII·

IXIT INPRVDENS
in corde suo non est deus. Nec enim ipsi sacrilegi
et detestandi quidam philosophi qui peruersa et fal
sa de deo sentiunt. ausi sunt dicere. Non est deus.
Ideo ergo dixit in corde suo. quia nemo hoc audet
dicere. etiamsi ausus fuerit cogitare. Corrupti sut
et abbominabiles facti sunt in affectionibus suis Idest. dum amant
hoc seculum. et non amant deum. ipsę sunt affectiones quę corrum
punt animam. et sic excecant. ut possit etiam dicere Imprudens in
corde suo non est deus. sicut enim non probauerunt deum habere in

47
A Psalter for the King of Naples

Naples, Italy, 1478
BL Add. 14779, f. 36v

The colophon and coat of arms of Ferdinand of Aragon (1423–1494), King of Naples, identify him as the owner of this book. It is a grand book, written in a grand script, which is entirely appropriate. The manuscript was written for the king by the Italian scribe Rodolfo Brancalupo (*fl.* 1480), and it shows the majestic form of Humanistic Minuscule (*Littera Antiqua, Lettera Antiqua, Littera Humanistica Textualis*); this was the text script used by Poggio Bracciolini in 1402–3 and adapted from Caroline Minuscule, the writing style at the time of Charlemagne in the ninth century. The letter-forms are based on a round letter **o** and related letters take their form from this, such as the letters **c**, **e**, **g**, **p**, **b** and **q**. The width of letters is also governed by that round **o** – it is not a narrow, cramped style. One difference between Carolingian letter-forms and those of the Humanists is that fine horizontal serifs were written at the bases of the feet of the downstrokes in the fifteenth century, whereas in the ninth century they were simple pen-lifts that created a curve.

The scribe has achieved a considerable feat in this book: without any letters apparently varying in width, or words squashed or expanded, the text is justified, with right and left margins virtually straight. This is extremely difficult to do while still making the script overall as regular and even as this. The hair sides and flesh sides of the vellum used for this book are very easy to identify, with the illumination being far more successful on the smoother flesh side and the writing being more precise on the hair side, which has more 'tooth'. On this page the hair follicles are clearly visible, indication that it is the hair side.

Humanistic Minuscule is an eminently readable style, and it is easy to see why the script would have inspired type designers of the time who modified it for print. They copied the two-storey letter **a** and the looped **g**, which few write in their normal handwriting but all recognise and read without problem because it is used in typefaces. Although the lettering is fairly dense on the page, colour helps with clarity, and the endings of sections are indicated by deep red *explicits* ('this is the end') in large Roman Square Capitals; the blue *incipits* ('this is the beginning') are also in Square Capitals. Enlarged initial letters and the column of decoration include *bianchi girari*, or white vine-scroll ornament, developed by the Humanists initially in fifteenth-century Florence, but soon spreading throughout Europe. Similar to the adoption of a lettering style that was thought to be classical, but was in fact of ninth-century date, the Humanists considered white-vine ornament to be antique, when actually the source of their inspiration was twelfth-century manuscripts from Italy.

48
Herbal of Apuleius Platonicus

Italy, *c.* 1483
BL Add. 21115, f. 23v

Herbals had been known in India and China for centuries before they became popular in Western Europe, and according to Pliny the first Greek herbal manual dates to the first century BCE. Perhaps the most famous herbal was the *Pseudo-Apuleius Herbarius*, or *Herbarium Apuleii Platonici*, compiled by the fourth-century CE Pseudo-Apuleius, while a sixth-century CE *Herbarium* (Leiden Voss Q 9) is the oldest surviving manuscript copy of his book. It became the most influential herbal in Europe, and this manuscript is a fifteenth-century copy. Herbals helped to identify plants so they could be used for medicines and remedies, and so may include illustrations as on the page opposite for Gentiana. Gentiana was used in mediæval times for digestive problems, and it was also included in a salve used if a man's hair fell out. Its bitterness stimulated the gastric juices and even now it is used in Angostura bitters to prepare the stomach before a meal.

Italic (Humanistic Cursive Book Script, or *Littera Humanistica Cursiva Libraria Media/Formata*) was invented by Niccolò Niccoli (1364–1437) in about 1420. The rather spikey pointed script is an idiosyncratic take on its more usual curved forms. Although a book script, where perhaps a degree of formality could be expected, this is essentially a working document and there are indications of speed in the writing. It features none of the many pen-lifts to write a single letter or manipulation of the nib to achieve certain stroke shapes evident in some previous styles, such as Roman Uncial or Gothic Textura, while the way in which strokes join one letter to the next throughout the manuscript also suggests a rapid pen movement. There are also no extraneous flourishes or decorations to the letter-forms. All is most efficiently done and there is a delicacy and lightness of touch to the writing which is small, sharp and exquisite. Space has been left for the coloured illustration of the plant, which is competently done but without a great amount of detail, as would be expected in a working manual. Initial letters on the left vary from a narrow Roman form (letters **A**) to a Half-Uncial (letters **H**); a defined and deliberate space has been left between these letters and the following text, not unusual at this time. As with other scripts, both the long **s** and the short **s** appear, the latter usually being confined to the ends of words.

A lij Torminalefin. Alij Tefticulum leporis.

N afcitur in montiu radicibus locis folidis et
piatis & cultis & maritimis.

A d vlcera difficilia & cicatrices.

h erbe Priapifci radices tundes & impones cica-
trices claudet.

A d Lippitudinem oculorum.

h erbe Priapifci fuco munges lippitudines & do-
lores tollet fine mora.

S iquis mulierem non poterit affectare.

h erbe Priapifci radicem i. tefticulum dextrum
qa maior eft, teris cum piperis albi granis xlvij.
& mellis uncijs tribus in uino optimo medicam
folius triduo fumis. Legis eam menfe Julio.

h erba Gentiana.

A gcis dr Gentiana

A lij Allongallicu
A lij Narcech promo
A lij Dardana
A lij Aloitos
J tali Gentianam
A lij Comicialem

N afcitur gemellis montibus hec herba ad oia
Antidota facit tactu molli guftu amaro fca-
po folido.

A d ferpentium morfus.

h erbe Gentiane radix ficca & in puluerem re-

49
The Sforza Hours

Italy, *c.* 1490, and The Netherlands, 1517–20
BL Add. 34294, f. 334r

Many manuscripts have a story, but that of the Sforza Hours includes a cloak (though not a dagger), stolen money, a secret meeting, a priest, an anonymous seller, a wicked friar, a huge valuation, an Italian noblewoman and two of the best artists of their time. The cloak was worn by Sir John Robinson of the Victoria and Albert Museum in London when he was in Madrid in 1871 looking for works of art. He had heard about 'a wonderful illuminated manuscript'[41] book, arranged to meet the priest who was selling it and tucked the peseta equivalent of £800 (worth £66,000 now) into his brown cloak. The money was stolen, but after a night-time meeting the book was secured, although Sir John never knew the name of the person selling it. However, some 350 years earlier, while it was being made in Milan by Giovan Pietro Birago (*fl.* 1470–1513) for Bona Sforza, Duchess of Milan (1449–1503), a disaster happened. Birago wrote to a sponsor and explained that Fra Johanne Jacopo, a friar from San Marco in Milan, had stolen part of the book. He went on to explain that 'The part which your excellency has is worth more than 500 ducats. The other part is with the illustrious Duchess…'.[42] This estimated value of only part of the book is astonishing, as Leonardo da Vinci's valuation of his *Virgin of the Rocks* in 1504–6 was 'only' 100 ducats.

The story of this manuscript does not end there as, after her death, Bona left the book to her nephew, Duke Phillibert II of Savoy (1480–1504); following his death, just one year after his aunt's, his widow, Margaret of Austria (1480–1530), took ownership. She moved to the Netherlands in 1506, and a little over ten years later paid the scribe Etienne de Lale to replace the text. The court painter Gerard Horenbout (*c.* 1465–*c.* 1541) '…made sixteen beautiful miniatures well illuminated to match the rich hours on parchment … for writing some leaves of those hours … for having made two text illustrations'.[43]

Birago's and Horenbout's styles are quite different, but both are superb. Birago uses rich blues, reds and gold to create a detailed Renaissance border with urns, foliage and suspended massive pearls or metal balls. An angel plays music in the top border and three angels sing in the lower border, appropriately for this Psalm: *Cantate d(omi)no canticum novum* ('Sing to the Lord a new song'). Birago's figures are notable for their high cheek bones, straight noses and very curly hair. Pages with illumination as 'busy' as this need a strong script if the text is not to be completely swamped. Prescissus endings to the strokes, and the Rotunda form used in Italy and southern Spain at this time, both enhance the delightful illuminations. The slight angularity of the letter **o** creates a lemon-shape counter (internal white space), which is reflected in related letters such as the **e**, **c**, **d** and **p**.

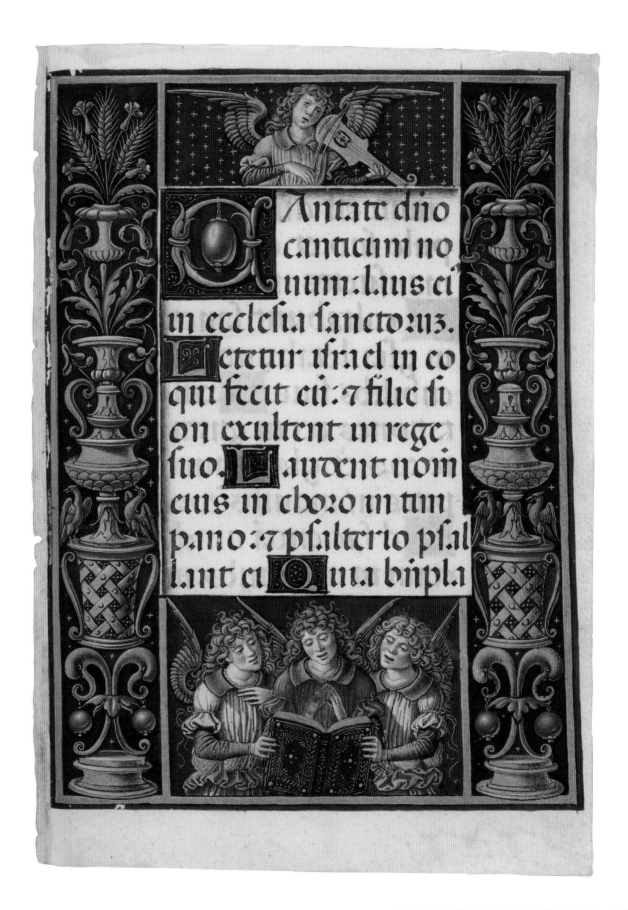

Antate dño
canticum no
uum: laus ci
in ecclesia sanctorum.
Ietetur israel in co
qui fecit eu: 7 filie si
on exultent in rege
suo. Laudent nom
cius in choro in tim
pano: 7 psalterio psal
lant ei Quia biipla

PANDVLPHI
COLLENVCII PISAVRENSIS
APOLOGVS:
CVI TITVLVS
AGENORIA

NER
tiam natu in
ter filias mi
norem, fatuã
alioquin atqʒ
inftrenuam

fœminam, Sed cui blanda ʃpecies atqʒ al
lectrix effet. Labori, commuuí gentium
Deo, Orcus pater vxorem dedit. In=
gentes (ut eft locuples deus) dotis nomi
ne diuitias pollicens, ʃi ex ea liberos gi

AE
TERN
VM VIR
TVS

SI
BENE FA
CTA MA
NEN?

50
Apologues and *Dialogues*

Rome or Florence, *c.* 1509–47
Royal 12 C.viii, f. 4r

Geoffrey Chambers (*fl.* 1517–21) was a Gentleman Usher of the Chamber and Surveyor-General at the court of King Henry VIII; he was also a friend for many years of King Henry's 'fixer', Thomas Cromwell. Geoffrey Chambers commissioned this book, to be presented to the king, from the scribe Ludovico degli Arrighi (1475–1527), possibly around 1510 when Arrighi was a bookseller in Rome. (Arrighi also produced the first writing book, *La Operina*, showing the Italic style of writing, also called Chancery Script). On the first page is a dedication from Geoffrey Chambers to King Henry VIII written in shell gold Roman Square Capitals on an ultramarine blue panel within a gold border: *Henrico octavo Britannicæ Galliæque regi invictissimo Gaufredus Chamber S. P.*

The illumination in this manuscript is by the renowned Italian miniature painter and illuminator Attavante degli Attavanti (1452–1525). It is a tour-de-force and resembles embroidered cloth of gold. The background to this elaborate border is shell gold that has been polished to a shine, with Renaissance-style naturalistic figures, one balancing a vessel on his head, the others supporting a structure; luxuriant foliage sprouts from both. The Tudor rose, a five-petalled red rose with a white rose inside, is the emblem representing the combining of the York and Lancaster factions after the Wars of the Roses. The dual-coloured flower united the red rose device of Henry's father, Henry VII, a Lancastrian, with the white rose of his mother Elizabeth, a Yorkist. Henry VIII's coat of arms is shown in the base border within a roundel, held by two angels clothed in red. Surrounded by the Order of the Garter, the Royal Arms display in the first and fourth quarters – the most important in heraldry – the fleur-de-lis of France, indicating the English claim to the French throne (the fleur-de-lis, and thus the claim, continued to be shown in the Royal Arms until 1801). The shield is supported by the red Welsh Tudor dragon and a white greyhound; the latter was associated with the Honour of Richmond and was used by Henry Tudor as well as John of Gaunt, from whom he was descended.

Arrighi's Italic lettering is exquisite. The springing arches to his letter-forms are regular and even, with supreme rhythm and flow. The letter **L** just below halfway on the page is particularly well-formed. Interestingly, the ink being used was rather thin, and it is possible to see where the scribe re-charged his nib. The ink gets paler in the word **cui** in the first full line under the enlarged initial letter, and problems of ink flow are apparent in **blanda**, with the first stroke of the letter **n** and the last of the letter **a** both rather blobby. Two lines down, the letters **orem** are quite pale and **dedit** is darker, particularly the letters **de**. And in the last line the first four letters of the word **pollicens** are pale, with the remaining ones much darker and less sharp due to excess ink.

mis, & ab his qui oderunt me : quoniam
confortati sunt super me.

Preuenerunt me in die afflictionis mee :
& factus est dominus protector meus.

Et eduxit me in latitudinem : saluum
me fecit quoniam voluit me.

Et retribuet mihi dominus secundū
iusticiam meam : & secundum puritate
manuum mearum retribuet mihi.

Quia custodiui vias domini : nec impie
gessi a Deo meo.

Quoniam omnia iudicia eius in con-
spectu meo : & iusticias eius non repuli
a me. Et ero immaculatus cum eo :
& obseruabo me ab iniquitate mea.

Et retribuet mihi dominus secundū
iusticiam meā & secundum puritate

51
The Psalter of Henry VIII

England, 1540
Royal 2 A.xvi, f. 19r

The lettering in this book is so even and regular that it looks almost like type. The scribe and poet Jean Mallard wrote a majestical French Humanistic Minuscule that is entirely appropriate, as this was Henry VIII's own copy of the Psalms. Henry himself annotated the book, marking out passages by highlighting with vertical lines and text, as can be seen in three places on the right of this manuscript page. It is thought the king studied this book, a view reinforced by an almost full-page miniature at the beginning of the Psalms showing Henry reading a book (perhaps this one?) and no doubt pondering the word of God 'day and night', as it says in the Psalms.

On the right of the text beginning the first Psalm ('Blessed is the man who walketh not in the counsel of the ungodly…') there is a hand-written note by Henry in Latin: 'note who is blessed'. Verses begin with an enlarged coloured or shell gold Versal initial encased within a shell gold or coloured rectangle; letter colours and their backgrounds seem to be in a random order with no particular pattern. Fine lines decorate these rectangles. The letters have the Humanistic Minuscule style of serifs with distinctive horizontal feet to letters where appropriate and more subtle serifs to the tops of the ascenders.

Mallard has some very characteristic letter-forms. First, the letter **a** is written with a very small bowl, which in places is almost detached from the downstroke, as in **ab** near the beginning of the first line and **factus** at the beginning of the fourth. Rather than writing a single curved-and-then-down stroke to complete this letter, the scribe makes the top curve almost as a serif, lifts the pen, and then makes the downstroke. This creates a tiny 'ear', and is shown particularly well in the letters **a** in **factus** (line four) and **manuum** at the beginning of line nine. The letter **t** is written as expected, apart from a very short crossbar; this occurs throughout the manuscript page shown, but particularly in **confortati sunt** on the second line. The letters **d**, **p** and **q** have all been written as a complete letter **o** followed by a downstroke, similar to the letter **d** written by Eadui Basan in the eleventh century and the Renaissance scribe Bartolomeo Sanvito. This is clear in the **d** in **secundum** on the last line, the **p** in **super** on line two and the two **q**s in the top line. The letter **g** also has a rather awkward lower bowl, stretching as it does far to the right underneath the next letter. However the ampersand is wonderfully lively.

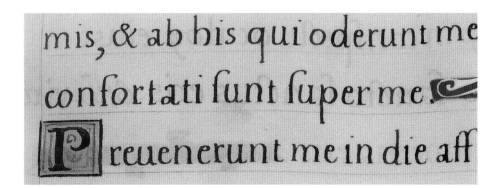

52
The Golf Book

Bruges, Netherlands, *c.* 1540
Add. 24098, f. 13r

In a number of manuscript books the paintings in the borders and margins are often as fascinating as the main part of the page. This is one such book. Although it is not complete, there are folios of wonderful miniature paintings thought to be by the Flemish artist Simon Being (1483–1561) and his studio. The family was clearly gifted: Simon Bening's father Alexander (d. 1519) was an illuminator and two of Simon's daughters were artists; one of them, Levina Teerlinc (*c.* 1510–20 to 1576), specialised in miniatures and became royal painter to Henry VIII.

The Golf Book is a Book of Hours, the bestsellers of their time. They enabled lay people to follow the services for the seven canonical hours or offices of the day in their own homes. The canonical hours were based on Psalm 119, v. 164: 'Seven times a day I praise you for your righteous laws.' The 'hours' consisted of matins (during the night, sometimes at midnight), prime (first hour of the day, that is, 6 in the morning), tierce/terce (third hour of the day, 9 o'clock), sext (sixth hour of the day, 12 o'clock), nones (ninth hour of the day, 3 o'clock), vespers (about 6 o'clock in the evening or when it got dark) and compline (about 9 o'clock in the evening, before retiring to bed). The page on the right shows the beginning of nones (the service for 3 o'clock in the afternoon), and opposite it is a full-page painting of the crucifixion. The border is mainly shell gold and on the left consists of a series of vertical lines on a brown background. On the right an architectural edifice painted in gold has three paintings in *grisaille*. These paintings in one colour, here grey, resemble stone statues, showing two figures on plinths and the scene of a hanging. In the base are what appear to be medallions in gold, with *grisaille* paintings of two profiles and a miniature of Abraham about to kill his son Isaac with the ram in the background, its horns being caught in the bush.

The text starts with an enlarged letter **D** in gold on a blue background, painted with a shadow to look three-dimensional. The first five lines are in red and black ink, with horizontal red ink guidelines clearly visible. The main body of the text is in a type of Italian Rotunda, not executed to the same high standard as in the Sforza Hours (see page 162). Some endings are prescissus, or 'cut off', but more are flattish-curves, and the ink appears to be a little blobby. The appearance on the page, though, is very even and the letters are well spaced. This book is called the 'Golf Book' because on folio 27r, the calendar page for September, there are four men playing what looks like golf. Three are each holding a club and trying to hit a ball into a hole.

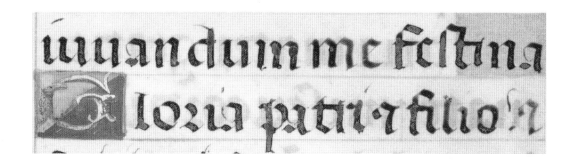

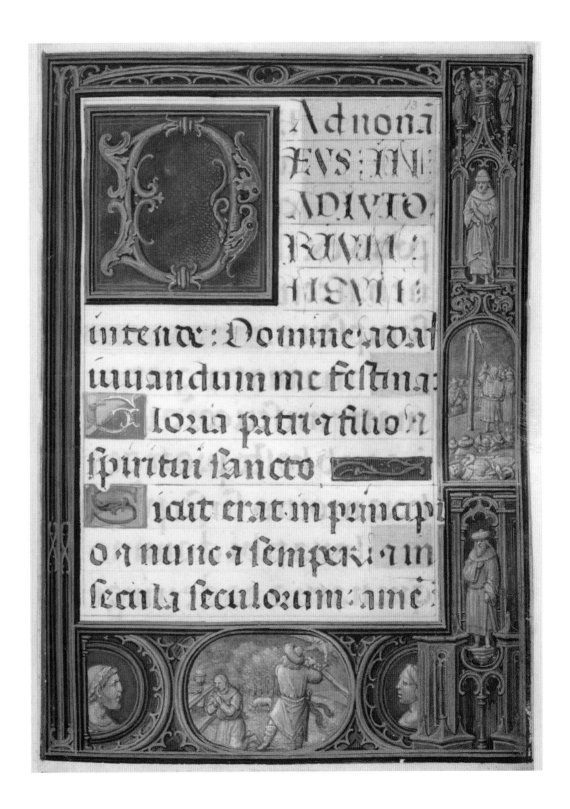

53
English Italic – Bartholomew Dodington

Cambridge(?), England, late sixteenth century
BL Lansdowne 63, No.84, f. 207r

This manuscript was written in England by Bartholomew Dodington (*c.* 1535–1595); the text is Latin, with a couple of lines of Greek just below halfway down the page. Dodington was born in Middlesex, near London, and studied classics at St John's College, Cambridge. He was Regius Professor of Greek at Cambridge from 1562 to 1585, and his scholarship was noted in the inscription on his tomb by William Camden in his guide to Westminster Abbey, published in 1600. Camden recorded that the stone inscription (translated from the Latin) praised Dodington as one who was 'nourished from boyhood on the finest arts … a man not only of excellent scholarship, but also of a most holy character, of singular integrity, and incomparable modesty'. Sadly his grave and its inscription are no longer marked in the abbey.

Dodington's lettering could be considered to be calligraphy rather than 'normal' handwriting because there is a beauty in his script that is rarely found today in normal correspondence. This is a measured Italic, with letters carefully formed, and so even and regular in appearance that it resembles type. Starting with an enlarged letter **C**, written with a little extra pressure towards the bottom of the curve to widen the stroke, other majuscule, or cap-

ital, letters have restrained flourished extensions to the strokes, for example the letters **H** and **D** on the second line. The letters are well proportioned with long ascenders and descenders; these occasionally clash between the lines, as in the tail of the **g** of **gravissimis** in line four and the **f** of **beneficiorum** in line five. Others are more successful: the shapes made by the tail of the **q** in **quam** in line five and the **b** in **oblata** in the following line are very neat. Note, though, that the tail of the **q** curves gently to the left in Dodington's writing, but is not confused with the letter **g** as may be expected; instead, the tail of the latter is made into a complete bowl and meets the rest of the letter. There are two forms of the letter **s**: the long one, which shows elegant curves to the top and bottom of the letter; and a short one, used almost invariably at the ends of words. Where there are two **s**'s, however, a long and a short one are employed with a beautiful ligature, as in **esset** in line six and **posse** towards the end of that line. As in most calligraphic pieces, the scribe seems a little tense at first, but then appears to have settled in to writing this. From line six onwards he occasionally adds a beautiful flourish to the base of the letter **e**, as in **pretermittere**, also on line six. The ampersand in line thirteen is particularly fine.

Cum benignitatis tuæ erga me ex quo me primum in patrocinium tuum recepisti
tanta magnitudo sit, Honoratißime Domine, ut eidem nullis officijs meis, nedum
exili hoc scribendi genere queam satisfacere: non committerem hoc tempore, ut tam leui
munere defungens, auribus tuis potius, quæ grauissimis reip. causis patere solent, conarer
obstrepere, quam tacita recordatione beneficiorum tuorum memoriam celebrarem;
nisi talis oblata eßet occasio, qualem prætermittere sine scelere uix poße uiderer. /
Detulit enim ad me iampridem scilicet patre, nuper autem benignissimo patrono orbatus,
filius fratris mei, se cum supplex tecum ageret de Locatione illarum ædium renouanda,
quas ei pater suus Westmonasterij reliquit, à te responsum quidem perliberale abstulisse,
sed tale duntaxat, ut cum me habitare in eisdem intelligeres, fontem beneficentiæ tuæ
mihi magis, quam illi aperueris. Reliquam etiam significationem summæ erga m̄
beneuolentiæ tuæ sermone subsequebatur: quam ego nullis meis meritis uel præteritis,
uel expectatis euocatam, grata animi memoria, & omni obseruantia, quoad uixero,
colam. Sepenumero etenim in aurem insusurrans uox illa Theognidis ualde hanc
labem uitandam eße monet: Δειλοὺς δ᾽ εὖ ἕρδοντι ματαιοτάτη χάρις ἐστίν· Ἴσον καὶ
σπείρειν πόντον ἁλὸς πολιῆς. Sed quæ eße omnino gratia poterit, quæ à me profecta
tantam assequi Dominationis tuæ bonitatem queat! aut quid denique gratuita bene-
ficentia tua præter se spectat! quæ in summo splendore quasi maioribus theatris pro=
posita, non usque eo se sustinet, quoad precibus (quod sero plerisqᷟ usuuenit) exorari poßit:
sed ipsa se mihi offert ultrò, et quodammodo ad petendum allicit. Quid igitur! oblatamne
conditionem tam benignè solus ipse uerecunda quadam recusatione amittam? At
dixerit aliquis fortasse: Μισῶ σοφιστὴν, ὅστις οὐχ αὑτῷ σοφός. Ego verò cum in hoc
ipso facile Prudentiæ tuæ probauero, mihi pietatis potius erga cognatum fratris filium,
quam proprij commodi ducendam eße rationem, tum illi uel soli delatum hoc quicquid
erit beneficij ut utrique commune a tua beneficentia profectum, non agnoscam solum,
sed profitebor etiam libenter. Quo nomine gratulor sane utrique nostrum: eße scilicet
et summa facultate qui poßit, & egregie propenso animo qui uelit, nostræ
seorsim solitudini ac inopiæ suis temporibus subuenire. Sed illa scilicet & fuit
iampridem, & deinceps erit semper gratulatio mea maior, quod communis patriæ hijs
difficillimis temporibus quasi in uigilia quadam consulari manes, eandemqᷟ in tanta
orbitate spe magna sustentas. Quæ ut quam diuturna sit magnopere omnibus est
expetendum, nobisqᷟ iuxta cum alijs uota indies facienda pro tua longa incolumitate, &
honoris amplificatione, proposui, ut pergas porro communi saluti sic operam nauare, ut
præteritorum prosperis progressibus, felices etiam futurorum exitus respondeant. /
Westmonasterij XII. Calend. Maij. 1 5 9 0.

Honori tuo deditißimus, ~
Bartholomæus Dodingtonus

54
A New Yeeres Guift – Esther Inglis

England, 1606–7
The Newberry Library, Chicago, Wing ZW 645. K29, p. 11

A most gloriously flourished letter **A** begins the text of this page by Esther Inglis (1571–1624). With flourishing, it is important that the letter-form is still obvious – the flourish should not distort the form – and there should also be a visual balance if multiple 'loops' are used. This skill of the writer is shown in the central portion of the flourish on the letter **A**: here a line almost describes a circle, and the strokes within that circle make the most evenly balanced smaller shapes. The Italic lettering that follows is well written, regular and even. There is a slight 'clubbed' thickening to the serifs at the tops of the ascenders and also to the tails of the descenders, the latter being very restrained, with the lower loops flattened to a very pleasing shape. The delicate flourish to the majuscule, or capital, letter **P** in the middle of the second line and the letter **A** in the last line do not detract from the enlarged, flourished initial letter **A** to the text. The words are easier to read once the long **s** and the **u** (instead of **v**) have been identified.

Inglis was also an author and a miniaturist, and there is a delicate, tomato-red flower with leaves above the lettering; the green pig-ment has deteriorated here, emphasising the challenges of this colour before artificial paint substitutes were available. This tiny book, only 8 by 10 cm (3 by 4 inches) in size, *A New Yeeres Guift*, is dedicated to 'The Right Honorable and Vertuous Lady the Lady Arskene of Dirltoun'. It is one of over 60 miniature books that Esther Inglis produced, some as small as 4 by 5 cm (1½ by 2 inches). Her skill as an embroideress is shown by the decorated covers of her books where she used seed pearls and gold and silver thread. Inglis was born in London or Dieppe, though the family moved to Scotland around either 1569 or 1574; her mother was also a calligrapher and her father a teacher of languages and scribal handwriting.[44] Both her parents were involved in her education, as she writes in one of her earliest manuscripts: 'Both parents having bidden me, a daughter has written, breaking the tedium of exile with her pen'.[45] Her father, and later her husband Bartholomew Kello, both wrote dedicatory verses for her. Kello even wrote in her books 'husband of the book's adorner', while Inglis herself often signed her books 'written and illuminated by me, Esther Inglis'.

XVI
REVELATIONS
OF
LOVE

Here beginneth the First Chapter.

THis is a Revelation of Love, that Jesus Christ our endless
Blisse made in XVI. Shewings: Of which,

The first is of his precious Crowning of Thorns, and therein was
conteined and specified the Blessed Trinity, with the Incarnation and
the uniting between God and Mans Soul, with manie fair Shewings
and Teachings of endless Wisdom and Love: In which all the Shew-
ings that follow be grounded and Joyned.

The second is, of the discolouring of his faire Face, in token-
ing of his dear Worthy Passion.

The third is, that our Lord God Almighty, all Wisdom

and

55
Revelations of Love

England, 1625
BL Stowe 42, f. 5r

Julian of Norwich (*c.* 1342–*c.* 1416) wrote or dictated the 'Revelations of Divine Love' after she recovered from a serious illness in May 1373. She was not expected to live and a priest had arrived to give her the last rites; he held a crucifix in front of her and at that point Julian saw sixteen visions of Christ, which became the inspiration for her writings. Julian wrote the 'Short Text' after this experience. The first book in the English language known to have been written by a woman, it had 25 chapters and was 11,000 words long. The longer version of her 'Revelations' explored the meanings of her visions and is 86 chapters and about 63,500 words long. It was probably written or dictated around 1393 as Julian wrote that it took her 'twenty yere saue thre monthys' ('twenty years save three months') for her fully to comprehend those first visions. She likened God to a mother:

> When (a child) is hurt or frightened it runs to its mother for help as fast as it can: and (God) wants us to do the same, like a humble child, saying, 'My kind Mother, my gracious Mother, my dearest Mother, take pity on me.'[46]

Julian was an anchoress [47] living in Conisford in Norwich, in a room attached to the church of St Julian. Her real name is not known, and she is called Julian because of her connection to this church. Julian was visited by many during her life and they appreciated her good advice. This manuscript page from a seventeenth-century copy emulates the format of some previous manuscripts. The heading is in Roman Square Capitals in a variety of sizes, with more than one pen-stroke being used to make the thicker strokes. Some letters are more successful than others: the smaller letters in the word **REVELATIONS** are quite well formed, for example, as is the first letter of **LOVE**, but the letter **O** has multiple strokes (see particularly the left-hand side of the stroke) making these parts of the letter much thicker than the widest strokes of the other letters on this line. The first diagonal stroke of the letter **V** has been made at slightly too shallow an angle, so that the letter looks as though it is falling backwards (unlike the more successful letter **V** in the second line). Spacing on this line is also interesting, with an unusually large gap between the **O** and the **V**. The sub-heading is in Humanistic Minuscule, and this is followed by the bouncing writing of the text that shows an ease, flow and rhythm with its pronounced, round-backed letters **d**. These are echoed by the widely curved descenders of the letter **g**. There is an occasional clashing of ascenders and descenders, such as in the middle of lines three and four, in **crowning** and **blessed**.

Specimens

Of the Running Hand, from the Performances of the best Masters,

By Geo. Bickham.

Aabbccddeefffgghhijkkllmnoppqrrrsfsttuvwxxyyzz.&

Prize exquisite Workmanship, and be carefully diligent.

It's a brave Thing to equalize Works excellently perform'd

Aaabbccddeefffgghhijkkllmnooppqqrrrsfsttttuvwwxxyyyzz.&

AABBCCDDEEFFGGHHIJKKLLMM

NNOOPPQQRRSSTTUVWWXXYYZZ.

As a legible and free Running hand is indispensibly Necessary in
all Manner of Business, I thought proper to introduce these Examples
for the Practise of Youth, and their more speedy Improvement

September 4th 1739. G.B.

56

The Universal Penman – George Bickham

London, 1741
BL 788.g.2, plate 3

Although printing did mean that there was far less demand for hand-written manuscripts, as printed books were considerably cheaper and easier to produce, fine writing did not stop after Gutenberg and the 1440s, as is shown by the richly decorated and beautiful books on the previous pages. However, the demand for bespoke books and manuscripts with gold and colour decreased, although the ideals of writing well did not. George Bickham, who was a supreme writer himself, was also a highly skilled engraver. Wooden printers' blocks had given way to copper plates, where a metal burin cut a line into the surface of the metal, to produce a much finer and more refined finish.

The impressive result is obvious on this page. The burin is held securely and then pushed into the surface of the copper, creating an effortless line. Although, as can be seen by the title and credit on this page from George Bickham's book *The Universal Penman*, it is possible to create the thicks and thins emulating a broad-edged nib, the natural movement is a smooth one. The angles of Italic and thickness of strokes created by the width of the pen nib, gave way to curved lines; here the width gradually increased and decreased as the burin is used to go over the thin line again

to swell the stroke. To reproduce this, a very flexible pen nib with a pointed tip is required, not one cut to a broad edge; this changed the cutting of quills and, later, in the 1830s, it influenced the shape of machine-made metal pen nibs. The surface on which the lettering was cut, a copper plate, also gave rise to the name of this writing style, Copperplate. It was based on Italic, with its narrow letter **o** form; this is reflected in the other letter-forms, and the script slants forwards.

Copperplate was the style adopted by the clerks of the British Empire, and schoolchildren would spend long hours in a school day practising their letters. Interestingly, although clerks were expected to have a 'good hand', the writing of the upper classes was often far less legible, and their letters not nearly so well formed. On this printed page George Bickham exhorts a legible running hand as being 'indispensibly Necessary in all Manner of Business', and so produced this engraving for the 'Practise of Youth, and their more speedy Improvement'. George Bickham's book *The Universal Penman* contains the collected works of 25 of the best writing masters in London. These were produced in parts over eight years, and were bound into books such as the one shown on the left.

57
An Address to Queen Victoria

England, 1887
The National Archives, PP 1/50/4 (3)

There can sometimes be too much of a good thing, and this address to Queen Victoria is a prime example of it. Starting with an enlarged, coloured and decorated letter **Q** with a very small, almost non-existent tail, this encloses a painting of the Royal Arms, with a rather daft-looking lion on the left. To the right of the page is a coloured floral scroll design. The drawn and painted decorated letters in the address are in three sizes and two main colours. The letters sit on a two-colour decorated background where a pale brown has been used to highlight the **V** of Victoria and the main parts of the words **GRACIOUS** and **MAJESTY** (although, for some reason, not the initial letters); but the initial letters in the top line are highlighted in reverse, creating two different shapes and sizes of blocks of colour. Above this is a patterned border, differing in colour scheme, pattern and effect from that which surrounds the address on the remaining three sides. Encasing it all is a red and gold line border, with a line and patterned gold border outside that. To the left is an elaborate, beautifully painted, wide border of foliage and fantastical flowers – although the effect is all rather overwhelming.

As expected, the beginning of the address starts on the top line, **MAY IT PLEASE YOUR MAJESTY**, but this is preceded by **WE**, which actually starts the text on the second line – a little confusing, perhaps. There were over one million signatories to this address, so it may be that the artist thought that in representing them all **WE** needed to be significant, but the result is rather bewildering. There is more two-colour decoration, with green behind the word **WE** and light brown under the rest of the top line and also highlighting both **WOMEN OF ENGLAND** and **JUBILEE YEAR**, which are also drawn, painted and coloured. The style of writing is an engrossing script, written with a broad-edged nib in black ink with phrases highlighted in red. The text is written between two parallel paler red lines, linking up to another red border with patterns in the corners. The lettering is not really strong enough to stand up to the riot of decoration and other lettering styles on this page. The margins are almost non-existent and the panel has been bound into a book where the turn-in, which can be seen here, has been decorated with four different types of gold line. However, this was very much the style of the time, and no doubt much admired. There is certainly skill and imagination in the painting and the drawn letters. The text emphasizes the evils of intemperance, which the Queen's son, the late Duke of Albany, underlined: 'Drink is the only terrible enemy which England has to fear.'

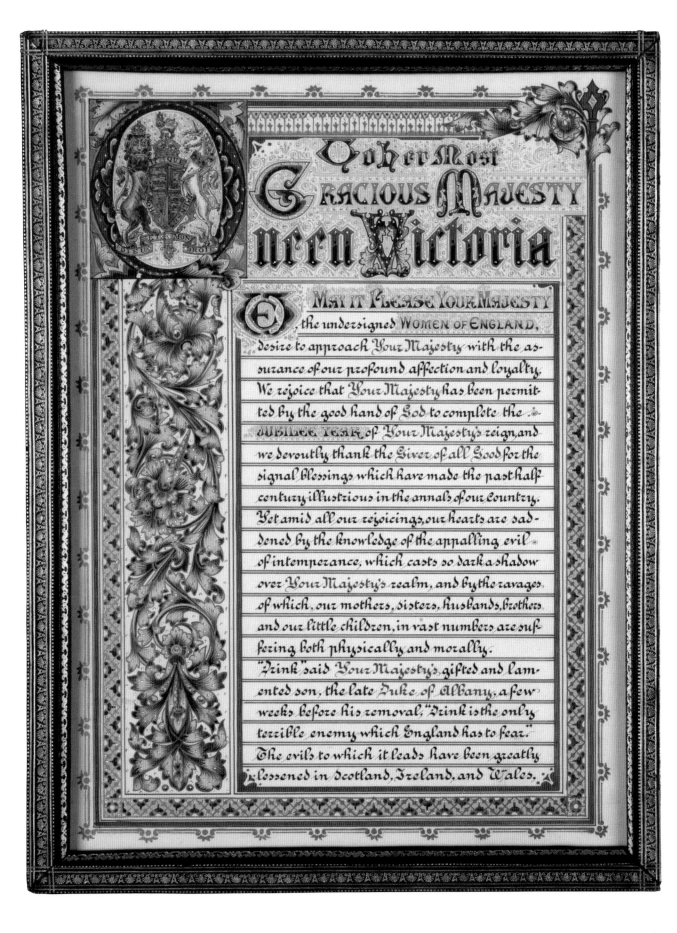

To Her Most Gracious Majesty Queen Victoria

O MAY IT PLEASE YOUR MAJESTY

the undersigned WOMEN OF ENGLAND, desire to approach Your Majesty with the assurance of our profound affection and loyalty. We rejoice that Your Majesty has been permitted by the good hand of God to complete the JUBILEE YEAR of Your Majesty's reign, and we devoutly thank the Giver of all Good for the signal blessings which have made the past half-century illustrious in the annals of our country. Yet amid all our rejoicings, our hearts are saddened by the knowledge of the appalling evil of intemperance, which casts so dark a shadow over Your Majesty's realm, and by the ravages of which, our mothers, sisters, husbands, brothers and our little children, in vast numbers are suffering both physically and morally.

"Drink" said Your Majesty's gifted and lamented son, the late Duke of Albany, a few weeks before his removal, "Drink is the only terrible enemy which England has to fear." The evils to which it leads have been greatly lessened in Scotland, Ireland, and Wales.

THE STORY OF HAWARD THE HALT

Chap: I Of the Icefirthers

HERE beginneth this story, and telleth of a man named Thorbiorn the son of Thiodrek, who dwelt in Icefirth at a house called Bathstead, and had the Priesthood over Icefirth; he was a man of great kin and a mighty chief, but the most unjust of men, neither was there any in Icefirth of might to avail to gainsay him: he would take the daughters of men or their kinswomen, and handfast them awhile, and then send them home again: from some he took their goods, and other some he drave away from their lands: he had taken a woman, Sigrid by name, young and high-born to be over his household; great wealth she had, which he would have on hand, and not put out to usury whiles she was with him

A man named Haward dwelt at the stead of Bluemire: he was of great kin, but come by now unto his latter days; in his earlier life he had been a great viking, and the best of champions; but in a certain fight he had gotten many sore hurts, and amongst them one

58
Icelandic Sagas: The Tale of Haward the Halt – William Morris

England, 1873–4
Fitzwilliam Museum, Cambridge, MS 270*, f. 133r

It takes most people many years of practice to achieve a good standard in calligraphy, and even more to perfect the skills and techniques of gold leaf illumination. This manuscript book was produced in 1873–4 during William Morris's five-year focus on calligraphy and illumination between 1870 and 1875, as noted by his biographer Fiona McCarthy,[48] during which time he worked on 18 manuscript books. The lettering, although not perfect, is quite remarkable. Initial letters are in a form of Gothic and the text in a rather spikey Italic, which was commented on by Graily Hewitt. The forward-sloping 'hooks' to the ascenders are not always successful; although they start well in the first line, it seems that Morris may have forgotten that this was the style and added them on after, as in the **h**'s of **mighty** (line five of the main text) and of **chief** a little further along the line. He may also have been having problems with ink flow or the texture of the paper: note the slightly blobby letters **e** and **a** of **stead** (fourth line from the bottom). The lower bowls of the letters **g** are not always very well formed towards the top of the page (**mighty** in line six), but by the last line they are written much more proficiently. Morris also uses two different forms of **g**: see **might** (line six) and **gainsay** (line seven).

However, none of this should detract from the sheer force and liveliness of the script and the wonderful, swooshing tails of the letters **y**. The large initial letter **H** is surrounded by subtle blue and green intertwining foliage and flowers and, typical of William Morris as a designer, it is particularly well balanced. The raised gold leaf on gesso is covered by a pattern of indented dots indicating that the gesso must have been exactly right: too brittle and the gesso underneath the gold would have cracked, too soft and the gold leaf would have fragmented. The Roman Capitals at the top of the page are alternately gold and silver, which is most impressive. Silver cannot be beaten as finely as gold, and so it is always more challenging to get it to adhere round a raised gesso surface. Morris wrote:

> I have always been a great admirer of the calligraphy of the Middle Ages ... As to the fifteenth-century books, I had noticed that they were always beautiful by force of the mere typography, even without the added ornament...[49]

The contrast between the complicated and rather overwhelming manuscript on the previous page and the simple beauty of Morris's work here is particularly striking. This manuscript is a good example of the way in which William Morris and the Arts and Crafts movement of the nineteenth century were looking not only at a revival of traditional craft but also to an improvement and purity in design.

59
The Scribe – Edward Johnston

England, 1929
Reproduced by kind permission of Elizabeth Bulkeley, daughter of Dorothy Mahoney,
for whom Edward Johnston wrote and dedicated this piece

Edward Johnston (1872–1944), known as the father of modern calligraphy, did much to influence the interest in and the study of manuscripts. His own fascination with historical letter-forms was kindled when he was taken to the British Museum (where the British Library was housed until 1997) by the curator and collector Sydney Cockerell (1867–1962) to study the lettering in manuscripts of the tenth century. Edward Johnston focused particularly on the Ramsey Psalter. That was the inspiration for the lettering style in this piece, which is in his own Foundational Hand. He devised a seven-point system for analysing the scripts: the angle the pen nib was held against the horizontal guidelines (here at about 30°); the height of the main body of the letters – the x-height – excluding the ascenders and descenders (here about four nib-widths); the shape of the letter **o,** which gives the shape and an indication of the width for the other letters (here round); the slant of the letters; the shape and construction of the serifs (here mainly 'beak' serifs), the sequence of strokes in constructing the letter-forms (usually to the left and downwards); and how quickly or slowly the letters are written. The script here would have been written at a normal pace for calligraphy because the pen-lifts create the separate strokes; there are few joining strokes, which indicate speed, but it would not have been as slow to write as the grand Gothic scripts such as

Textura and Prescissus. The title, in a compressed, angular Gothic style, is similar to Bâtarde, with a typical 'biting of bows'[50] in letters **b** and **e** of **Scribe**, which makes the line even shorter. The fact that it is narrower than the width of the poem allows for the blocks of small paler lettering either side of the title to fit in extremely well, rather than extending too far beyond the margins of the piece.

Johnston's calligraphy is always lively, as it is here, and there is a characteristic firmness and sureness of stroke. Initial letters are generally larger than the heights of the ascenders, which is typical for Gothic Textura, but not usual for the Foundational Hand; and where they are within the lines of the poem, as in the letter **I** in the line at the beginning of the second verse, and **E** in the fifth line of that verse, they do stand out a little. Both the round-backed **d** and the straight-backed **d** are used without, it seems, a particular pattern. The letters **y** and **w** do not appear in the Ramsey Psalter, so there is no exemplar, and though somewhat reluctant to comment on the Master's lettering, perhaps it could be said tentatively that they are not always successful. However, this is the piece that any student of Edward Johnston, or indeed anyone now, would be delighted to receive, as Dorothy Mahoney must have been.

The Scribe

By Walter de la Mare
From the English Association's
"Poems of To-day: second series"
Reprint of January 1924.
Transcribed for D. L. Bishop
by E. Johnston, Sept. 1929

The present Scribe introduced
the seven Larger Capitals in lines
9, 15, 21 & 26. And wrote the
Poem as two Verses; the Book not
indicating otherwise the breaking
it over the page between ll. 16 & 17.

What lovely things
Thy hand hath made:
The smooth-plumed bird
In its emerald shade,
The seed of the grass,
The speck of stone
Which the wayfaring ant
Stirs — and hastes on!

Though I should sit
By some tarn in thy hills,
Using its ink
As the spirit wills
To write of Earth's wonders,
Its live, willed things,
Flit would the ages
On soundless wings
Ere unto
My pen drew nigh:
Leviathan told,
And the honey-fly:
And still would remain
My wit to try —
My worn reeds broken,
The dark tarn dry,
All words forgotten —
Thou, Lord, and I.

The king of Egypt, living in Truth,
lord of both lands,
Nefer-kheperu-ra-ua-en-ra;
Son of the Sun, living in Truth,
Akhenaten, great in his duration;
And the great royal wife, his belov=
ed, lady of both lands
Nefer-neferu-Aten,
Nefert-iti, living and flourishing
forever eternally.

WRITTEN AND ILLUMINATED BY FLORENCE KINGSFORD IN EGYPT. FINISHED IN APRIL 1906

60
Hymn to Akhenaten – Florence Kate Kingsford

Written in Egypt, 1906
Fitzwilliam Museum, Cambridge, MS 8-1974, f. 6v

Florence Kate Kingsford (1872–1949) was one of Edward Johnston's first students. Her name was written in his hand as one of the class on a teaching sheet dated October 1899,[51] just a month after he started work at the Central School of Arts and Crafts. Interestingly, the same teaching sheet shows exactly this style of writing, which Edward Johnston described as 'A simple alphabet founded on various "half-uncial" [or "semi-uncial"] scripts useful for body of text, with Uncial Caps by holding pen perfectly <u>straight</u> … it can be made more "Roman" by <u>slanting</u> the pen'.[52] The pen is indeed held 'perfectly straight' in most of the letters by Florence Kate Kingsford; that is, at an angle of 0° to the horizontal guidelines, as can be seen by the fine line serifs at the tops of the letters, the base ends of strokes, and where serifs occur at the bottoms of the letters. The top serifs are small and wedge-shaped, and occasionally the pen slips to an angle of about 2–3° here, as it can be awkward holding the pen nib flat.

There is a power to these letters, and the selection of black ink for a very delicately illustrated piece might not always be the choice today. Although the lettering in black is very strong; somehow the page works as a whole: the sun beats down at the top, and the delicate painting of sailing boats on the River Nile, with a line of tiny figures driving animals along the river bank, beautifully reflected in the water, fills half the page. Kingsford has differed from Edward Johnston's suggestion of 'Uncial Caps' mainly, instead using Roman Capitals, apart from the Uncial letter **E** in the top line. There are delicate line fillers, similar to those used in Gothic manuscripts; these are in subtle colours sympathetic to the page, but are almost lost against the black text. The central circle of the sun on the top left-hand of the page is gold leaf on raised gesso, and the wiggling sun's rays beaming out are in shell gold; the difference between the two types of gold is particularly clear here.

Florence Kate Kingsford worked as an archæological artist for a time, travelling to Egypt in 1905 and 1906 (when this manuscript was completed) with the noted English Egyptologist Flinders Petrie (1853–1942) . She would have had first-hand experience of that fierce sun, and even in the dry heat of Egypt was able to get gold leaf to adhere – not always easy with very little humidity. Kingsford also handled paint in a most delicate way.

61

The Communion Service – Graily Hewitt
and partly illuminated by Allan Francis Vigers

BL Add. 40144, f. 2r

This looks very much like mediæval manuscript pages in books such as the Bedford Hours, but was in fact produced in the first part of the twentieth century by Graily Hewitt (1864–1952). He was one of Edward Johnston's first students and was clearly fascinated by mediæval illumination. Hewitt's studies and experiments with gesso (see page 47), the compound that creates a raised cushion on which tissue-thin layers of gold leaf sit, continued until his death. He wrote the 'Illumination' section in Edward Johnston's seminal book *Writing & Illuminating, & Lettering* (1906), and was a real master of his craft, achieving impressive results.

This page from the 'Communion Service' is typical of work produced by students of Johnston, and of Hewitt in particular, as it is based very much on those mediæval manuscripts. An enlarged initial Versal letter **O** in gold leaf encloses a painting of an angel that has perhaps more allusion to Edward Burne-Jones's style [53] than to any mediæval miniature; this figure was probably completed by Allan Francis Vigers. The figure is on a blue background with shell gold decoration, also not quite as sure as the hand of Hewitt. Enlarged Versal letters, again in leaf gold, fill the upper part of the left column. The serifs on the letter **F** and the way in which the tail curves round to the left, echoing the curve of the letter **O**, are particularly fine. Then follows a column of Uncial letters of gold leaf on gesso, which again follows the hierarchy of scripts – a mediæval tradition. An enlarged Versal **A** starts the second column of text with Uncials following. The remaining text is mainly in Johnston's Foundational Hand, with the rubrics [54] in red. As is clear from this manuscript, Graily Hewitt was able to lay gesso smoothly and cleanly, creating the finest of lines, to which gold leaf was applied and burnished with a polished stone to a mirror shine; this is extraordinarily difficult to do. He favoured parchment (sheepskin) rather than vellum (calfskin), and his lettering was not always entirely crisp as a result, although it does sound rather critical to point this out in such a wonderful page. The riot of decoration that surrounds the lettering is of white, pink and red roses with leaves, ripe and unripe blackberries, blue acanthus leaves and a smattering of raised gold dots, and fluid curving thin gold lines, which curl and bend, framing the text.

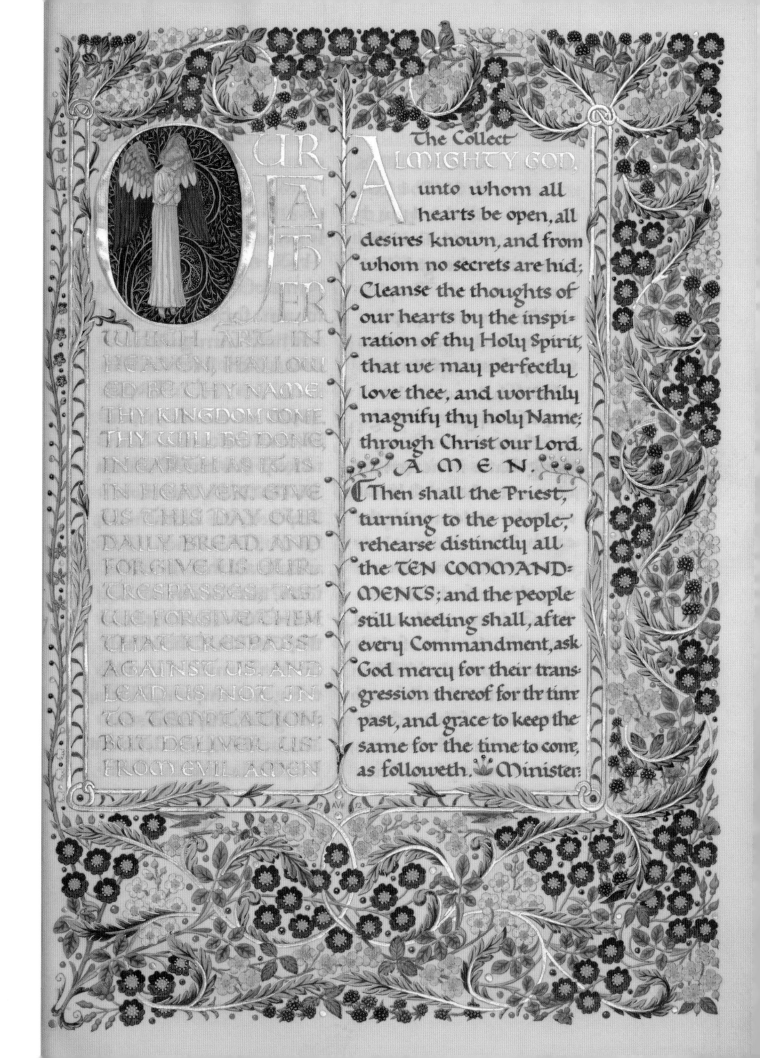

OUR FATHER

WHICH ART IN
HEAVEN, HALLOW
ED BE THY NAME.
THY KINGDOM COME,
THY WILL BE DONE,
IN EARTH AS IT IS
IN HEAVEN. GIVE
US THIS DAY OUR
DAILY BREAD. AND
FORGIVE US OUR
TRESPASSES, AS
WE FORGIVE THEM
THAT TRESPASS
AGAINST US. AND
LEAD US NOT IN
TO TEMPTATION;
BUT DELIVER US
FROM EVIL. AMEN

The Collect

ALMIGHTY GOD,
unto whom all
hearts be open, all
desires known, and from
whom no secrets are hid;
Cleanse the thoughts of
our hearts by the inspi-
ration of thy Holy Spirit,
that we may perfectly
love thee, and worthily
magnify thy holy Name;
through Christ our Lord.
A M E N.
Then shall the Priest,
turning to the people,
rehearse distinctly all
the TEN COMMAND=
MENTS; and the people
still kneeling shall, after
every Commandment, ask
God mercy for their trans-
gression thereof for tir tine
past, and grace to keep the
same for the time to come,
as followeth. Minister:

62

German black lettering – Rudolf Koch

Offenbach, Germany, 1921
Klingspor Museum, Offenbach

The delicate and often spikey lettering of William Morris may not seem obviously related to the heavy, dense lettering on the right. However, Rudolf Koch (1876–1934) was a great admirer of Morris and his approach to his work, including Morris's calligraphy. Koch was very patriotic, observing at a meeting in London: 'I feel such a closeness to him [William Morris] that I always have the feeling that he cannot be an Englishman, he must be a German.'[55] Koch was a contemporary of Edward Johnston and was similarly very interested in manuscript books, but he did not take the latter's approach of adapting letter-forms almost directly from historical scripts, but developed his own styles. He first trained as an engraver and an art teacher; this led him into designing book covers, mainly in the Art Nouveau style. However, in 1906 he started working for the Klingspor Type Foundry, then called the Rudhard Type Foundry, in Offenbach, Germany. He became fascinated by letters in all forms, and it is said that Koch considered the alphabet to be humanity's greatest achievement.

Many of the designs for his alphabets for typefaces were based on Gothic scripts, which were common in Germany at the time.

Following the dissolution of the Holy Roman Empire in 1806, the need to define the nation of Germany was paramount, and nationalists supported the Gothic style of type, such as Fraktur, rather than the Roman or Antiqua styles. Koch was in favour of these typefaces, and German books and newspapers were printed in this dense style, said by Adolf Reinecke to be 'a real reading script ... the words and images are clearer than Latin script ... German script does not cause nearsightedness and is healthier for the eyes than Latin script'.[56] The influence of Fraktur is reflected in this piece by Koch: the letters and the lines are placed closely together to create a dense block of text, giving an almost impenetrable feel to the page. In fact the spacing between the lines is so compressed that there are many instances where descenders extend into the words on the lower line, and vice versa for ascenders. It does not look instantly readable, yet there is clarity here. The enlarged initial letters with their irregularly shaped, multi-coloured backgrounds and the thickness of strokes (no fine Versal letters here) dominate at the beginnings of the text paragraphs, and the fact that they are perhaps unconventional becomes irrelevant as they suit the text so well.

Des andern Tages, der da folget nach dem
Rüsttage, kamen die Hohenpriester und Pharisäer
sämtlich zu Pilatus und sprachen: Herr, wir haben ge-
dacht, daß dieser Verführer sprach, da er noch lebte:
Ich will nach dreien Tagen auferstehen. Darum be-
fiehl, daß man das Grab verwahre bis an den drit-
ten Tag, auf daß nicht seine Jünger kommen und steh-
len ihn und sagen zum Volk: Er ist auferstanden von
den Toten; und werde der letzte Betrug ärger denn
der erste. Pilatus sprach zu ihnen: Da habt ihr die
Hüter; gehet hin und verwahret, wie ihr wisset. Sie
gingen hin und verwahreten das Grab mit Hütern
und versiegelten den Stein.

Als der Sabbat um war und der erste Tag
der Woche anbrach, kam Maria Magdalena und
die andere Maria das Grab zu besehen. Und siehe,
es geschah ein groß Erdbeben. Denn der Engel des

A know
that I if odour were
visible as color is, I'd see
the summer garden aureoled in
rainbow clouds, with such warfare of
hues as a painter might choose to
show his sunset sky or a forest aflame
while o'er the country-side the wide
clover-pastures and the bean-fields of June
would wear a mantle, thick as when
in late October, at the drooping
of the day arising the dark grey mist
blotteth out
the land with
ghostly
shroud

Now these
and such-like
influences of
tender specialty
must not —
so fine they be —
fall in neglect
and all their
loveliness be lost,
being
to the soul

deep springs of happiness,
and full of loving kindness
to the natural man.

63
Deep springs of happiness by Robert Bridges – Irene Wellington

Edinburgh, 1942
© The Irene Wellington Educational Trust. Crafts Study Centre,
University for the Creative Arts, Farnham, C. 84. 42 a

Irene Wellington (1904–1984) always considered that her best work was that done for friends, as then there were no restrictions on her imagination and she could include touches of humour, which she thought the recipient might appreciate.[57] This is one such piece. It was created for her close friend Charlotte Wellington, wife of Hubert; he became Irene's second husband after Charlotte's untimely death in 1942. Wellington first learned calligraphy at Maidstone School of Art, where she was taught by Arthur Sharp. In 1925, she won a scholarship to the Royal College of Art, where Edward Johnston was teaching for one day a week. Irene said of Johnston 'He was, of anyone I have ever met, the one to have the strongest influence on me, in both my life and my work. I learned from what he was'.[58] From 1927 Wellington became Johnston's assistant in his writing class, continuing as such until she moved to Edinburgh when she married her cousin in 1930. Wellington did not feel that she was a natural teacher as she found it exhausting and a strain; she preferred the personal approach rather than class teaching, and would spend a great deal of time trying to find exactly the best reference and materials for individual students. She did, though, have considerable influence on a number of people who went on to be excellent and inspirational scribes, including Ann Hechle (see page 196) and Donald Jackson (see page 206).

This delicate panel, written with a crowquill on unstretched vellum, is tiny at only 14 by 9 cm (5½ by 3½ inches). Most of the text, which is by Robert Bridges, is written in the form of a heart-shaped leaf for the violet flower, the latter being painted realistically. Apparently Wellington favoured pen-made illustrations to accompany calligraphy, so this is a departure from the norm for her. The script is in a bouncing, wide Italic with springing arches, and combines black ink with red, blue and green watercolours. The flourishes and extensions to letters around the edges of the leaf delineate its shape, particularly the wonderful lower bowl to the letter **g** in the word **drooping**; this neatly outlines the lower part of the leaf, and is echoed by the **s** and **g** of **arising** in the last line on the left. There are some delightful Wellington touches, such as the descender of the **f** in **flame** extending for four lines, with the top arch exploding into pen-made flames. It is intriguing to consider whether the words **June** and **mist** on the right were intended to be written outside the main shape or whether they were omissions. The block of text on the left anchors the whole piece and everything leads the eye to the title of the piece: 'deep springs of happiness'. The painted flower in delicate shades of blue, purple, pink and violet, neatly balances the block of text on the left.

64
Royal Air Force Book of Remembrance – Sheila Waters

England, 1959–65
© Sheila Waters

So many people lost their lives in the First and Second World Wars that a great deal of effort was made to ensure that their names were recorded and not forgotten. War memorials were erected in towns and villages with the names of the dead cast in bronze or cut in stone, and most churches and cathedrals made Books or Rolls of Honour in which the dead of the parish or locality were recorded calligraphically. The armed forces also instituted such books. In the Royal Air Force Church of St Clement Danes in the Strand, London, shrines of remembrance line the aisles with illuminated glass cases containing open books showing two long columns of names on each page; the pages are turned every day with a long bone 'sword'. The renowned calligrapher and promoter of Italic handwriting, Alfred Fairbank (1896–1982), organised the whole project, and a team of the best calligraphers worked mainly on one book each, the individual books taking about two years for all the names to be written.

The writing style is a Compressed English Caroline Minuscule, similar to the lettering style of Eadui Basan. However, the arches on letters such as **b**, **d**, **h**, **k**, **m**, **n** and **p**, and also in reverse on the letter **u**, spring high up on the downstroke and follow the writing in the Ramsey Psalter (see page 98), showing again the continued influence of Edward Johnston (see page 182). Sheila Waters was one of the scribes; she wrote the names beginning with **A** and **B** in black ink, and her writing appears on this manuscript page. Sheila Waters writes:

> I wrote a lot for the St Clement Danes Roll of Honour. It amounted to about 33,000 names over a period of six years, during which I had two children so it had to be fitted in with changing nappies and feeding babies! I found little short cuts, like making **m**'s in one stroke instead of three, which Alfred Fairbank, who supervised writing the books, didn't notice, and the project taught me how to write with precision and speed on vellum. I had to rewrite one section of sixteen pages because I had left out a name on the first page![59]

Waters's writing is remarkably crisp and even, and the vellum skin is clearly well prepared. When working on a major project such as this, time must be allowed for preparing the skin and for ruling the lines. Then when the ink has been allowed to dry, which usually takes at least 24 hours, the lines normally have to be erased, but in these books Alfred Fairbank wanted to emulate the mediæval tradition, so the lines have been left visible.

George Jones Armitage
Oliver Holden Armitage
Thomas Elliot Armour
Durban Victor Armstrong
Frederick Carr Armstrong
George Powell Armstrong
George Wheeler Armstrong
Hilliard Mark Armstrong
James Armstrong
John Armstrong
John Lewis Pasteur Armstrong
Percy Towns Armstrong
Ralph S. Armstrong
Sydney Armstrong
William Austin Armstrong
William James Armstrong
Douglas Arneil
Samuel Walter Arnheim
Charles Vernon Arnold
Harwood James Arnold
Herbert Edward Arnold
Joseph Victor Arnold
Peter Forrester Arnold
Arthur Alison McDonald Arnot
Harold Dwight Arnott
Leslie Arnott
Leonard Arrand
George Frederick John Arrowsmith
Richard Gordon Arrowsmith
Desmond Lucins Arthur

Henry Arthur
James Arthur
William Herbert Arthur
Philip Walter Rivers Arundel
Edward Dannett Asbury
Basil Drummond Ash
Maurice Grassam Ashby
Sydney Ashby
Charles Henry Boden Asher
Ronald Stuart Asher
Lionel Arthur Ashfield
Alfred Ashford
Nora Ashley
Cecil George Ashton
Frederick William Ashton
George Gilbert Ashton
Hardric Grey Ashton
Guy Arthur Jones Ashwin
Frank Ashwood
Frederick Edward Ashwood
Charles Ashworth
Roger William Ashworth
John Vincent Aspinall
Thomas Aspinall
Henry Norman Aston
Leonard Hugh Aston
Leonard Edward Atha
Francis Wright Atherton
William Atkin
Ceril James Edwin Atkins

TOWN HOUSE WROTHAM
KENT
1620 – 1975

Home of Nancy Stanfield since November 1975

THE TOWN FARM HOUSE, BARN AND YARD

The Orchard	Great Ranger	Chalk Pit
Barn Field	Little Ranger	Churchlane Field
Little Staples	Bitmans Field	Maiden Field
Great Staples	Coneybury Field	Pasture Field
White Hill	Elm Field	Plain Mead
Round Kings Hill	Churchfield	Little Field
Long Kings Hill	The Warren	Plain Field
Common Field	The Butts	

THE PRESENT STATE OF WROTHAM [1759]
The Town of Wrotham is situated close at the bottom of the chalk hill; in the midst of it stands the Market Place & the Public Well, both which ought to be repaired by the Lord of the Manor. It has a fair annually on the 4th. May for horses, cattle etc. & had formerly a market on a Tuesday, which has been disused for many years.
Extract from The History and Topographical Survey of the County of Kent by Edward Hasted of Canterbury M.DCC.LXXXII Volume II.

NORTH

Butts Hill

The Orchard

The Parsonage

Stone Garden · Lady Pembrokes Walk

Kitchen Garden

Courtlane
Robt. Wybarnt fe:te:an

Backside

TOWN HOUSE

The Square

Bull Lane

Remsing Lane

Backside

Mr. Brian free:

Mr. Hutch inson

Mary West

St. Marys Lane

Orchard

A detail of Parte of the Mannor of Wrotham in Kent Survayed in May 1620 by John Hine

Oak Cottage My Home

Mr. Vearete

Freely drawn from the original by Dorothy Mahoney May 1976

65
Map of the Town House – Dorothy Mahoney

Kent, 1976

Reproduced by kind permission of Elizabeth Bulkeley, daughter of Dorothy Mahoney

Dorothy Mahoney (1902–1984) was awarded a scholarship to the Royal College of Arts in 1924, and was a student of Edward Johnston from 1926 to 1928. She was so talented in lettering that, even while she was learning in his class, Mahoney became Johnston's student assistant. The following year she was appointed his Deputy Assistant, and she was often asked to teach, prepare lessons and make the orders for tools and materials, as Edward Johnston was unable to attend his classes due to ill-health on a number of occasions.

Dorothy Mahoney was gifted in many ways. Not only was she a superb calligrapher, but she was also a talented artist and cartographer. This piece of work, completed only eight years before her death at the age of 82, combines all three skills. The narrow panel on stretched vellum has two black line borders, the outer edged with a freely drawn, slightly thicker line of shell gold. Eight raised gesso squares with leaf gold are at each intersection of lines. Mahoney has also used gesso, which has been covered with gold leaf and burnished to a brilliant shine to write the subtitle under the red Versal letters at the top, the name of the Town House in the village, and a tiny gold dot at the bottom left, marking 'Oak Cottage: My Home'. The title presented a difficult design conundrum, with three words in the top line and a short word, 'Kent', in the second. There is no obvious compression or expansion in these two lines, but a

close look at the second line shows that the letters are spaced very slightly further apart, so that this line does not appear unduly short. Beneath this section is a delightful line and wash painting that captures the time when cows were guided out of their field to cross the road for milking at the farm. The middle section of lettering is written in red and black, with a fine nib in a bouncing cursive Italic. It has great rhythm and flow.

The map in the lowest section shows Mahoney's cartographical strengths. It is simple and clear, and yet includes everything that should be there. Delicate line drawings indicate the church, the position of the Town House, the Parsonage, the Manor House and the other houses in the village, including Oak Cottage. Their bright red roofs echo the touch of red in the farmer's scarf, the chimney-stacks in the top painting and the red lettering that occurs throughout. The grey road, edged in a light green wash, adds just enough colour to prevent the map from being dull. Rather than have a compass to indicate the map's orientation, the two roads that join at the top fork are at just the right angle for the word 'NORTH' to be written exactly in the middle of the piece. The names of roads, fields and houses are written in the same vibrant Italic, giving a wonderful cohesion to the whole panel.

66
'Narrative' from *Aspects of Language* – Ann Hechle

England, 1981–2
© Ann Hechle. Crafts Study Centre, University for the Creative Arts, Farnham, C.95.8.1

Ann Hechle and Donald Jackson were in the last tranche of students, in 1958–60, to be taught calligraphy by Irene Wellington at the Central School of Arts and Crafts in London (now Central St Martin's College of Art and Design). Wellington subsequently retired when the subject was removed from the curriculum at the college. She was a student of Edward Johnston, and so the direct line of craft skills being passed on from generation to generation had been maintained.

In mediæval manuscripts there was a hierarchy of scripts: Roman Capitals for the headings and enlarged initial letters, the latter often written as Versals, which showed that both were the most important, Uncials for the first few lines as the next important, and then the body of the text in, say, Caroline Minuscule or Proto-Gothic. Here Hechle uses a similar idea of scripts representing more than just the words, so that they often reveal a hidden, or create a visual, meaning. This piece, 'Narrative', is written on vellum using Chinese stick ink and watercolour. It is one of four panels, 38.5 by 50 cm (15½ by 20 inches), in the *Aspects of Language* series, the others being 'Sound', 'Rhyme' and 'Rhythm'. Each panel, all with a restrained colour scheme, is held together by a horizontal line of large writing. Here it is the 'Twister a-Twisting …', where the liveliness with which the initial letter **T**s have been written and their shape suggests vibrant movement. The twisting is echoed in the tiny black Italic writing that dances around this straight line, and where the

form of the lines suggests a twisting movement akin to that of a rope or length of string.

There are three panels of writing above this line, each with a different feel. The central one is the nursery rhyme 'Humpty Dumpty', but in German. Here Hechle has used Gothic Textura,[60] with the English version woven between the Gothic in a contrast colour of red and in tiny majuscules. On the lower lines, the letterforms of this red script break up almost completely and dance around, as Humpty Dumpty cannot be put back together again. The outer two panels are headed by elaborate flourishes, those on the left suggesting peacock feathers and those on the right emphasising the 'dilly dilly' or 'diddle diddle' of the poem. Different letter-forms and colours delineate the separate lines and phrases, creating an overall balance. Four smaller blocks of text are at the bottom. 'The cow with the crumpled horn' winds itself up into a boxy maze, with 'The house that Jack built' at the centre. The serried ranks of regimented soldiers changing guard in strict lines create an exact square, in contrast to Alice's explanation about a soldier's life, with a delightful flourish on the letter **y**. 'Rats' is an exclamation, placed centrally in another square, where extensions to the letters look like rats' tails. The last spiral reflects the snail's shell, as there is encouragement from the whiting to walk a little faster, with the text increasing in size and gradually unravelling as the strange duo progress.

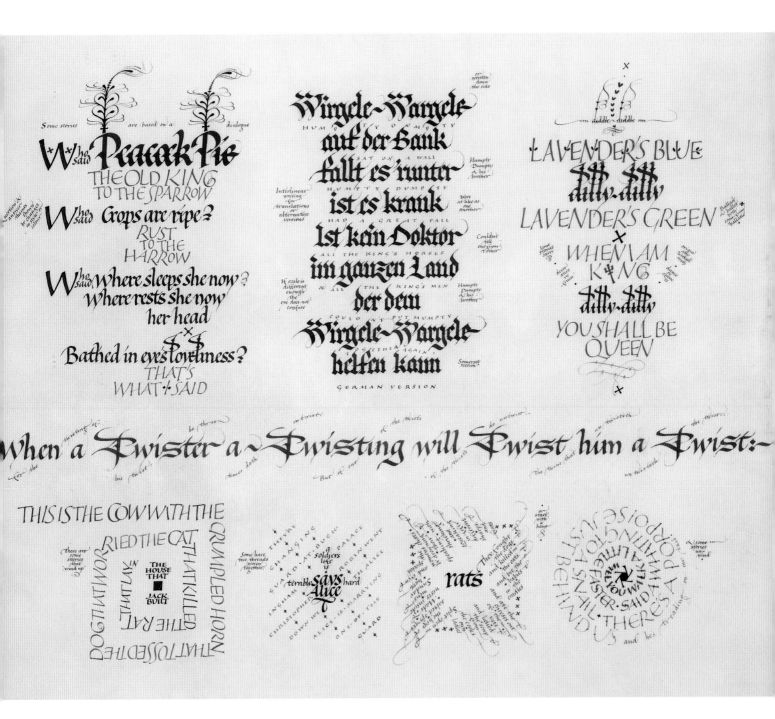

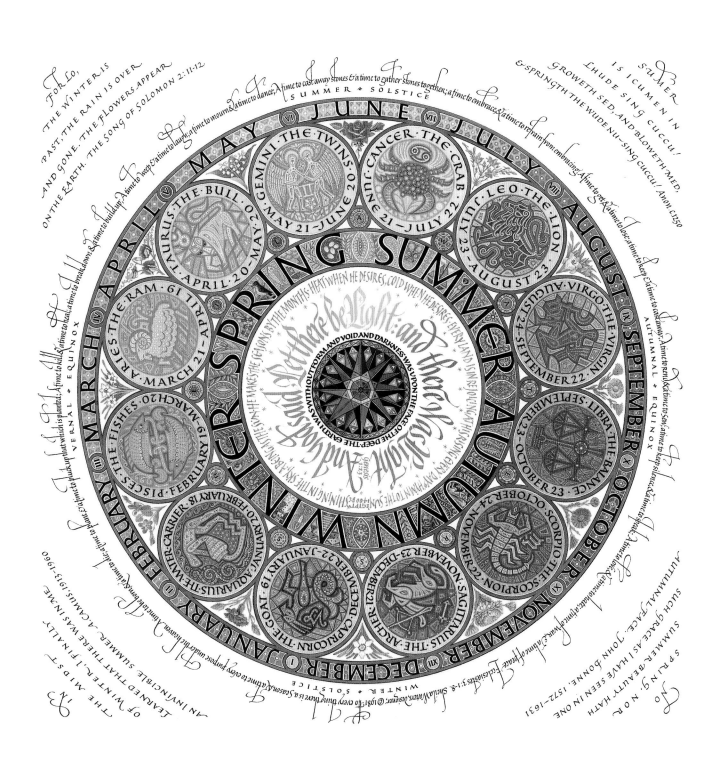

67
Roundel of the Seasons – Sheila Waters

Maryland, USA, 1981
© Sheila Waters

Some pieces of modern calligraphy are relatively spontaneous in that they come together quite easily; others take very much longer, both in the planning and execution. In the case of this most complex of pieces, the *Roundel of the Seasons*, over 1,000 hours of concentrated work were required. Waters's inspiration for this wonderful example of contemporary calligraphy was the title page she designed when she wrote out Dylan Thomas's celebrated play for voices, *Under Milk Wood*.[61] For that, the colour scheme of the background of the black letters of the title was reflected in the gradual tonal change, representing the 24-hour period of the play. For the *Roundel,* the idea was adapted for the seasons – the cold blues and purples of winter, bright greens of spring, warm yellows of summer and the glorious reds of autumn – with each zodiac sign being very subtly different in colour from the previous and following one. Initial thoughts on pencil roughs show the four seasons in large majuscules written in an inner circle, with smaller circles for each astrological sign separated by vertical columns of design. In successive designs, the smaller circles enlarged until they touched, as in the finished piece. The original design also included dying flames around the central compass, with leaves of the seasons on a blue background. However, Waters thought this to be too dense and lacking in contrast, and at one point almost gave up. With encouragement from her husband, she used a blade to scrape away the paint from this section of the panel, revealing the vellum; it must have been heartbreaking to remove these wonderful watercolours representing so many hours of detailed work. Three circles of lettering of two quotations from Genesis and one from the *Hymn to the Sun* in different weights, colours and sizes were the replacement.

The detail in each of the sections is to be admired. The main circle is just under 25 cm (10 inches), yet the smaller roundel with the names of the seasons encompasses a flying kite, wellington boots and an umbrella, a sunbather, tennis racquets and balls, and a snowman! Within the zodiac circles are the astrological symbols as well as depictions of the animals and people, and between them tiny vignettes of flowers of the seasons. It cannot be stressed strongly enough how challenging it is to write in a circle and to achieve lettering so rhythmic, and spacing so even, as here. This demonstration of supreme skill is repeated again and again, from the central lettering circles of lively lettering to the black majuscules of the seasons' names, to the lettering within the zodiac circles, and so to the dancing, delightful, flourished letters of the encircling extract from Ecclesiastes. And if this were not enough, there are four quotations about the seasons which neatly fill each corner, five lines each, all starting with a delicate flourished initial and holding the whole piece together. This really is a tour-de-force.

68
Gingo Biloba – Hermann Zapf RDI

Darmstadt, Germany, 1988
Fitzwilliam Museum, Cambridge, CAL 54-2007

The purity of the letter-forms in this panel can be likened to that of the writing masters in the Renaissance: here there is no gold, only two colours and no illustration. Many manuscripts in the Renaissance are similar in their restraint. Hermann Zapf has written this poem in black ink, with the title and credit in red, using a narrow pen nib. It is written on handmade Japanese tissue paper that contains dried ginkgo biloba leaves as well as flecks of gold and flecks and strands of silver: it is a challenging writing surface. The lettering looks like handwriting, which indeed it is. Zapf wrote very much like this, but it is still very calligraphic, with its restrained flourishes to some ascenders and descenders, and individual strokes on certain letters extended slightly, such as the letter **z** in the third line and the letters **d** in the last. The simplicity suits the poem, which is about the gingko biloba tree with its divided, heart-shaped leaf: 'Is it one living being … Are there two which choose to mingle?' Johann Wolfgang von Goethe (1749–1832) associated the gingko biloba tree with friendship and love; he dedicated the poem to his friend Marianne von Villemer (1784–1860) wife of the banker Johann Jakob von Willemer (1760–1838).

Hermann Zapf's lettering may well be familiar. It was this handwriting style that he chose as the basis for his Zapfino typeface (see below). This is used for many different purposes, including headings, invitations, in advertising and for standout captions, but rarely as a type for text. Using calligraphic letter-forms as an inspiration for typeface design is not new. Hermann Zapf notes that 'calligraphy has influenced typeface design since Johannes Gutenberg',[62] and Gothic Textura, was indeed the inspiration for Gutenberg's first printed books. Similarly Humanistic Minuscule gave rise to Roman typeface designs. Hermann Zapf[63] also comments on the typefaces developed by William Morris with the Kelmscott Press, in which Morris drew upon inspiration from the fifteenth century, and the designs of Nicolas Jenson (1404–1480) for his Golden Type. The great calligrapher Edward Johnston developed the distinctive lettering style for the London Underground. Eric Gill, another of Johnston's students, designed many typefaces, including Gill Sans, Perpetua and Joanna, the last named after his daughter. Rudolf Koch (see page 188), himself an inspirational calligrapher, was also a great type designer. Many of his styles were based on Gothic Textura and Fraktur,[64] but one of his most noted was Neuland, which he designed in 1922–3. This heavy, monoline style has a great charm, although it was described by some at the time as unbelievably ugly. Interestingly, some present-day scribes use the Neuland style in their calligraphic works turning this full circle; it requires much pen manipulation to create the monoline letter-forms.

Poem by Goethe first published in 1819 (apparently Goethe changed 'Gingko' into 'Gingo' to avoid the hard sound of the letter 'k').

GINGO BILOBA

Dieses Baums Blatt, der vom Osten
meinem Garten anvertraut,
gibt geheimen Sinn zu kosten,
wie's dem Wissenden erbaut.

Ist es ein lebendig Wesen,
das sich in sich selbst getrennt?
Sind es zwei, die sich erlesen,
dass man sie als eines kennt?

Solche Fragen zu erwidern
fand ich wohl den rechten Sinn:
Fühlst du nicht an meinen Liedern,
dass ich eins und doppelt bin?

Goethe

Hermann Zapf 1955

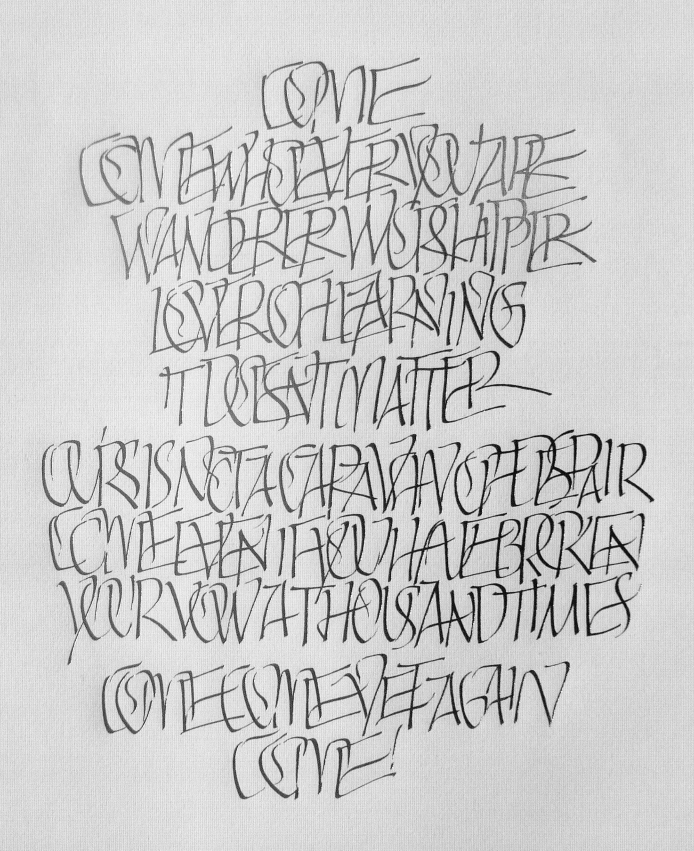

69
Extract from Jalludin Rumi – Ewan Clayton MBE

England, 1996
© Ewan Clayton

The cheaper, quicker and more easily produced books of the printing press resulted in a decline in the demand for calligraphy. Occasionally, however, lettering finds a use for printing, as in the case of this magnificent piece of calligraphy in gold by Ewan Clayton. The original was written with a quill on a smooth surfaced paper, allowing great flexibility of movement, the whole essence of the piece. The script is entirely in majuscules and the letters dance and glide, clashing and separating with great rhythm, vitality and verve. There are elements of historical styles in that letters overlap, as in the letters **O** and **M** in the first line, and share strokes with 'biting of bows',[65] as in **DOESNT** in the fifth line. There are also elements of an Uncial form in the rounded letter **M** in the first and second rows; the idiosyncratic **E** form at the end of the first line and towards the end of the second is essentially a Roman form, but there Uncial elements with the wonderfully curved and extended crossbar. There are some particularly pleasing letter-forms and combinations, for example in **DESPAIR**, at the end of the sixth line. Here the letter **S**, the third letter in the word, overlaps the letter **D**, the first letter, and a wonderful juxtaposition of strokes is made with these letters and the intervening letter **E**. The lengthened crossbar of this letter **E** is extended to form part of the bowl of the letter **P**, leading the eye on to the apex of the small letter **A** sitting just below. The only punctuation is the restrained exclamation mark at the end. The initial impression is one of almost illegibility with a vision of a tangle of overlapping strokes, yet it is surprisingly easy to read.

Once the piece was written it was printed in gold, and this really brings the piece alive, as gold so often does. Ewan Clayton writes:

This piece accompanied a booklet I wrote in 1996, *The Calligraphy of the Heart*. The booklet came with a series of posters. My thinking was that the calligraphy we see in reproductions seldom matches the actual size at which things are written. By moving out of the book into a poster format I could show things as they really were. The words come from the poetry of Jalludin Rumi, the Sufi poet. I chose the paper because it was made of unbleached flax fibres, it would last forever and it had a smooth surface. I could slide my pen around easily, movement was important to this work. And the quill was chosen over modern metal nibs because it too can glide over the surface. The overlapped letters recall how Rumi composed these poems, as he was dancing. It was he who invented the whirling dance of the dervishes.

The original calligraphy was written with a goose quill on Barcham and Green's Chatham Vellum handmade paper. The work was then gold-foil blocked on to a textured Gilbert 100% Cotton paper.

70
Pythagoras QED – Lin Kerr

Twickenham, England, 2002
Fitzwilliam Museum, Cambridge, CAL 19-2007

Although calligraphy was often used to write out mathematical formulas in historical manuscripts, rarely have calligraphy and design been used to prove a theorem. Here, on Roma Fabriano paper that has very defined laid and chain lines,[66] specially selected by Lin Kerr as one of her favourite surfaces, paint and ink have been applied to give the impression of ageing; it is almost as if this is a piece of paper that has been discovered by an archæologist. Carefully placed and constructed mosaic squares sit on a background of dancing Italic text, written in a pale colour to resemble the handwriting of a Renaissance scribe. The squares are coloured carefully – shades of red and green, shades of blue and orange, and shades of purple and yellow, all pairs of complementary colours – to give a defined and striking vibrancy to the piece. These mosaic squares of different sizes are positioned so that the spaces between them form right-angled triangles, relating to Pythagoras's theorem. A broad vertical line of schlag[67] gold squares is broken by a depiction of Leonardo da Vinci's Vitruvian Man, in which the Renaissance artist demonstrates the proportions of a man using the geometry of a circle and square. A line of blocky letters made from rubber stamps created by the scribe have a link to Greek scripts and prove the theorem; these are preceded and followed by the freely written names of the Greek mathematicians Pythagoras and Euclid, and the great artist Leonardo da Vinci. Lin Kerr writes:

I like working with an elegant, exquisitely designed structure as a basis for calligraphic artwork. Having decided to explore a mathematical theorem in a visual way to demonstrate the beauty of geometry, I discovered that there are many proofs of the Pythagoras theorem and that Euclid and Leonardo had their own proofs. I decided to create a visual proof and a verbal proof within one artwork.

The verbal proof is written out in full in a lyrical script with a hand-cut nib to provide a background. The visual proof involves a right-angled triangle which is constructed from 3mm blocks, with complementary colours such as red and green on the short sides, flanking the right-angle. Here the colour goes from pure red or pure green to a darker red or a darker green. On the hypotenuse a block is constructed where the red changes gradually to green. The other two triangles are treated in the same way, using blue and orange or yellow and purple. The sum of the number of red blocks and green blocks equals the number of blocks ranging between red and green on the hypotenuse square. Each square surrounding a triangle has three blocks gilded on gesso to add extra sparkle.

QUOD ERAT DEMONSTRANDUM

71
Word Made Flesh – Donald Jackson MVO

England and Wales, 1999–2011
© 2002, The Saint John's Bible, Saint John's University, Collegeville, Minnesota USA

Donald Jackson, official scribe and calligrapher to the Crown Office of the United Kingdom of Great Britain and Northern Ireland, wrote:

> I believe that the humanity of handwritten letters can reach out from the surface of the page. Even the 'perfection' of a skilled hand contains the breath and heartbeat of its imperfect maker. But how to make the word of God come alive on a page or transcribe the sounds of voices raised in songs of praise? We must first cultivate an openness to the text before allowing our feelings to come through us into the marks we make. On this page I drew and painted inscriptional capital letters to express the proclamatory words of John 1:14, but chose to use a fine-cut quill to 'scribble' the lacy, black and gold script for the chorus of human voices emerging from the cosmic darkness.[68] Throughout, I used gold in varying tones and brightness to signify the Divine Presence. Gold draws the eye and rewards the questing glance – if it invites you to enter the sacred spaces within each turning page – I have performed my task.

The Saint John's Bible project was on the scale of Bible productions at the scriptorium of St Martin in Tours in the ninth century and the grand Bibles of the twelfth century. In this case, though, the Bible is not a pandect,[69] but in seven volumes. They are huge, however, with a page size of 61 by 46 cm (2 by 1½ feet). A team of artists, led by Donald Jackson, worked on both the lettering and the illumination, while others managed the vast project. The book is written on vellum with quills and Chinese stick ink, and the illuminations are in hand-ground pigments, gold and platinum leaf, as well as shell gold. Without doubt for the first time in such a book, computers were used to plan the layout and the line-breaks for the text.

In this magnificent illumination, planned as a double spread with a powerful *incipit* [70] on the opposite page, the shadowy shape of a figure in gold dominates the page – appearing to emerge from the shadows, 'becoming flesh' as in the text with almost every step. Patterns of crosses in pale grey, silver and gold are scattered around the gold halo, extending completely to the feet of the figure. Delicate gold circles of tracery add to the complexity and detail of the design. The opening words of the verse are in shell gold on the left and raised leaf gold on gesso on the right, both in majuscules that incorporate elements from insular manuscripts. The fine lettering of the text, in both gold and black on the left, and the black lettering on the right, is very calligraphic, and written at speed to great effect.

72
In Regio Loidis by Carol Ann Duffy – Stephen Raw

Manchester, England, 2012
Artwork © Stephen Raw,
Poem © Carol Ann Duffy reproduced with permission from Rogers, Coleridge and White

The rich blues, greens, reds and gold, and the application of the colour in this glorious piece of lettering by Stephen Raw reflect Carol Ann Duffy's poem 'The stained glass windows bleed their light on to the floor, where we walk now, good citizens; or drop their colours, petals, on the singing boys from Burley, Wortley, Armley, Headingley' and 'Joy in glass' in the last line. Raw's approach is very contemporary in feel, with blocks of text in different sizes, a mix of minuscules and majuscules in single words, and letter-forms stretched and compressed. There are many delightful ways of using letters, such as the treatment of the title of the poem on the top left of the piece, which looks very much like mediæval enlarged decorated initial letters set in a square. Blocks of text towards the end of the piece are written on a background of purple and green encased in white rectangles and really do look like 'the slabs we tread on'. The arrangement of letters in words and the combinations of letter-forms where strokes are shared or extended also resemble a similar approach to that of historical scribes, who were, of course, unconcerned about typographic conventions of later centuries. The vertical letters of **the** in line four, **of** at the end of line five, and again **the** in line eleven, echo those designed and written by Eadfrith in the Lindisfarne Gospels. The different forms of individual letters such as Uncial and Roman letters **E** in **bleed** in line thirteen also feature in a number of historical manuscripts. The curling letter **O** sharing a stroke with the letter **Y** (looking very much like that by the Renaissance scribe Bartolomeo Sanvito) on the last line is truly joyous!

Stephen Raw writes:

When Leeds Parish Church was given the status of Minster to mark The Queen's Diamond Jubilee year in 2012, the Poet Laureate, Carol Ann Duffy, was invited to celebrate the occasion with a poem. In turn, I was commissioned to paint an artwork of the poem. Carol Ann and I visited the building and we were inspired by many of the characteristics of the place – the 'penny window' light and the surrounding gravestone slabs being just two. When conventional type and typography are put aside, it gives me the freedom to make a piece with site-specific references – the slab words being a case in point. Further, my eclectic attitude to letterforms allows me to use some of the letters I sourced from the Minster.

IN REGIO LOIDIS

HARD NORTH;
a thousand years,
a sacred site here—
between the RIVER and
the HUMAN CHURN of
CLOTHIERS, MILLERS. merchants, SQUALOR, WEALTH—
till Walter Farquhar Hook's
SERMON IN STONE
OPENED, UTTERED... for every child
A school...
to the slum-trapped poor.

THE STAINED GLASS
WINDOWS
BLEED their LIGHT onto the
FLOOR,
where we walk now, good CITIZENS;
or drop their COLOURS,
PETALS, on the SINGING BOYS
from Burley, Wortley, Armley, Headingley,

THE SLABS WE TREAD | ON AS WE | WON, OR DID | Sacred

to the Memory • of the PARISH DEAD;
the PENNY WINDOW in
LIT BY SUNLIGHT'S GLANCE, JOY GLASS

73
Prophesies on a Circular Wing – Gaynor Goffe

Cambridgeshire, 2015
© Gaynor Gaffe

Gaynor Goffe is best known for her lively Italic lettering, so this piece all in majuscules is unusual, but the letter-forms are still, typically, full of energy. The quotation from the Oglala Sioux includes: 'Ancient teachings of the earth' and 'Ancient songs of the earth', and these phrases are sympathetically reflected in the colours chosen for the whole piece and in the textures of the background washes. The work is created on hot pressed paper using acrylic washes, gouache, ink and bronze powder.

Suspended from a narrow stick of wood at the top, two coloured triangular shapes with smooth stones attached act as sentinels either side of the title, which, by being written in a circle, ingeniously reflect the title, *Prophesies on a Circular Wing*. The extended and elongated letter-forms here are reminiscent of those used in some insular manuscripts and make a most interesting texture. White writing contrasts with the dark earth-colour washes and a dense, speckly, textured background on three horizontal panels. These sections alternate with two horizontal panels that have dark, earth-colour lettering written on lighter washes of blue, red and orange. At the base of the work are elongated triangular shapes, with attached smooth stones, and the credit, again written in a circle echoing the title. The lettering has elements of Uncial and Insular scripts, while the playful double and treble diagonals to the letters **N** and the crossbars to the letters **H** and **A** are also to be found in manuscripts of these historical periods. The letters are written with a narrow nib with the thicker parts of the letters reinforced by additional strokes – in the same way as Versal letters. Variations in letter-forms, Uncial and Roman letters **E**, three different types of the letter **R** and two different forms of the letter **G** (all in the lowest panel) all add to the visual difference.

Gaynor Goffe writes:
> I am trying to achieve an organic feel to this piece, which is based on thumbnail sketch ideas, usually made on train journeys. It may be that looking out on the landscape on my travels has an effect on producing ideas! Colours of the earth and sky were chosen for the backgrounds, with alternating lighter and darker areas of acrylic washes for contrast. I enjoy experimenting with capitals and the variety of letter-forms used here were written spontaneously. I made writing trials on spare pieces of wash background to ensure sharp strokes, using gouache for the dark lettering and liquid acrylic for the white. The circles and triangular decoration with stones make a contrast to the more rectangular shapes elsewhere in the composition.

74

In Memoriam: 373 Children – Peter Halliday

(The names of 373 children from newborn to the age of 17 killed in the bombarding
of Gaza in the summer of 2014. Source: Save the Children)
Staffordshire, England, 2016
© Peter Halliday

There was a political element to many manuscripts written in the past. Charlemagne (*c.*747–814) gave purple-dyed bibles to favoured churches to keep their support. Charters granting land and property to the followers preferred by the sovereign were written out in clear script, and Humanists in the Renaissance deliberately chose a completely different writing style for books containing the texts of classical authors. All of these, in different ways, were statements of a political nature. Some people have a view that contemporary calligraphy (apart from the functional calligraphy used for presentation addresses, invitations, scrolls and the like) is only for the writing out of Bible verses or poems with painted flowers. This stunning piece by Peter Halliday, which, when framed, measures 60.5 by 34.0 cm (24 by 13½ inches), is written on manuscript calfskin vellum using watercolour, Japanese Sumi ink, raised and burnished gold on gesso and gold leaf. It shows that contemporary calligraphy can convey messages just as powerful as those of historical manuscripts, if not more so, and has little to do with pretty flowers.

In the summer of 2014 in Gaza, 373 children were killed; the names of each individual child are written on this piece. Narrow triangles of raised gold leaf on gesso are placed on a red background, resembling the rays of the setting sun. Blue shards, darker at the bottom and then getting lighter, link the base with the upper part of the piece, eventually dissolving into light-blue and grey cloud-like formations. The names of the children are written at different angles on the sides towards the bottom and then in gentle curves at the top, echoing the cloud shapes. At this point it is clear that the setting sun for these children marks the end of their lives, and that what is depicted here could also be interpreted as an explosion.

In this work Halliday has explored what he describes as 'the unique quality that vellum allows when using subtle layers and washes of watercolour'. He writes:

My original idea was to use a formalised pictorial representation of an explosion with the smoke and clouds formed out of the names. There are so many names that they would form the clouds. After quite a lot of research looking at photos of explosions, pop-art type representations and the effects of modern day ordnance, I developed an aggressive sun burst (or sunset if you will). Having looked at some of the horrifying photographic images of dead children from the Gaza bombardment I thought that they were too graphic to use in any way, and settled for a symbolic memorial showing a mass of names exploding into oblivion. We memorialise the dead with lists of names and the sheer quantity leaves a lasting impression. I live close to the National Memorial Arboretum, which is full of lists of names. I see people just touching and caressing the names of their loved ones to create a connection. I hope that the humanitarian aspect of this work will leave an even stronger impression by the explosive nature of the image.

75
A Thousand Wishes – Denis Brown

Ireland, 2016
{Text}ure Gallery & Art Bar, Asheville, North Carolina USA

When is calligraphy not calligraphy? Does it have to be written on paper or vellum, or could it be etched on glass as here, or on other surfaces? And does it have to be legible? This not only looks different from manuscripts such as the Book of Kells or the Bedford Hours, but it is also physically different, being presented in a different format. On looking closely, however, there are possible similarities. A direct similarity is the free calligraphic strokes creating the leaves of the dandelion flower on the bottom right and left, which incorporate some pen-made animal heads; these are very reminiscent of insular manuscripts. Some of the lettering is legible, but most needs close reading to decipher, again as in some insular and later manuscripts, where letter-shapes can be distorted, difficult to fathom and can take some time to decipher. Gold and silver-coloured aluminium enhance the work, adding brilliance and reflecting the light as these precious metals did in mediæval and later times. The piece also conveys people's hopes and wishes, and this could well be the interpretation of historical religious books, which sought to reassure and perhaps promise a better life. For the scribes and artists, creation of such works was their *opus dei* (work for God) and many must have hoped, as did William de Brailes in the thirteenth century, that these artistic endeavours would save them from damnation.

Denis Brown writes:

Handwriting is now becoming eclipsed by many other means of written communication. Calligraphers may now seek applications that are more artistic than clearly functional. Legibility may be sacrificed for expressive effect. In my work, however, I seek to communicate artistically through text, even when it is illegible. The mass of text here contains the wishes of many people, however most are concealed in overlapping circular layers. On close inspection of an original, a single wish engraved in a circle on the topmost sheet of glass may be deciphered. All others, although implicit, remain secret. Text becomes texture, an evocative mass of floating lines conveys an image and embeds a multiplicity of ideas. I had sent out a request for wishes to my mailing list, which is comprised mostly of calligraphers. Responses by email began pouring in. I realised that what I was doing was playfully provocative: I was asking calligraphers to be creative with words, but *without* picking up a pen. The creative act of composing one's wish and sending it by email could possibly be an engagement as well as a release. Of course I cannot make wishes come true. However, by engaging with one's wish and expressing it, anyone might become closer to the possibility of realising it for themselves.

Six sheets of glass, engraved with handwritten wishes, are spaced apart in a box frame over a painted and aluminium gilt paper with flecks of gold leaf. Flourishes in the lower half lie on another aluminium gilt paper, attached to the third glass sheet down, and LED lights inside the frame edge light the glass. A handwritten label above the image reads 'Wishie/Pusteblume'. *Pusteblume* is the German word for dandelion and literally translates as 'breath flower'.
Denis Brown

76

From A to Z by Ted Walter – Patricia Lovett MBE

Kent, England, 2007
Fitzwilliam Museum, Cambridge, MSPB, CAL 29.4-2007

The old, but perfectly usable, piece of thick, unstretched vellum used in *A to Z* could possibly have been provided by Edward Johnston to one of his students and has a texture which is different and more suede-like than most skins made today. This provides a link to the beginning of the twentieth-century and the tools, materials, skills and techniques used to write the letters and decorate the piece echo those used in mediæval and Renaissance manuscripts – quills, gesso, gold leaf and shell gold. The Kent poet Ted Walter encapsulates in his poem the need for us all to work together. Vowels, which are soft sounds and could be likened to children, and consonants, harder and harsher sounds – perhaps like adults – need to co-operate and collaborate both in words and also in life. Two colours of gouache [71] were used for the verses of the poem, red and blue, representing the repeating two aspects of the theme, and they were fed into the pen nib a little at a time. The process is not difficult but it does not encourage rhythm and flow because the colour has to be carefully controlled so that neither one nor the other dominates – and this applies not just to the preceding letters but also to those in the line above. The dancing flourished majuscule letters of the central panel are also in two colours, but the vowels are written in shell gold, and there are also tiny dots of leaf gold on gesso sprinkled throughout this column and before and after the title. The need to work together as exemplified in this piece, and indeed in mediæval scriptoria where scribes, illuminators, bookbinders and, for luxury books, those who added jewels and precious objects to the outside covers all collaborated towards the end result, ensured that the best calligraphers and letterers in the world co-operated in putting together a permanent collection of contemporary calligraphy and lettering at the Fitzwilliam Museum in Cambridge. Many great institutions throughout the world have collections of mediæval and Renaissance manuscripts, but very few are able to house examples of the best contemporary lettered artworks. The eighty or so pieces in the Fitzwilliam Museum Collection of Contemporary Calligraphy include works on stone, wood, and ceramic, as well as manuscript books, and artworks on paper and vellum and all can be viewed online. The exhibition of selected pieces, *Calligraphy Today*, was held in 2012–13 and extended twice owing to popular demand.

Adults, the angular, upright letters
 are rigid and fixed by age;
ancestral grunting, chanting, still
 sounds in their souls.

A
B
C
D
E
F
G
H
I
J
K
L
M
N
O
P
Q
R

Children, the vowels, the open ones,
 have fluid, mellifluous lives,
shape and sound and colour delight;
 their futures wait.

The A in play; the E in me;
 I that is sometimes assertive;
the O of surprise; the U in us;
 & the Y of the constant question.

Their presence can change an alphabet
 of hurt and hate into loving,
where jungles and savannahs wait,
 clean air to breathe in.

FROM A TO Z

If every adult & child maintained
 their role together,
remembered the strengths of the words
 they share, & respected each other,

S
T
U
V
W
X
Y
Z

vowel and consonant, parent & child,
 hold in their hands
everything named, the whole of their world;
 they should be friends.

Notes

THE ART AND HISTORY OF CALLIGRAPHY
1 *Encyclopædia Britannica.*
2 Fairbank, Alfred, in *Lettering of Today*, Studio (London, 1937).
3 Brown, Michelle, *A Guide to Western Scripts from Antiquity to 1600* (London, 1990).
4 Eusebius, *The Life of the Blessed Emperor Constantine, Bk 4, Chap 36, Constantine's letter of commission* (New York, 1890).
5 Gamble, Harry, 'Codex Sinaiticus in its Fourth Century Setting' in McKendrick, Scott, Parker et al, (eds), *Codex Sinaiticus: New Perspectives on the Ancient Biblical Manuscript* (London, 2015).
6 Migne, Jacques Paul, *Patrologia Latina 28*, col 1142 (Paris, 1890).
7 The Old English *thorn* continues in use up to the present day. Losing its ascender and with the bowl opened to be similar to a letter **y**, it occurs in 'quaint' cafés and tourist shops as 'Ye Olde Englishe Tea Shoppe' etc. The Old English '**þ**', of course, being a *thorn,* is pronounced as **Th**.
8 Einhard, *Vita Karoli Magni.*
9 de Hamel, Christopher, *A History of Illuminated Manuscripts* (Oxford, 1986).
10 The writing style was called the 'Corbie ab minuscule' because of the distinctive nature of the letters **a** and **b**.
11 Kwakkel, Erik, *Commercial organisation and economic innovation* in Gillespie, and Wakelin, (eds), *The Production of Books in England 1350–1500* (Cambridge, 2011).
12 Peterhouse College, Cambridge, MS 110.
13 https://medievalbooks.nl/2015/05/22/medieval-bargain-books/
14 A quire is four sheets folded in the middle to make eight pages.
15 The Septuagint was a Greek version of the Bible made for the Greek-speaking Jews in Eqypt in the second and third centuries BC. It consisted of the Old Testament and the Apocrypha.
16 Wardrop, James, *The Script of Humanism* (Oxford, 1963).
17 Petrarch, *La scrittura*, discussed by Armando Petrucci, *La scrittura di Francesco Petrarca* (Vatican City, 1967).
18 Codex Vat. Lat. 6852.
19 Brown, Michelle P and Lovett, Patricia, *The Historical Source Book for Scribes* (London, 1999).
20 De la Mare, A C, and Nuvolini, Laura, *Bartolomeo Sanvito: The Life and Work of a Renaissance Scribe (The Handwriting of the Italian Humanists II),* Hobson and de Hamel (eds), with contributions from Scott Dickerson, Ellen Cooper Erdreich and Anthony Hobson, Association Internationale de Bibliophilie (Paris, 2009).
21 Wardrop, James, *The Script of Humanism* (Oxford, 1963).
22 Brown, Michelle. P and Lovett, Patricia, *The Historical Source Book for Scribes* (London, 1999).
23 Wardrop, James, *The Script of Humanism* (Oxford, 1963).
24 A chancery is strictly defined as a place for the sending out and receiving of letters.
25 L. V., Ryan, *Roger Ascham* (California, 1963).
26 Wardrop, James, *The Script of Humanism* (Oxford, 1963).
27 Wardrop, James, *The Script of Humanism* (Oxford, 1963).
28 Paper is folded and cut into eight leaves of 16 pages – an octavo. When printed, sewn and attached to other gatherings, this produces a small, pocket-sized book.
29 Barker, Nicolas, *Aldus Manutius and the Development of Greek Script and Type in the Fifteenth Century,* 2nd edition (New York, 1992).
30 MacCarthy, Fiona, *William Morris: A Life for our Time* (London, 1994).
31 Op. cit.
32 Op. cit.
33 Letters of Edward Johnston to Sir Sydney Cockerell, 1900–1924, NAL at V&A (mss. English. 78).
34 Op. cit.
35 Cited: Johnston, Priscilla, *Edward Johnston* (London, 1959).
36 Holliday, Peter, *Edward Johnston: Master Calligrapher* (London, 2007).

HOW MANUSCRIPTS ARE MADE
1 *Ethymologiæ*, vi, 14; ed. Migne, *Patrologia Latina*, 82.241.
2 A dutching tool consists of a wooden handle attached to a metal (usually brass) rod, which conducts heat well. There is no written evidence of why the heating of feathers to make quills is called 'dutching'. Whether this was because the Dutch first heated feathers or not is unknown, but this seems rather unlikely.
3 Cennini, Cennino, *Il Libro dell' Arte* ('The Craftsman's Handbook'), translated by Daniel V Thompson Jr. (New York, 1960).
4 *Saturday Magazine,* published in the years 1834 and 1838–39 by John William Parker (unknown authors).
5 Gerarde, John, *The Herball, or Generall Histories of Plantes* (London, 1597 and later editions).
6 Kenyon, F G, *Ancient Books and Modern Discoveries* (Chicago, 1927).
7 Cennini, Cennino, *Il Libro dell' Arte* ('The Craftsman's Handbook'), translated by Daniel V Thompson Jr (New York, 1960).
8 *De coloribus et artibus Romanorum* is the oldest and most complete compendium on art and craft techniques of the Middle Ages. It was thought to have been written between the seventh and twelfth centuries and is attributed to Eraclius.
9 Cennini, Cennino, *Il Libro dell' Arte* ('The Craftsman's Handbook'), translated by Daniel V Thompson Jr (New York, 1960).
10 Pliny the Edler, *The Natural History,* translated by John Bostock and H T Riley (London, 1842).
11 Jacoby, D, 'Silk Economics and Cross-Cultural Artistic Interaction: Byzantium, the Muslim World, and the Christian West', in *Dumbarton Oaks Papers* 58 (2004: 197–240).
12 Ibid.
13 Merrifield, Mary, *Mediæval and Renaissance Treatises on the Arts of Painting* (original texts with English translations) (New York, 1967).

CALLIGRAPHY THROUGH THE AGES
1 http://britishlibrary.typepad.co.uk/
2 Wachtel, Klaus, 'The Corrected New Testament Text of Codex Sinaiticus', in McKendrick, Scot, et al, (eds), *Codex Sinaiticus: New Perspectives on the Ancient Biblical Manuscript* (London, 2015).
3 Morison, Stanley, *Selected Essays on the History of Letter-forms in Manuscript and Print,* McKitterick (ed.) (Cambridge, 1980).
4 Kurt Weitzmann saw 'no reason to doubt' that the St Augustine Gospels had either been brought over by St Augustine in 597, or had been sent by Pope Gregory in 601. Weitzmann, Kurt, *Late Antique and Early Christian Book Illumination* (London, 1977).
5 Elmham, Thomas, *Historiæ Abbatiæ S Augustini* (Trinity Hall MS 1, f. 77).

6 Binski, Paul and Panayotova, Stella (eds) *The Cambridge Illuminations; 10 Centuries of Book Production in the Mediæval West* (London, 2005).

7 A colophon is a note, usually written at the end of the book, by the scribe or a later writer about the book, when it was written, for whom and by whom. There are some rather humorous colophons about how much the scribe's hand aches, that the text was tedious and too long to write out, and also where the writer calls for wine at the end of this hard labour.

8 A gloss in a manuscript is a translation or explanation of the text.

9 Brown, Michelle, *The Lindisfarne Gospels: Society, Spirituality and the Scribe* (London, 2003).

10 A paste-down is the endpaper that is glued to the cover of a book.

11 In calligraphy Versal letters are a style of writing where the nib is held for most of the strokes at 0° to the horizontal, that is, flat, and for some strokes, such as the serifs on letters **C**, **E**, **F** and **Z** and for certain strokes on the letters **M**, **N** and **Z**, at 90° to the horizontal. The thicker parts of the letters are made by two or more pen-strokes.

12 An historiated initial is one that illustrates a story.

13 Brown, M. P, 'Female Book-Ownership and Production in Anglo-Saxon England: the Evidence of the Ninth-Century Prayerbooks' in *Lexis and Texts in Early English: Studies Presented to Jane Roberts*, Kay and Sylvester (eds) (Amsterdam/Atlanta, 2001).

14 Dodwell, C. R., *Anglo-Saxon Art, A New Perspective* (Manchester, 1982).

15 Op. cit.

16 Raithby (ed.), (1820). *Statutes of the Realm* (Rot. Parl. 12 § 13 Gul. III. p. 1. n. 7). 7: 1695-1701. Great Britain Record Commission.

17 Bernard Meehan, Keeper of Manuscripts, Trinity College, Dublin, via email.

18 Leather is soaked in aluminium salts and mixed with binders such as egg yolk, which reults in a flexible skin.

19 Tiro (died *c.* 4 BCE) was Cicero's secretary. He devised a system of symbols when taking dictation, similar to shorthand.

20 'Calender' is a machine or a process that makes paper, cloth and other surfaces smooth by pressing down the fibres, such as using smooth metal rollers or a book binder's bone folder.

21 Colgrave (ed.), *The Earliest Life of Gregory the Great* (Cambridge, 1985).

22 Bepler, Jochen et al, *The Albani Psalter* (Germany, 2008).

23 Op. cit.

24 A hide was a unit of land measurement, originally intended to be the amount of land required to support one household; depending on where this was, it was about 120 acres. However, it was also used as a tax assessment.

25 *Anglo-Saxon Chronicle*

26 https://www.abdn.ac.uk/stalbanspsalter/english/essays/personalities.shtml

27 Hamilton, Bernard, *Queens of Jerusalem*, (Oxford, 1978).

28 'Gesta sacristarum', *Memorials of St Edmund's Abbey*, Arnold (ed.), 2, Rolls Series, 96 (1892).

29 Having copied this page, I found that the illumination took about ten days to complete; this is, of course, without having to design it initially.

30 The Septuagint is a Greek version of the Old Testament, including the Apocrypha. It was made for Greek-speaking Jews in Egypt in the third and second centuries BC, and was used by the early Christian churches.

31 Donovan, Claire, *The de Brailes Hours*, (London, 1991).

32 Brown, Michelle, *The Luttrell Psalter: A Facsimile* (London, 2006).

33 Op. cit

34 Backhouse, Janet, *The Sherborne Missal*, (London, 1999).

35 See footnote 19.

36 The title given to the heir apparent of the French throne from 1350–1791, and then, after the French Revolution, from 1824–1830. Guy IV, Count of Vienne had a dolphin on his coat of arms, and Humbert II (1312–1355), one of Guy's descendants, sold land with this name to King Philippe VI of France (1293–1350) on condition that the heir to the French throne assumed this title.

37 Bell, Susan Groag, *The Lost Tapestries of the City of Ladies: Christine de Pizan's Renaissance Legacy* (California, 2004).

38 Paper is made by dropping paper pulp fibres on to a wooden frame across which are stretched fine wires called laid wires. These give an impression in the paper as parallel lines and are known as laid lines. Other lengths of wire, or 'chains', are placed at right angles to these and hold the whole structure together; the impressions of these wires are called chain lines. 'Wove' paper, which does not have these marks, is made by using a very fine wire mesh.

39 Blake, N F, *William Caxton and English Literary Culture*m (London, 1991).

40 The boys known as the Princes in the Tower, Edward, aged 12, and Richard, aged 9, were put there 'for their own safety' by their uncle Richard, Duke of Gloucester, after King Edward IV's untimely death. They both disappeared, and there are various theories as to what happened to them.

41 Evans, Mark, *The Sforza Hours* (London, 1992).

42 Op. cit.

43 Op. cit.

44 Ross, Sarah G., 'Esther Inglis: Linguist, Calligrapher, Miniaturist, and Christian Humanist' in Campbell and Larsen (eds), *Early Modern Women and Transnational Communities of Letters* (Farnham, 2009).

45 Op. cit.

46 Spearing, Elizabeth (transcribed), *Julian of Norwich: Revelations of Divine Love* (London, 1998).

47 Anchorites and anchoresses retired from the world to live a solitary life of prayer.

48 MacCarthy, Fiona, *William Morris: A Life for our Time* (London, 1994).

49 Morris, William, *His Aims in Founding the Kelmscott Press*, (Lechlade, 1898).

50 'Biting of bows' is where the bowls of two letters are compressed and written together – usually sharing part of one stroke as here, where part of the bowl of the letter **b** shares the same stroke with the bowl of the letter **e**.

51 Holliday, Peter, *Edward Johnston: Master Calligrapher* (London, 2007).

52 Ibid.

53 Edward Burne-Jones, 1833–1898, a Pre-Raphaelite artist and contemporary of William Morris's.

54 The 'instructions' in a church service.

55 Cinamon, Gerald, *Rudolf Koch. Letterer, Type Designer, Teacher* (London, 2000).

56 Reinecke, Adolf, *Die deutsche Buchstabenschrift*, (Leipzig, 1910).

57 Child, Heather, et al, *More than Fine Writing*, Farnham (Surrey, 1986).

58 Op. cit.
59 Via email on 22 April 2016
60 See page 27 for the significance of Gothic Textura in Germany.
61 *Under Milk Wood* is now at the Wormsley Library in Surrey.
62 Zapf, Hermann, 'Calligraphy and Typeface Design', in Lovett, Patricia, *The British Library Companion to Calligraphy, Illumination and Heraldry* (London, 2000).
63 Op. cit.
64 Fraktur is a German-style of Gothic Black Letter or Textura.
65 See footnote 50.
66 See footnote 38.
67 Schlag is a form of imitation gold, made from zinc and copper. It is available in various shades of gold.
68 Colossians 1: 15–20.
69 The bible in one volume, such as the Moutiers-Grandval Bible (see page 92)
70 An *incipit* marks the beginning of a chapter or book.
71 Gouache is similar to watercolour in that it consists of pigment and an adhesive, but it has a filler, chalk or *blanc fixe* (artificial barium sulphate) added to it which makes it opaque. It resembles egg tempera but it much easier to handle and used by most calligraphers when they write with colour.

Acknowledgements

Writing this book has been a pure joy, and having the excuse to study the letter-forms in many favourite manuscripts, and others not so familiar, has been such a delight. I am so grateful to Rob Davies and Jon Crabb at the British Library for both suggesting this book and then working so very hard to bring it to fruition.

Sally Nicholls and Pauline Hubner have done a terrific job in obtaining high-quality images from a number of sources, overcoming many challenges in the process. Maggi Smith's brilliant design work does full justice to these wonderful manuscripts. I owe a huge debt to many kind and patient palæographers who have freely shared their knowledge and made the scripts more meaningful. I have also appreciated the questions and ideas of many students, both in the lectures I have given and in practical courses I have taught. Lastly, none of this would have been possible without the continued support of my family, for which I am truly grateful.

Index

Figures in *italic* refer to pages on which illustrations appear
Figures in **bold** indicate a reference in an illustrated main entry